SPECTACULAR HOMES
of Ohio & Pennsylvania

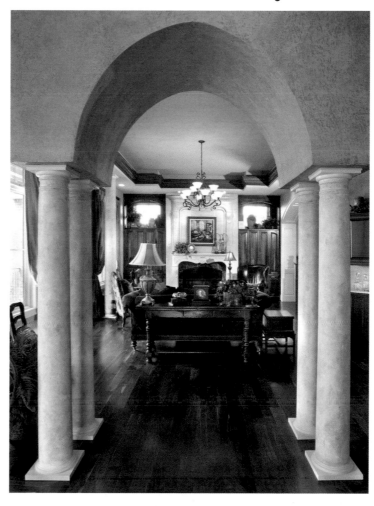

AN EXCLUSIVE SHOWCASE OF OHIO & WESTERN PENNSYLVANIA'S FINEST DESIGNERS

Published by

PANACHE
PANACHE PARTNERS, LLC

13747 Montfort Drive, Suite 100
Dallas, Texas 75240
972.661.9884
Fax: 972.661.2743
www.panache.com

Publishers: Brian G. Carabet and John A. Shand
Associate Publisher: Monique Kennedy
Editor: Rosalie Wilson
Designer: Emily A. Kattan

Printed in Malaysia

Distributed by Gibbs Smith, Publisher
800.748.5439

PUBLISHER'S DATA

Spectacular Homes of Ohio & Pennsylvania

Library of Congress Control Number: 2006935822

ISBN 13: 978-1-933415-25-3
ISBN 10: 1-933415-25-8

First Printing 2007

10 9 8 7 6 5 4 3 2 1

Previous Page: Diane Kidd, Kidd Interiors
See page 187 *Photograph by Robin Victor Goetz, RVG Photography*

This Page: Jean O Bugay, Jean O Bugay and Associates Design Firm
See page 217 *Photograph by Craig Thompson*

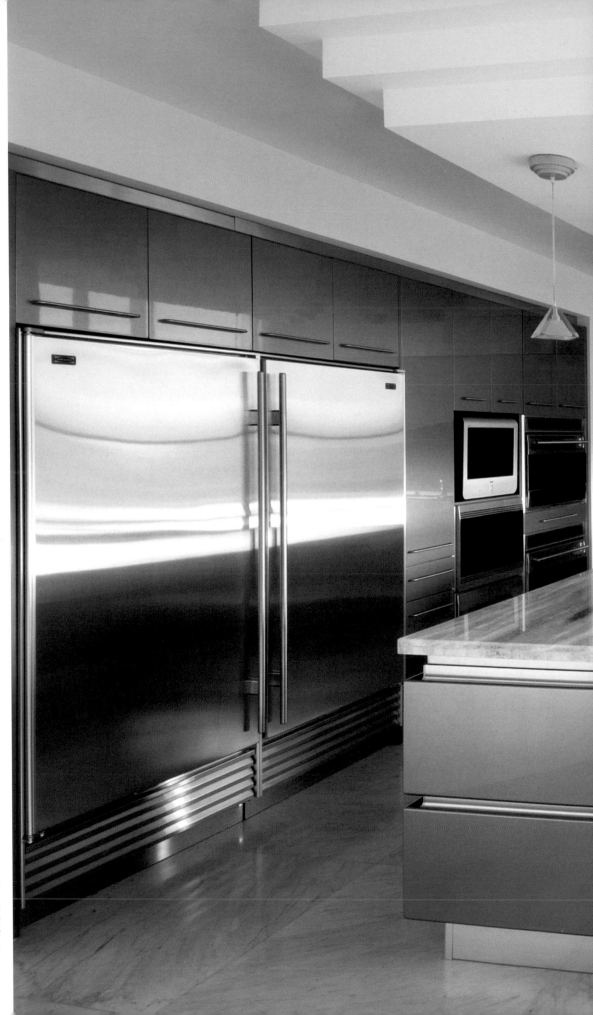

SPECTACULAR HOMES
of Ohio & Pennsylvania

AN EXCLUSIVE SHOWCASE OF OHIO & WESTERN PENNSYLVANIA'S FINEST DESIGNERS

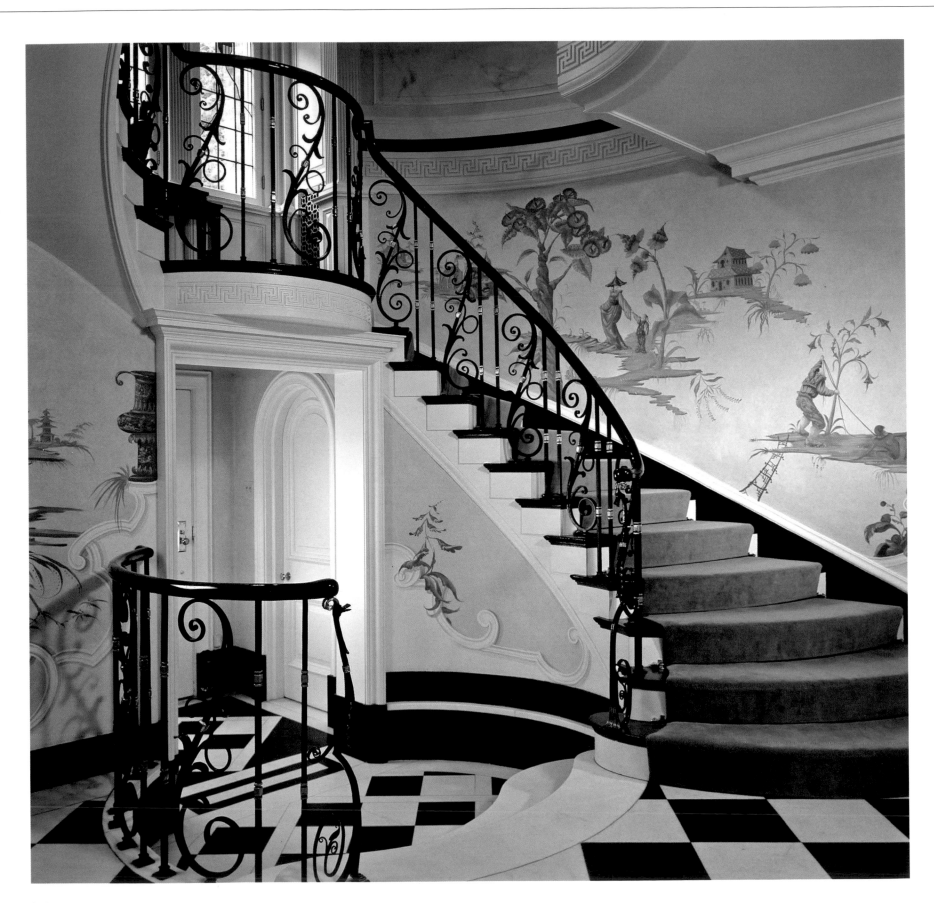

Creativity abounds in the beautiful, historic states of Ohio and Pennsylvania. The interior designers and decorators featured in this spectacular collection of words and images have chosen to call the region home not only for its cultural richness but for its stylistic possibilities, as well. Some of these professionals design in the towns in which they grew up, while natives of other states, even countries, made their way to the area as soon as they could.

Whether self-taught or trained at one of the country's finest institutions, just beginning their design journeys or celebrating multiple decades of success, these women and men are passionate about their work and dedicated to mingling fresh ideas with the Midwest's tried-and-true traditional flavor. All of the designers and decorators fully immerse themselves in the process of helping clients realize their definition of home, whether that be in a Conservative, Contemporary, Eclectic or even historical vernacular.

The striking interiors featured on the pages that follow were crafted expressly for an individual or family. The residents' interests and desires as well as current and future needs were thoughtfully considered, so if you could see yourself living comfortably in a home designed for someone else, just imagine what one of these designers could create with your specific preferences and lifestyle in mind.

Enjoy!

Brian Carabet & John Shand

Brian Carabet & John Shand
Publishers

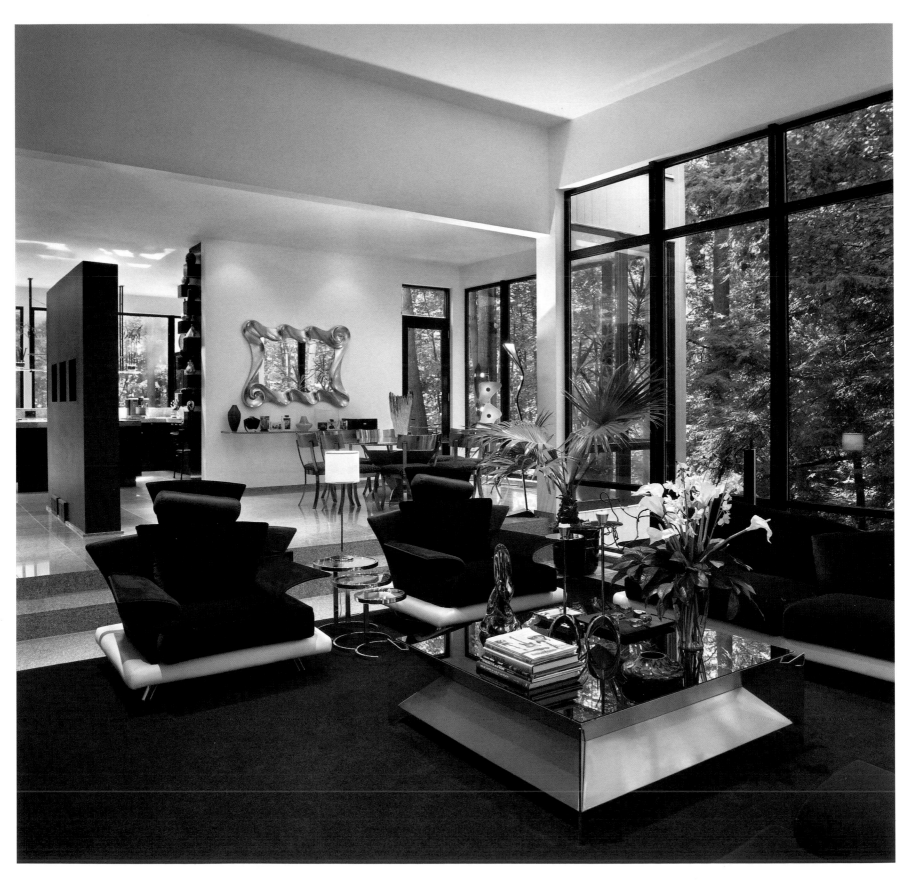

TABLE OF CONTENTS

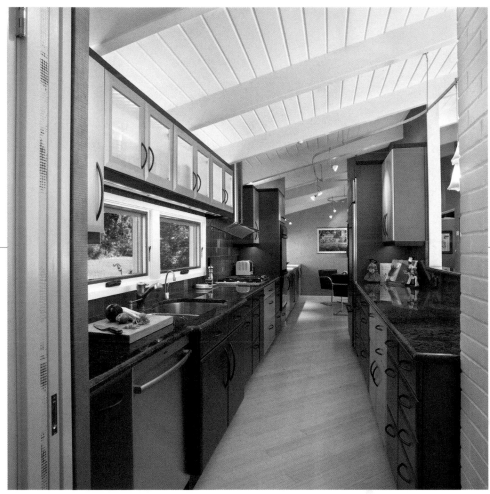

DESIGNER: Purdy's Design Studio, *Page 93*

Northern Ohio

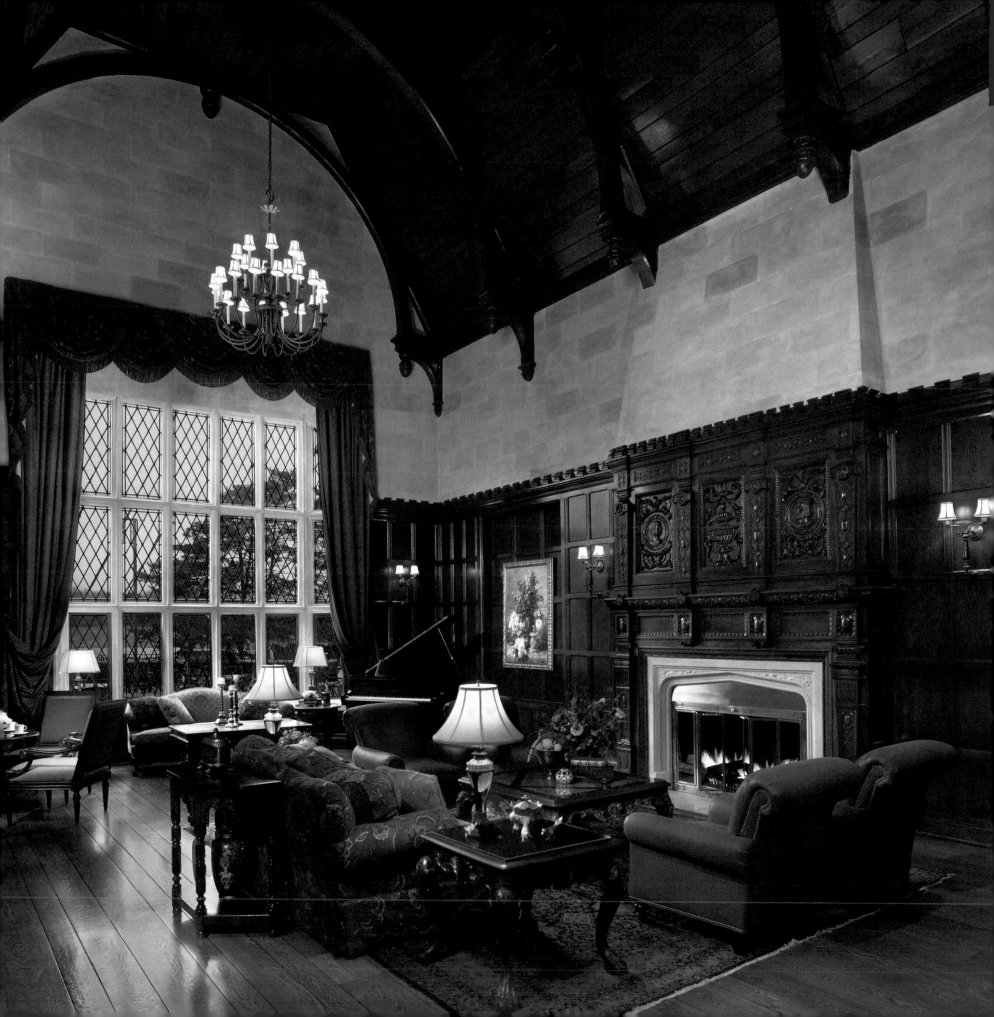

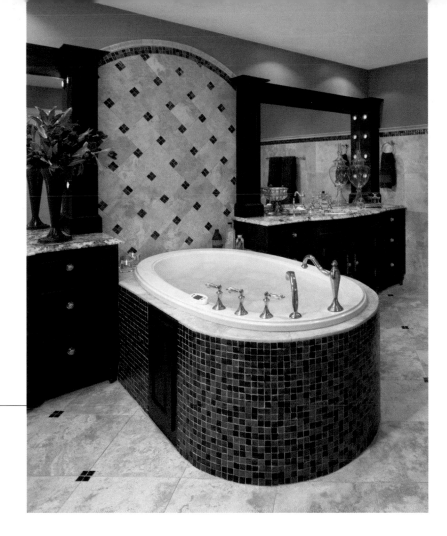

TRAVIS ABBOTT
TRAVIS ABBOTT INTERIOR

Travis Abbott has consistent and unique style and taste, but always works primarily to serve the vastly different needs of each project. He has designed Chicago lake view condominiums, Florida Keys vacation houses, and Ohio country homes and country clubs with equal panache.

Fashionable without being trendy, Travis' designs will stand for years without looking dated. He works closely with his patrons, guiding them through the design process, but not pushing them through it; he knows that letting the client steer the process is the best way to create a place in which the client wants to live, work or relax.

In Hudson, Ohio, Travis directed the renovation of Lake Forest Country Club's 1930's Tudor clubhouse, to the immense satisfaction of the club's members. Working with a design committee, he stayed true to the look of the period and unified the clubhouse's previously eclectic colors, fabrics, furniture and accessories.

Simply because it looks good in a magazine, or magnificent on a home tour, doesn't mean it is right for a specific client's house. Travis recognizes that everybody is different, as is every home. Once Travis and his clients have chosen an aesthetic, he follows through with it in every detail. This is accomplished by developing a close relationship not only with his clients, but his suppliers and sub-contractors as well. His success stems from being very particular, always following through and getting the most for his clients' money, within their allotted budgets.

Travis Abbott Interior specializes in full-service residential design, assisting clients through the selection of architectural details, collaborating with architects and builders, creating functional and inspiring living spaces and designing lavish custom furnishings.

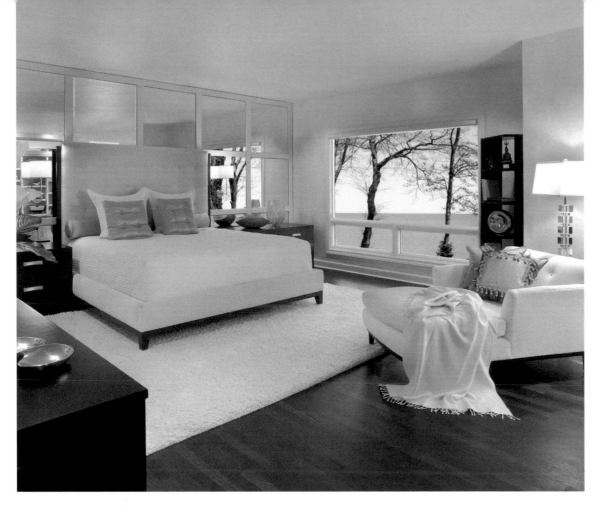

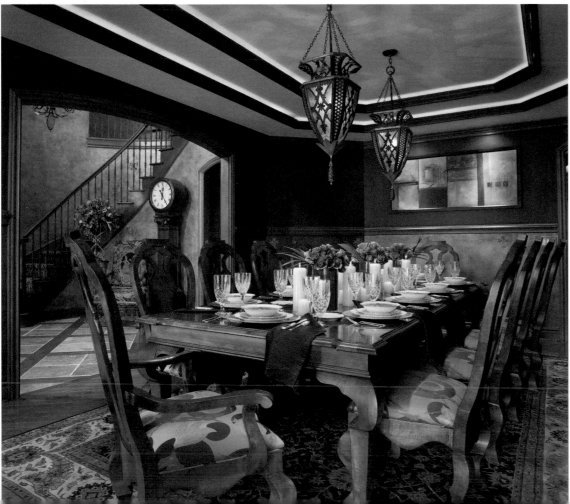

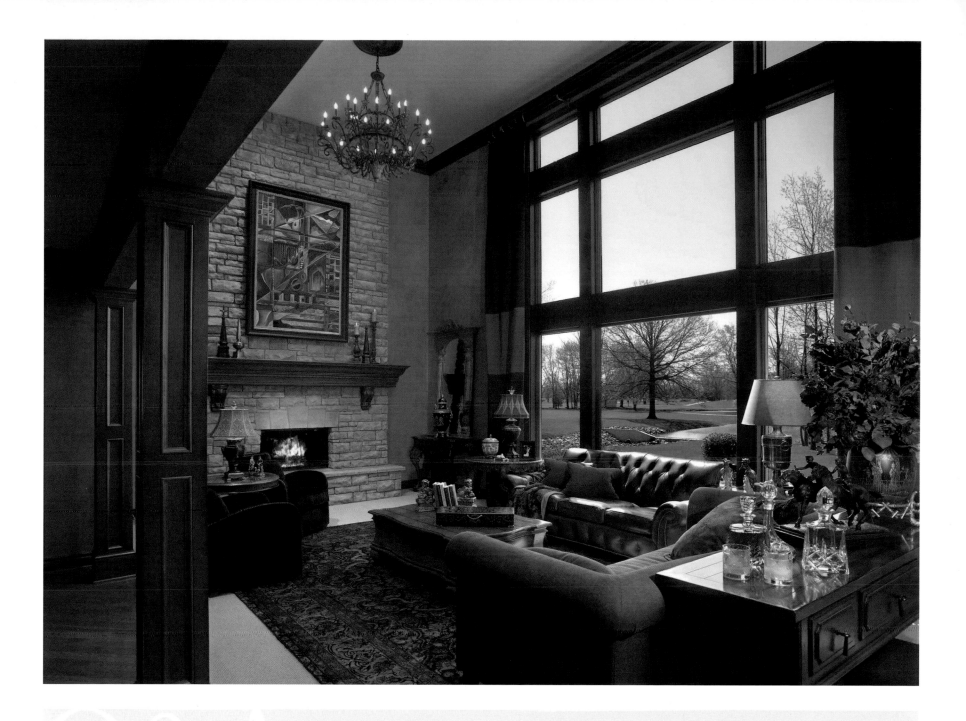

Q&A

more about Travis ...

WHAT PHILOSOPHY HAVE YOU STUCK WITH FOR YEARS THAT STILL WORKS FOR YOU TODAY?

Every project is different and one style never fits all.

WHO HAS HAD THE GREATEST INFLUENCE ON YOUR CAREER?

My grandmother had the biggest influence on me. She knew what was tasteful and what wasn't. She had a great sense of style.

WHAT IS THE MOST VALUABLE LESSON YOU HAVE LEARNED?

The greatest lesson I've learned in my career is to listen to my clients. Listening is really important. It's not about the business; it's not about me as a designer, it's all about my clients and their needs and desires. If I don't listen to what they're looking for and if I don't give them what they're looking for, then I'm not doing my job.

TRAVIS ABBOTT INTERIOR
Travis Abbott
11900 Edgewater Drive
Cleveland, OH 44107
216.401.5367
Fax: 216.228.1418
www.travisabbottinterior.com

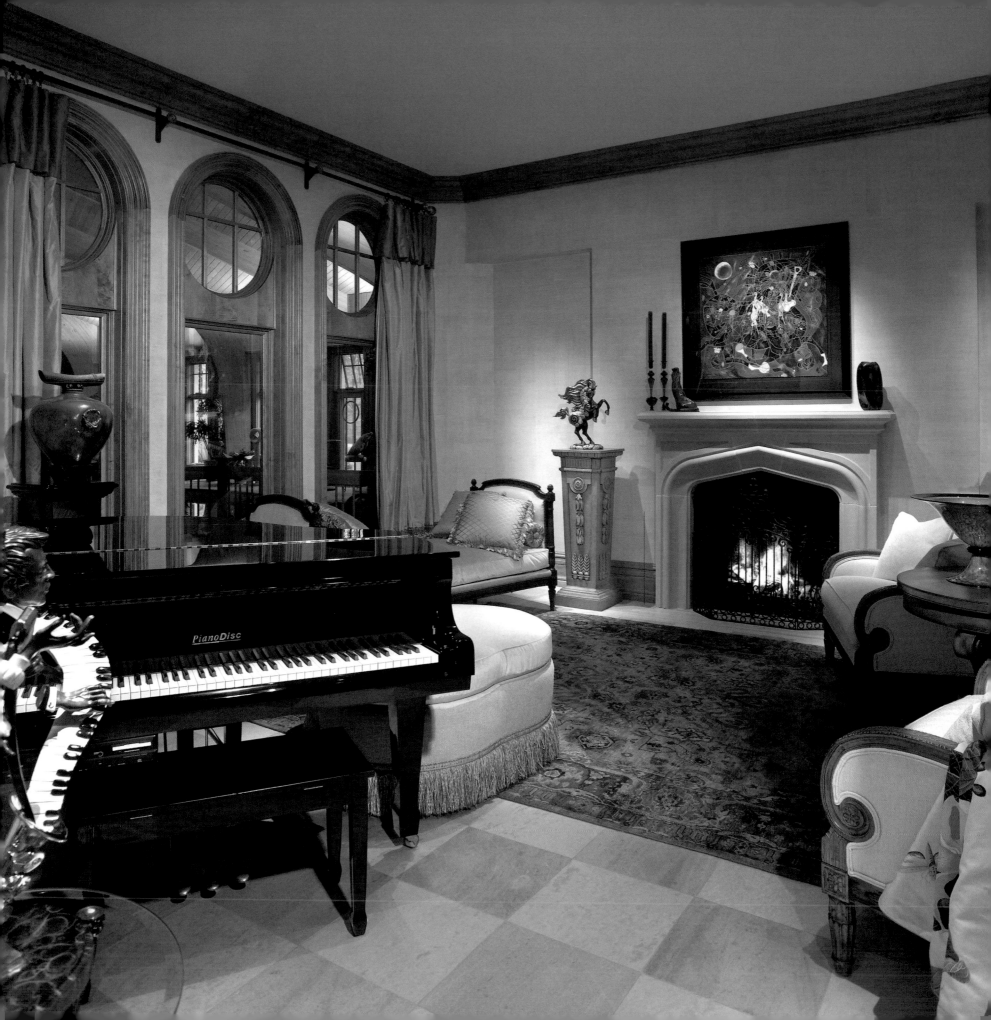

ASTIN/MUCKENSTURM
INTERIORS

Jon-Michael Astin and Rita Muckensturm encompass an extraordinary interior design firm that does more than mere design work—they strive to improve their clients' standard of living by reflecting the emotions, values and lifestyles that their clients embody.

With every client their focus and priorities lie within the elements of style, quality and value, which create projects that have a warm, comfortable and timeless appeal.

When Jon-Michael and Rita leave a project, anyone who visits it would know is that it was designed magnificently. Their goal is to reflect their clients' lifestyles, perceptions, comfort levels, colors and their visions of a dream house.

As their careers progress, Jon-Michael and Rita are finding that their clients are spending more and more time in their homes and because of this they want something comfortable and elegant. That is why it is imperative for their designs to be functionally beautiful for their clients.

A successful element to their business is the fact that the two work together to create cohesively wonderful interiors for their clients. Jon-Michael and Rita have realized that it helps a project blossom into its full potential when they work together. They say it helps to have two sets of ears and two sets of eyes on each project. They work within a masculine/feminine dynamic that makes for extraordinary final products.

When the pair designs a space for a client the first thing they tend to discuss is scale: Does the scale of furniture and accessories match the room? They ask themselves, "Is this the right furniture for this room? Is it comfortable and will most people feel it is?" In the end, these questions, when answered to their satisfaction, leave their clients in amazement at the comfortable elegance achieved.

ABOVE
The challenge in the great room of this northeast Ohio grand retreat of a home was to arrange the seating to create an intimate setting within a palatial space.
Photograph by Maguire Photographics

FACING PAGE
The color palette of this serene formal living room, soft shades of aqua and cream, is meant to allow the owner's collection of original art to stand on its own.
Photograph by Maguire Photographics

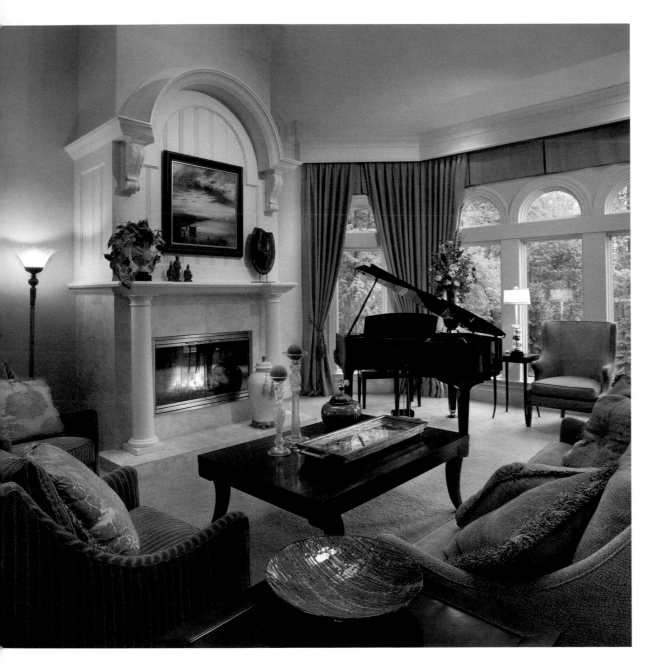

An important part of all design projects is building trust between Jon-Michael, Rita and their clients. Once this happens the project is smooth sailing. They achieve this trust through clear communication, an open dialogue and their knowledge of the business gained through experience. The goal is to complete a project to the customer's ultimate satisfaction, so when it's time to redo another room or vacation home they always get another call for their exquisite aesthetic.

Operating on the philosophy that every client that seeks their professional guidance has a different personality, has different needs, and works in different ways, Jon-Michael and Rita always make sure that when that project is finished it reflects their clients' aspirations, lifting the project's potential and delivering a dream come true.

LEFT
An elegant and eclectic design approach tamed the dominating architectural features of this living room to create warmth using softened earth tones.
Photograph by Maguire Photographics

FACING PAGE
A master suite that evolved into a weekend getaway destination best describes this magnificent outcome using plum and cream tones accented with citrus green.
Photograph by Maguire Photographics

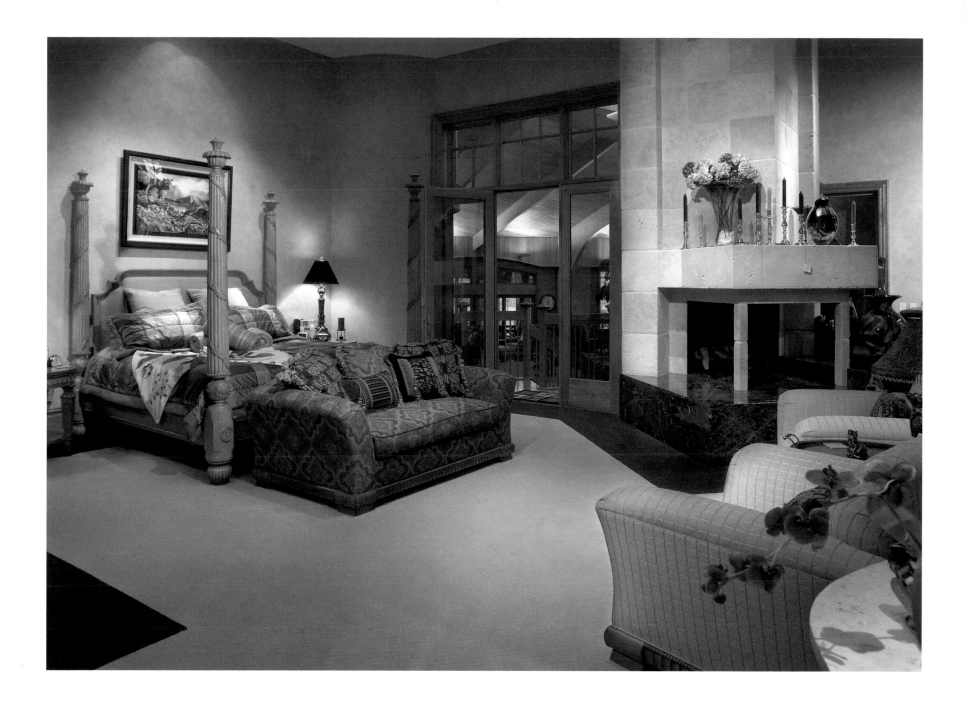

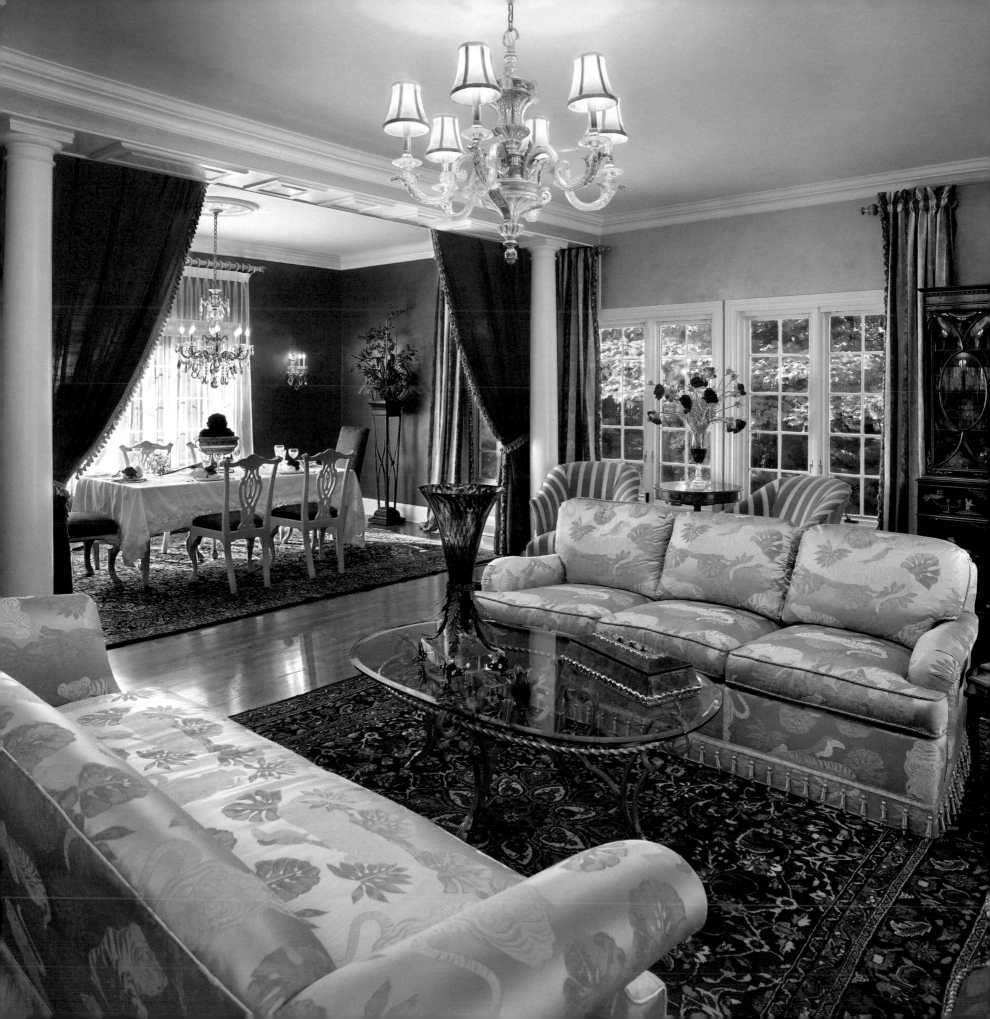

Bonnie Banks

BONNIE BANKS DESIGNS. INC.

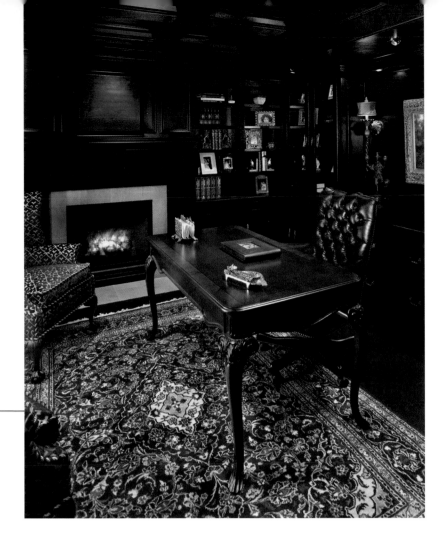

Bonnie Banks, Allied Member ASID, studied interior design while being a wife and mother of three. She began her career rather late in life, at the age of 35. After finishing school, she was excited to put into practice her talent and training by being hired at a prestigious design firm, Bonhard's in Shaker Heights, Ohio.

After a number of years working with two prestigious design firms, Bonnie started her own company, Bonnie Banks Designs, Inc., in 1981. She has since provided exquisite interiors for clients of various income levels because she feels everyone deserves to be surrounded by beauty.

Bonnie was born in Tuskegee, Alabama, where her father was a horticulturist. He relocated the family back to Cleveland, Ohio and became the chief horticulturist for the city's greenhouse, gardens and parks. Bonnie's father had a major influence on her interior design aesthetic because she was always surrounded by beautiful flowers and the colors they encompassed. Her father was the first person to tell her that all colors in nature work together. That nugget of aesthetic wisdom allowed her the ability to use color combinations most people would never have chosen, much to her clients' delight.

Designing specifically for clients, Bonnie doesn't believe she has a signature look. She spends a great deal of time with client interviews to determine and define their personal taste and style. She likes an eclectic design that incorporates different styles into a unique mix of timeless interiors.

Although today Bonnie is primarily a high-end residential designer, she has done many commercial projects in the past that have contributed to her respected and admired design portfolio. She worked on the renovation of the Cleveland Water Department and Harvard Yards, as well as joint venturing on the Cleveland Hopkins International Airport Renovation Project. She has held contracts with the Cleveland Metropolitan Housing Authority, in which she renovated many public spaces, lobbies and model suites. She has also designed numerous model homes for developers.

ABOVE
The office's custom cherry cabinetry and paneling are complemented by red lacquer, a hand-painted wall covering on the back wall and the exquisite coffered ceiling.
Photograph by Jim Maguire of Maguire Photographics

FACING PAGE
An elegant living room features faux-finished gold walls, sofas upholstered in gold satin and striped damask window end panels in red and gold. Red silk draperies separate the living and dining rooms. Draperies by Carmen's Custom Drapery.
Photograph by Jim Maguire of Maguire Photographics

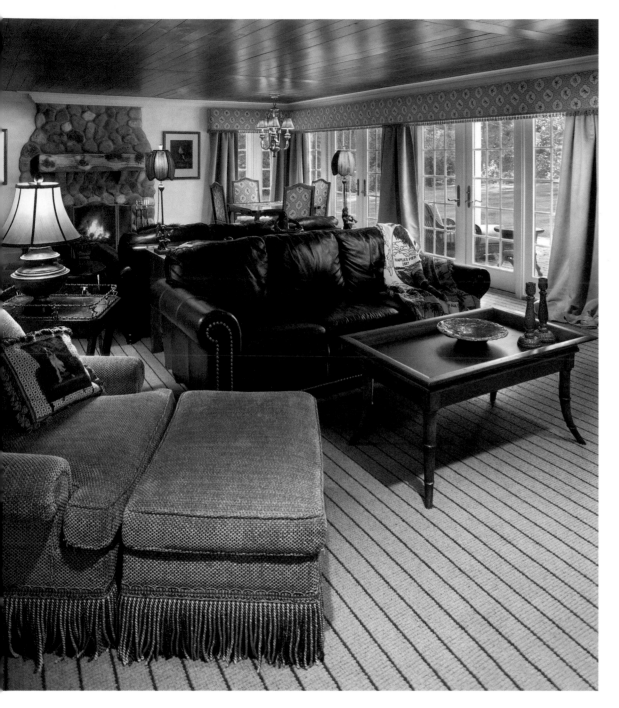

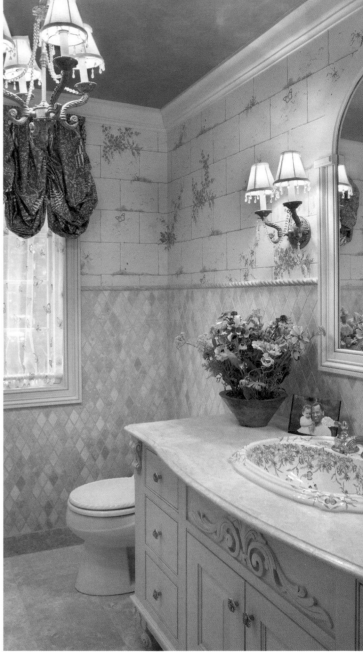

An aspect of Bonnie's career that has proved successful is her ability to market herself. She was the first to design, develop and present an interior design segment for television. Her 30-minute segment on "The Morning Exchange," airing between 1981 and 1984, was broadcast on the local ABC affiliate television station.

When working with an architect or builder, Bonnie works closely to ensure there is a cohesive design throughout the project. Her goal is not only to design for her clients' current needs, but to anticipate their future needs as well. She is satisfied when her clients are happy with the final project.

At the end of the day, Bonnie's greatest pleasure is spending time with her three adult children, grandson, other family members, wonderful friends and her inquisitive cat, Smokey.

ABOVE LEFT
The family room cleverly accommodates two seating arrangements, which face stone fireplaces at opposite ends of the room.
Photograph by Jim Maguire of Maguire Photographics

ABOVE RIGHT
This exquisite girl's bathroom includes a faux-painted ceiling, hand-painted wallcovering, limestone tile, marble flooring and countertop, a hand-painted sink and a butterfly-embroidered sheer under a balloon valance.
Photograph by Jim Maguire of Maguire Photographics

FACING PAGE LEFT
Ultrasuede wall panels within the master bedroom's alcove tie in with the dust skirt and drapery beyond.
Photograph by Jim Maguire of Maguire Photographics

FACING PAGE RIGHT
An elegant bathroom boasts skylights, a faux-finished ceiling, marble vanity tops, hand-painted sinks and custom cabinetry.
Photograph by Jim Maguire of Maguire Photographics

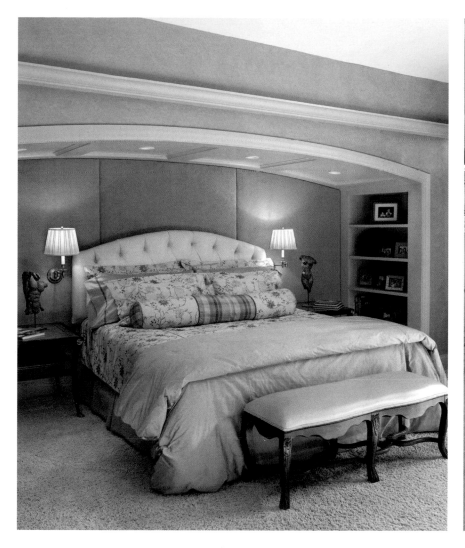

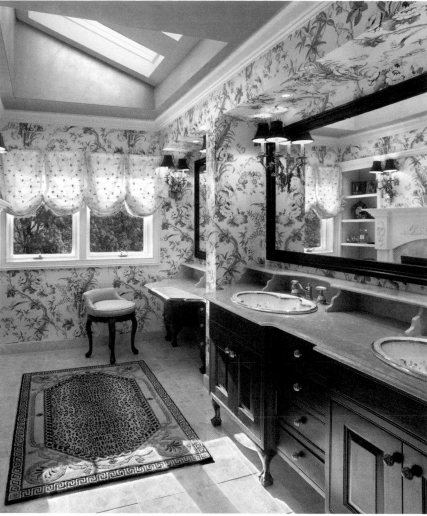

more about Bonnie ...

DESCRIBE YOUR INTRODUCTION TO THE INTERIOR DESIGN BUSINESS.

I was elated to be hired by The Bonhard Company and grateful for the chance to work with and learn from some of the most talented designers in the area. This family-owned business gave me an incredible opportunity to hone my skills and develop my talent. Those years were priceless and began my wealth of experience in the interior design industry.

WHAT WOULD YOU DO TO BRING A DULL HOUSE TO LIFE?

Use interesting paint colors and unique faux techniques.

WHAT IS THE BEST PART OF BEING AN INTERIOR DESIGNER?

Being able to meet new and interesting people and to express my creativity while incorporating my clients' tastes and styles.

WHAT ONE PHILOSOPHY HAVE YOU STUCK WITH FOR YEARS THAT STILL WORKS FOR YOU TODAY?

Listening carefully to what people want and need and maintaining a relaxed, open line of communication.

BONNIE BANKS DESIGNS, INC.
Bonnie Banks, Allied Member ASID
19024 Winslow Road
Cleveland, OH 44122
216.561.2677
Fax: 216.561.1771

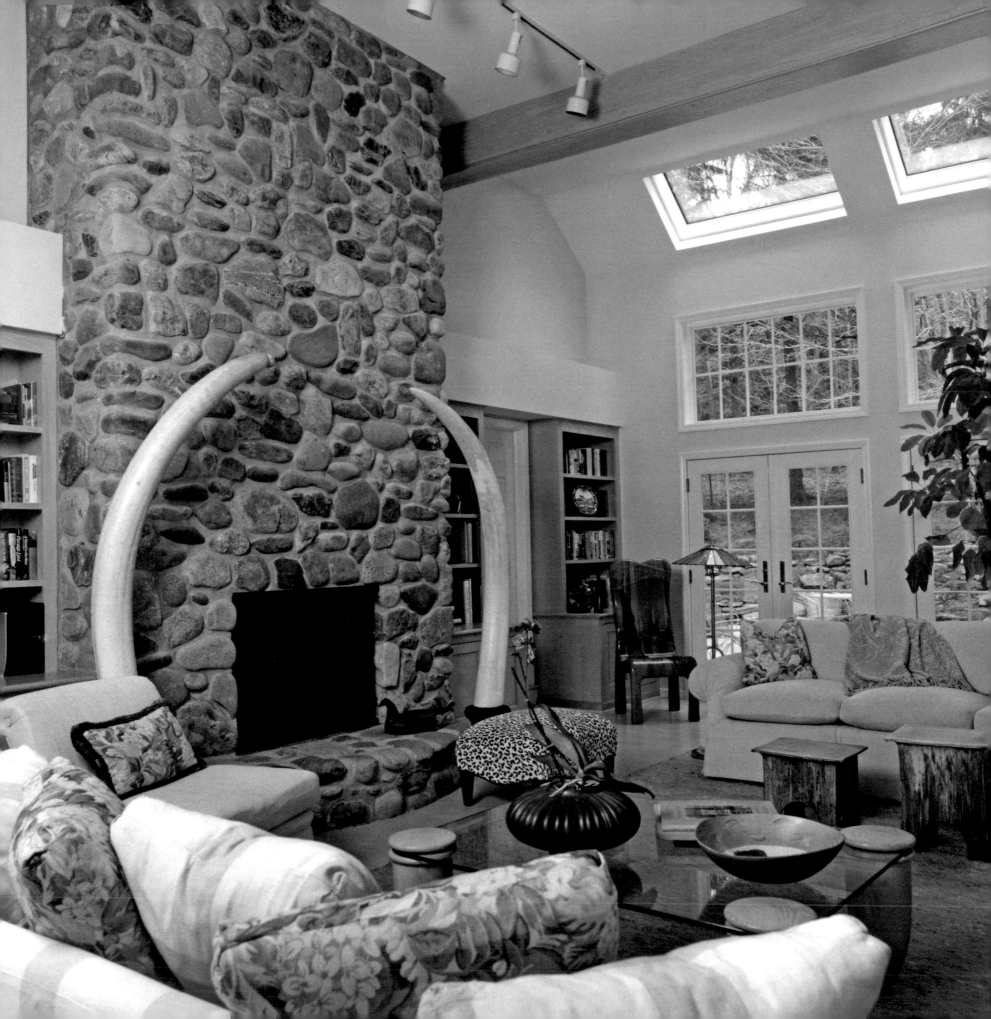

REITA BAYMAN
REFLECTIONS INTERIOR DESIGN

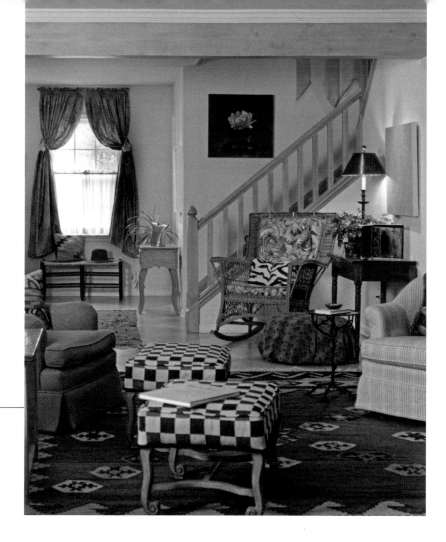

During the eight years she spent as a Registered Nurse in Public Health, Reita Bayman discovered that people who kept their homes clean and orderly were consistently happier and better adjusted. When she began creating peaceful environments as a favor for friends, she realized she had a talent for interior design. She then added formal knowledge to her skills, studying via correspondence with the New York School of Design.

In 1980, Reita formed Reflections Interior Design, and the firm began taking commissions in Ohio, Florida, Maryland, North Carolina, Illinois, Colorado and New York City, winning five ASID awards along the way.

Guiding every project Reflections undertakes is Reita's philosophy: Good design is about solving problems.

The first step in creating solutions for clients is to put them through a series of questions to see how they feel about the specific design elements of contrast, color, texture and scale. Then style preferences are analyzed, keeping in mind that frequently people say they like a particular style when, in fact, what they actually like might be the straight or curved lines common to that style. This process of discovery is often as revealing for the client as it is for the designer.

The next step is to look at the architectural features of the house and compare them to the intended uses of the space and the traffic patterns, both current and ideal. After this, remedies are described in terms of those design elements. Only then can a decision be made on what should go into the space in question. "The most common mistake people make when they design on their own," Reita says, "is that they go shopping without a plan and wind up buying only what they like. This creates rooms filled with things they like but that don't like each other. Spaces like this just don't work; they are

ABOVE
The appropriate use of color, texture, scale and feel with rhythm and relationships produces a comfortable feeling that draws you in and encourages you to sit down and relax.
Photograph by Jean Van Atta

FACING PAGE
Where to put your seven-foot ivory tusks? This design solution creates interest and discussion. Elements from nature connect the inside to the outside through the doors, windows and skylights.
Photograph by Jean Van Atta

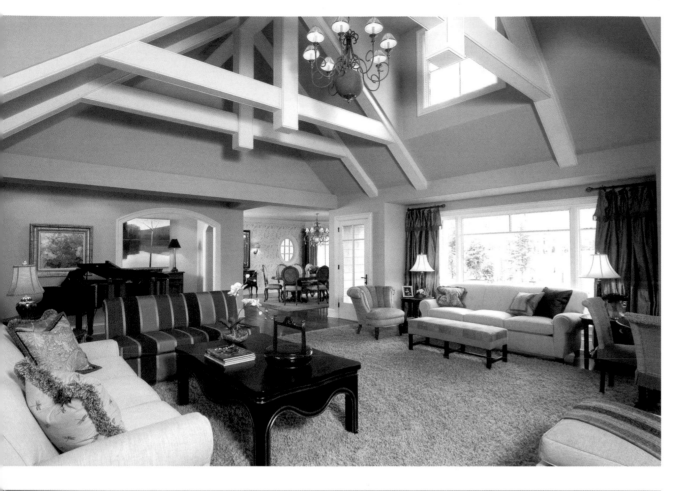

uncomfortable and out of balance. Many people have good taste; what they lack are the skills to turn their ideas into reality. That's what we provide."

For the last 15 years, Reflections has offered "The Secrets of Interior Design." In these six, two-hour classes, clients who prefer to do their own interior design work apply The Design Formula, learn to create rhythm and relationships, practice analyzing space, develop floor plans and learn to save money by using things they already own while sticking to a realistic budget.

Cable shows about good design fill the classes with clients frustrated at seeing rooms they like but are unable to create. Once the "secrets" are explained, frustration turns to understanding and spaces (like the ones Reflections creates for clients) are peaceful, comfortable and in balance.

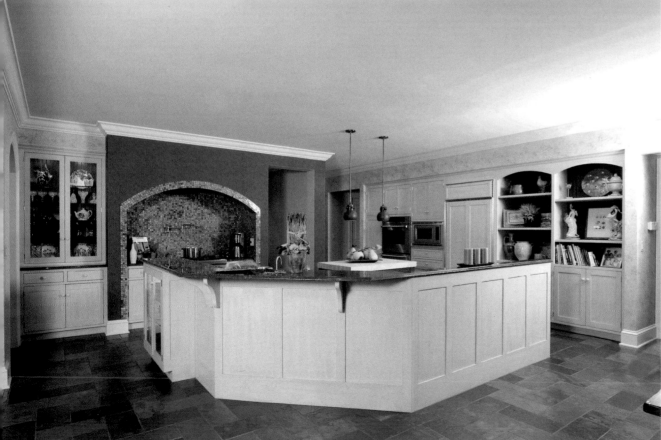

TOP LEFT
The design goal for this huge ninth-green great room was to create several intimate conversation groupings that were warm and inviting.
Photograph by Jean Van Atta

BOTTOM LEFT
This kitchen sits in the center of the house and is highly visible. Bookcases and a library counter make the space comfortable and serene.
Photograph by Jean Van Atta

FACING PAGE
The conversion of the 36-foot *See ya!*, from a fishing clubhouse to a comfortable and peaceful environment, was honored with an ASID Award for "Creativity in Interior Design."
Photograph by Jean Van Atta

more about Reita ...

DESCRIBE YOUR STYLE OR DESIGN PREFERENCES.

We do not impose our personal preferences on our customers. We interview them first to determine their design preferences, the uses of the spaces in question, and feel they want to achieve. Then we help them create the space they had in mind. As such, we do not have a "style." If there is a style to our work, it is that the rooms and spaces we create are warm, inviting, peaceful and comfortable. The elements in them relate specifically to the people whose rooms they are, not Reflections Interior Design LLC.

WHAT ONE PHILOSOPHY HAS STUCK WITH YOU THROUGH THE YEARS?

The Design Formula is the tool we use to create rhythm and relationships using color, texture, scale and feel. We use it to plan what we intend to do, to check on what we are doing while we are doing it, and to evaluate our results. Rooms that do not make use of The Design Formula are often out of balance and uncomfortable, no matter how many of the elements within it are favorites of the person whose room it is.

REFLECTIONS INTERIOR DESIGN
Reita Bayman
12423 Cedar Road
Cleveland Heights, OH 44106
216.229.1000
www.reflectionsinteriordesign.net

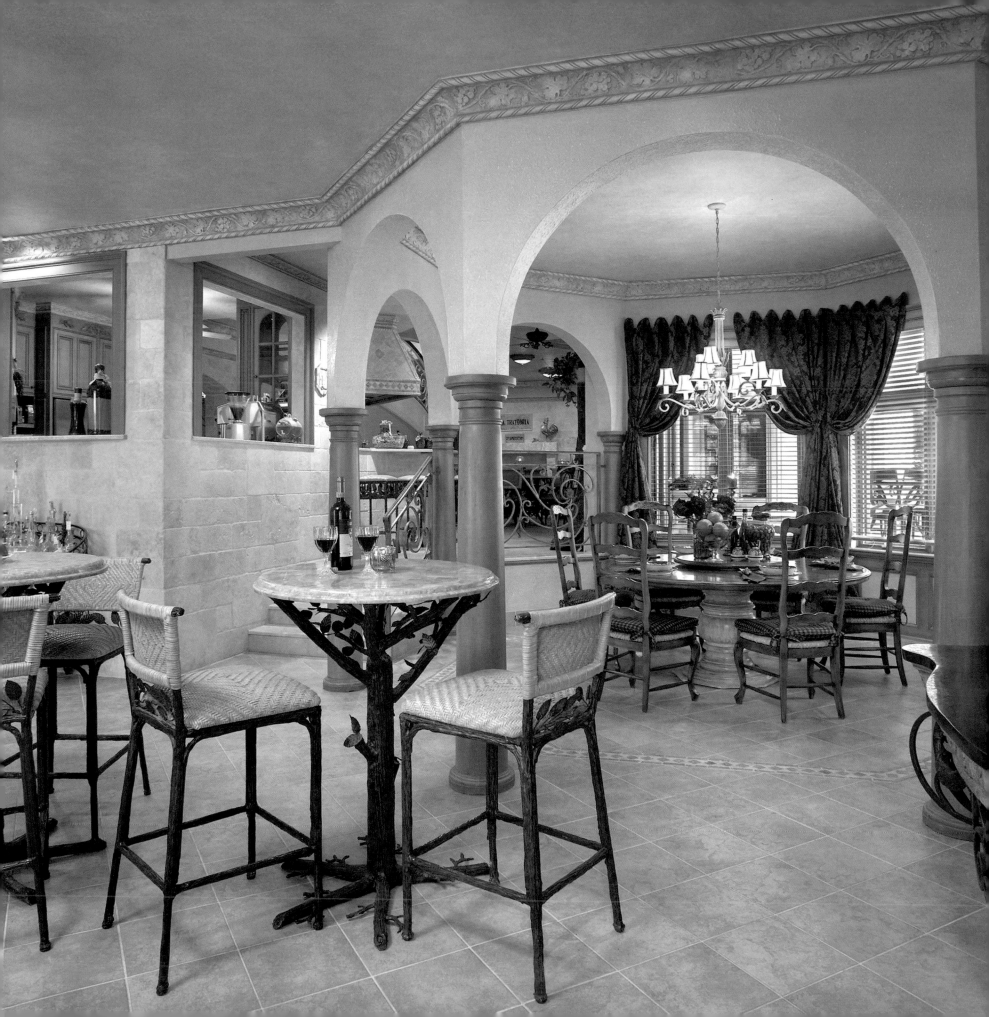

PAULA JO BOYKIN
SPECTRUM DESIGN SERVICES

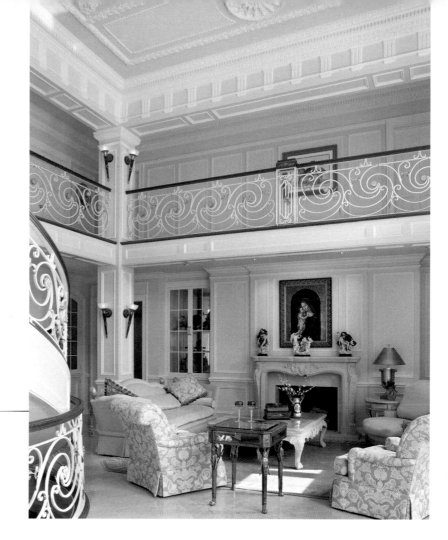

Paula Jo Boykin, ASID, isn't your typical interior designer. She won't come to your house just to reorganize your closet or help you pick out living room draperies. But if you've got 15,000-square-feet's worth of flooring, windows, and doors to consider, she's the lady to call. If your 6,000-square-foot penthouse needs to be gutted and remodeled, Paula's got the staff and resources for the job. And if you need the drawings to keep contractors on your 35,000-square-foot manse on track, look no further.

With offices in Cleveland, Ohio, and Cornelius, North Carolina, Paula's company, Spectrum Design Services, currently employs a team of 10 design and administrative professionals (including the owner-operator). The staff varies in age and experience, allowing for input and influences from different perspectives. That's one advantage of the firm, but the biggest separation between SDS and others is the company's roots in hospitality design. Designing hotels and restaurants provides a strong foundation for residential design, allowing the team to create wholly unique solutions to the executive entertaining and living requirements of the high-end homeowner.

SDS began 26 years ago as a hospitality design firm. Working on branded and independent hotels, resorts, and conference centers nationwide, and helping to revolutionize the look of hospitality design, brought a tremendous amount of knowledge and insight to the residential division. It has evolved through the years into a firm that takes on a variety of commercial work for major national corporations as well as high end residential projects.

Always trying to improve their services and alliances for quality client satisfaction, SDS recently merged with the widely respected firm of mbi | k2m Architecture, Inc. With offices in south and west Florida, Houston, Texas and Cleveland, Ohio—and 30 employees—the duo is working together to bring exquisite custom-built projects to all corners of the country.

ABOVE
Opulent and formal, with exquisite architectural details by Anthony Paskevich, describe this monochromatic living room.
Photograph by Jim Maguire of Maguire Photographics

FACING PAGE
A lower-level Tuscan dining option for guests in this 15,000-square-foot Tuscan villa.
Photograph by Jim Maguire of Maguire Photographics

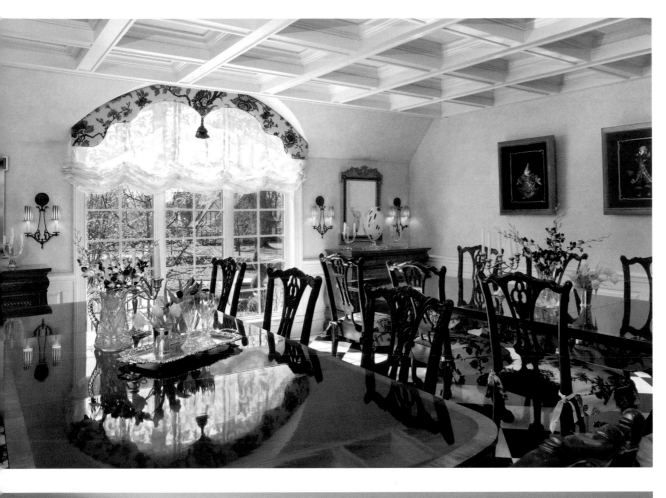

"Working on a home is just as complicated as a multimillion-dollar office or hotel," Paula says. And the designer's strong business aptitude and communication skills come into play in both. So does her buying power: She is often able to use her leverage to gain access to custom work, products not readily available to most residential designers, or lower prices for premium goods.

And because she is a designer whose reputation precedes her—many of her residential clients are executives associated with her commercial projects—the homeowners who hire Paula do so with confidence. They know she has a passion for what she does and a commitment to quality.

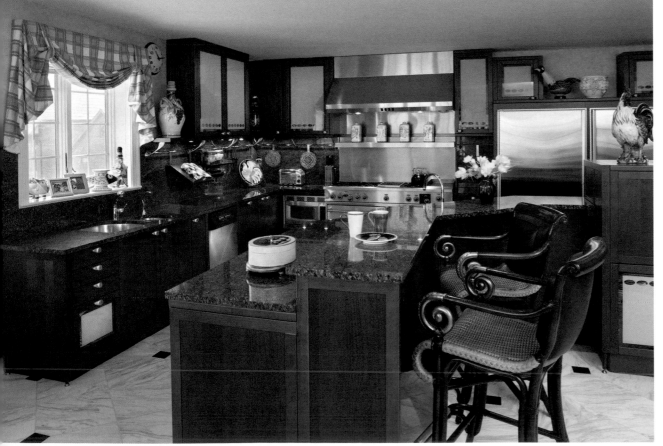

TOP LEFT
A mirror image dining room offers dining for 24 special guests.
Photograph by Jim Maguire of Maguire Photographics

BOTTOM LEFT
Italian-made Snaidero cabinetry in cherrywood warms up this spacious commercial kitchen.
Photograph by Jim Maguire of Maguire Photographics

FACING PAGE LEFT
A powerful statement is made in the foyer of this country home with its timeless, bold black and white marble floor, carved doors and leaded glass windows.
Photograph by Jim Maguire of Maguire Photographics

FACING PAGE RIGHT
A cozy retreat in the gourmet kitchen is complete with a raised fireplace and casual seating.
Photograph by Jim Maguire of Maguire Photographics

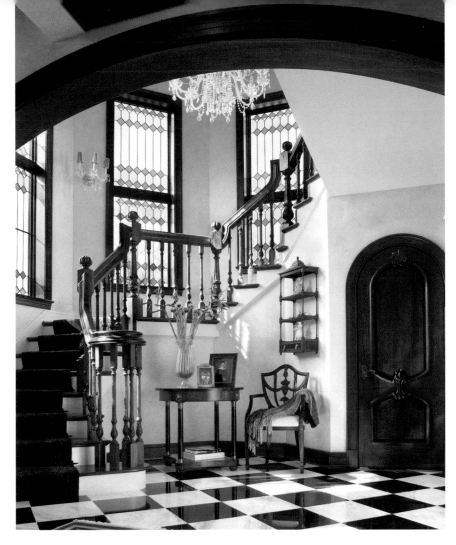

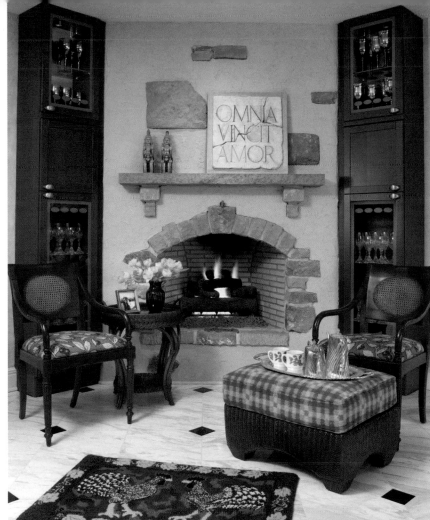

more about Paula Jo ...

WHAT PERSONAL INDULGENCE DO YOU SPEND THE MOST MONEY ON?

With my husband, I have traveled the world: Antarctica, Africa, South America, Australia, you name it I've been there or want to go. Tahiti, Italy, Myanmar and Hong Kong are among my favorite destinations. When I'm on the road, my camera never stops clicking. I feel very fortunate to be able to do so much global travel and see design solutions all over the world. My travels are experiences I share with my team and my clients.

WHAT'S ONE THING MOST PEOPLE DON'T KNOW ABOUT YOU?

As the oldest of six children, I come from a big family. I also have 75 first cousins spread out from Ohio to California—all of whom I've met.

WHEN YOU'RE NOT WORKING, WHERE CAN PEOPLE FIND YOU?

In my free time, I like to paint watercolors and write—I've authored two college textbooks on hospitality design and would like to write a novel someday. I'm also a grandmother of two and enjoy spending time with my grandchildren.

SPECTRUM DESIGN SERVICES
Paula Jo Boykin, ASID, IIDA
45 West Prospect Avenue, Suite 1510
Cleveland, OH 44115
216.241.8450

19824 West Catawba
Cornelius, NC 28031
704.894.0955
www.spectrumdesign.com

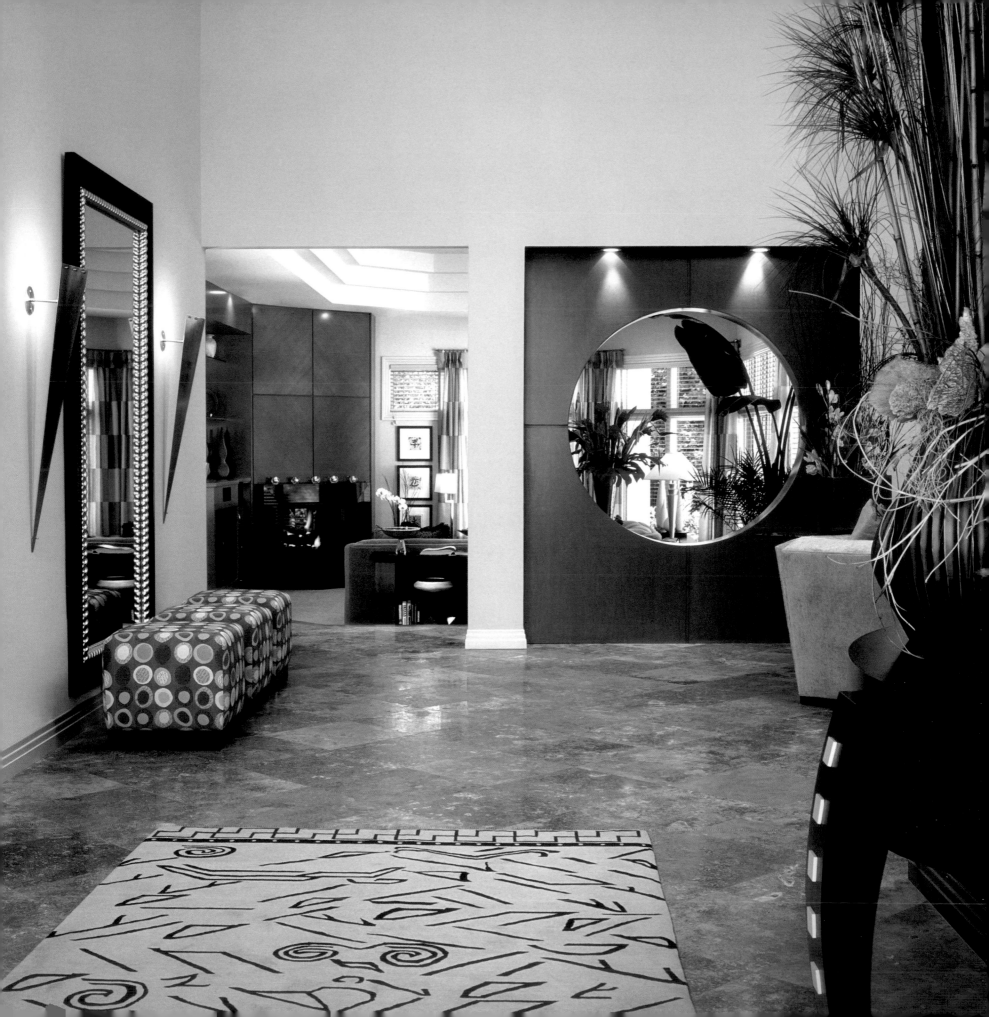

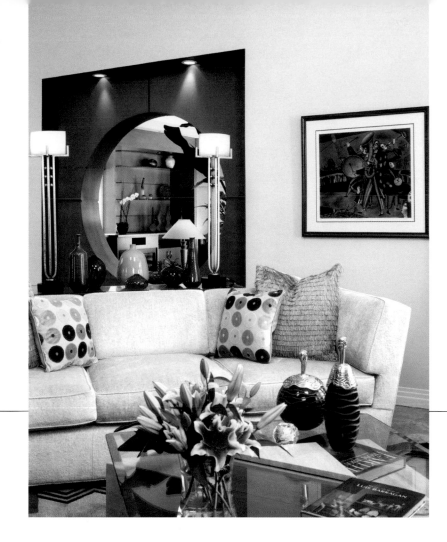

JORGE CASTILLO
JORGE CASTILLO & ASSOCIATES

Jorge Castillo feels that his interiors are more than furniture, paint and artwork; in fact he feels that his work is a direct artistic expression of his passion and lust for life. His clients get to enjoy the embodiment of this enthusiasm in their homes on a daily basis.

Originally from Mexico, Jorge moved to Cleveland 18 years ago, went to school, had an internship with a local designer and then in 1998 started his own interior design firm, Jorge Castillo & Associates. Since then, he has created fine interiors for both residential and commercial projects with an emphasis on architectural details in new construction.

With an intimate knowledge of interior architecture and all things related to architecture, Jorge relishes working with architects and builders from the blueprint stage. A very hands-on designer, he gets involved 100 percent on every single project.

Known for his signature style that tends toward the Modern, Jorge is aware of the fact that clients may come to him for his clean, sophisticated and simple designs but that they also have their own ideas. He is always happy to accommodate their wishes. His strategy is to apply the wants, desires and personality of his clients within the context of his style—thus creating a happy medium that clients enjoy coming home to for years. However, he does create traditional interiors as well and feels that educating a client about a broad range of stylistic possibilities is a duty for every designer who wishes to broaden the design horizons of their community.

The biggest influences for Jorge have been Philippe Starck and Mexican architect Luis Barragan. Jorge enjoys Starck's work because he feels that

ABOVE & FACING PAGE
The feel is neutral with splashes of color. Jorge divided the living room from the family room with an accent wall that has a circular cut out.
Photograph by Bill Webb, Infinity Studio

| 31 |

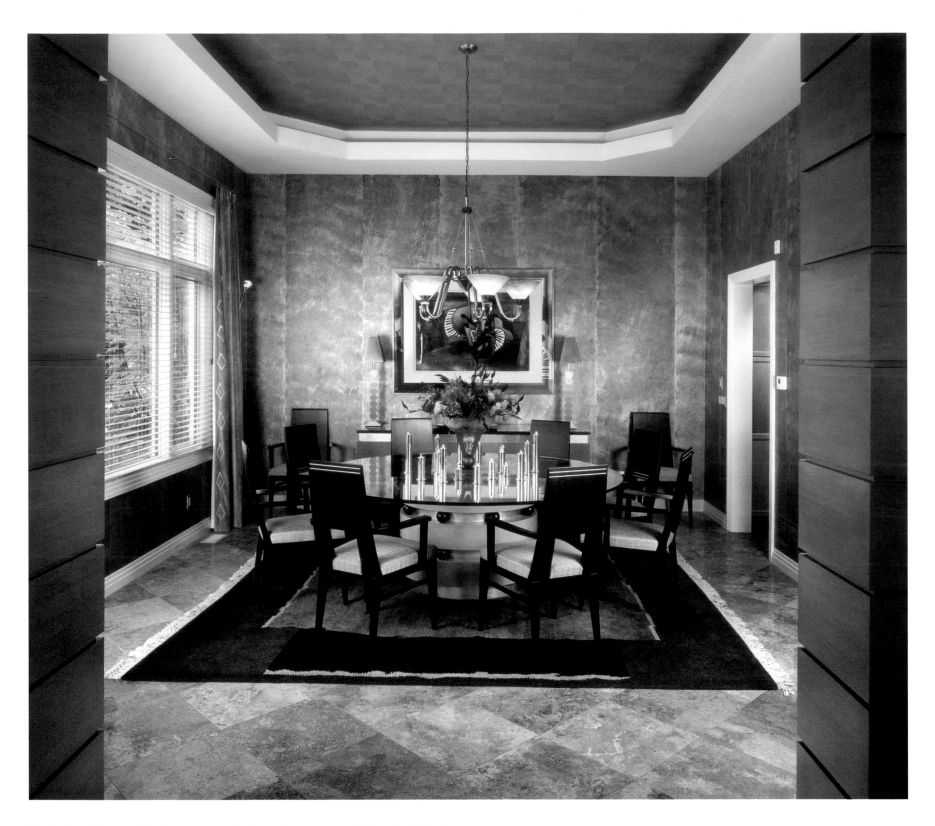

his designs have soul and substance that create a warm and theatrical feel; he enjoys Barragan's work because it is minimal yet sumptuous in both color and texture. He incorporates these philosophies into his own work by putting his interiors into context and expressing a thought, feeling or dream to which his clients can relate. This makes their homes and offices ultimate getaways from the everyday stresses of life.

ABOVE
For the Sexton's dining room, Jorge designed a round table that creates a welcoming and casual atmosphere.
Photograph by Bill Webb, Infinity Studio

FACING PAGE
Glass accessories and fresh flowers complement a Jamali painting that hangs over a floating console.
Photograph by Bill Webb, Infinity Studio

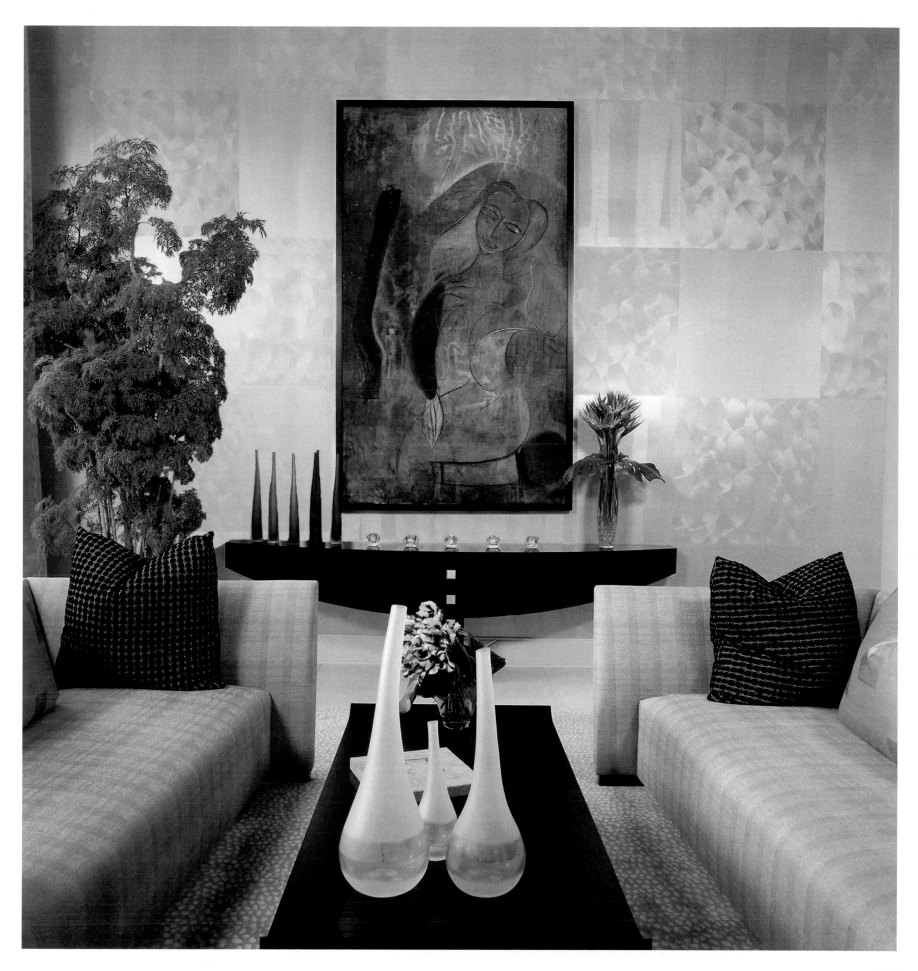

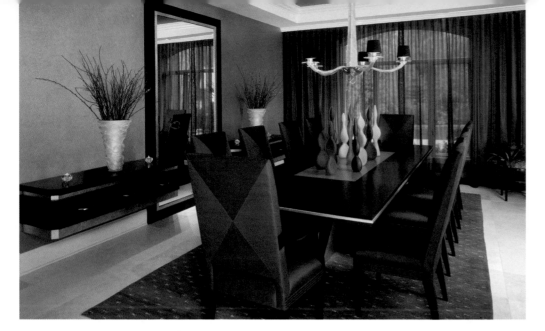

Jorge provides a unique level of customer service by doing everything in his power to create a complete design; this often includes custom furniture and other special pieces. Mostly creating in the medium of wood, he works closely with a woodworker to invent furniture that is very contemporary, clean-lined and always beautiful.

Following in the footsteps of Philippe Starck and Luis Barragan, Jorge strives to create wonderful interiors that convey a sense of beauty through a fantastic blend of client wants and needs, the expressions of which are always magical.

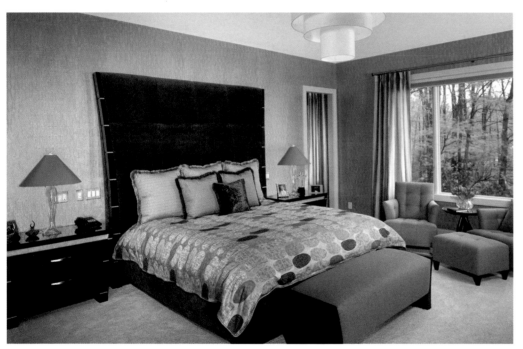

TOP LEFT
Jorge designed the table, console and mirrors crafted of mahogany and silver leaf accents. The chairs are from Donghia and recovered in two contrasting silk fabrics.
Photograph by Bill Webb, Infinity Studio

MIDDLE LEFT
Bed, nightstands and bench designed by Jorge. The bed is upholstered in a chocolate brown chenille fabric. The nightstands are mahogany and silver leaf.
Photograph by Bill Webb, Infinity Studio

BOTTOM LEFT
This living room features two Donghia island sofas and Klismos chairs. Jorge designed the built-ins on each side of the fireplace. The built-ins are finished in silver leaf.
Photograph by Bill Webb, Infinity Studio

FACING PAGE
The cabinets are crafted of anegre and sapelli woods. The concrete bar top and side has inlaid fiber optic lights. The round table is made of resin.
Photograph by Bill Webb, Infinity Studio

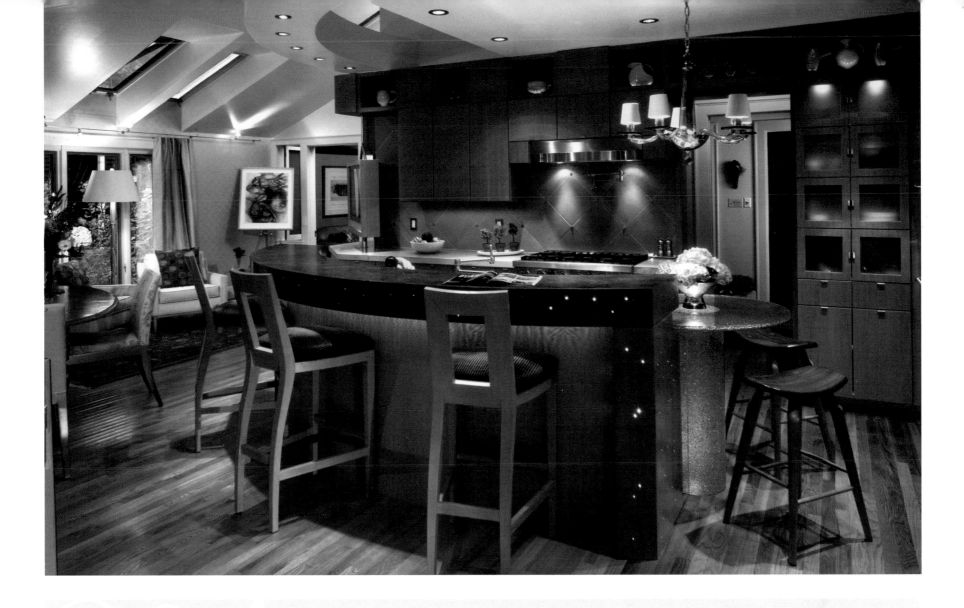

more about Jorge ...

WHAT SEPARATES YOU FROM YOUR COMPETITION?

My style.

WHAT ELEMENT OF YOUR BUSINESS DO YOUR CLIENTS FIND MOST VALUABLE?

When we do new construction, for example, it is very important to communicate our ideas, and the best way to do so is by presenting elevation and perspective drawings. Clients appreciate that we go the extra mile because it inevitably leads to a successful result.

WHAT IS THE HIGHEST COMPLIMENT THAT YOU HAVE RECEIVED PROFESSIONALLY?

The gratitude and thanks that I receive from my clients.

WHAT ONE ELEMENT OF STYLE OR PHILOSOPHY HAVE YOU WORKED WITH FOR YEARS THAT STILL WORKS FOR YOU TODAY?

It is taking furniture and elements from the mid-century and applying them with Modern design. It is a clean and simple style. No clutter and no fuss.

WHAT IS THE MOST UNIQUE ELEMENT OF YOUR BUSINESS?

I feel that I am very easy to work with, approachable and have a great sense of style. Plus, I'm good at reading people and helping them figure out what design will suit their lifestyle.

JORGE CASTILLO & ASSOCIATES
Jorge Castillo
13302 Cormere Avenue, Suite #304
Cleveland, OH 44120
216.991.9779
Fax: 216.991.9799
www.jorgecastillodesign.com

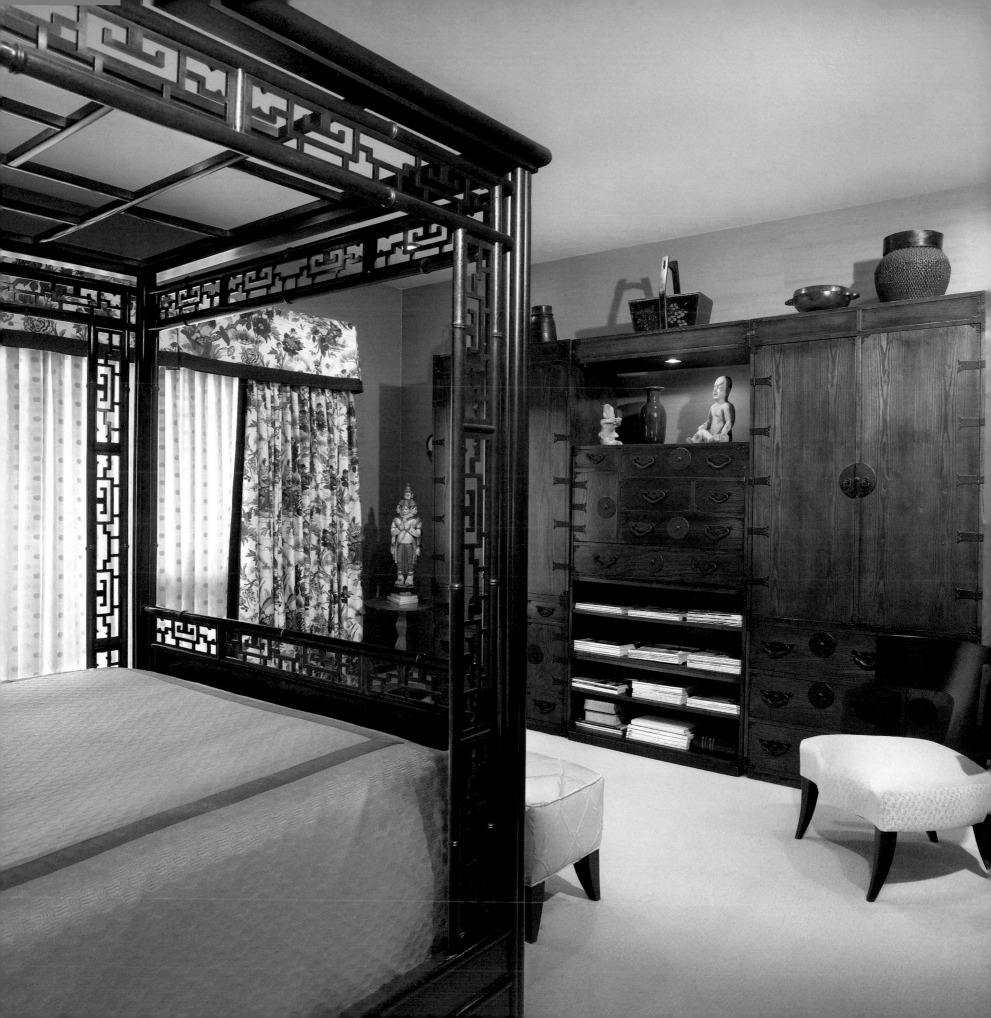

DONALD DOSKEY

DONALD DOSKEY DESIGN

For Donald Doskey, creating exquisite interior designs is like painting a canvas: Each brush stroke must be well thought out, but not be meticulously planned, and every stroke must come together in an organic way that delights and mystifies clients.

Donald's career manifested itself when he became the partner in a new Cleveland restaurant and was given the opportunity to design the aesthetics of the eatery. For that project, he won *Restaurant Hospitality* magazine's "Editors Choice Award," which led to other commissions. From there, he went to work with Charles Hartman & Associates and just a few years later, in 1990, he opened his own business, Donald Doskey Design.

Donald feels that designs should happen naturally and that the elements of design shouldn't be contrived else the end product may feel forced and less dynamic. He recognizes that well-designed rooms look comfortable and collected, and although more effort is required to achieve such an ambience, his clients deserve the best and Donald goes to great lengths to produce fabulous results. The perfect components to a room are seldom found in one

place, so Donald plans accordingly, devoting significant time to acquire the appropriate décor for each individual project.

Looking through his vast portfolio of interior designs, Donald can honestly say that he is proud of every one. Each project invites new challenges, and he welcomes opportunities for growth. One such unique undertaking involved sound baffles patterned in a Mondrian style for a recording studio; although this was new territory even for the experienced designer, the clients were delighted with the final product. It is no wonder that notable publications, including *Cleveland Plain Dealer*, *Northern Ohio Live* and the first volume of *Brunschwig & Fils Style*, have sought to feature Donald and his designs.

ABOVE
Antique botanical prints are accentuated by Maya Romanoff wallpaper in the meditation area of a master bathroom. Beautifully textured Stark carpet beneath a Donghia chaise and table add to the ambience.
Photograph by Jim Maguire of Maguire Photographics

FACING PAGE
Elegant fretwork sets the master bedroom's tone. Floral window treatments feature Manual Canovas fabric while the Klismos chair is upholstered in Nancy Corzine.
Photograph by Jim Maguire of Maguire Photographics

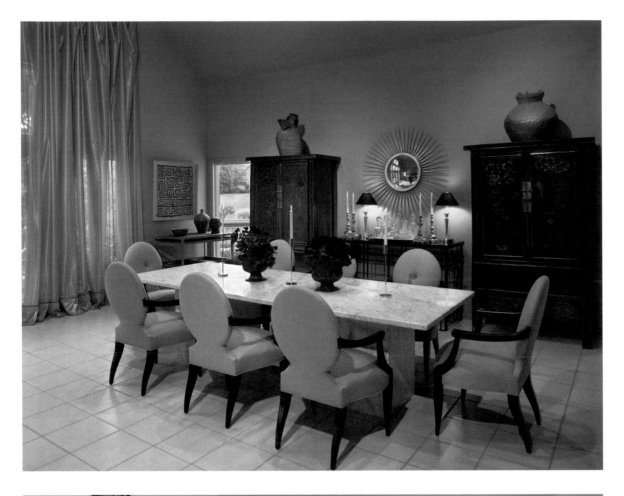

Priding himself on his sans-signature style, Donald conveys that if he had to choose one design element to be known for, it would be color, since he has such a great eye. He is an expert at selecting hues that enhance residents' lives and lightheartedly conveys that the color blue best describes his personality because it is an easy color to be around and nicely complements many others. Whether designing in a Traditional or Contemporary vernacular, Donald strives to create for his clients rooms that seem to wrap their arms around all who enter and provide a sense of welcoming comfort.

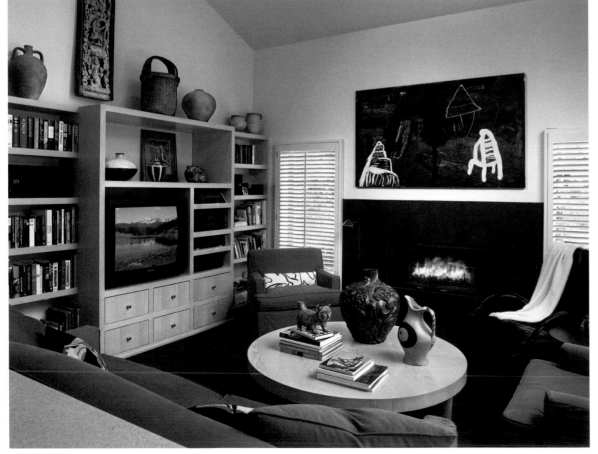

TOP LEFT
Floor-to-ceiling draperies using Larson frame the dining room, while antique Chinese cabinets flank the focal point console table. Chairs by Donghia.
Photograph by Jim Maguire of Maguire Photographics

BOTTOM LEFT
A family den's media accessories are housed in custom cabinetry by Artistic Finishes. Upholstered chairs by Cellura Design. Artwork selected by Gail Berg.
Photograph by Jim Maguire of Maguire Photographics

FACING PAGE
Atop a sisal rug by Stark sits a Coco Chanel sofa, coffee table by J. Robert Scott, Rose Tarlow Sabreleg chairs, and Donghia club chairs, end tables and lamps. Larsen drapery hangs behind the French Wrightsman III chair by Erika Brunson. Art consultation by Gail Berg.
Photograph by Jim Maguire of Maguire Photographics

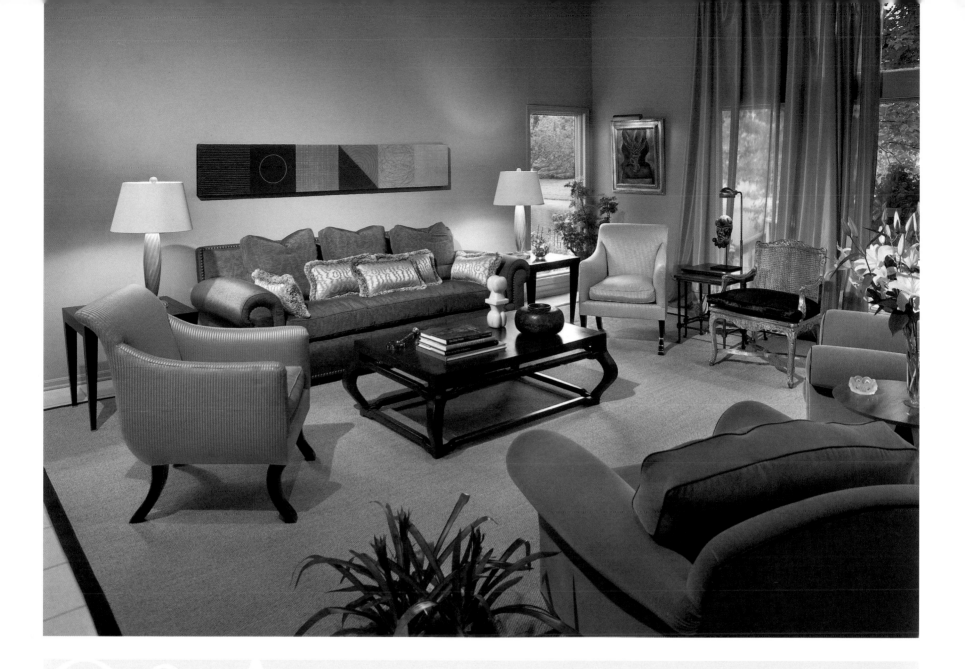

more about Donald ...

WHAT IS THE BEST PART OF BEING AN INTERIOR DESIGNER?

The opportunity to live in fabulous spaces, even if they're only in my head.

IF YOU COULD ELIMINATE ONE DESIGN TECHNIQUE FROM THE WORLD, WHAT WOULD IT BE?

Vinyl siding and bad shutters.

WHO HAS HAD THE BIGGEST INFLUENCE ON YOUR CAREER?

Angelo Donghia and Parish-Hadley. Also, two Cleveland designers: Kenneth Mehall and Charles Hartman.

WHAT IS ONE OF YOUR MOST IMPRESSIVE PROJECTS?

I elegantly designed the interior of a Stanford White home on Lake Erie—the details are amazing.

WHY IS OHIO AN IDEAL PLACE TO PRACTICE INTERIOR DESIGN?

Everybody is really friendly here; we have excellent craftspeople and convenient access to the Ohio Design Center.

DONALD DOSKEY DESIGN
Donald Doskey
12923 Shaker Boulevard
Cleveland, OH 44120
216.283.4853
Fax: 216.991.8144

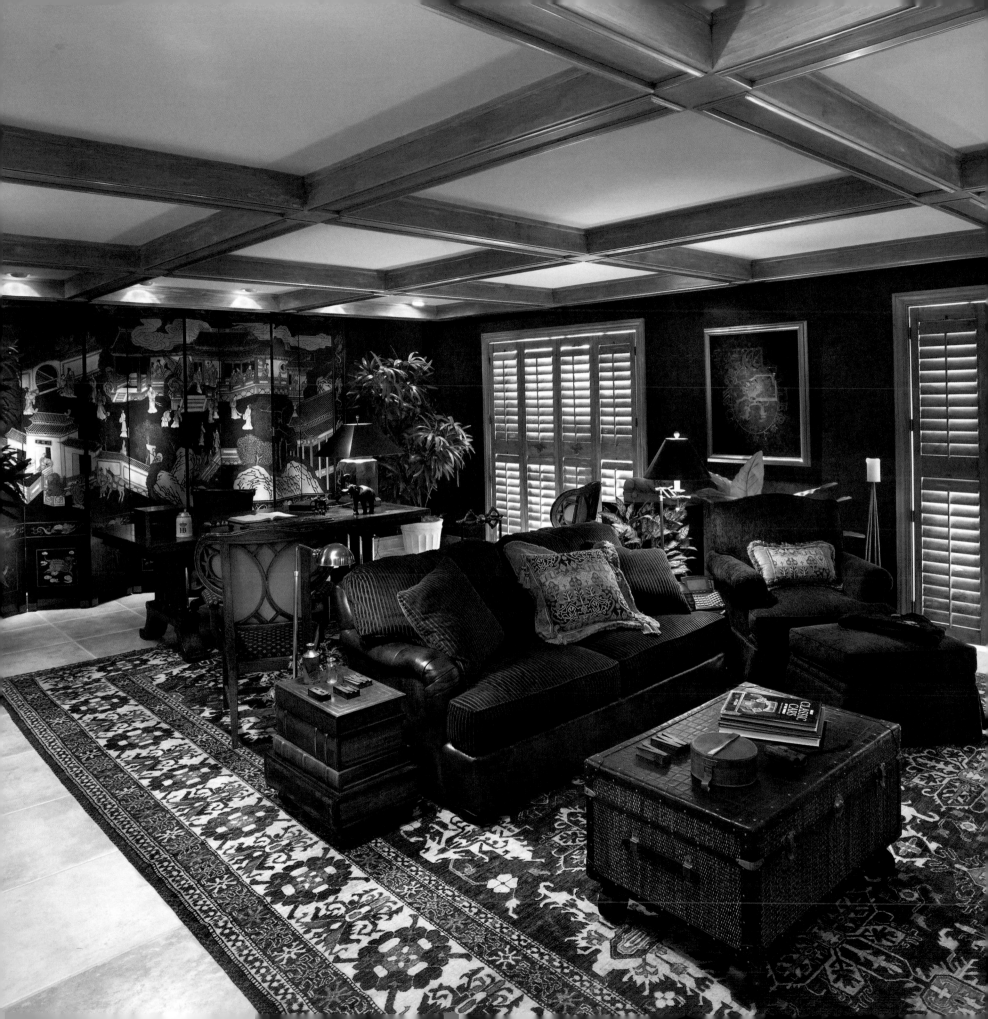

ALAN GARREN

ALAN GARREN INTERIOR/EXTERIOR DESIGN

Interior designer Alan Garren, ASID, specializes in complete residential projects from beginning to end, inside and out. His emphasis is on creating a space that is functional, comfortable, interesting and attractive. His design style ranges from Restoration to Contemporary depending on his clients' wishes. "Give me enough adjectives, and I'll design the house you want," he says.

Alan's philosophy is to work first with the architecture of a home by designing space plans for each room that are functional for the needs of his clients. He calls this "designing from the inside out," and says that this is by far the most important aspect of the whole process. "I never saw a set of house plans that I couldn't improve," he says about working with clients on the details of their house plans.

Alan's style is to build architectural character into each room before any furnishings go in. This might be in the form of a beamed ceiling detail,

bookshelves, windows or specially designed millwork. He says, "I help build character ... for your house."

Another important quality that Alan brings to his clients' projects is comfort. This comes about in many forms. First of all, the furniture should be comfortable for each client's preference, size and age. Next, the quality, quantity and character of the lighting, both natural and artificial, must be considered. Color preference, balance and flow are also important to the overall comfort level of the space. Acoustics are also a consideration. Sound insulation and reflection should be factored into the architecture, choice of furnishings and wall treatments when designing a space.

ABOVE
Spectacular front entrance to a house on Congress Lake designed by Alan "from the ground-up, inside and out."
Photograph by Alan Garren

FACING PAGE
This office was designed by Alan for the owner of a car dealership. The large table serves as a desk in front of an eight-panel Coromandel screen that slides open to reveal a work surface and storage.
Photograph by Jim Maguire of Maguire Photographics

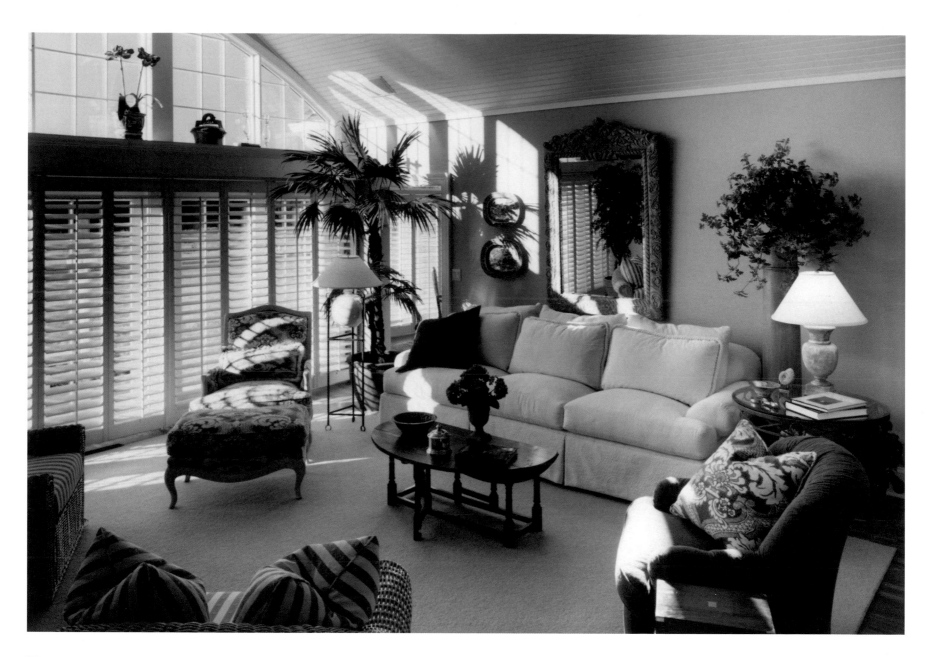

When building a house, Alan says that two things will give a homeowner stress: money and making decisions. He says he can help with the second one. And whether a client is building a home or just furnishing one, he says, "Don't be concerned with the price of any thing. Be concerned with the price of everything."

Alan compares his work to that of a movie director. Like a movie director, he works in a creative and collaborative artform overseeing and coordinating many different tradesmen and artists working towards a common goal: To produce great results.

Alan's projects have been featured in the following publications: *The Chicago Tribune; Miami Herald; Charlotte Observer; Atlanta Journal Constitution; Cleveland Magazine; Northern Ohio Live; West Side Leader; Akron Beacon Journal; The Canton Repository; Kitchen and Bath Design; Bath Country Journal; and Shingle Style Home Plan Book.*

A professional member of the American Society of Interior Designers, Alan is NCIDQ Board certified. The ASID Ohio North Chapter has recognized Alan's work with 11 "Interior of the Year" awards.

ABOVE
This living room illustrates Alan's use of large windows to add natural light and character to a space.
Photograph by Jim Maguire of Maguire Photographics

FACING PAGE LEFT
Fiddleback maplewood and Corian were used by Alan when he designed the cabinets for this master bath remodel.
Photograph by Jim Maguire of Maguire Photographics

FACING PAGE RIGHT
Alan selected teak and granite for his design of the counters and cabinets to showcase the unusual stone sink used in remodeling this guest bathroom.
Photograph by Jim Maguire of Maguire Photographics

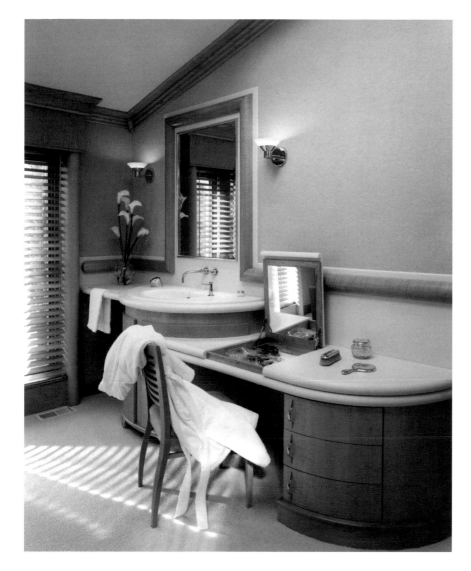

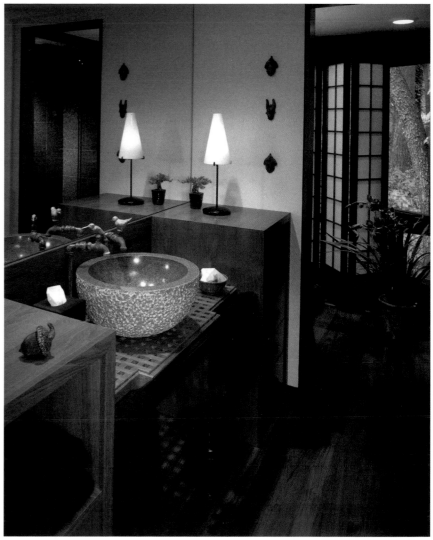

more about Alan ...

NAME ONE THING MOST PEOPLE DON'T KNOW ABOUT YOU.

I was a serious musician, a percussionist, before I started my career in interior design. If a type of music has a drum part in it, I have probably played it: jazz, classical, rock, big band, etc. Interior design and music are similar in that they both require structure, communication and collaboration to be done well. I have enjoyed the variety of styles that I have experienced in each.

WHAT SINGLE THING WOULD YOU DO TO BRING A DULL HOUSE TO LIFE?

Any home can be dramatically improved by changing the windows. I think that windows are the most important architectural element of any structure. Make them large and with interesting character. This one change would bring in more natural light and make the space more interesting and comfortable. Sky lights and solar tubes can help in the same way.

Photograph by Jack Darrow

ALAN GARREN INTERIOR/EXTERIOR DESIGN
Alan Garren, ASID
Akron, OH
330.990.5436
www.alangarren.com

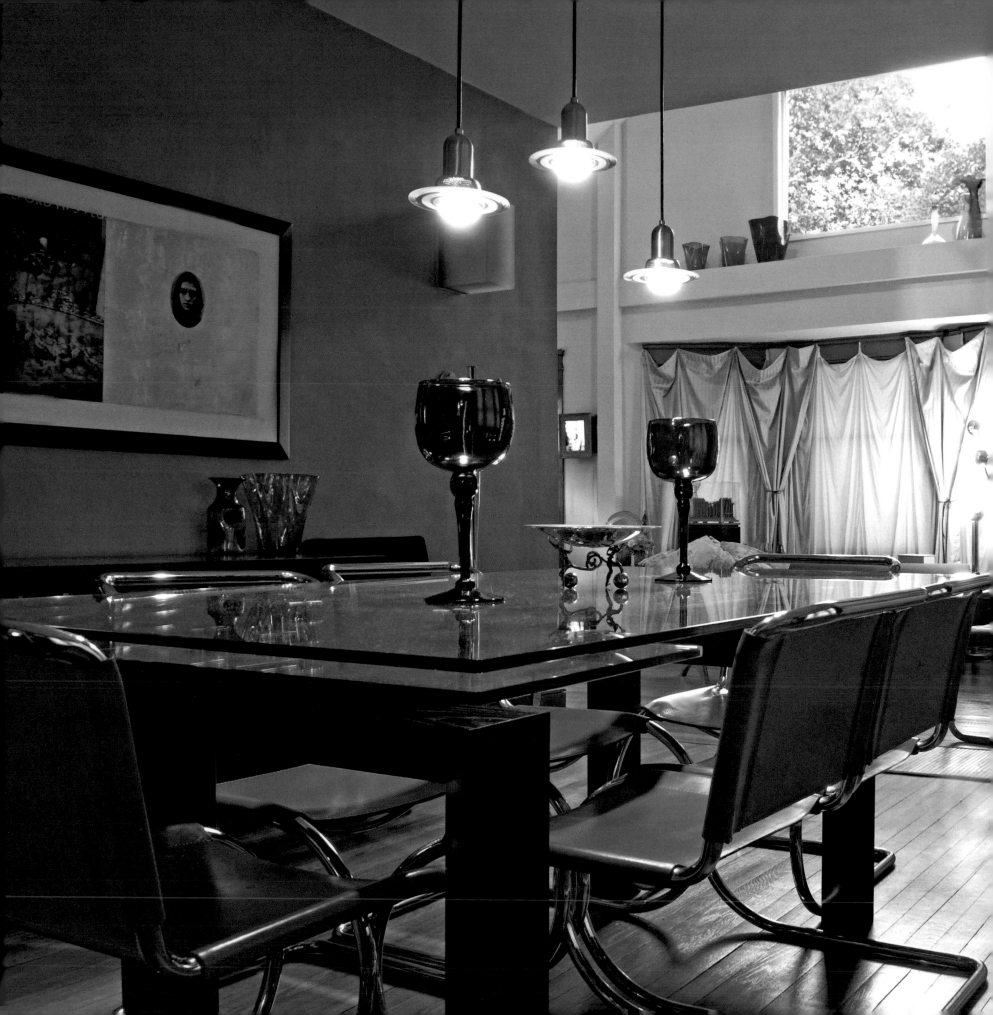

MATT GARSON

M%

M% is a consulting firm as unique as both its owner and its name. When listening to owner Matt Garson explain the meaning of M%, not only his intent, but his vision becomes clear. Simply stated, M% stands for many things: the "M" stands for Matt, Millennium (the year he started the firm) and Modern, and it is the Roman numeral for 1,000, because Matt insists on giving each client and each project 1,000 percent.

M% focuses on clients seeking assistance with art acquisitions and installations, as well as arts management, consisting of framing, conservation, appraisals and inventory. M% also consults on a number of design projects, which include architectural renovation, remodeling and interior design work.

Matt's philosophy on art and design shows his passion for perfection and drive for success. He strives for the fusion of life, art and style, in a constant effort to create experiences that enhance not just one's home, but one's life as well.

Matt is always pushing the boundaries with his clients. He is inspired by such architects as Eliel Saarinen and Frank Lloyd Wright because of their concern with the entirety of a project, down to every detail. For Matt, no stone is left unturned on a project, from the architecture to the furniture to the artwork that hangs on the walls. Every aspect is of equal importance and dealt with as such, leaving clients trusting the savvy designer to help them discover interior designs that wow and inspire.

In 2002, M% opened a gallery, creating an environment and context to better understand and communicate with art. The gallery feels more like a living room, with contemporary furniture and corrugated galvanized steel walls that showcase exhibitions of cutting-edge artwork from regional, national and international artists. Some of the emerging artists that M% represents include: Marty Ackley, Mike DeFabbo, Valerie Hammond, Katsumi Hayakawa, A.D. Peters, Mary Ann Strandell and Lenore Thomas.

ABOVE
A dormer was added and now features a Petah Coyne sculpture and three Bill Armstrong photographs. The stairway leads to the third-floor master bedroom.
Photograph by Ryan DiVita

FACING PAGE
A modern glass dining table by Naos is surrounded by chairs designed by Mies van der Rohe.
Photograph by Ryan DiVita

Matt has the uncanny ability to picture a space completed in his mind, down to every detail. Matt looks at everything as a whole and then takes 1,000 steps back and starts from the beginning, to create a cohesive design that reflects the client's personality and needs in a special and creative way.

In 2006, M% opened a new gallery in Cleveland and is working on opening one in New York in 2007. With other art and design projects in Chicago, Los Angeles and Miami and a push to diversify even more, the future for M% looks strong.

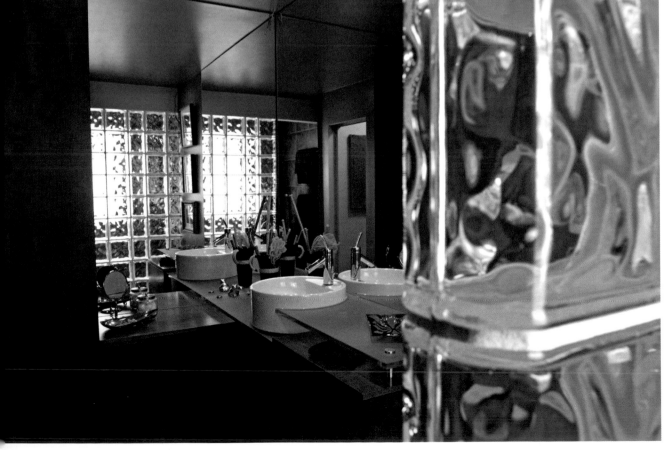

TOP LEFT
Lofted bedroom with exposed brick shows how parts of the 1920's home were kept during the renovation. Brian Fink photograph and Mixed Media piece by Don Harvey.
Photograph by Ryan DiVita

BOTTOM LEFT
The master bath has a glass block wall with a step-in shower. A split-level frosted glass counter and mirrored walls finish off the space.
Photograph by Ryan DiVita

FACING PAGE
Bold, bright colors are the focus in this home. A collection of glass and contemporary art from artists around the world fill the space.
Photograph by Ryan DiVita

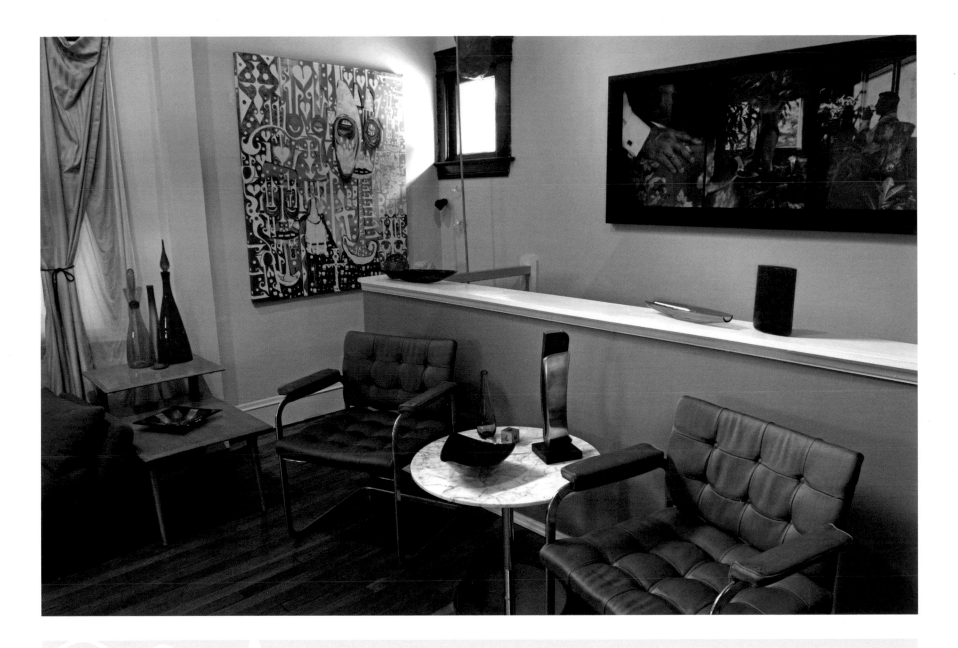

more about Matt ...

WHAT IS THE HIGHEST COMPLIMENT THAT YOU HAVE RECEIVED PROFESSIONALLY?

Even at 40 years old, we always want to please our parents. My father has always been incredibly successful, and recently he put his hand on my shoulder and said, "I'm incredibly proud of what you are doing with your life and with your business, you are doing an amazing job." As sons, we always look for validation in whatever we do in life from our fathers. I'll remember that moment forever. I take great pride in my accomplishments and also in the fact of knowing that I have enriched the lives of my clients by creating unique environments, filled with cutting-edge contemporary artwork, which brings the space to life.

WHAT SEPARATES YOU FROM YOUR COMPETITION?

My confidence, I have great taste and am confident about my designs. I also think my personality, I'm fun and outgoing!

DO YOU HAVE A SIGNATURE STYLE?

No, I don't have a signature style. The way I design a home is based on the owners. When you walk into someone's home you should never say, "It looks like so-and-so designed this." It should be, "Wow this is awesome, and this is what I pictured you would live in." The home should be an extension of the homeowner.

M%
Matt Garson
1332 West 64th Street
Cleveland, OH 44102
216.990.3349
Fax: 216.651.2307
www.mpercent.com

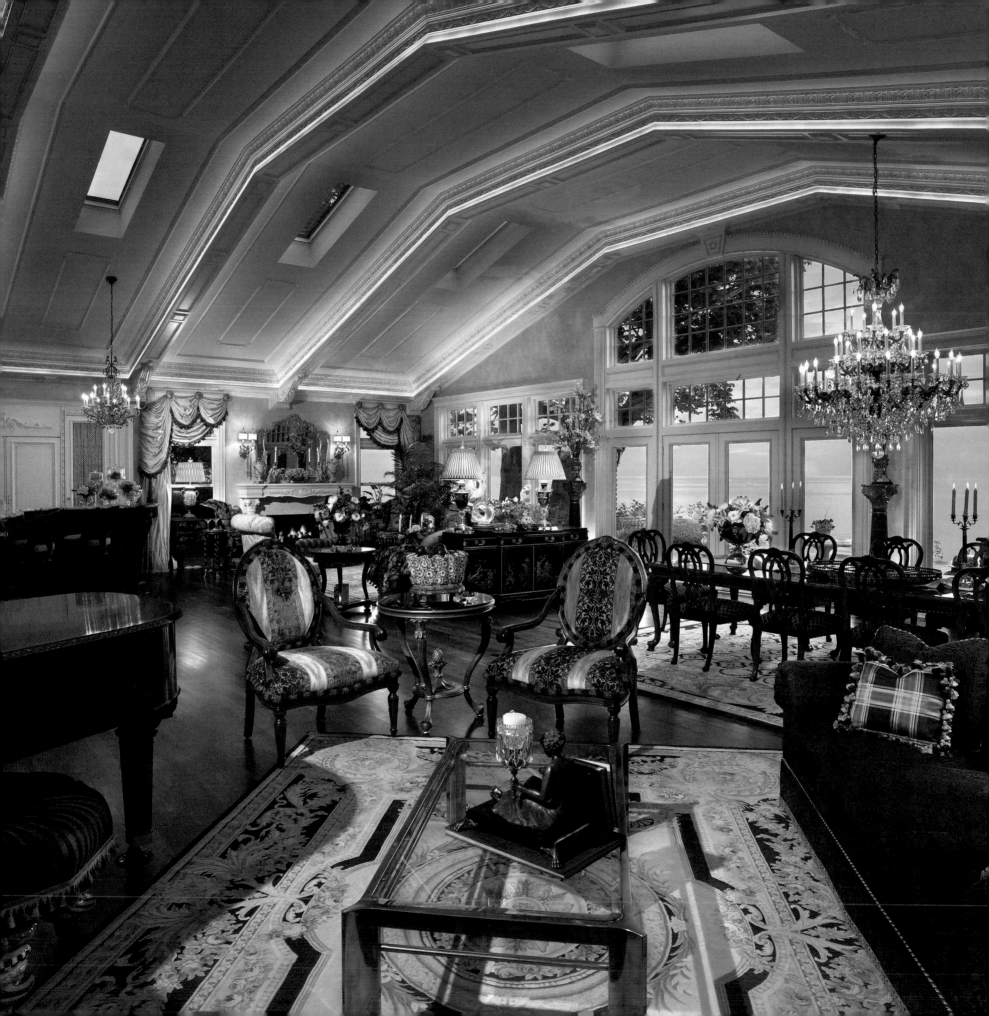

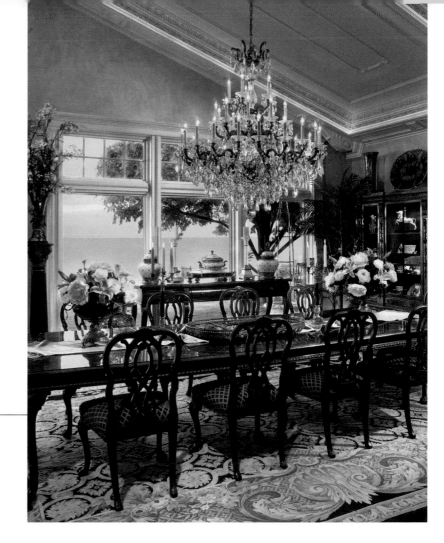

KITTY GILDNER
KG DESIGN FINE HOME DECOR

Kitty Gildner, owner/operator of KG Design, offers a full service interior design and retail shop. She caters to clients who are looking for fine attention to detail and an exquisite eye for astounding aesthetic.

Kitty shops the designer markets throughout the year purchasing items for her designer-motivated showroom. She is always finding those special items that make the difference in her clients' homes ... that "WOW" factor.

Kitty started her career in another field but quickly realized, through encouragement of friends and family, that she had a natural ability to create beautiful astonishing interiors. She considers her keen aesthetic a "gift" and treats her knowledge and talents as such.

When working with clients, Kitty feels that interior design is an art form and approaches each project with the eye of an artist. Using all her combined resources, as paint on a canvas, she is able to create an inspired room setting which is always warm, inviting and balanced. Kitty considers EVERY ROOM ... A SIGNED ORIGINAL!

Having what is called "the eye," Kitty knows that she possesses an incredible gift. She can walk into a room and know what is required to create a dynamic but functional space. She pays attention to the details in all aspects, whether it is paint, upholstery, window treatments, or the placement of an accessory. She knows there is more to a room than the basic furniture. The architecture and interior design must work together. The walls and floors are as important as the fabrics and furniture. All aspects of the design must allow the rooms to "blend and flow," into one another.

Many times it is not what you have, but what you do with what you have. This is what Kitty calls, "The art of placement," which entails proportion and elevation. This is her key to accessorizing.

ABOVE
The custom leaded crystal chandelier and well-proportioned accent pieces create a balance and harmony for the large dining table and breakfront, set on one of three companion carpets.
Photograph by Jim Maguire of Maguire Photographics

FACING PAGE
The design scheme of this spectacular room of five living areas flows gracefully with sensitive use of color and great attention to proportion, details and the client's needs. The addition of softly lit ceiling mouldings creates a sense of warmth and elegance to the grand scale.
Photograph by Jim Maguire of Maguire Photographics

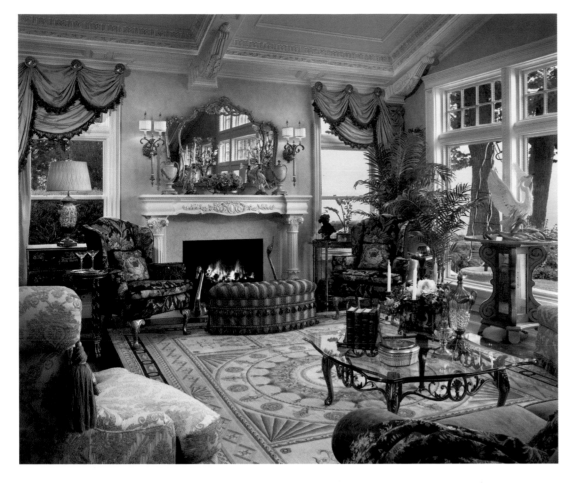

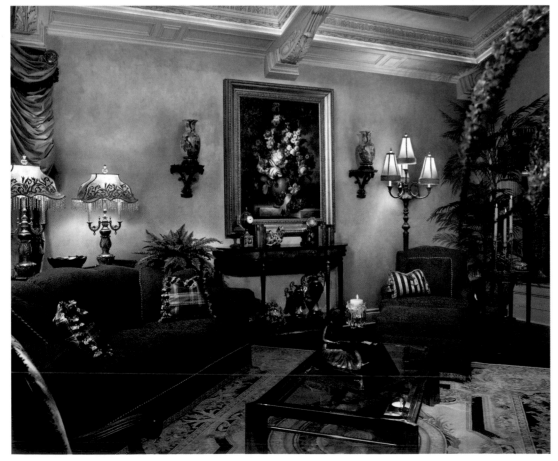

Design is a process and layering effect which produces the richness that has become Kitty's signature style.

She can utilize pieces in a room that are totally unexpected and if placed properly, using the right proportions and elevations, will be pleasing to the eye. She is a hands-on designer in every aspect of her work and when she completes a project her clients realize that the smallest of details do make the difference.

The best part of being an interior designer for Kitty is the reaction she receives from clients the first time that they walk into a completed room. For her, the look of wonderment on their faces is priceless, and their verbal gratitude is overwhelming. It is a validation that she has pleased her clients by helping them realize a new lifestyle.

Kitty truly appreciates the hand-written notes of praise that she receives from her clients. One such note stated, "Words can't express the thanks I want to convey to you for my beautiful home. Every day I sit in each room in awe! You have enhanced all my precious collectibles and turned my house into a magnificent showplace." The note continued, "As I sit to pray, I can't help but wonder if heaven will be as pretty as this! But never fear—Kitty will arrive at those pearly gates and work her magic."

TOP LEFT
Kitty created a comfortable intimate setting in this grand room with large fireside and swivel lounge chairs for conversation or viewing sunsets on the lake. Windows were draped to add warmth and elegance.
Photograph by Jim Maguire of Maguire Photographics

BOTTOM LEFT
The large Flemish floral painting reflects the colors and elegance of this comfortable setting for the grand piano. The eclectic accessories act as the jewelry for this inviting tableau.
Photograph by Jim Maguire of Maguire Photographics

FACING PAGE LEFT
The opposite end of the grand salon features a conversation area around the faux-finish stone fireplace. The luxurious fabrics reflect the deep, rich texture and design of the area carpet.
Photograph by Jim Maguire of Maguire Photographics

FACING PAGE RIGHT
This grand Tudor home with its leaded glass windows and fine Gothic ceiling recalls the past. With the use of multiple paints and glazing, the beauty of the original plaster work is greatly enhanced. Plush elegant fabrics create an inviting setting for viewing the television, housed in a custom lift-top credenza which raises the lamps and accessories with a touch of the remote.
Photograph by Jim Maguire of Maguire Photographics

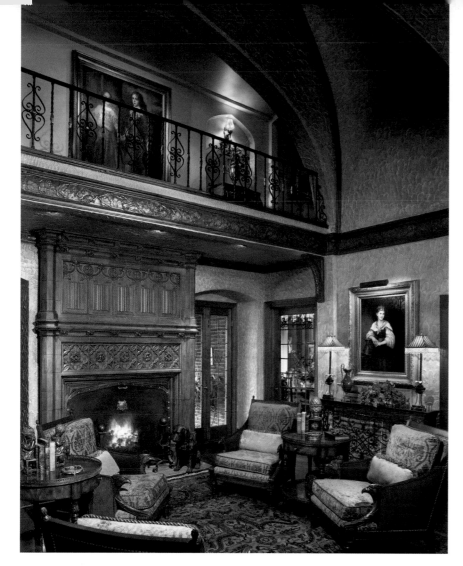

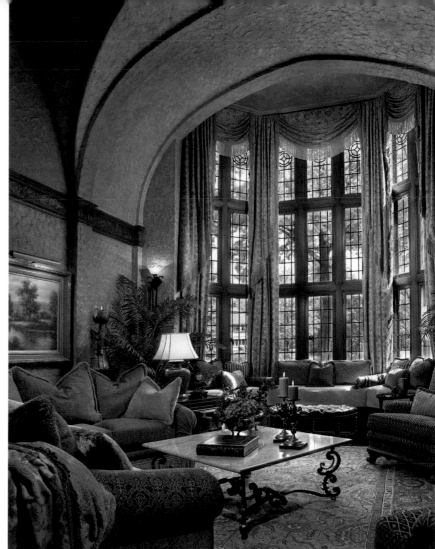

more about Kitty ...

NAME ONE THING THAT MOST PEOPLE DON'T KNOW ABOUT YOU.

In my younger years I wanted to become a professional ballerina and choreographer. It was something I had my heart set on for many years. Life is strange, now I choreograph houses and room settings instead.

WHAT COLOR BEST DESCRIBES YOU?

It would have to be neutrals such as butter cream, camel and ivory. I personally look good in butter cream, and they say people choose colors they look good in.

IF YOU COULD ELIMINATE ONE STYLE FROM THE WORLD WHAT WOULD IT BE?

I do not like ultra Contemporary where everything is sharp and sterile. It lacks personality and detail.

KG DESIGN FINE HOME DECOR
Kitty Gildner and Tassel
Allied Member ASID, Associate Member IDS
19900 Ingersoll Drive
Rocky River, OH 44116
440.333.5717
Fax: 440.333.4699
www.kgdesigncenter.com

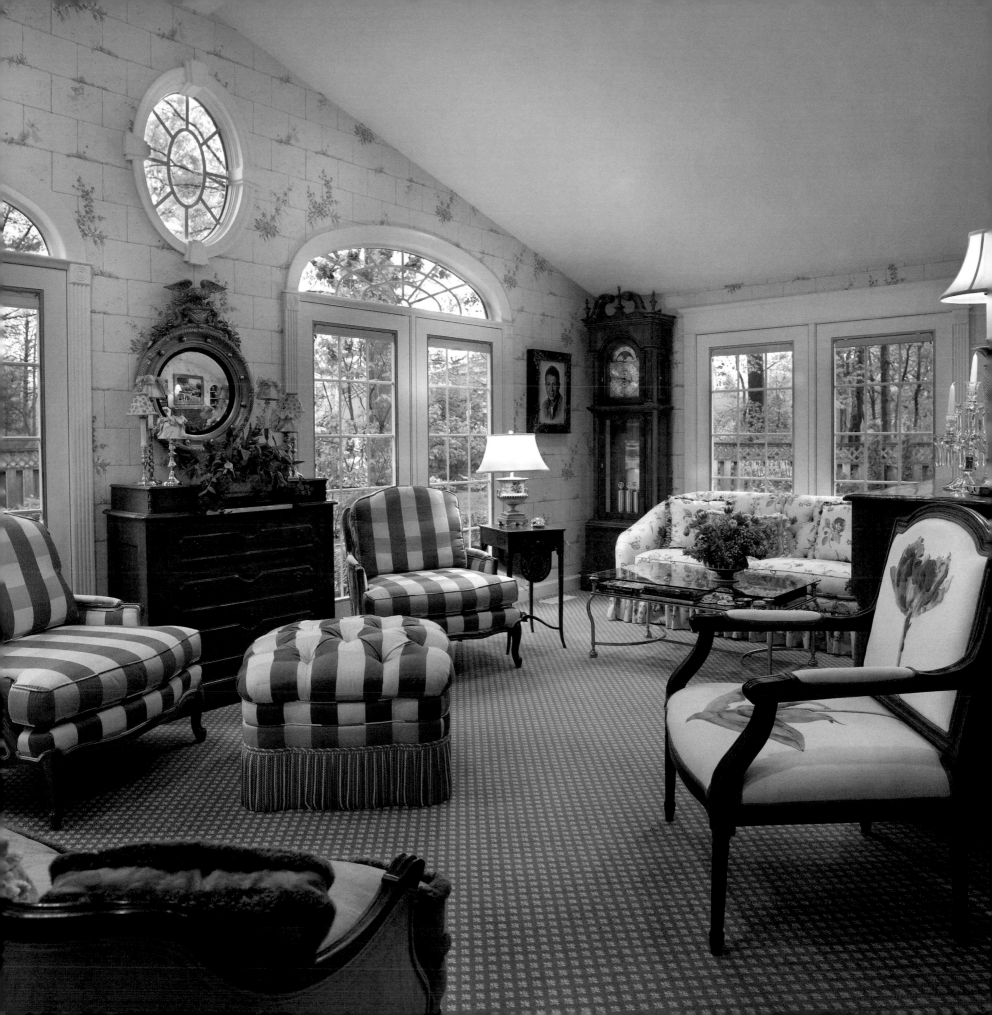

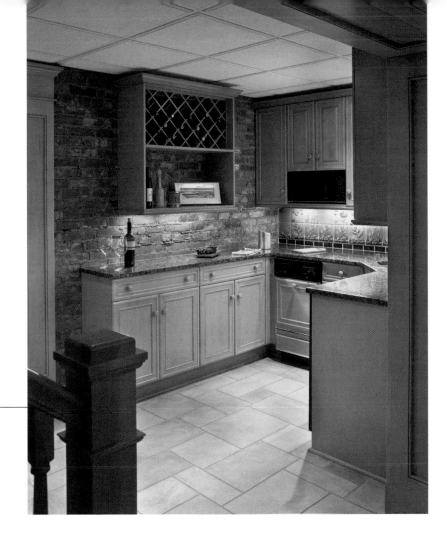

SUSAN HUNT

SUSAN HUNT INTERIORS, LTD.

When clients contact Susan Hunt of Susan Hunt Interiors, Ltd. they discover more than just an expert interior designer; they also find a friend and a genuinely interested individual. "Residential design is very personal and requires attention to all aspects of your client's life." Susan continues, "Above all else you must be a good listener and really be interested in your client's well-being and goals."

Over the course of a lengthy interior design practice, Susan has endeavored to create cohesive designs that blend elegance and lifestyle. "It is of the utmost importance to me that the finished project be a reflection of my client. I am not interested in repeating a signature look in my projects. I know that my clients have dreams of the types of homes that they want but problems arise for them when they try to transform that vision into a concrete reality. I consider that I have been successful when my client tells me that I have managed to translate their dreams into a living reality and I have improved the quality of their life."

Influenced by designers with classical European-based design perspectives, Susan creates interior spaces that incorporate a casual elegance and tend to draw upon the use of a family's history. "It is my impression that especially in today's environment we have lost a real sense of the individual. Even though our society verbalizes individuality, we seem to have been lost in sameness. We are moving swiftly into a society where everyone buys from the same stores and purchases an instant heritage; I find this troublesome and strive in every way to reject it in my practice of design." When Susan interviews a client she arrives as a student ready to learn whatever they will teach her about their particular lives. Ultimately these

ABOVE
As part of a basement renovation, this kitchenette has transformed a previously unused area of this 1920's Tudor home into a vital living space where the original brick serves as a reminder of its past.
Photograph by Jim Maguire of Maguire Photographics

FACING PAGE
The eye cannot help but to invite the garden into this lovely room addition. The use of architectural features and finishes work in concert to extend the boundaries of this room.
Photograph by Jim Maguire of Maguire Photographics

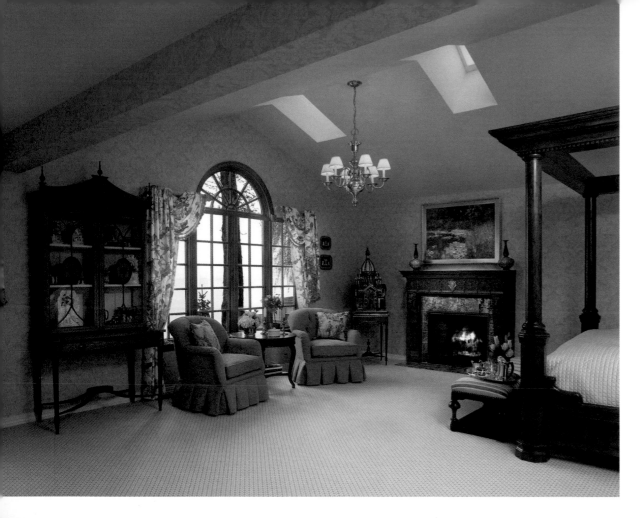

insights provide the guidance for the journey together in creating their new home.

The relationship that is created between herself and her client is a major contributor to the success of the final project. "One of the nicest compliments is when a client tells me that they love staying at home, that it really makes them feel happy and content. After all, our homes should be a sanctuary which comforts us with thoughts of our past, present and hopes for the future." Susan considers that she is merely the interpreter of a personal language that each family already knows but needs help expressing.

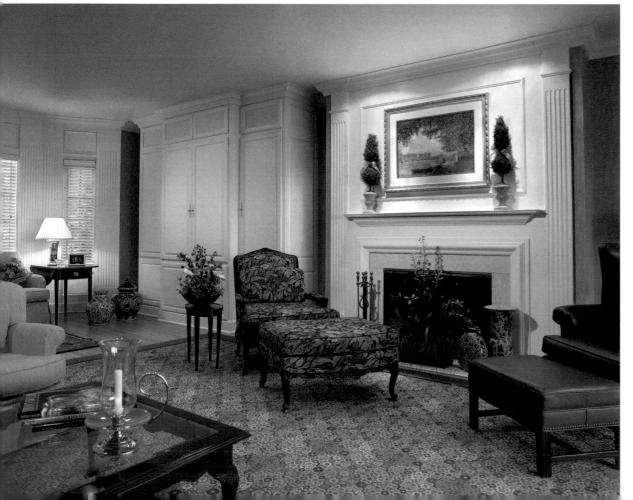

TOP LEFT
In this wonderful lake-view master bedroom the use of color enhances the relationship of the interior to its environment, and the use of strong classical design elements connect this Contemporary room addition to the home's traditional roots.
Photograph by Jim Maguire of Maguire Photographics

BOTTOM LEFT
To create a space that at once invites and possesses a classic elegance, the designer employs the warm glow of coral walls, symmetry and archetypal forms.
Photograph by Jim Maguire of Maguire Photographics

FACING PAGE TOP
The sense of nature abounds in this living room with a wall covering that is reminiscent of stone garden walls that become a haven for ivy and climbing flowers.
Photograph by Jim Maguire of Maguire Photographics

FACING PAGE BOTTOM
The breakfast room design as well as the outside shed and landscaping were developed by the designer to maximize the size of the interior by the repetition of color and form in the garden.
Photograph by Jim Maguire of Maguire Photographics

Q&A

more about Susan ...

WHAT SINGLE THING WOULD YOU DO TO BRING A DULL HOUSE TO LIFE?

Everything is very interrelated. You can't say a hand is more important than an arm because you really need them both. But color, for me, is my number one tool.

WHAT IS THE MOST ENJOYABLE PART OF BEING AN INTERIOR DESIGNER?

When you are working with a client who is easy to work with, every aspect of the project is enjoyable. I like meeting with people, finding out what makes them tick, and helping them problem solve. I really love the whole process.

WHAT IS THE HIGHEST COMPLIMENT YOU HAVE RECEIVED PROFESSIONALLY?

I used to hate my house, but now I never want to leave it.

WHAT SEPARATES YOU FROM THE COMPETITION?

One of my guiding principles is a commitment to express the individuality of my clients—to mirror their tastes, values and personality—in every aspect of their design. I consider gaining an understanding and appreciation of those things which matter most to my client to be an important part of the design process. Consequently, each of my projects has a unique outcome tailored to the personality and lifestyle of the individuals for whom I design. I would also have to say that service is of paramount importance and something which I consciously seek to provide.

SUSAN HUNT INTERIORS, LTD.
Susan Hunt, Allied Member ASID
29507 Lisaview Drive
Bay Village, OH 44140
440.835.1834
Fax: 440.899.1670

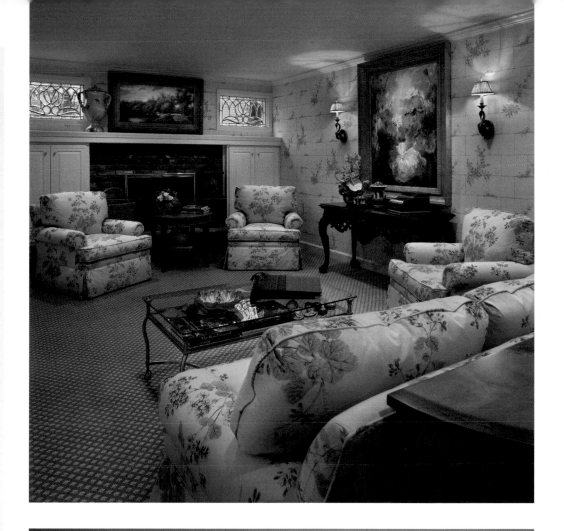

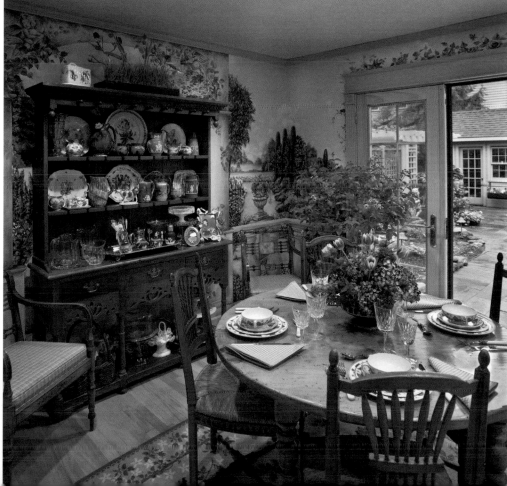

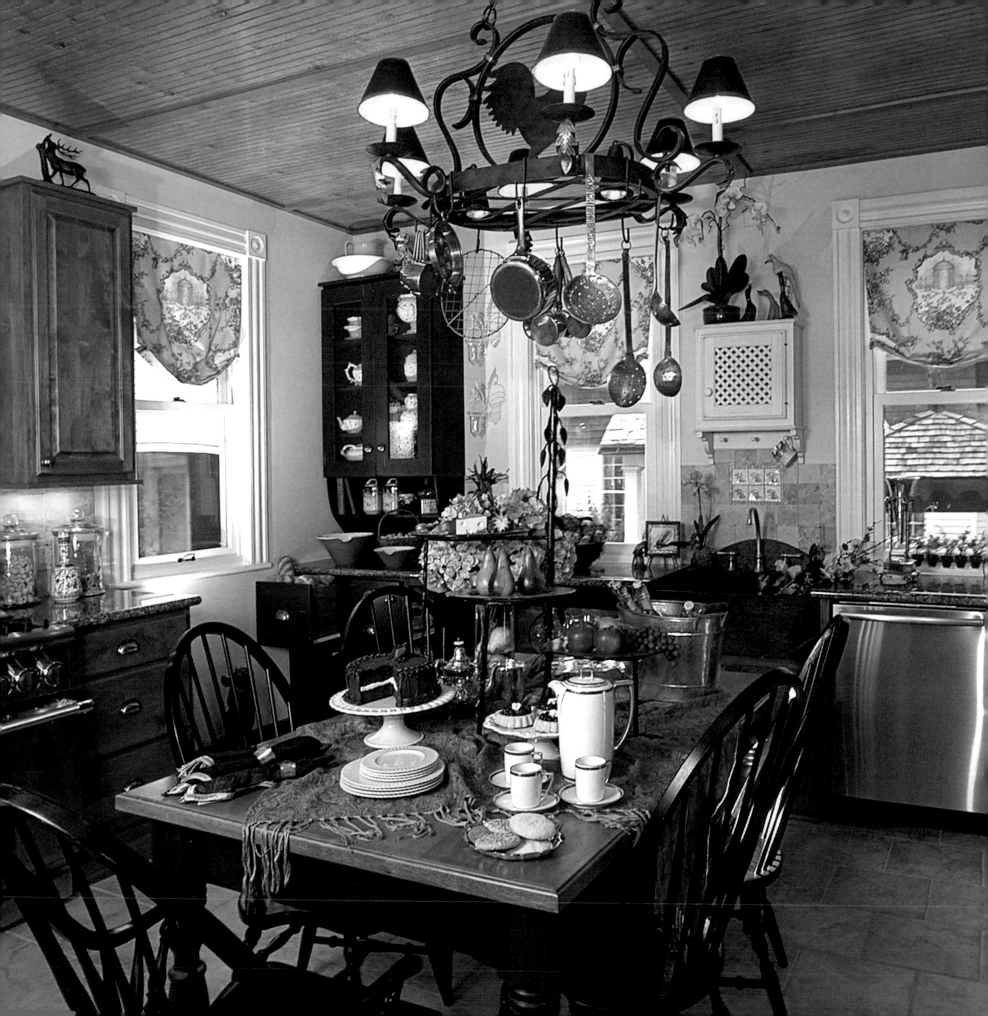

KITCHEN
DESIGN GROUP

Since 2000, the founding team of Kitchen Design Group has combined their nine decades of experience and inherent talent to offer dynamic solutions and aesthetic enrichment in the special niche of kitchen design and beyond.

The four-member team of Deanna Carleton, Barbara Dillick, James Niggemyer and Robert Kieft collaborate and work as four very unique individuals with strengths that complement and support each other, yet each enjoys his and her own clientele who seek their individual style.

Despite what their name may suggest, Kitchen Design Group's natural affinity for the design of the home's most functional spaces extends beyond kitchens to custom bathrooms, entertainment centers, armoires and offices. Their work on kitchens and these other areas of the home have been featured in several Designer Showhouses.

To ease the decision-making process, Kitchen Design Group's stylish and cozy studio-showroom enables clients to browse, experiencing a myriad of material samples firsthand. It is just another way Deanna, Barbara, Bob and James uphold their firm's renowned level of customer service.

This full-service design firm provides—from conception to completion—all that is needed to rehabilitate or create the kitchen of their clients' dreams. Each designer strives for a cohesive look and continues working throughout the process to ensure their client's vision is realized. From luxurious cabinets to inlaid limestone flooring to brilliant lighting schemes, Kitchen Design Group first begins with a desire or need, and transforms it into a space of distinction.

ABOVE
The sandstone walls were intentionally uncovered for added character and charm. The jelly cupboard provides storage and enhances the "unfitted" feeling of space.
Photograph by Shane Wynn

FACING PAGE
The Simon Perkins Mansion (circa 1837), site of the Junior League Designer Showhouse. Custom distressed cabinetry in two tones of knotty alder achieved an "unfitted" kitchen look that evolved over generations in the Perkins family.
Photograph by Shane Wynn

KITCHEN DESIGN GROUP
Deanna Carleton
Barbara Dillick
Bob Kieft
James Niggemyer
843 North Cleveland-Massillon Road
Akron, OH 44333
330.666.4392
Fax: 330.666.3483

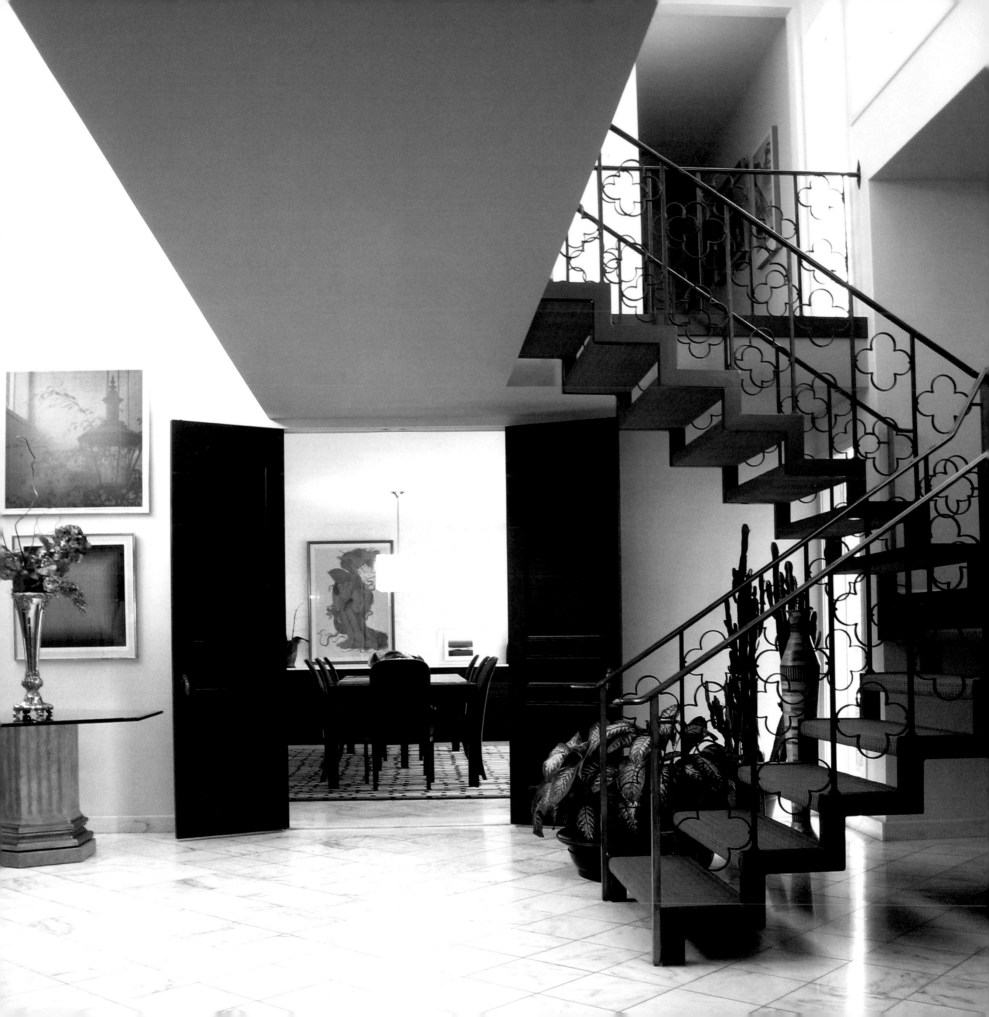

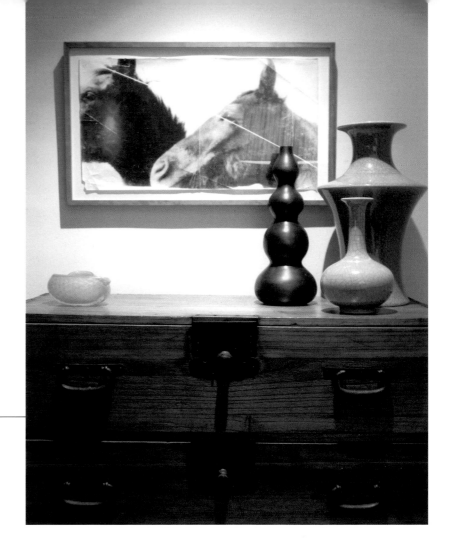

JOHN KONCAR

JOHN FLORIAN KONCAR INTERIORS

John Koncar started rearranging the furniture in his parents' house at the age of 12, so it's little wonder how the dynamic interior designer landed a rewarding career creating some of the most magnificent interiors of the Midwest.

After graduating from the respected University of Cincinnati College of Design, Architecture, Art and Planning, John apprenticed in the field for four years to achieve a broad knowledge base before deciding to go solo. Then in 1980, with a goal of working intimately with clients to create highly individual interiors, John's independent design business was launched.

A visual organizer at heart, John says that when clients bring him items that inspire them—such as paintings, sculptures and furniture—he instinctively finds ways to integrate them into the design process. Every change or addition is planned upon a very organized approach, resulting in interiors that are clean, streamlined, and straightforward, but never over-designed or "fussy." Even his more traditional work has a certain youthfulness, in terms of colors, textures and pattern play.

Early in the design process, John engages clients in a dialogue to discover how they live, how they interact with their environment, and any special needs they may have. One client desired an elegant and stylish interior where her four dogs could be equally "at home." The result was an inspired, carefully planned home through which her pets could traipse with wet paws without the homeowner having to live in terror that the floors would get ruined. John feels that homeowners should not be slaves to their own homes, and that good design results in the perfect marriage of aesthetics and function. After all, says John, "A functional house doesn't need to look frumpy."

While John focuses almost exclusively on residential interiors, periodically a client will persuade him to bring his distinctive aesthetic to an enticing office or restaurant interior project.

ABOVE
A photograph by the Starn Twins completes a composition which includes a 19th-century kiri wood tansu, a collection of vessels and a glass bowl by Barovier Murano.

FACING PAGE
In Shaker Heights, John Koncar polished and restored a sprawling mid-century home using deep blue accents to complement the statuary marble floors. The railings were treated to a patinated bronze finish. Vasarely in the foreground and a marvelous Bjorn Wiinblad painting in the dining room inspire the color scheme.
Photographs courtesy of John Florian Koncar Interiors

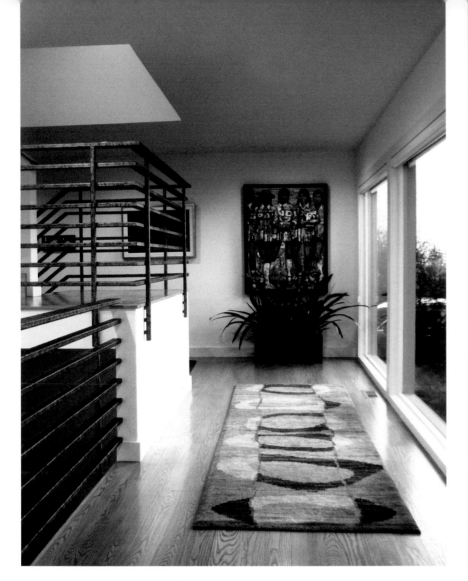

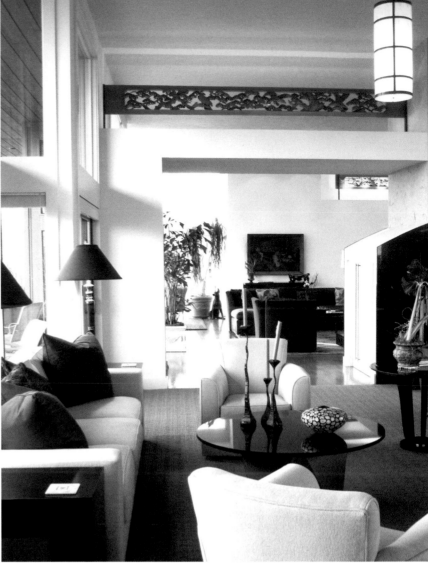

Early on, John's inherent curiosity with all aspects of design led to a job with a large interior design firm in Cleveland. A unique and educational aspect to this old-style firm was that they had an upholstery shop, a carpentry shop and a painting workroom all under one roof. John was fascinated with the upholstery shop and the carpentry area. "I was drawn to it," John said. "I could see firsthand what made a quality piece of furniture. It never left me, so whenever I have the opportunity to do that for a customer, I like to. It gives a project something that is unique unto itself." John now creates custom furniture for clients, with designs usually stemming from John's passion for a softened Modernism, a vintage level of quality in construction and upholstery, and even his love of the vintage automobile.

John is not a registered architect, but his architectural background, combined with his other fields of expertise, give him the unique ability to play a larger role in a client's project than could most interior designers. He is always excited to look beyond the interior space and conceptualize ways to integrate a home's architecture, exterior and the landscape into the design plan.

Whether Modern or Traditional, the consistent hallmarks of a John Koncar-designed interior are confidence, classicism, elegance, and foremost, comfort. His vision and knowledge guide him in creating environments that are unique to every client, complementary to their personalities, and appropriate to the way they live.

ABOVE LEFT
John exercises his architectural background with details such as the copper handrails that, in this case, lead the eye to a powerful oil painting by New Mexico artist Erin Currier.

ABOVE RIGHT
Ever the expert mixologist of styles, John combines a custom-designed African granite fireplace surround, a 19th-century Japanese transom (carved from a single piece of wood) and custom light fixtures to affect a worldly composition in an Aurora, Ohio residence.

FACING PAGE TOP
John is drawn to softly curving lines when designing his own furniture, shown here in his swiveling rudder chair and front parlour sofa. Quiet colors and plush textures make this space especially satisfying. The African sculpture is from the clients' own collection.

FACING PAGE BOTTOM
A Lichtenstein triptych inspired the fearless color scheme and the heroic scale of John's "Oakridge Sectional Sofa" in a Cleveland Heights art collector's home. The rug is Tibetan.
Photographs courtesy of John Florian Koncar Interiors

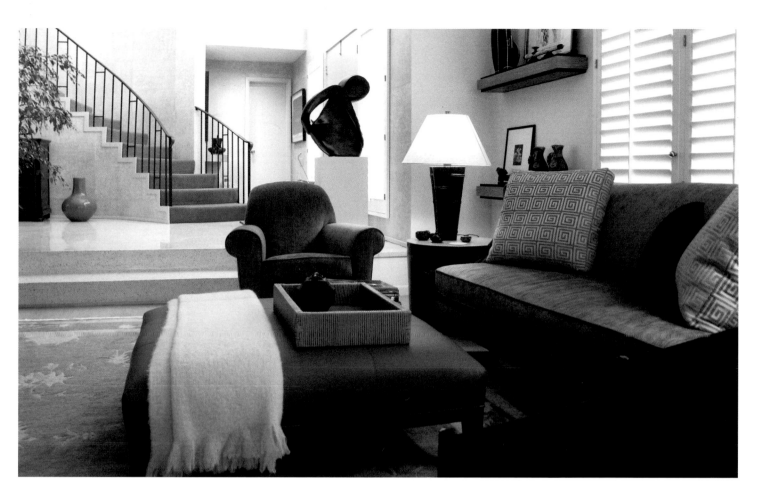

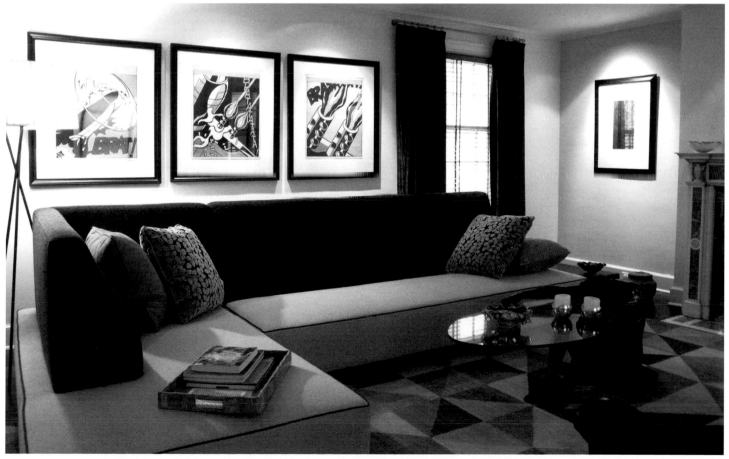

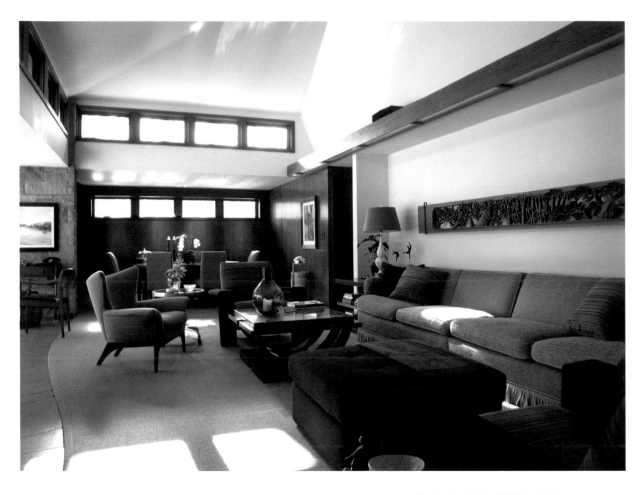

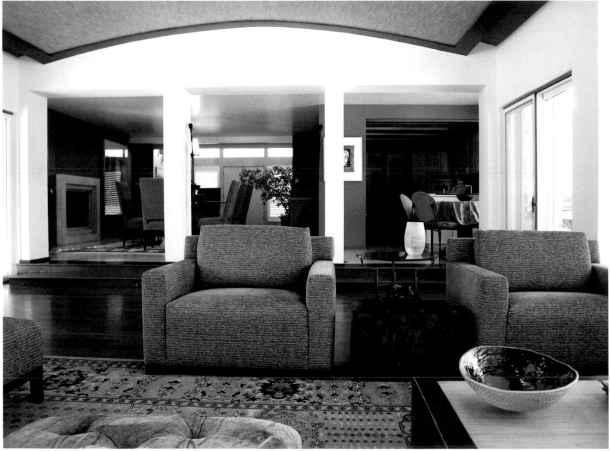

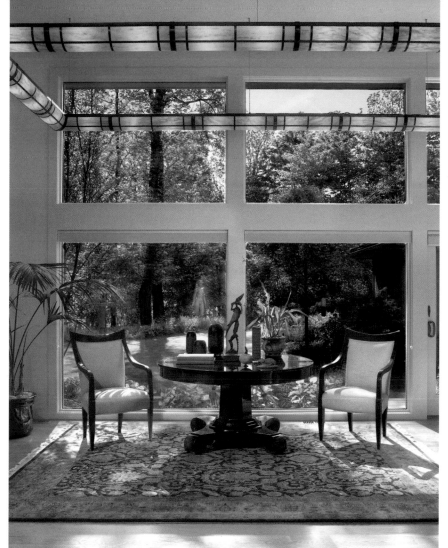

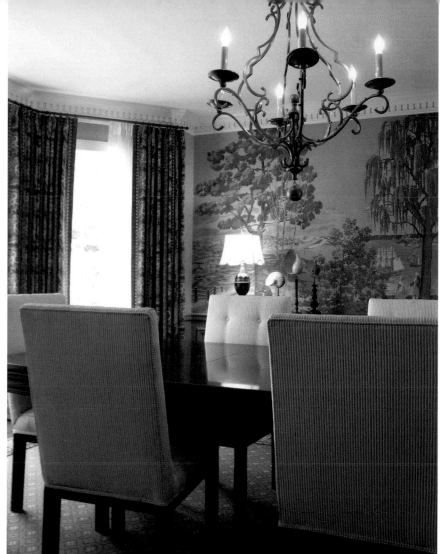

more about John ...

ON WHAT PERSONAL INDULGENCE DO YOU SPEND THE MOST MONEY?

Cars. I never carry a lease to full term. You might say I'm automotively unfaithful.

NAME ONE THING MOST PEOPLE DON'T KNOW ABOUT YOU.

I ran away from dental school to pursue interior design.

WHAT IS THE BEST PART OF BEING AN INTERIOR DESIGNER?

The satisfaction of transforming space and affecting mood. It's very much like being a sculptor, but with many mediums.

Photograph by Tim Sefranek

JOHN FLORIAN KONCAR INTERIORS
John Koncar
6396 Gates Mills Boulevard
Mayfield Heights, OH 44124
440.442.9501
Fax: 440.442.9503
www.johnkoncar.com

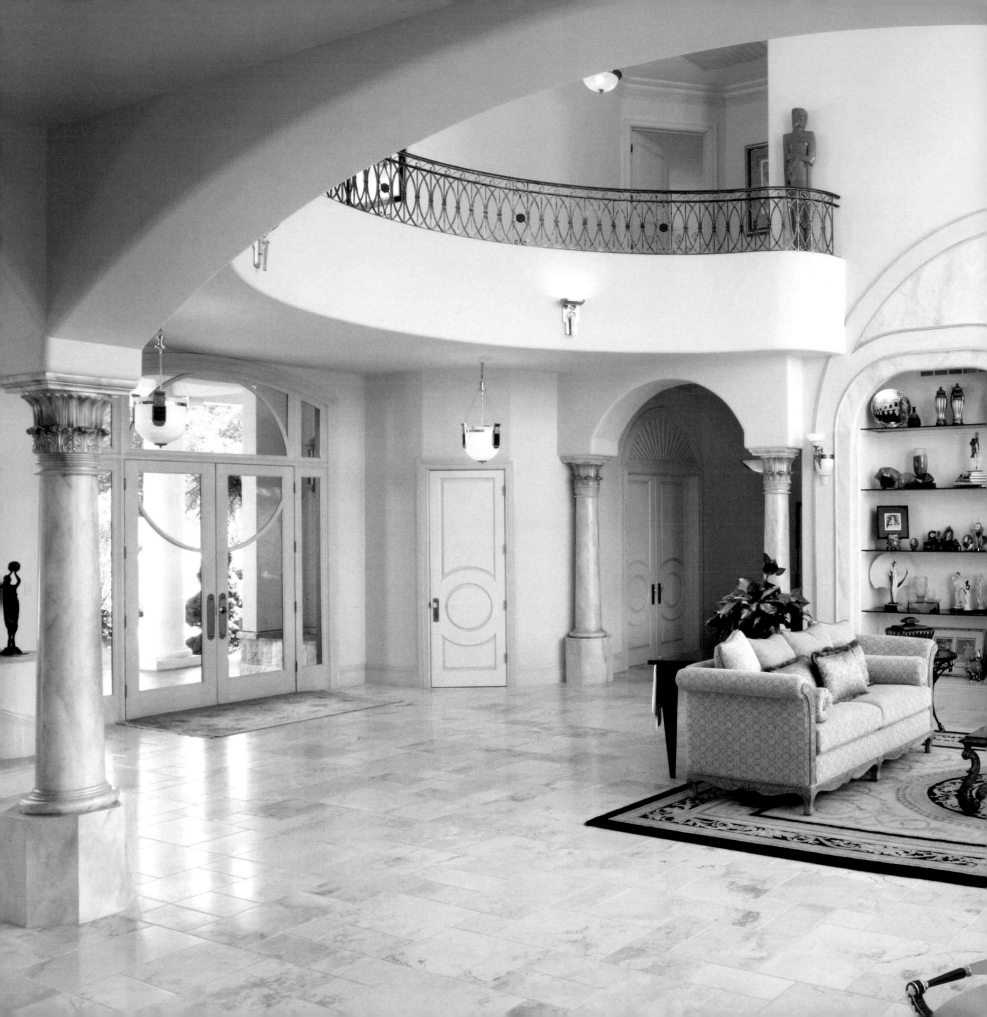

CAROLYN LEIBOWITZ

GENESIS GIFTS & INTERIORS, INC.

Carolyn Leibowitz, founder of Genesis Gifts & Interiors Inc., believes her occupation is a fine art. She feels that magnificent interior design is created much like a painting where furnishings, fixtures and finishes are the medium and the home is the canvas. It is with this mindset that she approaches each project using objects as brush strokes to complete her painting.

With a degree in art, Carolyn started Genesis Gifts & Interiors Inc. as a curio shop and started designing interiors for customers who needed help with the placement of their purchases. It was evident that interior design was her destiny when as a little girl she would visit the old prestigious houses of her hometown Akron, Ohio (including the famous Stan Hywet Hall), knock on doors and ask if she could have a peek inside. It was more than the history of the homes that interested her. She wanted to see the design and to see if the majesty of the outside was reflected in the interior as well. This natural curiosity has greatly benefited Carolyn in her chosen career, and the homes she explored as a youth have stayed with her in her vast love of the array of different styles that comprise people's homes.

LEFT
This formal living room reflects a French architectural expression.
Photograph by Scott Galloway, Galloway Photography

BOB MILLER
ANNE MILLER RUGGIERO

BOB MILLER INTERIORS

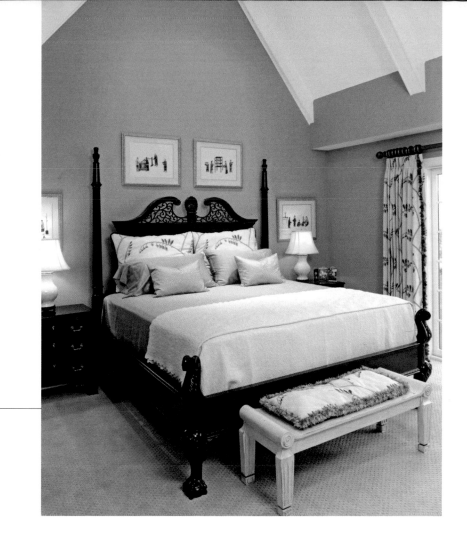

The strength of Bob Miller Interiors lies in a genuine desire to translate clients' style preferences into pleasing, unique, functional spaces. Never imposing their own stylistic opinions on their patrons, Bob—who founded the company in 1984—and his partner/daughter Anne, are well-versed in a variety of genres and delight at the opportunity to work in Traditional, Transitional and Contemporary vernaculars alike.

Although each composition is as distinctive as its residents, all of Bob and Anne's work is grounded with the fundamental principles which yield timeless design. The designers work independently yet have the advantage of one another's professional opinions. Bob blends his nearly four decades of interior design experience with that which he learned while working with his mother and father, who were also notable interior designers. With the benefit of three generations of design perspective and expertise, Bob and Anne are quite familiar with the comfort level of their clientele and successfully marry Midwest sensibility with forward-thinking aesthetics. They attend international and regional markets on a regular basis, keep track

of market trends and subtly introduce homeowners to fresh possibilities and concepts, all the while allowing each client's taste to guide the design development.

Just as Bob encourages his clients to explore their many options, he wholly supported his daughter in any career path that she decided to pursue; yet just like her father, Anne was innately drawn to the exciting field around which she was raised. It is a rarity in this profession for a business partner to not only be business savvy but have a true understanding and appreciation for the creative process; Bob's wife, Mary, is such a partner. She lends her talents to the full-service design firm by managing the flow of day-to-day responsibilities so that her family members can focus on clients' design needs.

ABOVE
Four Oriental hand-painted silk pictures—which explain how silk is made—surround the highly detailed, broken and pierced headboard pediment. Serene colors and textures of the chenille and crewel draperies and shams complement the bed's formality.
Photograph by Scott Hall

FACING PAGE
Touches of rich cinnabar red complement the chocolate walls to produce a warm and inviting feel. The sophisticated style of fabrics enhances the uptown ambience.
Photograph by Scott Hall

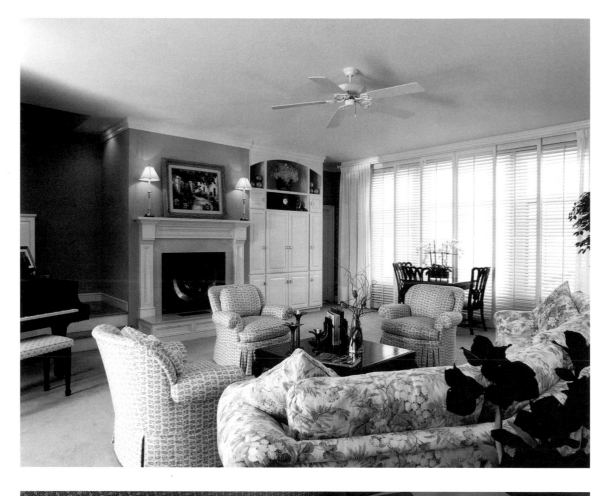

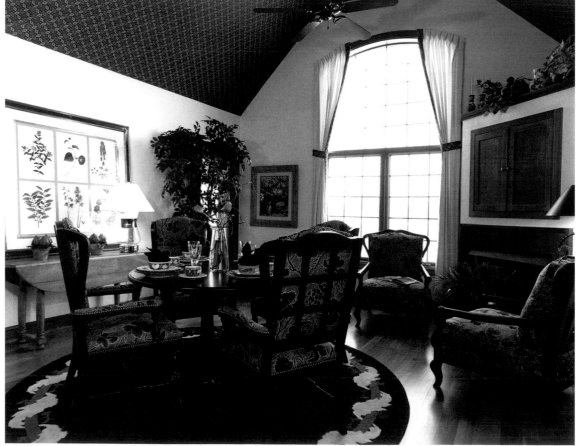

At the heart of Bob Miller Interiors is the deep-rooted philosophy that a respectful partnership between client and designer yields the best results. Bob relates, "Our concern is for the client's ultimate satisfaction, and if someone is not fond of the first selection that we present, it's not going to offend us; we simply redirect the design until everyone is comfortable." The designers are extremely patient—fully recognizing that some people make decisions in a matter of minutes, while others need a bit more time—but through their organized approach, clients feel confident every step of the way.

Offering services from conceptualization through installation—including custom furniture fabrication, draperies and other accessories—Bob Miller Interiors is celebrated for incorporating elements of surprise into every design. A deep understanding of the intricacies involved with bringing concepts to reality is a skill that only comes with experience. Over the years, Bob Miller Interiors has assembled an impressive team of subcontractors and specialists, so regardless of the task, they have the knowledge and resources to ensure exquisite results.

Clients benefit from the firm's extensive resource library of superior quality wall coverings, floor coverings, furniture, trims and fabrics. Bob and

TOP LEFT
The open living room's neutral palette draws attention to views of the water, giving a relaxed undertone.
Photograph by Scott Hall

BOTTOM LEFT
Warm colors in the handcrafted patterned rug and wallpapered ceiling tie the morning room in with the kitchen.
Photograph by Scott Hall

FACING PAGE
Highly reflective, black lacquered paneled walls provide a beautiful backdrop for the custom, sectioned glass table, which can be reconfigured for more intimate dining. Embroidered chairs collectively read, "At dinner we will eat wisely but not too well and talk well but not too wisely."
Photograph by Scott Hall

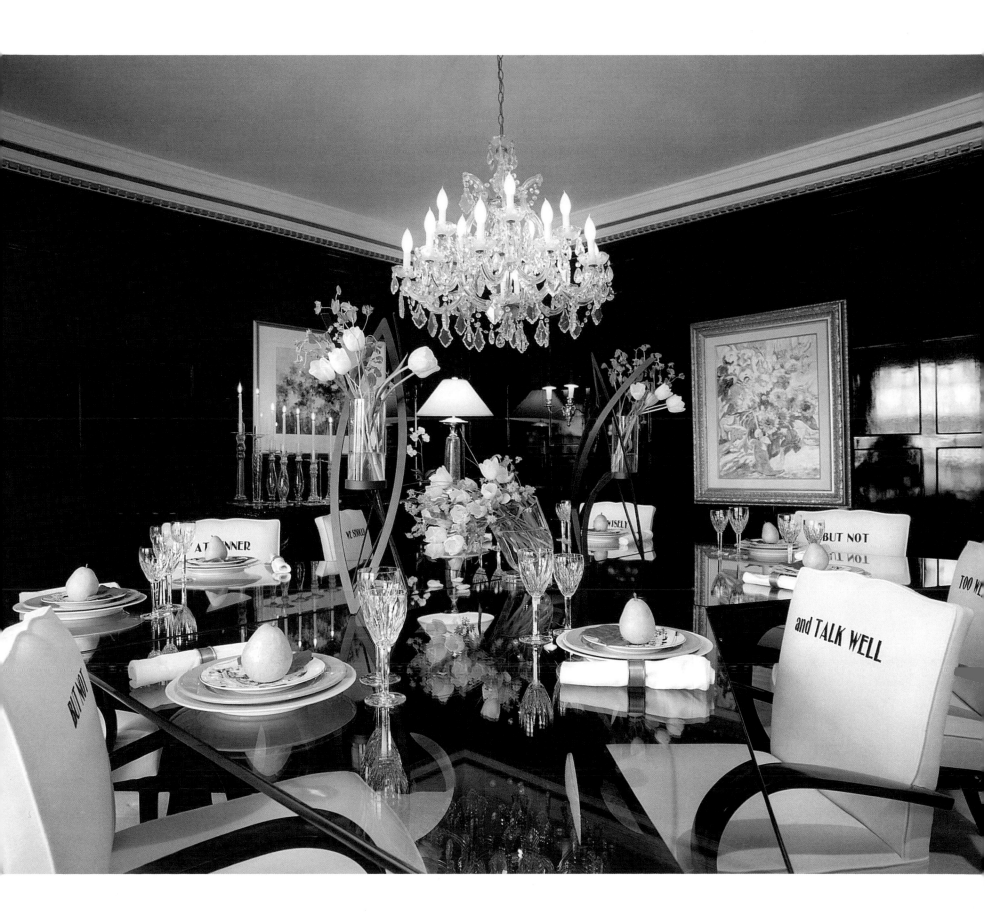

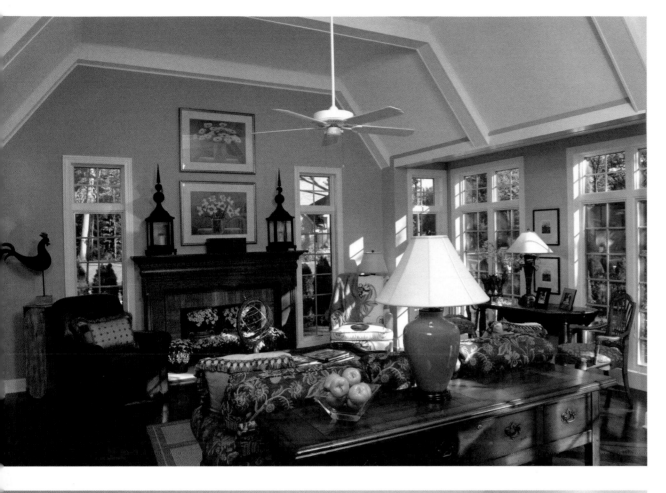

Anne believe in devising original designs with interesting texture and color combinations because there are so many great textiles and furnishings that repeating a style is never necessary, or even an option. The Bob Miller Interiors showroom offers clients the opportunity to experience, firsthand, the impressive quality of materials that will soon infuse their home: An eclectic mingling of classic and contemporary furnishings produces a cohesive look that appeals to a broad clientele.

Bob and Anne transcend not only styles but age groups; they can relate to first-time homeowners and retired patrons alike. Many clients, in fact, have become lifelong friends and refer their family members, friends and neighbors to the firm.

Projects to Bob Miller Interiors' credit span the states of Ohio and Michigan, yet also grace the landscapes of North Carolina, Florida, Arizona, California and many states in between. While a thread of eclectic classicism and timeless elegance weaves throughout all of the firm's work, the possibilities are endless with the imaginative minds of Bob and Anne.

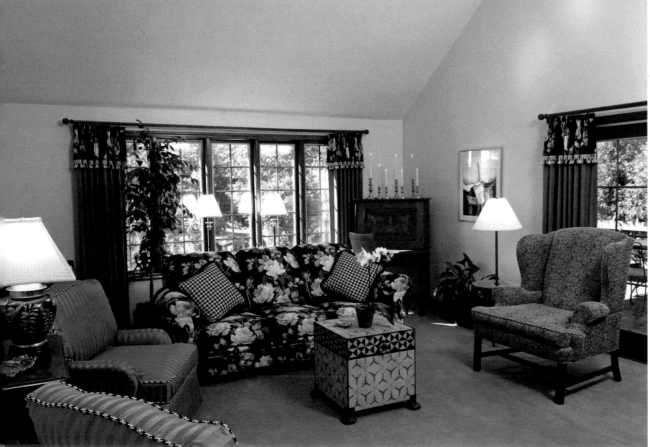

TOP LEFT
The beamed, coffered ceiling and large windows, along with chenille and sisal textures, give the family room a sophisticated yet relaxed atmosphere.
Photograph by Scott Hall

BOTTOM LEFT
A mix of sophistication and spunk, the family room is coordinated but not contrived. The client painted all of the featured artwork.
Photograph by Scott Hall

FACING PAGE
Details of the hand-knotted rug and slate top chest make the home warm and inviting—a cheerful relief from the hectic nature of life.
Photograph by Scott Hall

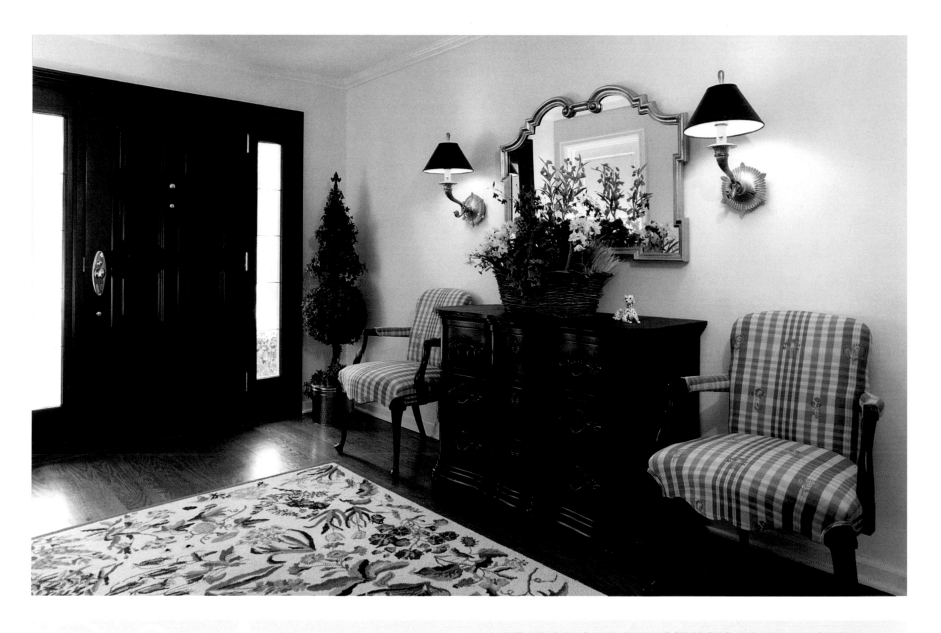

more about Bob & Anne ...

HOW DO YOU DESCRIBE YOUR COMPANY'S SERVICE OFFERINGS TO PROSPECTIVE CLIENTS?

We express our sincere desire to make their homes beautiful and personality reflective. It is our responsibility as designers to introduce clients to resources not available to the public, and because Bob Miller Interiors is a full-service firm, we are able to guide clients through the entire process.

OF WHAT ARE YOU MOST PROUD?

We are proud to have a family tradition of interior design. It is quite an honor to work with clients who have entrusted us to surround them with beautiful design for many decades.

ANNE, WHO HAS HAD THE MOST PROFOUND INFLUENCE ON YOUR CAREER?

Since I chose to follow in my family members' footsteps, they have obviously been tremendous sources of inspiration. We all love what we do and are inspired every day by our clients.

WHAT IS THE BEST PART ABOUT BEING INTERIOR DESIGNERS?

We enjoy the opportunity to work in an industry that is constantly evolving. Our clients are truly outstanding and it's a sincere pleasure to help them achieve their dreams.

BOB MILLER INTERIORS
Bob Miller
Anne Miller Ruggiero
203 Conant Street
Maumee, OH 43537
419.891.1199
Fax: 419.891.9611

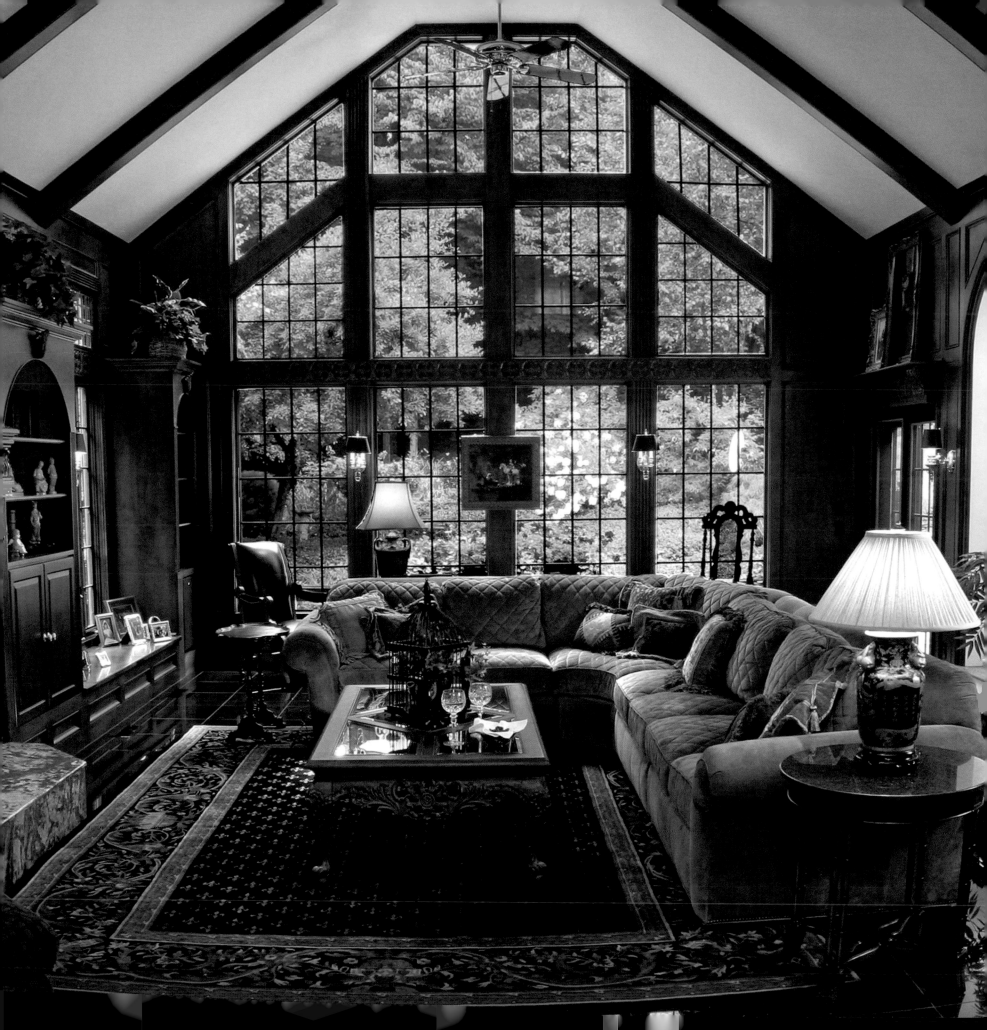

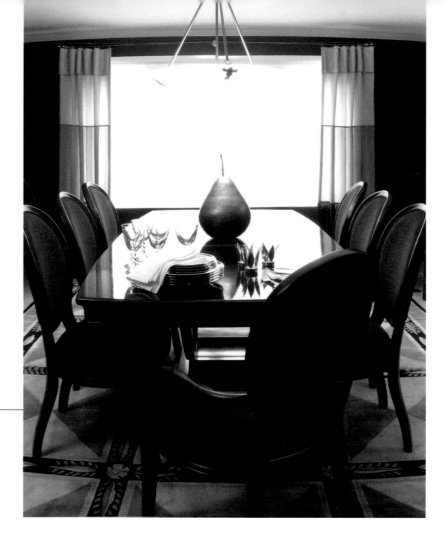

NICK MONACHINO
JENNIFER MONACHINO

MONARCH INTERIORS

Everyone enjoys a good love story. However most love stories don't begin and end with beautiful love-inspired interior designs, happily satisfied clients and the wonderful magnetism that Nick and Jennifer Monachino, of Monarch Interiors, exude to everyone with whom they come in contact. In essence, this is a true love story—a designer's dream come true.

Working within the design district Jennifer noticed a talented interior designer (Nick) visiting the showroom looking for products for his projects. She liked what he was doing aesthetically, thought him to be very creative and then one day 10 years ago, Nick asked her to come and work for him.

They began working diligently, shared meals together, entertained clients together and then one day three years ago Jennifer drew the line in the sand—she said they should get married and he couldn't resist.

Today, the two are inseparable much to their clients' satisfaction. They love catering to their clients, whether it's entertaining them or giving them designs that inspire love in their own lives.

They have a unique relationship with their clients because they become highly involved within their clients' lives. They become friends and every evening is occupied with client dinners—a client event or just spending time with a client. As long as the two are together and are deeply involved in a creative process they are happy.

The duo creates designs for residential and commercial projects that have included high-end homes, restaurants, law offices and other commercial projects, encompassing everything from new construction to remodeling existing structures, including historic preservation. They don't have a specific look to their designs; they try and encompass the lifestyle of their clients.

ABOVE
Faux wine-colored leather walls give this Transitional-style dining room the sophistication in which to entertain. A whimsical hammered-metal pear provides flair.
Photograph by John Quinn

FACING PAGE
This great room presents an elegant atmosphere with a wall of glass windows, granite floors and a custom suede sofa with quilted cushions for added softness.
Photograph by John Quinn

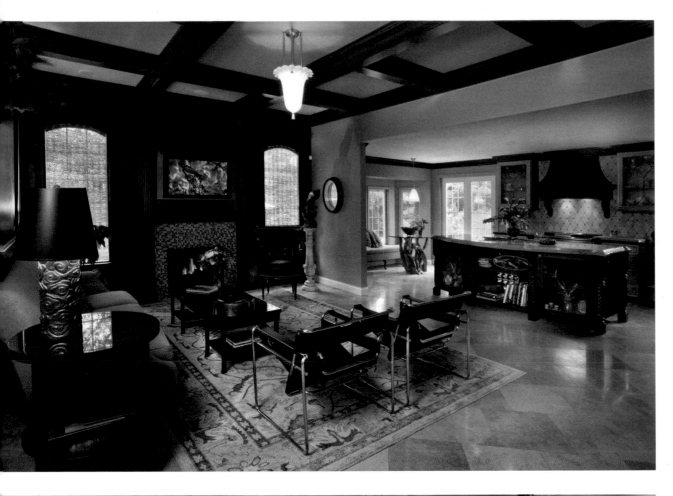

The pair has developed a niche within the Ohio market. They are one of the few who specialize in log home design because of the recent surge for the "rustic living" aesthetic.

Nick and Jennifer love and respect each other very much, love designing living spaces that change their clients' lives and their clients love the dynamic way in which their lifestyles, interest and passions are conveyed into rich interiors that, afterwards, they realize they can never live without.

Monarch Interiors' design on Cleveland's Blue Canyon Kitchen & Tavern won "Best Interior Design" from *Cleveland Magazine*'s "Silver Spoon" awards.

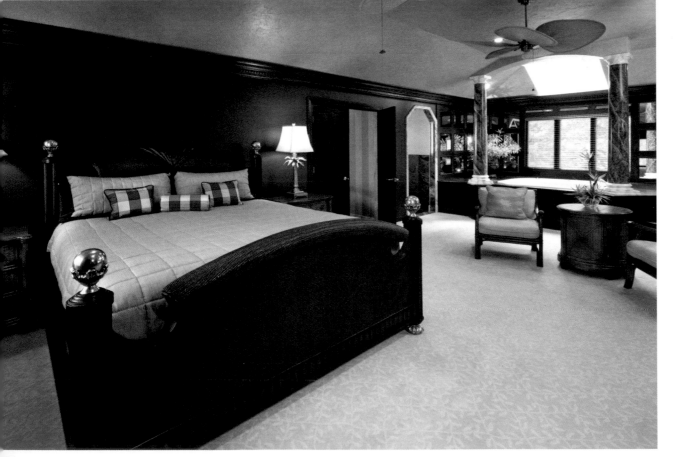

TOP LEFT
This floor plan offers a wide space for this great room/kitchen combination. Contemporary vintage chairs are set up against an island which provides a grand workstation for entertaining.
Photograph by John Quinn

BOTTOM LEFT
A grand scale bedroom provides a private retreat with saturated navy blue walls and a soaking tub flanked by columns. The room was designed with a West Indies influence.
Photograph by John Quinn

FACING PAGE
A full kitchen remodel with a French Country inspiration created a tremendous work environment and entertaining stage. A custom mural was inspired from a well-traveled client.
Photograph by John Quinn

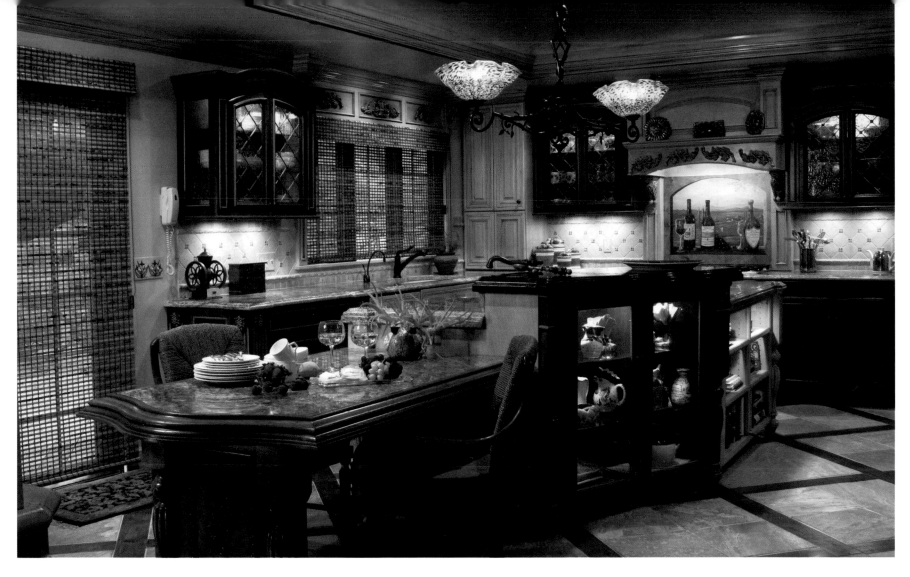

more about Nick & Jennifer ...

JENNIFER, WHO HAS HAD THE BIGGEST INFLUENCE ON YOUR CAREER?

I would have to say that Nick has been the biggest influence on me. I would never be where I am; I would never have had the opportunities. Nick set the pace for who we are. Thirty years of experience isn't something that you can create over night. He has dedicated his life, he created the atmosphere, he built up the clientele and I had the opportunity to walk in, pick up what I could pick up and run with it. I could have never done that without him or gotten this sort of education in school. I feel I owe him everything.

WHAT SEPARATES YOU FROM YOUR COMPETITION?

We are very hands on. We get involved from the onset of construction. Our clients always get more than what they expect. We wear all kinds of hats because we get involved in every aspect of the design, even when it comes to the foundation or to the landscaping. We encompass the whole idea of design and not just interior design. We get involved from the inside to the outside.

MONARCH INTERIORS
Nick Monachino
Jennifer Monachino
392 East Kilbridge Drive
Cleveland, OH 44143
440.473.0555
Fax: 440.473.0653

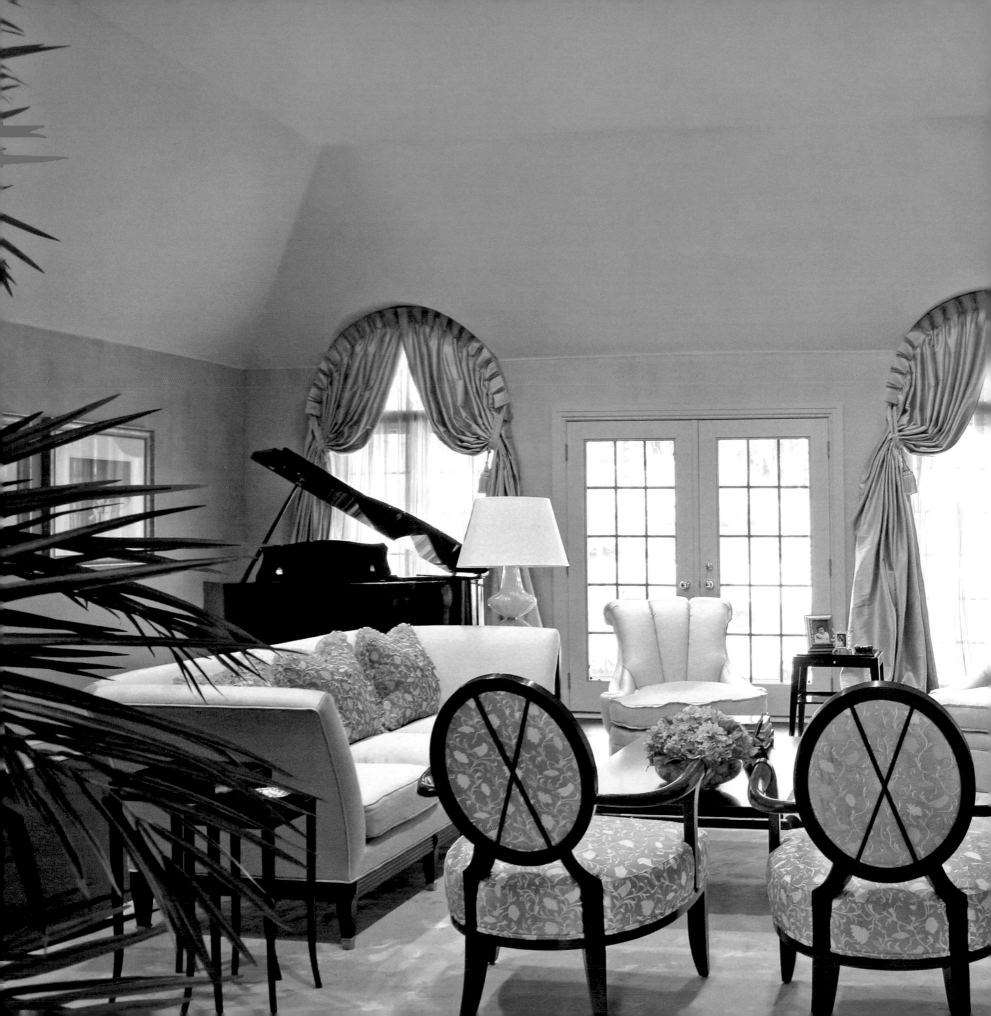

LIBBY PALMIERI

PALMIERI INTERNI

Libby Palmieri, of Palmieri Interni, found her way into the interior design business by happenstance and an instinctive ability for design that was led by an imagination that provoked the ordinary. Her clients find the elements of her design refreshing, inspiring and a genuine reflection of Libby's sentient personality.

Married to a builder/developer, Libby found herself moving six times in as many years and recreating her home after each move. Despite the inconveniences incurred over the years, the love of creating extraordinary spaces became innate. And because a builder's best selling point is a job well done, her husband would bring his clients to their own home to show them the quality of the construction. During the course of one such home tour, a couple was more than complimentary to the interior appointments.

LEFT
Inspired by the client's desire to capture the glamour of a bygone era, a sophisticated screen starlet look was created through a neutral palette of shimmering textiles.
Photograph by Pete Maric

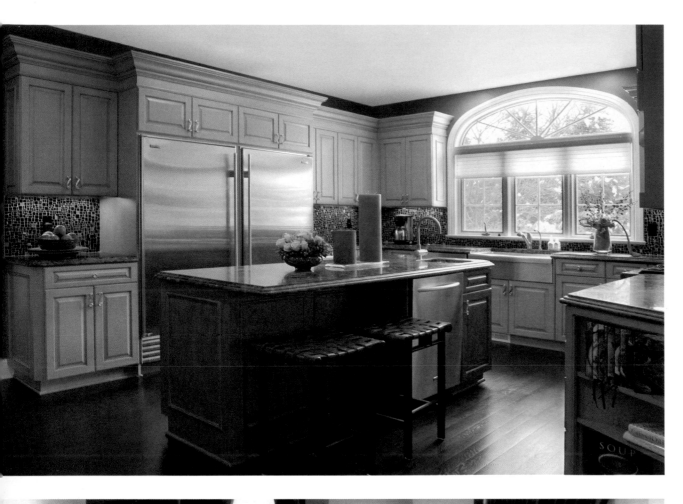

They offered Libby her first job. Ultimately, with her husband's encouragement, Libby designed the interior of the couple's home and started her own interior design business.

Never one to shy away from color or bold architectural elements, Libby is able to capture her audience by spinning the expected into something that demands notice. Inspirations for her interiors are all based on classic elements, but what her clients truly revel in is the manner in which Libby carries out her visions. Coalescing archetypes that echo many eras past while winking at clean Modern aesthetic keep Libby's designs fresh, young and unequivocally glamorous.

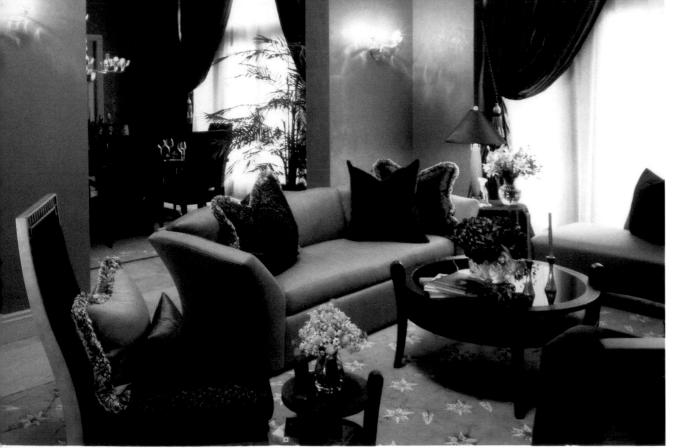

TOP LEFT
The asymmetrically patterned glass mosaic backsplash, persimmon walls and tangerine accents add excitement to the otherwise neutral palette of light wood and stainless steel. The built-in bookshelf serves as both a graphic and storage element.
Photograph by Pete Maric

BOTTOM LEFT
Ideal for entertaining, the two-story living room transitions smoothly into a dining room with variations on the color scheme of bronze and fiery cinnamon. Tied back custom draperies with 20-inch tassels accentuate the dramatic space. Coffee and end tables are by J. Robert Scott.
Photograph by Pete Maric

FACING PAGE
Completely remodeled, the master bedroom's ambience is created with the up-lit rotunda, series of five panels and luxurious textiles. The juxtaposition of masculine and feminine is demonstrated in the defined bed with hand-blocked organza draperies and his and her night stands.
Photograph by Pete Maric

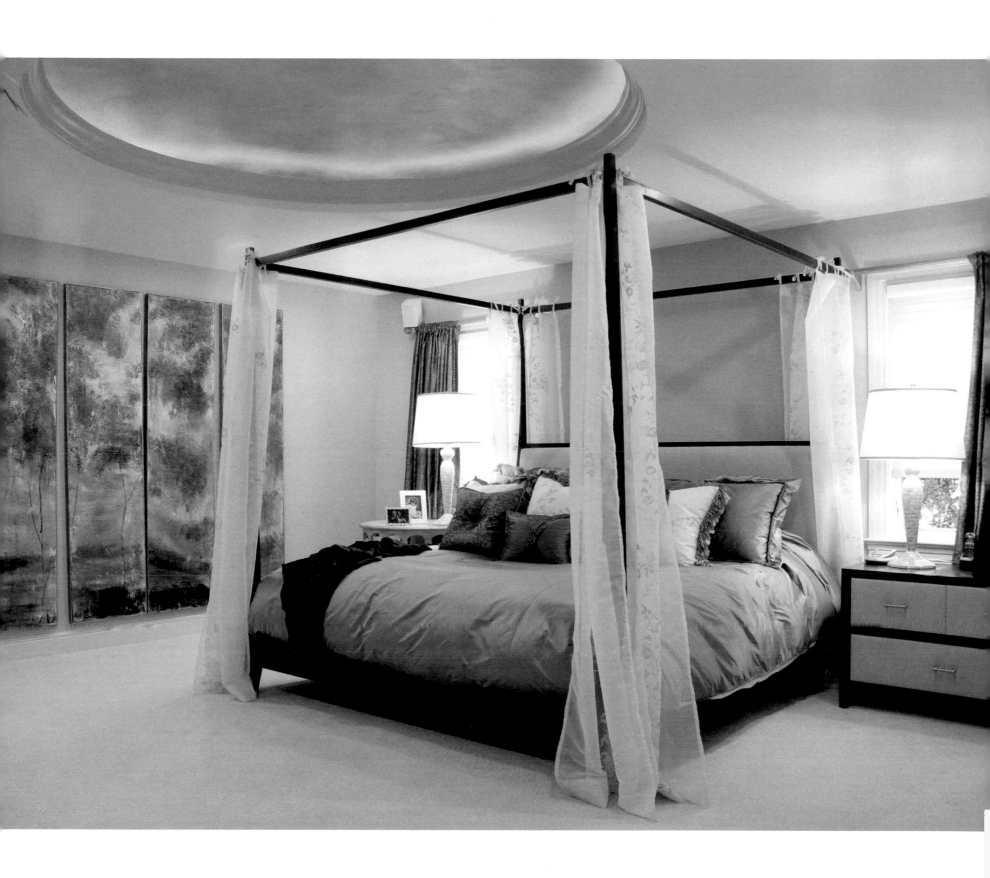

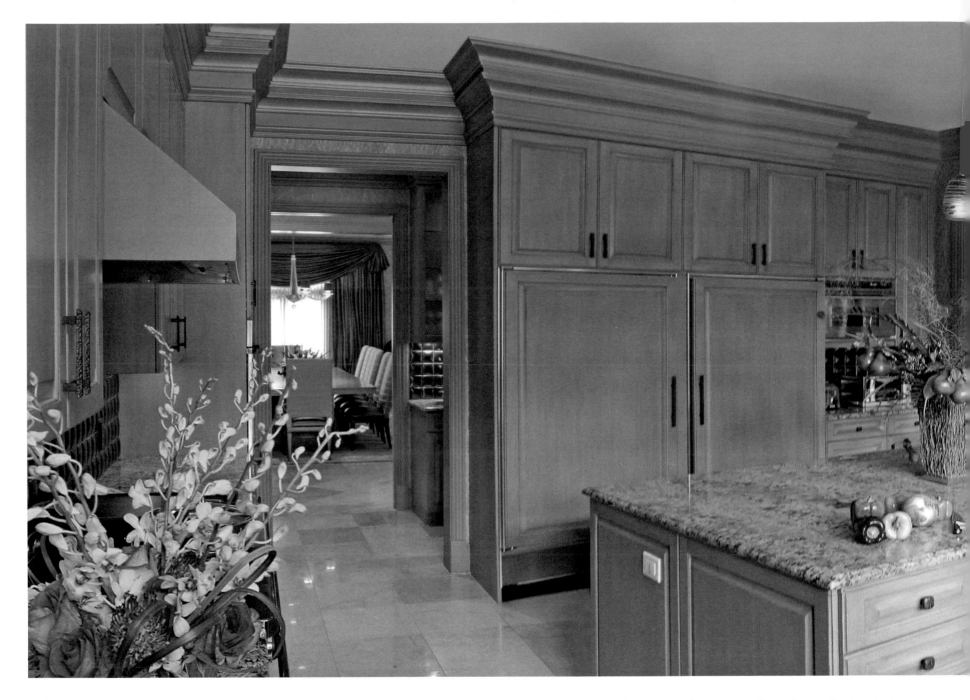

Trust is the most defining element in any relationship the designer enters with a client. The conviction of knowing and understanding what a client is trying to convey to her is the most critical component to having a working partnership that can endure the stresses that typically accompany designing a person's home. Libby's strength rests on her ability to ascertain the body of work, and then weave a fantastical web of ideas and visuals to help capture the clients' initial concepts of what they want to create: A sublime reality.

"Beautifully functional" is a perfect way to describe a house that Libby has had a liaison with. She is keenly aware that if a client has five dogs or a two-year-old child, there are materials that she should use because of the sheer practicality, or not use, because of the lack thereof. As a young mother herself, her life experiences help her with these critical details of home design and the process of personalizing a home to a client. The fan base she has acquired over the years appreciates her impeccable taste, fastidious eye for the smallest of details and adores her insouciant demeanor.

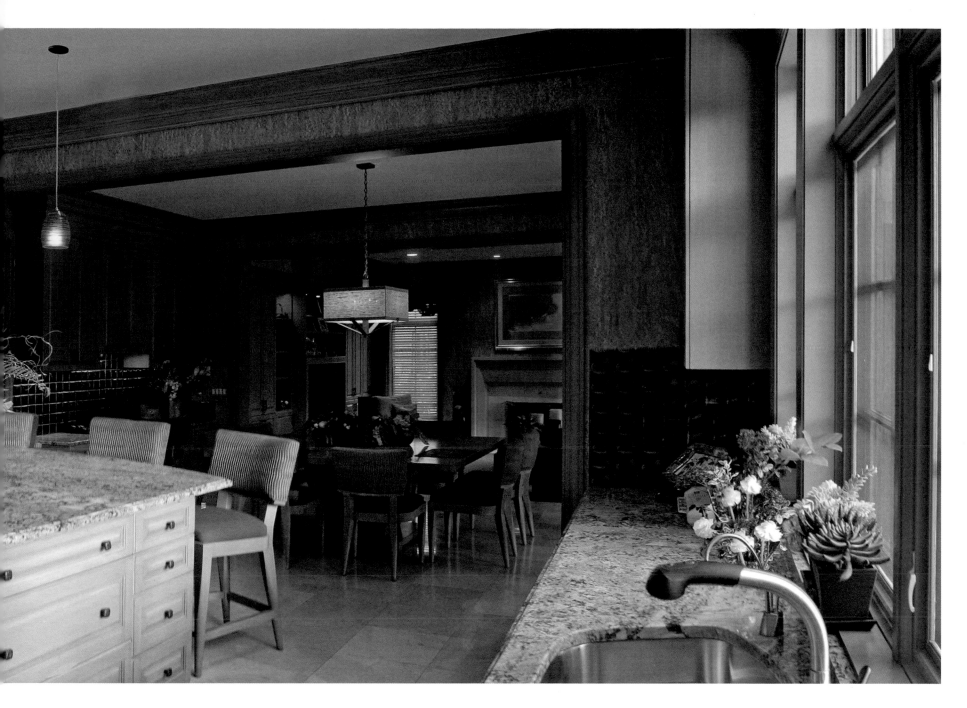

In the very demanding business of interior design Libby prides herself on being very generous with her time, energy and the verve she puts into a project. When working on a home she is always receptive to her clients' needs.

Proud of every project that she has worked on, there isn't one that she favors more than another because she finds herself enamored with each and every one. Every new undertaking is set to the standards of excellence to which she holds herself. Moreover, it's the passion that she approaches each project with

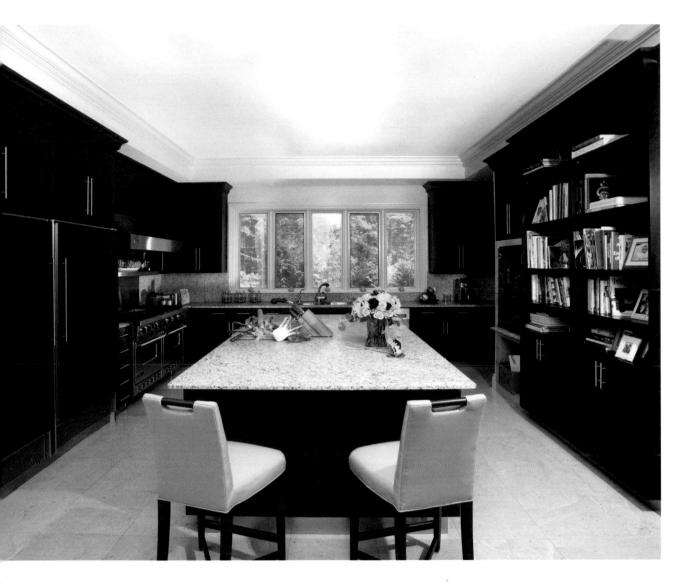

that fuels her creativity and is quenching for clients. "Every project for me is a new game, a new adventure and a new source of energy because my work is my pulse." Her level of enthusiasm is unequivocal whether the job involves a master bedroom suite or a 15,000-square-foot home—and that is ultimately what her clients love.

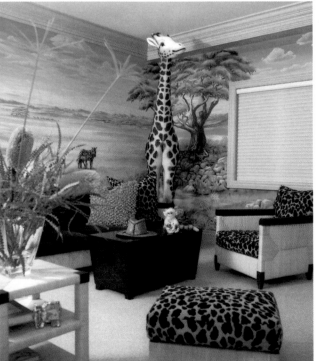

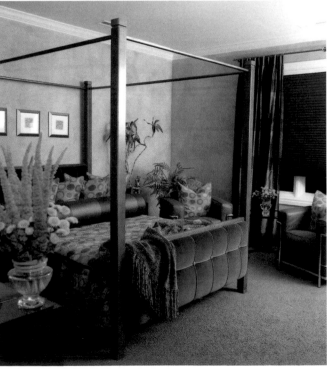

TOP LEFT
A serious island—nearly eight feet by five feet with plenty of space on either side—for a serious chef, is surrounded by espresso-stained cabinetry, two dishwashers, a commercial grade range and a wood-burning oven.
Photograph by Pete Maric

BOTTOM FAR LEFT
To match the rest of the home's sophistication, Donghia furnishings ground the playroom's composition. The colorful mural is brought three-dimensional with a Steiff giraffe.
Photograph by Anne Swider

BOTTOM LEFT
Designed for a little boy's long-lived enjoyment, the classic contemporary bedroom boasts a lively scheme of blues and purples, harmonized with cherrywood furniture. The blue leather Cassina chair raises the level of refinement.
Photograph by Anne Swider

FACING PAGE
The gigantic master bedroom, which is flooded with natural light, boasts two sitting areas and a dramatic wall of veneer and leather panels. Concealed at the base of the bed, a plasma television pivots 360 degrees for viewing pleasure from anywhere in the room. An archway leads to the gentleman's closet on the right and the bathroom suite and lady's walk-in closet on the left.
Photograph by Pete Maric

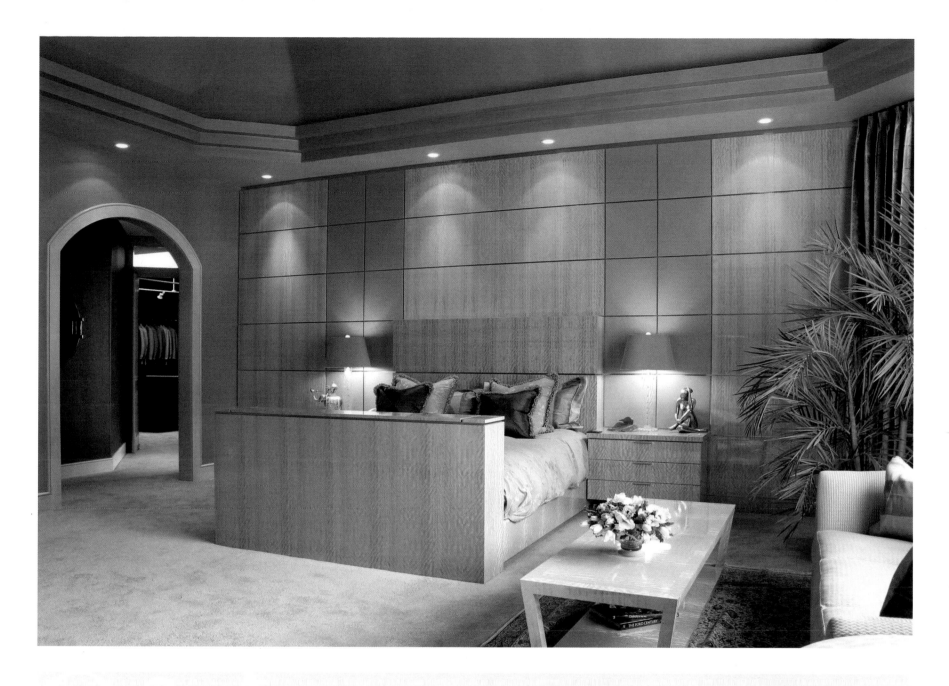

more about Libby ...

WHAT SINGLE THING WOULD YOU DO TO BRING A DULL HOUSE TO LIFE?

I think the houses being built today are somewhat lacking in any specific architectural aesthetic, and therefore, I would add at least one element architecturally that would enhance the space.

IF YOU COULD ELIMINATE ONE BUILDING TECHNIQUE FROM THE WORLD, WHAT WOULD IT BE?

Formica! I hate Formica. I would ban it from anything, except perhaps a garage.

WHO HAS HAD THE BIGGEST INFLUENCE ON YOUR CAREER?

The number one influence in my career would have to be my husband. He is my source of inspiration. If it wasn't for him encouraging me to take that first job I wouldn't be where I am today. I always rely on him because he is an amazing resource, having built so many homes. I always go to him when I need advice or a question answered. He is always my best bet.

PALMIERI INTERNI
Libby Palmieri
31875 Solon Road, #5
Solon, OH 44139
440.248.7502

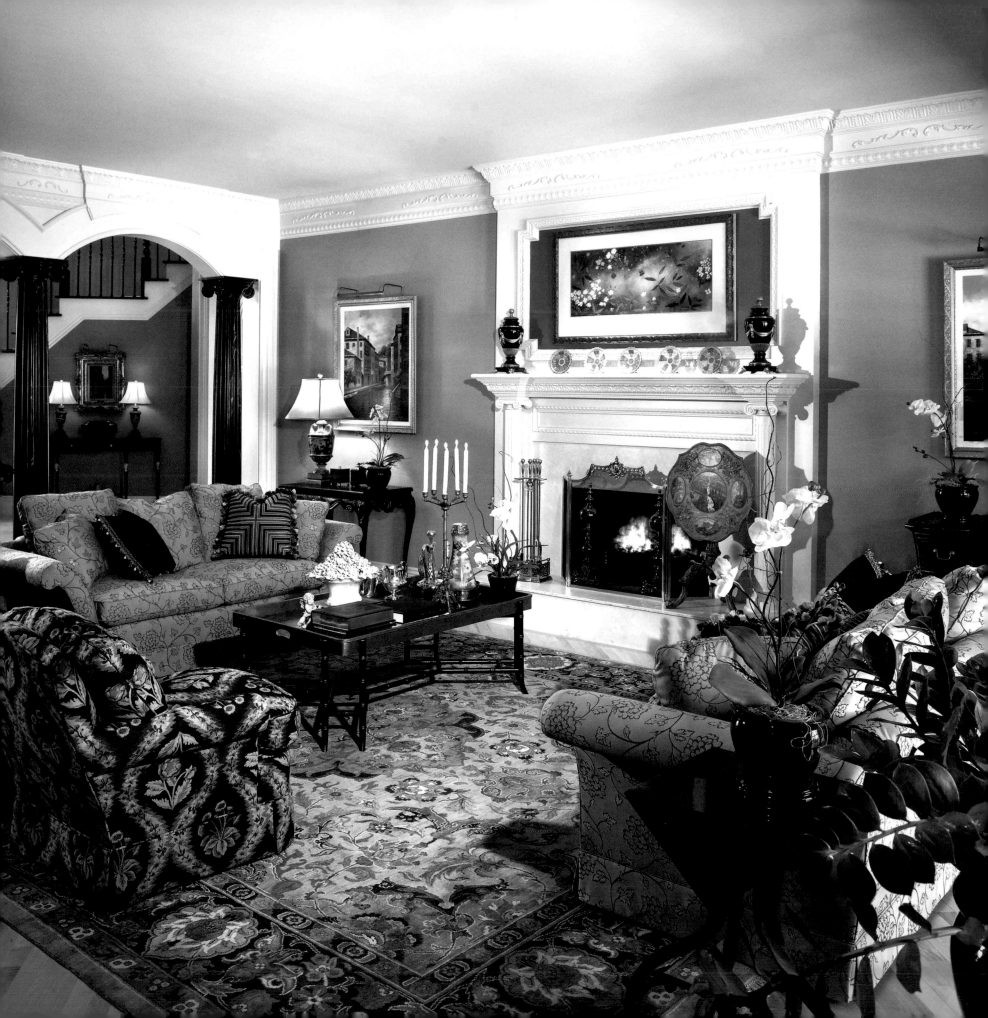

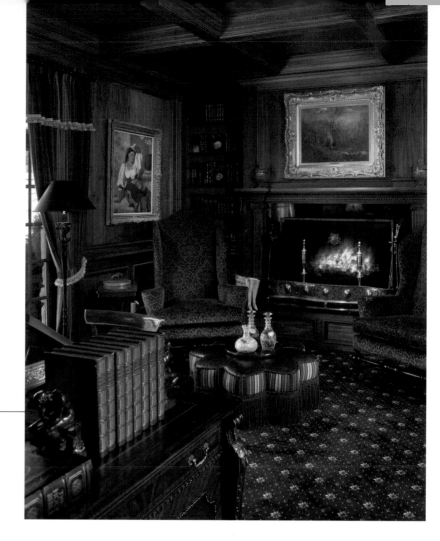

TRAC PAPISH

ASSOCIATED DESIGNS

Life is about giving back what you've been given. And for Trac Papish—who has been blessed with an abundance of creativity, a distinctive style, and a keen ability to take an abstract concept and transform it into a tangible achievement—that means giving his clients custom designs that exceed their imaginations.

Trac realized his gift at a young age, when he would join his parents on their new home construction site with his Tonka trucks and Legos. Alongside the contractors, he'd dig tiny basements and build elaborate structures with his toys. Later on, he'd help out a family friend in an architectural firm. By his junior year of college, at the prestigious Columbus College of Art and Design, he was well on his way to becoming an architect. That's when a professor steered him toward interior design and architectural drafting.

His first break came fast, just 18 months after he'd graduated from college, and at age 25 Trac started Associated Designs. Seventeen years later, the small firm is renowned for commercial and residential interior renovation and new construction, with clients in the United States and the United Kingdom ranging from high-end residential to hotels and restaurants.

Four principles define the philosophy behind Associated Designs: communication, concept, specification, and implementation. These are the strengths and the dynamics that have allowed the company to become a firm with a reputation for innovation and progressive work. Each relies on the others, and all carry equal weight in the success of a design and a client's satisfaction.

ABOVE
The walnut-paneled formal library, with its coffered ceiling and hand-woven wool rug, creates a formal and classic library. The Baker, from Stately Homes, velvet wing chairs in Cowtan and Tout fabric provides a comfortable environment for the oversized fireplace. The oil paintings are antique from Paris and London.
Photograph by Jim Maguire of Maguire Photographics

FACING PAGE
This French Normandy estate features detailed millwork, Italian antiques, Baker Knapp and Tubb furniture, and artwork gathered in the client's travels through Italy.
Photograph by Jim Maguire of Maguire Photographics

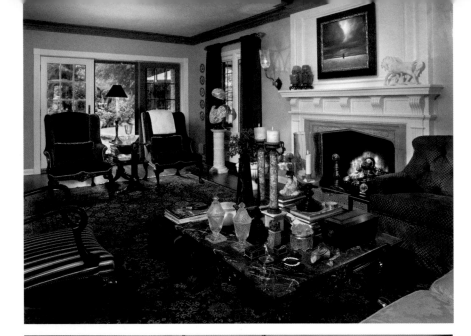

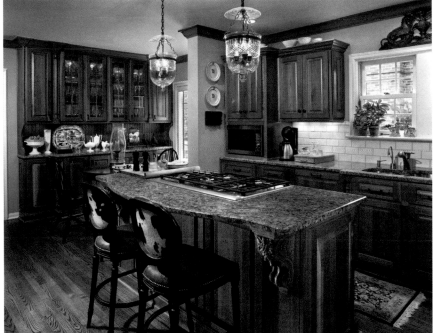

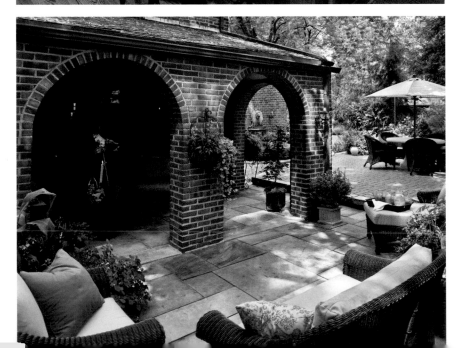

The jumping-off point for every new project is communication, Trac says, emphasizing, however, that communication is crucial at every stage. Residential clients in particular can be trepidatious at the start of a job, but the designer has perfected ways to set them at ease and gain their trust, all the while gleaning information he needs to give them the home of their dreams. What is your life like? Where do you get dressed in the morning? Do you read in bed? Do you eat in bed? Where do your pets sleep? These are the types of questions that calm a homeowner's nerves yet build in them excitement about their new rooms.

The second aspect of a project is taking the information learned during the initial discovery process and creating a concept that reflects the client's lifestyle, personality and specific needs. Focusing on the individual means never having to use cookie-cutter designs, Trac says. It means giving someone an entirely custom environment, considering everything from the size and shape of the bathtub, to the placement of a built-in spice rack, giving them a sunlit corner in which to read a book, incorporating a precious family heirloom, or using a color that delights that person's heart.

TOP LEFT
The living room of the Country French 1920's brick and stone home features leaded windows, a handmade wool Indian rug, collaborating new Baker furniture with beautiful 18th- and 19th-century antiques. The contemporary oil painting above the mantel is a stunning focal point and a place for one's eye to rest.
Photograph by Jim Maguire of Maguire Photographics

MIDDLE LEFT
The kitchen of the above stated home was re-designed by allocating space into the original breakfast room, thus creating a multi-faceted entertaining area with a hutch that can be utilized as a bar or a buffet. The cow skin bar stool provides a contemporary twist to the classic, traditional design.
Photograph by Jim Maguire of Maguire Photographics

BOTTOM LEFT
Exterior spaces can be just as rewarding and livable as interior. Elevations are created within the topography thus creating multiple levels as one would find within their home. Good design direction combines interior and exterior living spaces. This terrace lies right outside the photograph at the top left.
Photograph by Jim Maguire of Maguire Photographics

FACING PAGE
This Neo-Classic dining room is the collaboration of the old and the new, maintaining the home's 1920's design, a palette of white, black and values of tones thus allowing the eye to focus on the shadows of the imagery and not a bold color scheme. Many of the items are John Widdicomb from the Russian collection with accessories from American glass, marble, American silver and porcelain.
Photograph by Jim Maguire of Maguire Photographics

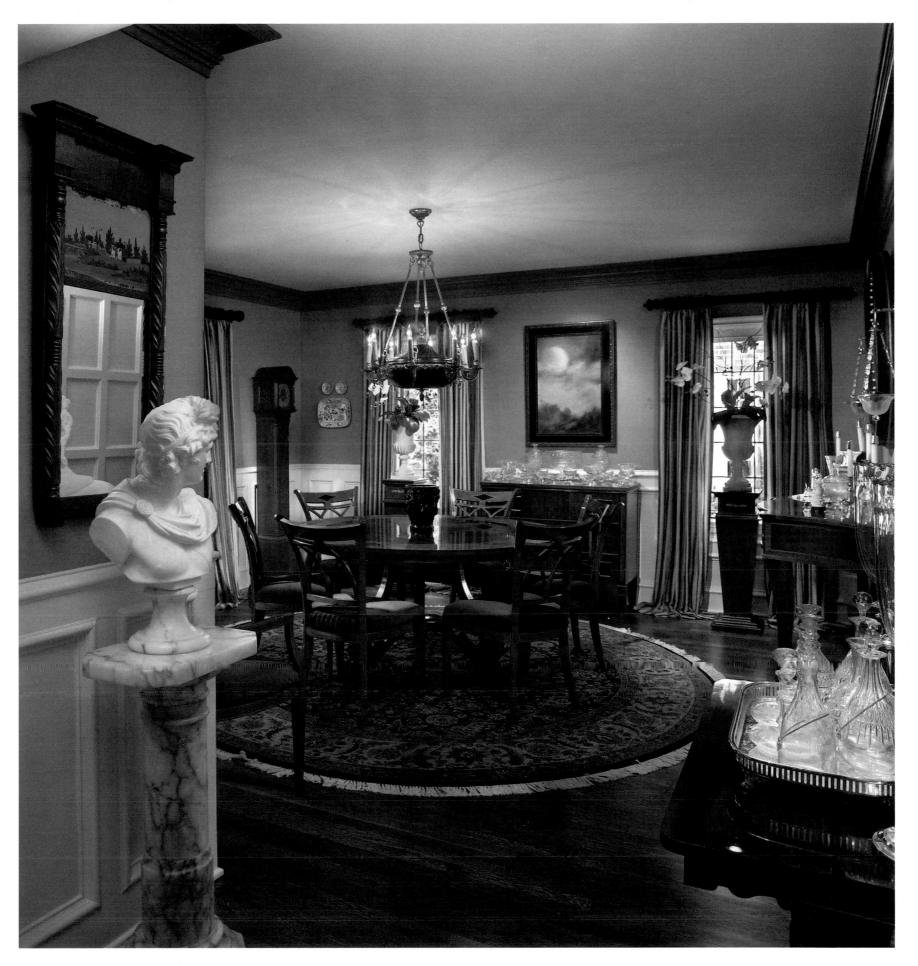

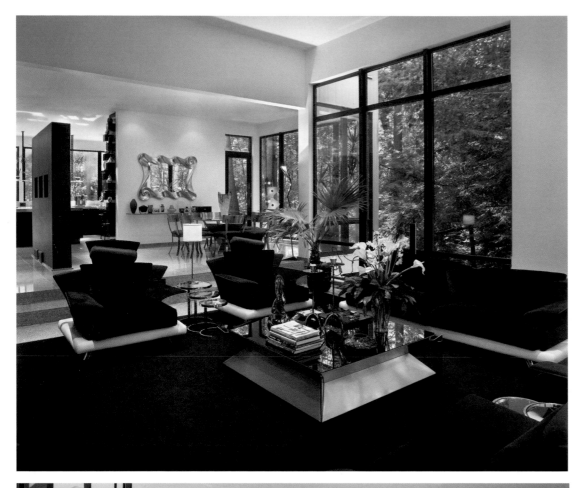

Design specifications and documents are the third important principle in Associated Designs' operating technique. Taking careful notes and documenting every conversation ensures that Trac accurately and efficiently interprets a client's goals. The designer's arsenal also includes highly developed drafting skills involving perspectives, working floor plans, reflective ceiling plans, section cuts, isometrics and elevation. His design dexterity allows him to manipulate shape, space and form in traditional and experimental concepts for superior space planning.

The final component of any job is implementation: The bringing together of communication, concept and specification in an ingenious way to not just fulfill but surpass the client's notion of exquisite living.

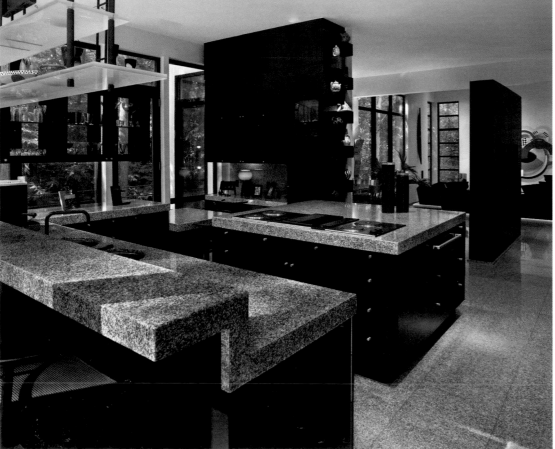

TOP LEFT
This modern tree house is a home built on pedestals that tier high in the trees. Designed with floor-to-ceiling windows, granite floors, white walls and Campaniello furniture created and imported from Italy add sophistication. Stainless steel Breuton provide an exciting environment through the use of texture and value.
Photograph by Jim Maguire of Maguire Photographics

BOTTOM LEFT
From the same home, the floating island and peninsula are within the kitchen. The only color added in the palette throughout the entire home may be viewed. This sapphire blue free-standing wall becomes a sculpture within the space.
Photograph by Jim Maguire of Maguire Photographics

FACING PAGE
A lovely English Country estate with beautiful acreage surrounding the home features a grand master bedroom with formal seating, a king-size bed and intimacy in a corner fireplace. A sprayed French blue barrel ceiling captures an endless sky, allowing the eye to bring the outdoors in.
Photograph by Jim Maguire of Maguire Photographics

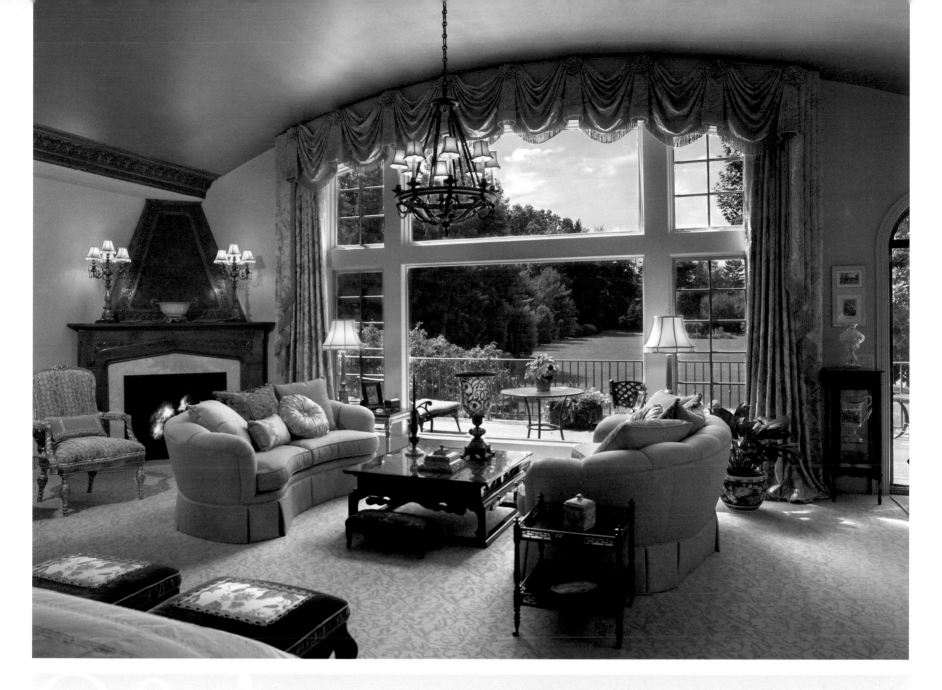

Q & A

more about Trac ...

WHAT IS SOMETHING MOST PEOPLE DON'T KNOW ABOUT YOU?

I have an intense, gregarious personality and many think of me as the life of the party. However, I'm actually quite shy, sensitive and more introverted than people realize. Likewise, many think of my work as mostly Traditional, but my portfolio reveals a wide range of styles, including many Contemporary and Modern designs.

WHAT COLOR BEST DESCRIBES YOU AND WHY?

I am most like the value of white, because I am capable of both reflecting and absorbing other colors. Like white, I am receptive to the things around me.

WHAT WOULD YOUR FRIENDS SAY ABOUT YOU?

They would tell you that I am consistent and complex, that I have a heart of gold and a door that is always open.

WHO HAS HAD THE BIGGEST INFLUENCE ON YOUR CAREER?

From the beginning my parents were very encouraging. They told me, "Go, live life." And I've done that with gusto, passionately giving my clients beautiful spaces in which to live their lives.

ASSOCIATED DESIGNS
Trac Papish
17427 Shelburne Road
Cleveland Heights, OH 44118
216.321.5270
www.associated-designs.com

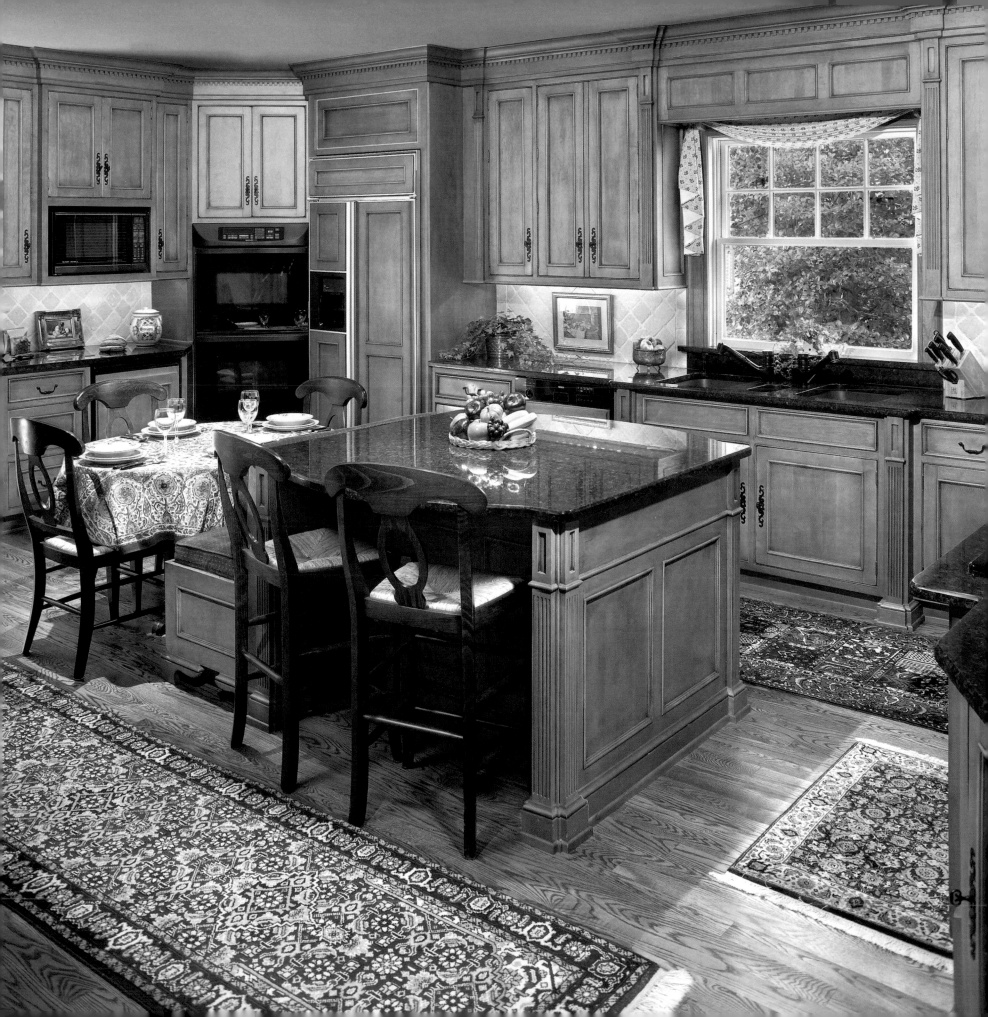

WILLIAM PURDY

PURDY'S DESIGN STUDIO

The center of the home and the room that nourishes the growth and love of a family is the kitchen. Bill Purdy of Purdy's Design Studio knows how critical kitchens are to a house and the family that lives within it.

For over 40 years Bill has been designing superior kitchens for families. He knows kitchens can be one of the most difficult elements of home construction or remodeling; however his years of experience and his college architectural background give him an edge over the competition.

Frank Lloyd Wright said, "Form follows function," and this philosophy is what Bill uses when he designs his kitchen creations. Having designed thousands of kitchens throughout his career Bill knows that his clients want a functional but also aesthetically pleasing kitchen. His designs inspire and nurture those families that he touches.

Whether it is working with interior designers, architects or the homeowners themselves, Bill uses his extensive knowledge, diverse experiences, relationships with vendors and a philosophy of form following function. Bill's desire is to enhance his clients' lives by providing a kitchen design that is not only their dream kitchen but one that is beyond their dreams!

ABOVE
A striking contrast of warm- and cool-toned surfaces makes this kitchen exquisite. Contemporary lighting fixtures hang from the sloped ceiling.
Photograph by Jim Maguire of Maguire Photographics

FACING PAGE
The graciously sized kitchen's custom cabinetry is accentuated by granite countertops. Adjacent to the breakfast table, an island provides additional preparation and storage space.
Photograph by Jim Maguire of Maguire Photographics

PURDY'S DESIGN STUDIO
William Purdy
2101 Richmond Road
Beachwood, OH 44122
216.831.1520
Fax: 216.831.1669
www.purdysdesign.com

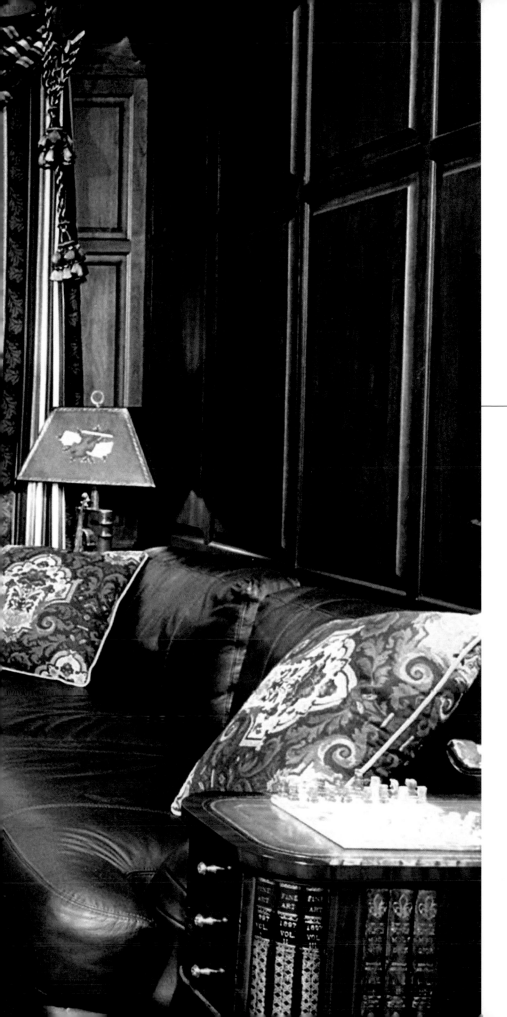

BUSHRA RAHIM

BR DESIGN, INC.

Before Bushra Rahim became the mother of four, an interior designer, space planning architect and licensed general contractor, she sewed almost all of her own clothes. Just as she found joy in the creative process of making one-of-a-kind apparel, from coats to suits and dresses that could be as detailed or as simple as she wished, Bushra views her vocation as an opportunity to translate her clients' wishes into homes that not only fulfill their needs and reflect their aesthetic desires, but improve their quality of life.

Bushra's background in art has been an invaluable asset to her interior design work, and clients reap the benefits of her worldwide experiences. Raised in Iraq, she earned her baccalaureate degree in art from Baghdad University, and although her father tried to dissuade a career in architecture, she pressed onward in her studies. After undergraduate school, she moved to London for several years, during which time she and her husband traveled extensively and started their family. Upon moving to the States, she added another degree to her already impressive

LEFT
A cozy place to read and relax, the library has warm cherry paneling that is accentuated with rich jewel tones in the upholstery fabric, draperies and rug.
Photograph by Ahmed Rahim

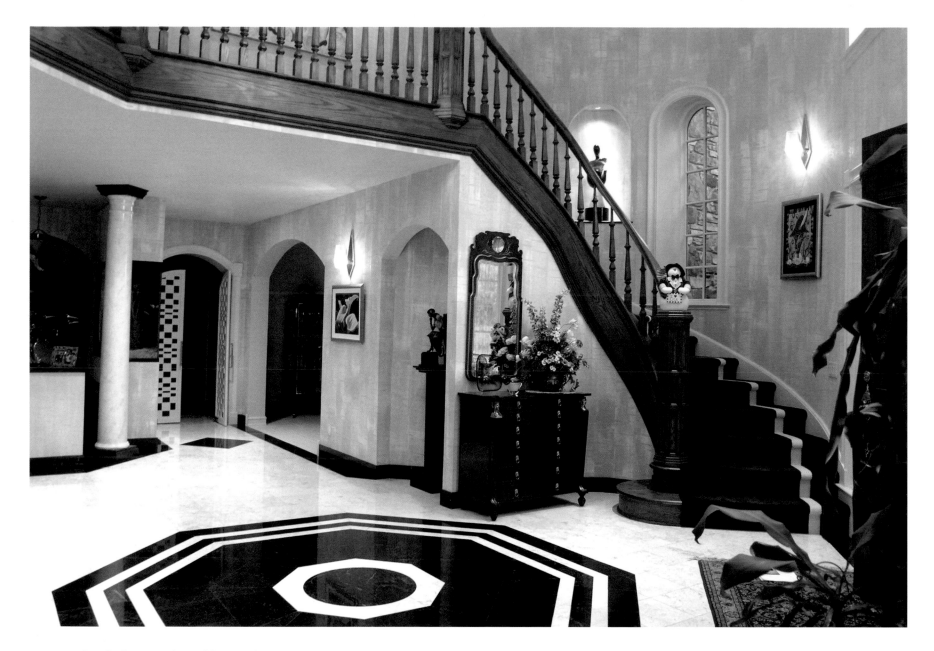

resume—just before earning a Master of Art she left to fulfill her dream and get an associate's degree in interior design—and began working in the field of luxury homes.

Though many years of refining her design approach and process led up to the establishment of her firm, BR Design, Inc. in 1981, Bushra has continued to search out new ways to exceed her clients' wishes. She has chosen to maintain a small company, which ensures that each client receives personal attention and professional results. The multi-functional firm offers services from architectural layout, to construction administration for new homes and renovation projects, interior design—material specification, cabinetry design, draperies, upholstery and faux finishes—and even landscaping, literally each and every aspect that lends to a cohesive result.

Whether clients need to have a small room updated or a 15,000-square-foot home designed from the ground up, Bushra has the talent and resources to help her clients envision their dream homes, and she delivers spectacular results. Her innate ability to walk through a space and see a completed project in her head has proven tremendously advantageous and earned her the respect of industry peers and clients alike.

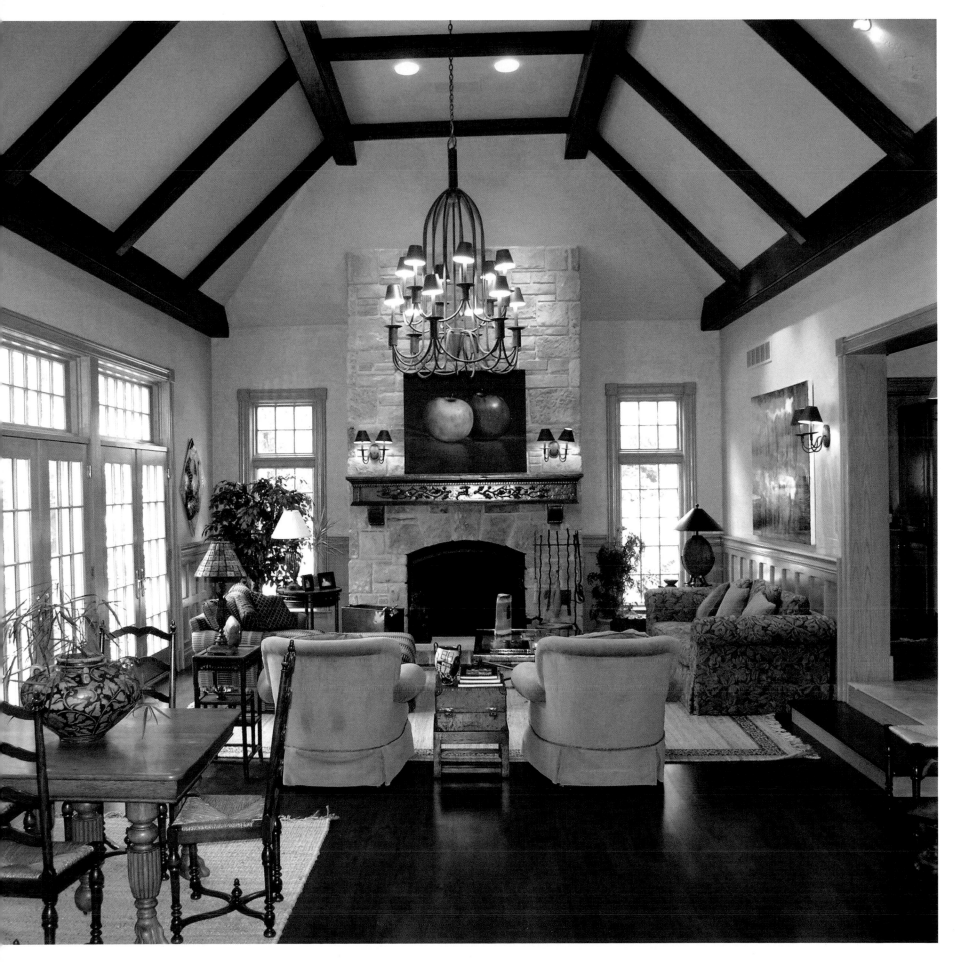

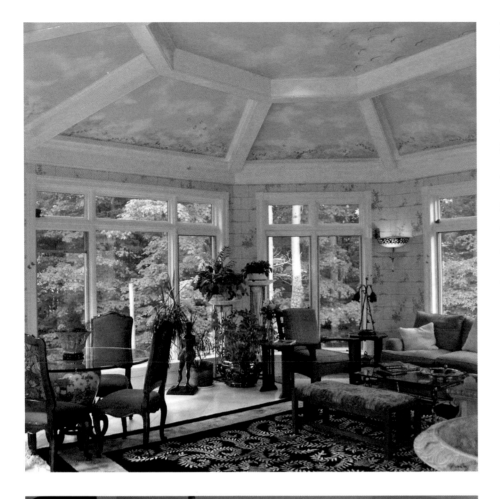

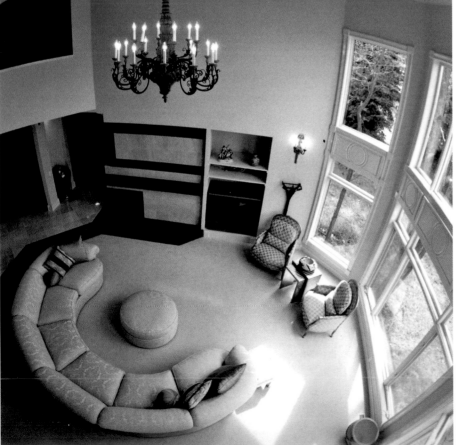

In Bushra's quest for successful, smoothly flowing projects, she has become intimately familiar with a full spread of disciplines relating to home design. "I work with clients from A to Z; once I ascertain a family's needs and wants, I design a comprehensive plan, work with an architect to create blueprints, act as the general contractor and finish out the interior with thoughtful design."

While she delights in the entire process, the designer admits that she is most drawn to the problem-solving aspect. There is just something wonderful about being able to quickly devise alternatives, present them to clients, and get them excited about the project, relates Bushra. Aside from process-related challenges, she enjoys the unique opportunity that each client and their project affords.

Stylistically, traditional design has become somewhat of a specialty. However, Bushra is happy to accommodate a mixture of preferences and has extensive experience working in Contemporary, Neo-classical and Country vernaculars. A tribute to her ability to creatively meld clients' individual desires with practical design, patrons continue to refer Bushra to their closest friends and family. Bushra has designed in Massachusetts, Washington, D.C., Iowa, Florida, Chicago and even Beirut, Lebanon. Bushra's multi-cultural experiences, along with a strong art background, serve as the foundation for her timeless designs with an international flair. In all of her projects, big or small, she strives to bring each space and its inhabitants to their fullest potential.

TOP LEFT
Overlooking a lush ravine, the garden room was designed to draw in the outdoors. The combination of a ceiling fresco, cove lighting, sconces, Brunswick wall covering and eclectic furnishings invites guests to linger.
Photograph by Bushra Rahim

BOTTOM LEFT
A three-way marble fireplace serves as the focal point for this two-story family room. The natural color palette, which is carried through to adjoining rooms, draws attention to the lake views through the wall of windows.
Photograph by Ahmed Rahim

FACING PAGE LEFT
This two-story living room is customized with niches to display the owners' art glass collection and a floor-to-ceiling limestone fireplace.
Photograph by Bushra Rahim

FACING PAGE RIGHT
Suspended by chains from the voluminous dining room ceiling, an oak beam sets off the lighting fixtures.
Photograph by Bushra Rahim

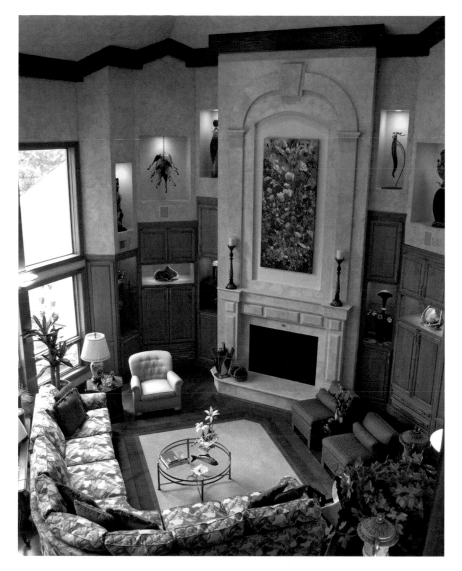

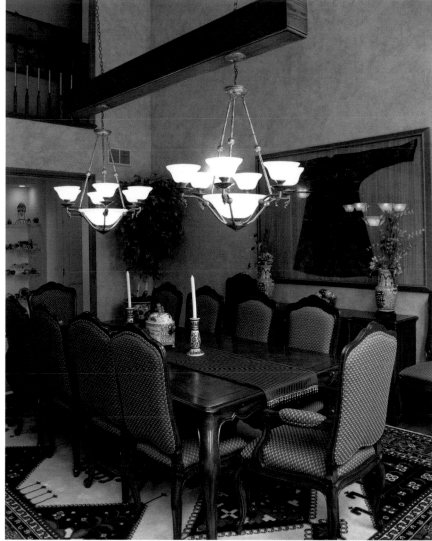

more about Bushra ...

WHO HAS HAD THE MOST PROFOUND INFLUENCE ON YOU?

My mother; she was artistic in everything that she did. She taught me how to sew, cook and decorate, and I think that early exposure inspired me to pursue this creative field.

DO YOU HAVE ANY LONG-STANDING PHILOSOPHIES?

I've adopted my mother's belief that if you want to do something, do it right. She also taught me to always be honest and go straight forward with what I believe is right. In design, I always think that homes should reflect people's personality and lifestyle.

WHAT SEPARATES YOU FROM OTHER INTERIOR DESIGNERS?

In addition to my well-rounded background and meticulous attention to detail, the spaces I design are always inviting, despite being well adorned.

HOW DO YOU REFLECT YOUR CLIENTS' NEEDS WITHIN THEIR HOMES?

I always visit extensively with my clients to learn their needs and preferences. By working with different styles, color palettes, materials and space arrangements, I'm able to reflect their personalities in a pleasing manner.

BR DESIGN, INC.
Bushra Rahim
5222 Richmond Road
Bedford Heights, OH 44146
216.831.1510
Fax: 216.831.1615

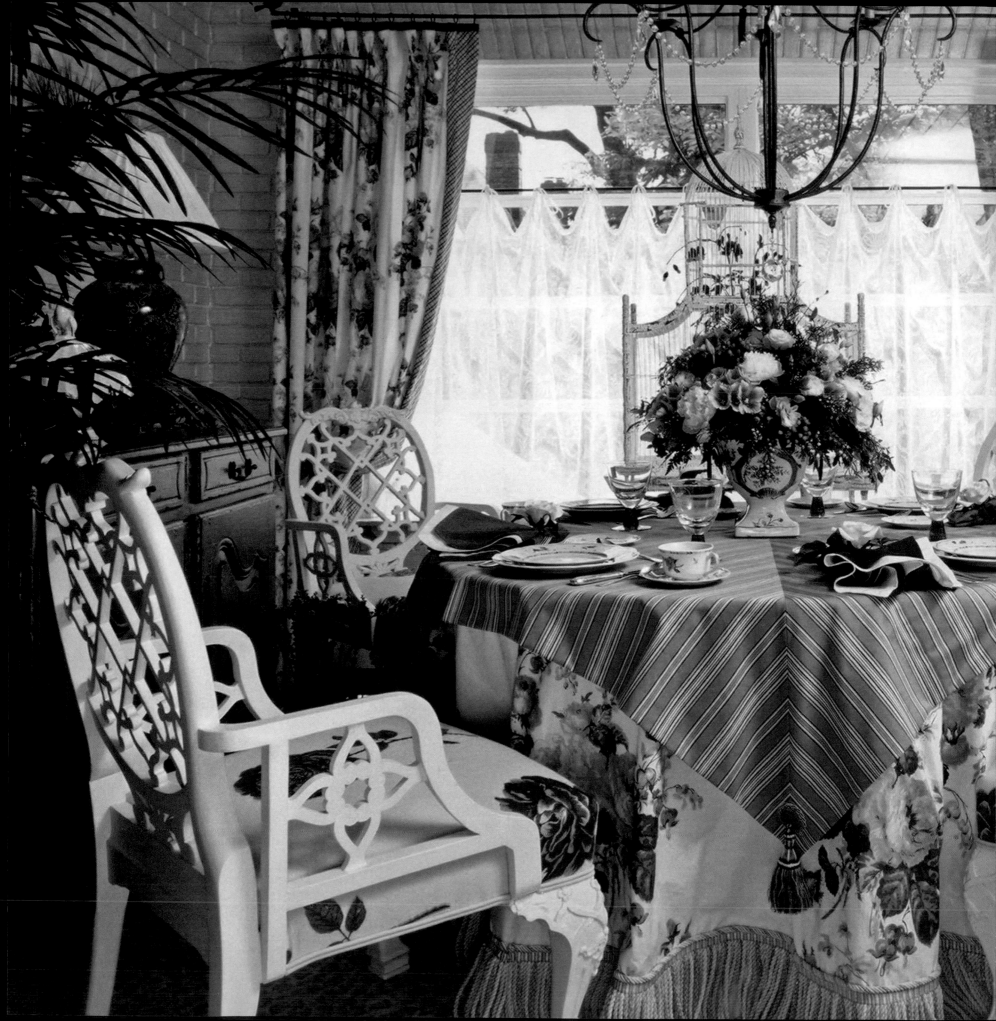

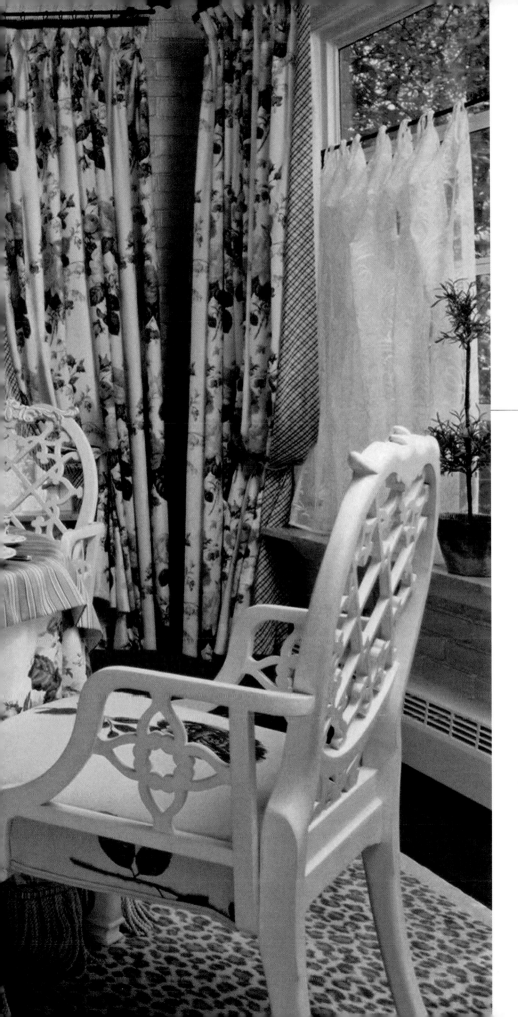

LINDA S. RUSSELL

RUSSELL INTERIOR DESIGN. INC.

As much as interior design is a creative process, it is also a service business. When Linda Russell interprets her clients' needs into workable plans, her priority is to maintain an open line of communication. By doing this, she ensures that her clients' personalities and lifestyles are reflected in a timeless manner that will be enjoyed well into the future.

Beginning her career as a graphic designer, Linda held different jobs before entering a position at a major bank in Akron where she assisted in the renovation of the interior spaces of its branch banks. Inspired by this unique introduction into design, she started her own business in 1995 and has been in the design business for nearly three decades.

Although she doesn't have a "signature look," the interiors she designs are functional, attractive and ultimately fit the clients' needs. Linda tries to individualize her designs to make every scheme unique to that client.

LEFT
This morning room represents a relaxed sophistication with its trellis dining chairs, layered patterns and playful leopard print underfoot. A cozy nook for breakfast or a small dinner party.
Photograph by Al Teufen, Al Teufen Photography

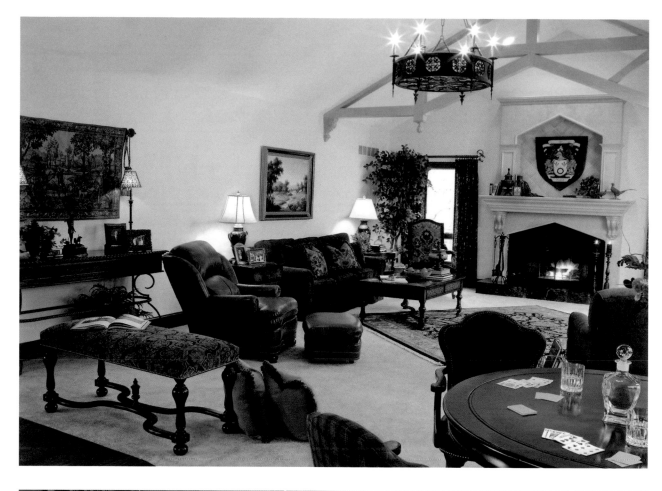

She believes that interiors should be practical and incorporates that philosophy into her business. By designing for the overall ambience and small details alike, Linda has garnered many compliments, in the form of return clients and phrases such as, "This room feels really good, and I'm comfortable in it."

A professional member of The Interior Design Society, Linda is the current president of The Northeast Ohio Chapter.

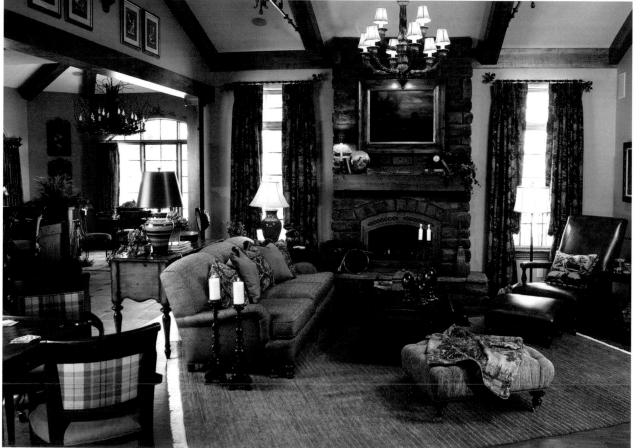

TOP LEFT
Upon entering the family room of this home, a guest is immediately drawn to the coziness of the large space and to the oversized arched fireplace featuring a custom iron, hand-painted family crest. The warmth is conveyed in the tartan plaid, tapestries and rich colors throughout in upholstery, linen draperies and Gothic-style chandelier.
Photograph by Bruce Gates, The Art Factory

BOTTOM LEFT
This room, in a country house, reflects an intimate feel with timeless, classic furnishings, colors of the earth and patterns inspired by nature. A multi-color toile on the draperies, exposed beams and the stone fireplace convey the time-worn feel.
Photograph by Bruce Gates, The Art Factory

FACING PAGE TOP
Based on an English floral print used on upholstery and draperies, the living room has evolved into a welcoming space in this open floor plan. The coral and sage complement the stained mantel wall and subtle shadings in the coffered ceiling detail. Two seating areas serve guests in this room as well as the adjoining kitchen/dining areas.
Photograph by Al Teufen, Al Teufen Photography

FACING PAGE BOTTOM
A two-story addition to their Tudor-style home, this butler pantry became a key design element to join both areas and convey the same Old World feel. Parchment color maps cover the walls and a custom medallion stenciled with the owner's initial enhances the reception area.
Photograph by Bruce Gates, The Art Factory

Q&A

more about Linda ...

WHAT SINGLE THING WOULD YOU DO TO BRING A DULL HOUSE TO LIFE?

I'd suggest a creative use of paint! Color can do wonders for a room and bring interest and excitement to a space.

WHAT IS THE BEST PART OF BEING AN INTERIOR DESIGNER?

Working with clients to create homes in which they can share life's important moments: holidays, parties and friendships. When I return after years of completion, I find that the designs still bring great enjoyment!

WHAT PHILOSOPHY HAVE YOU STUCK WITH FOR YEARS THAT STILL WORKS FOR YOU TODAY?

Communication and honesty throughout a project are critical to create a partnership that lasts and a reputation for satisfied and enthusiastic clients!

WHAT INSPIRED THE INTERIOR DESIGNS OF YOUR CHILDHOOD?

When I traveled on vacations with my parents, my first designs were of the motel room's furniture layout. Then it was on to constructing rooms from my mother's empty shoeboxes and furnishing them.

WHAT COLOR BEST DESCRIBES YOU?

Blue—from cobalt to robin's egg. I find blues happy and soothing at the same time.

RUSSELL INTERIOR DESIGN, INC.
Linda S. Russell, IDS
475 North Portage Path
Akron, OH 44303
330.867.7992

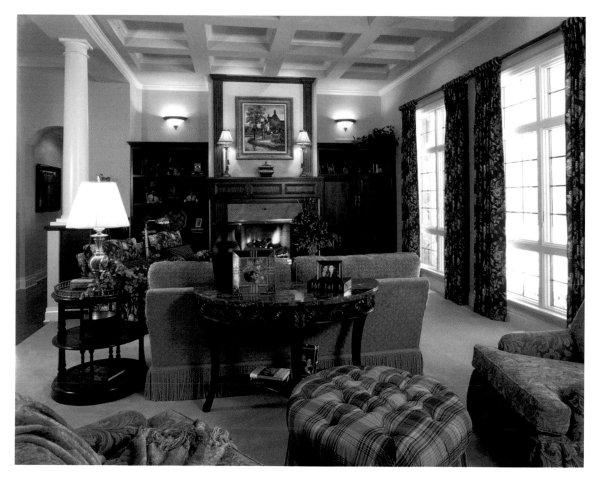

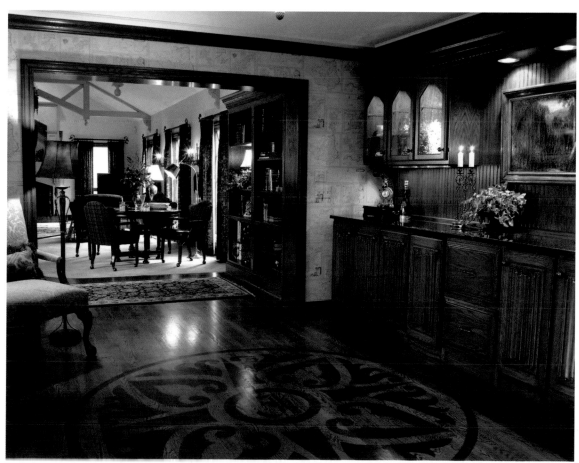

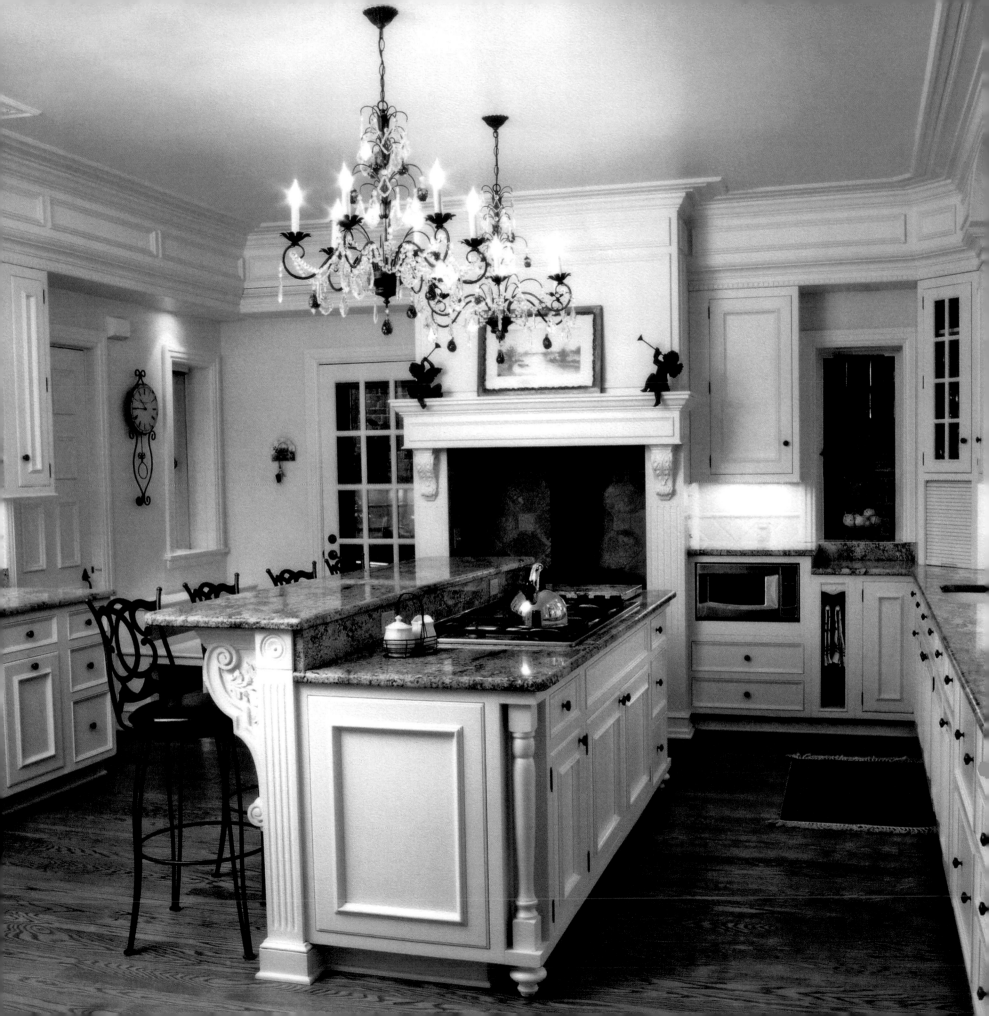

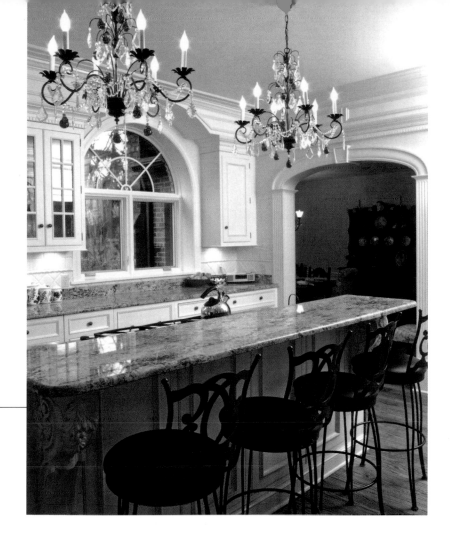

ROBERT SOMRAK JR.

SOMRAK KITCHENS

A trusted name in kitchens for over 50 years, Somrak Kitchens has been creating awe-inspiring custom kitchens for many of the spectacular homes in Ohio.

Robert Somrak Sr. began his professional career in the kitchen industry in 1949 and built an impressive reputation designing and installing custom kitchens for many of the most extraordinary homes in Ohio. Bob Somrak Jr., Certified Kitchen Designer (CKD), joined the family business in 1984, and has continued the Somrak tradition of quality and customer service.

Although Somrak Kitchens specializes in food preparation areas, the firm's services run the whole gamut of residential interior design services. They create and install everything from kitchens to custom-built entertainment centers, built-in bedrooms, master suites and auxiliary kitchens. They also work with institutions such as schools, hospitals and libraries to solve their unique interior needs.

Part of Somrak's unique business model is that they not only design and sell cabinetry from their two showrooms, they install them as well and consider this level of customer service part of their success. Bob says that Somrak Kitchens has worked on several of Cleveland's architects' personal homes because they realize how difficult it is to design and install cabinetry. It is an exact science and kitchen design isn't something that architects are taught in depth. Clients come to Somrak Kitchens because they are looking for a quality product and the vision to make it functional. When looking at the design and quality of the kitchens produced by the two-generation company, it's obvious that every kitchen produced is an award-winning kitchen.

ABOVE
This circle-top window invites ambience for the family's guests, while seated at the two-tiered island.
Photograph by Jesse Kramer

FACING PAGE
Refined elegance defines this flavorful kitchen. Cream colored custom cabinetry acquires architectural interests through the details.
Photograph by Jesse Kramer

SOMRAK KITCHENS
Robert Somrak Jr., CKD
26201 Richmond Road
Bedford Heights, OH 44146
216.464.6500 Ext 229
Fax: 216.464.8385
www.somrakkitchens.com

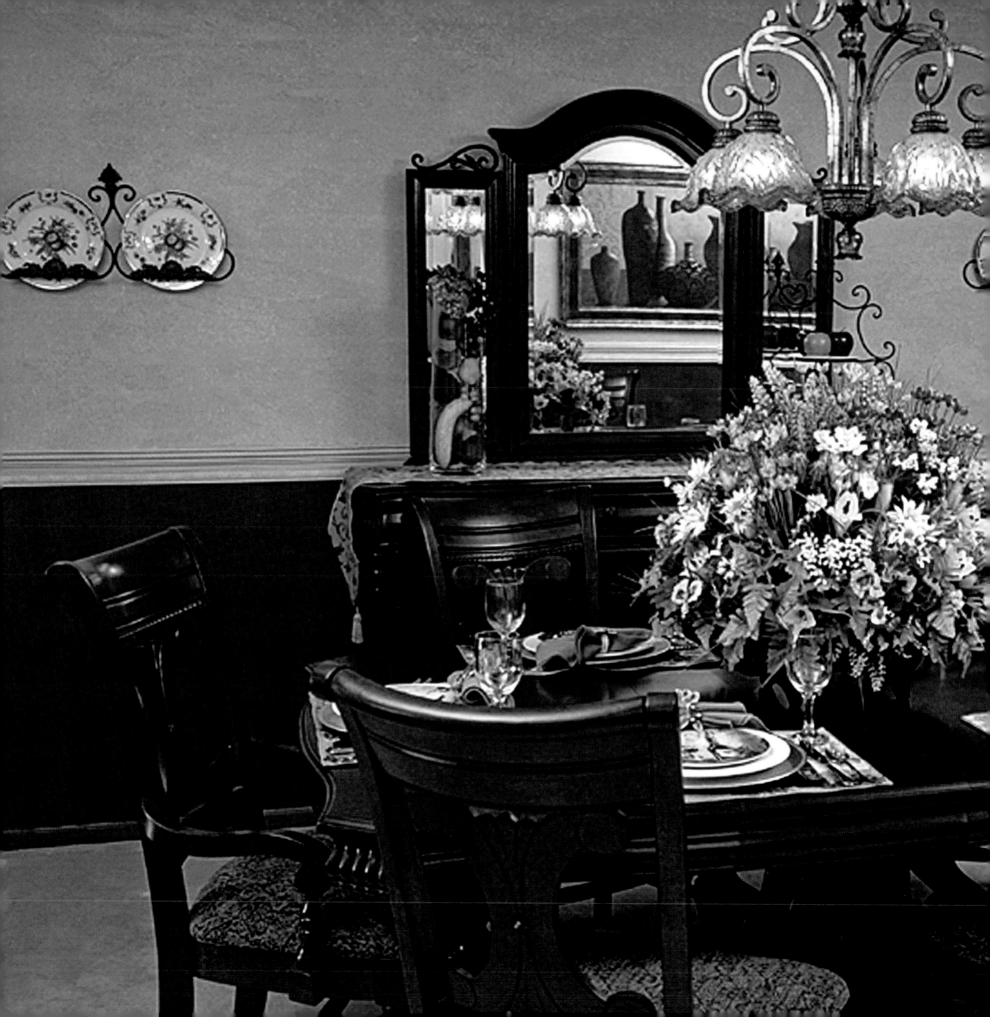

VICKIE J. HAMILTON SPRINGER

ADORN LTD.

Vickie J. Hamilton Springer, interior designer and owner of Adorn Ltd., has the unique ability to provide her clients both interior design and home improvement services. Her husband, Mark W. Springer, heads up Adorn Ltd.'s home improvement division. Their combination of talents and services enables Vickie and her design team to implement designs from concept to completion.

Vickie's signature style is "Transitional" which is on the cutting edge of design. Transitional design is a combination of many different styles. Her innovative design concepts combine the sophistication of traditional design with the stylish elegance of contemporary design, while mixing in a few unusual accessories for that eclectic edge. By taking the conservativeness out of traditional style and the sometimes coldness out of contemporary style, she creates a very casual and comfortable feeling. Her designs are warm and sophisticated.

LEFT
Carved wood, sculptured wrought iron, hand-blown glass and an over-the-top floral arrangement make every day a day for entertaining.
Photograph by Diane Alexander, Alexander Photography Studios

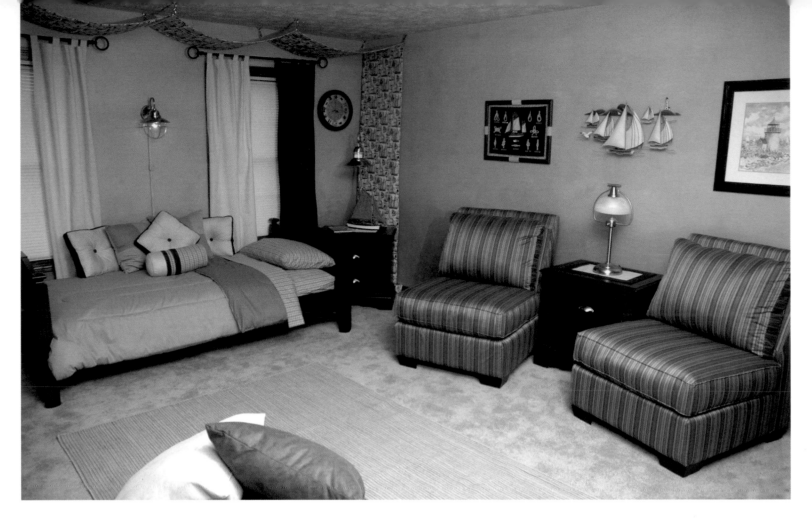

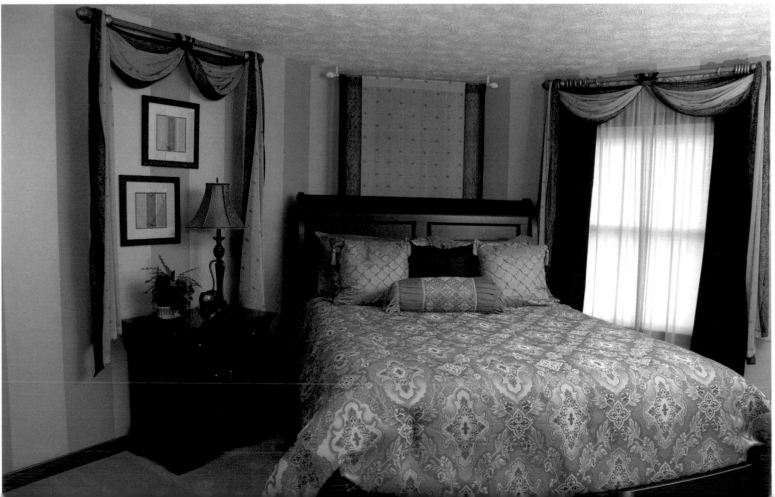

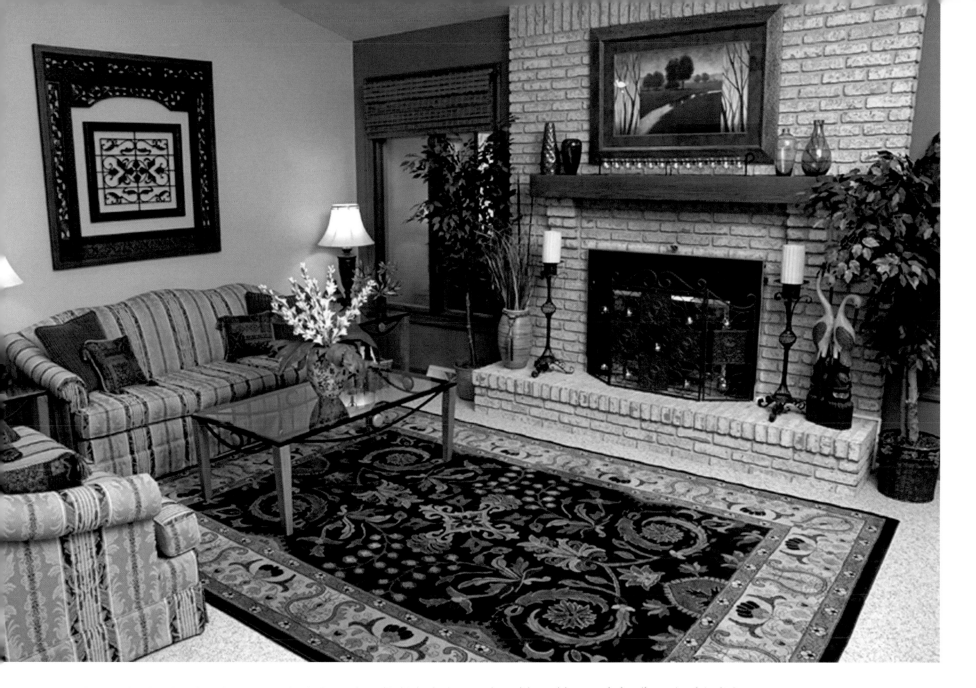

Texture and natural materials are important elements in Vickie's designs and are expressed in her thoughtful selections of fabric, window treatments and furniture. Incorporating her good eye for line, scale and drama, she carefully chooses furniture, accessories and colors to make her signature statement.

Vickie's color palette includes a composition of warm, earthy colors including rustic reds, chocolate browns, golden caramels, toffee tans, organic greens plus cool, watery blues. In addition to painting accent walls for that "transitional" touch, her creative faux-painting techniques are often requested.

When it comes to selecting or designing furniture for clients, Vickie enjoys mixing contemporary elements of glass, metals and mirrors with traditional styles of Old World, Arts & Crafts, or even Shaker. Traditional-style cabinetry

with architectural details stained in light maple, dark espresso, or light or medium stained cherry blends seamlessly with contemporary design, making

ABOVE
Warm and earthy colors in the family room accent the fireplace
and welcome guests to unwind and relax.
Photograph by Diane Alexander, Alexander Photography Studios

FACING PAGE TOP
A boy's bedroom hosts a nautical theme with water-colored walls painted with five colors of glaze,
a sailboat canopy hung with boat hardware, and seating for two for television viewing.
Photograph by Diane Alexander, Alexander Photography Studios

FACING PAGE BOTTOM
A guest bedroom is adorned with elegance and flair. The burgundy and gold-veined shears
against the drama of alternating stripes of solid and iridescent blues
elicited a one-word compliment from her client: "Wow!"
Photograph by Diane Alexander, Alexander Photography Studios

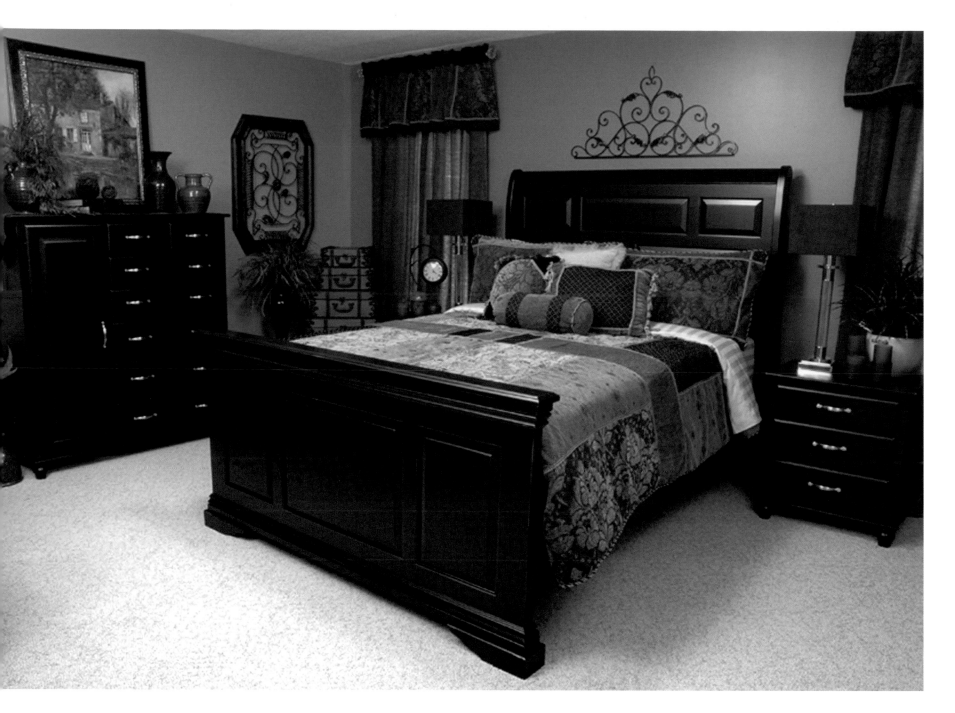

for a marriage of opposites that keeps her designs fresh and interesting. Her Transitional style allows for clean, timeless and very appealing interior design.

In addition to interior design and home improvement services, Adorn Ltd. has a retail store, Adorn Your Home. For those clients who can appreciate the quality of bench-crafted furniture, the store offers custom-designed, heirloom-quality, hardwood bedroom, dining and living/family room furniture in birch, cherry, hickory, maple, oak or quarter-sawn oak woods. In addition to furniture and home décor, the store also features custom window treatments, bedding, decorative cabinet hardware, area rugs, wall art and mirrors.

Vickie and her company believe that every client deserves to enjoy a well-designed and inviting home. Her talent to create warm, stylish, and inviting interiors with her down-to-earth, client-centered approach ensures that her company, Adorn Ltd., has a design niche in the Ohio market that is soundly secure.

ABOVE
Bench-crafted, hardwood furniture takes center place in this classic, transitional style master bedroom.
Photograph by Diane Alexander, Alexander Photography Studios

FACING PAGE
Warm colors, textured fabrics and stylish accessories make this master bedroom an inviting retreat and a haven of rest.
Photograph by Diane Alexander, Alexander Photography Studios

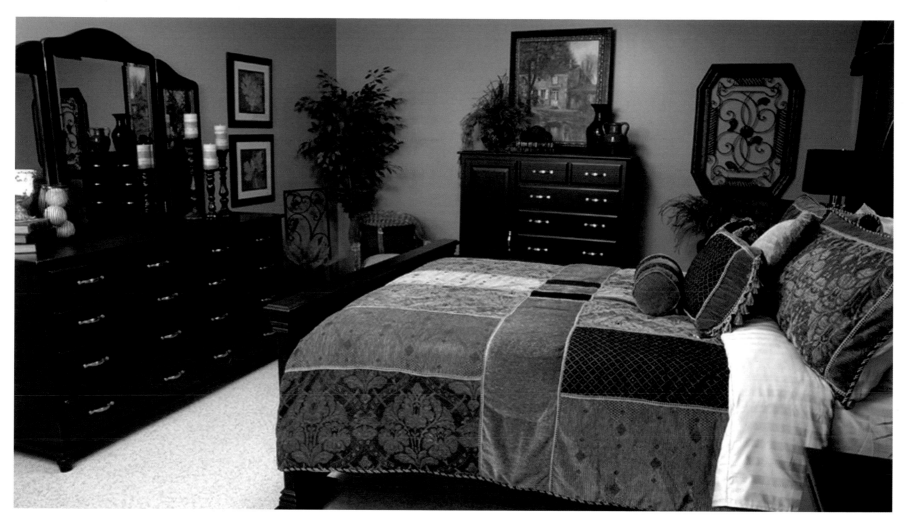

more about Vickie ...

WHAT IS THE BEST PART OF BEING AN INTERIOR DESIGNER?

I enjoy helping homeowners achieve the personal, emotional and social benefits of a well-designed, comfortable home. There is nothing more rewarding than seeing a design come to life, seeing the joy on a client's face and hearing the words of appreciation. The best compliment I've ever received was "Wow, you've really outdone yourself. I can't wait to see what you will do in the next room!"

WHAT PERSONAL INDULGENCE DO YOU SPEND THE MOST MONEY ON?

Decorative accessories. I enjoy changing out decorative accessories, floral arrangements, linens and even artwork for the holidays and seasons.

WHAT SINGLE THING WOULD YOU DO TO BRING A DULL HOUSE TO LIFE?

Change. Change the décor. Change the window treatments. Change the flooring. Change the accessories. Change the light fixtures, hardware, etc. Many clients are "stuck in a style" and could benefit from change. Adorn Ltd. initiates change.

ADORN LTD.
Vickie J. Hamilton Springer
ADORN YOUR HOME
5543 Dressler Road Northwest
North Canton, OH 44720
330.497.2201
Fax: 330.497.8980
www.AdornYourHome.com

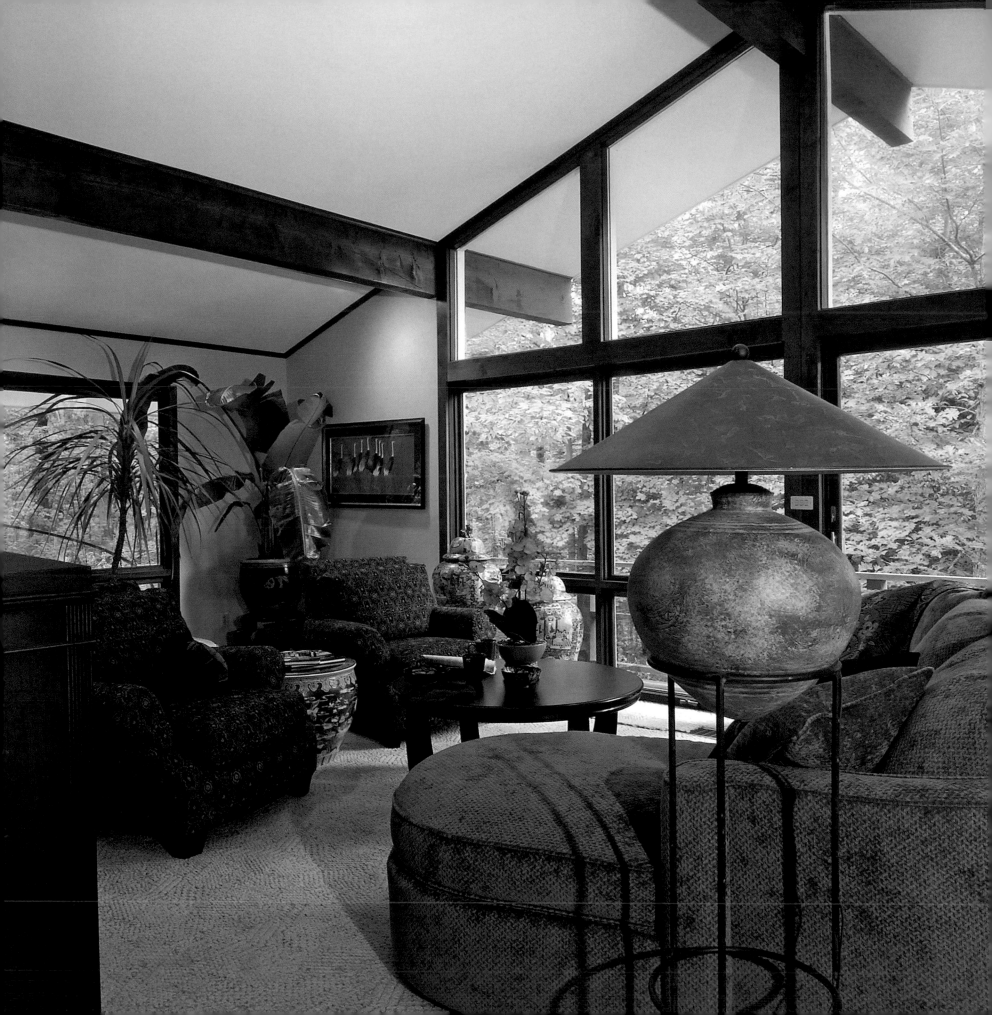

KATHERINE SUGLIA
LAURA SUGLIA

KAS INTERIORS

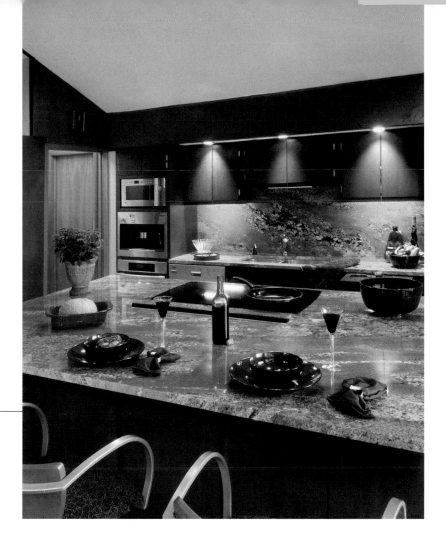

KAS Interiors, a true family business, was started 22 years ago by Katherine Suglia and her oldest child, Michael. When he passed away daughter Laura Suglia stepped in to fill the gap. She has since helped propel the company into a successful incarnation.

The mother and daughter team work on every project together, and when hired, combine mutual experience and talent to create interiors that are bold, innovative and functional for their clients.

With a host of skilled tradesmen at their fingertips, Katherine and Laura work on a wide variety of projects including both residential and commercial. They are essentially a "one stop shop" of interior design offering both finish selection services and architectural interior design services. Clients come to Katherine and Laura with interior design problems and the duo creates unique ideas and perspectives that get the quandary solved—much to each client's satisfaction.

The most enjoyable part of each design process for the mother and daughter team is meeting the clients, getting to know them, and at the end of each project, witnessing their amazed reaction at the completion of each fabulous final product.

In the future, Katherine and Laura will continue to have fun with their wonderfully diverse clientele on each project whether the interiors are big or small.

ABOVE
There is seating for guests at the island designated for meal preparation. Custom walnut cabinets are topped by granite countertops.
Photograph by Ron Wilson Photography

FACING PAGE
The owners of this home enjoy entertaining. Large windows let the observer look out to the dense woods and a pond surrounding the home.
Photograph by Ron Wilson Photography

KAS INTERIORS
Katherine Suglia, ASID
Laura Suglia, ASID
46200 Mather Lane
Chagrin Falls, OH 44022
440.247.5597
Fax: 440.247.3321

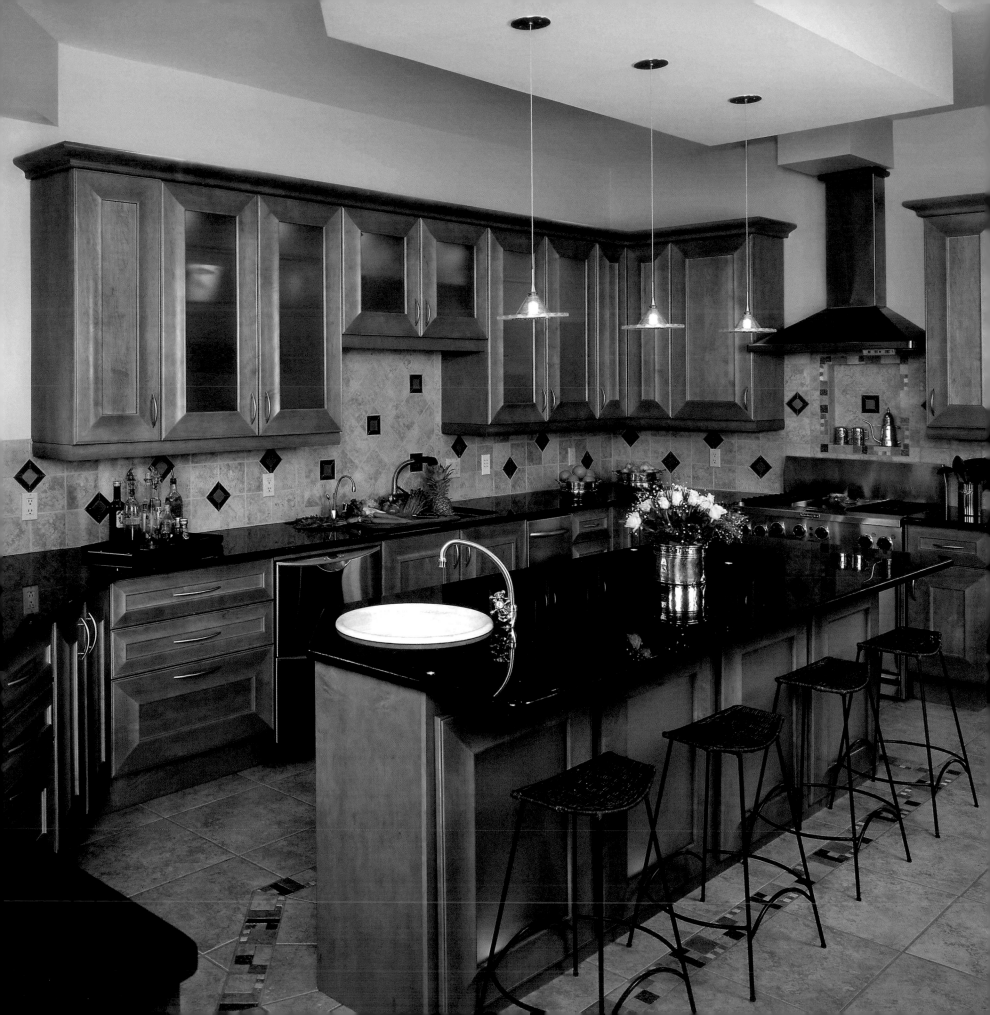

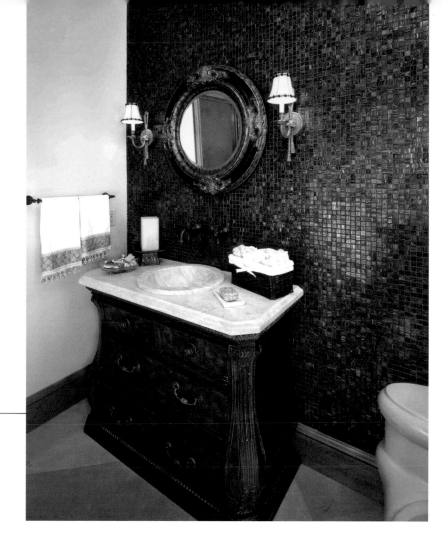

SORAYA TABET

SORAYA INTERIOR DESIGN

Soraya Interiors is a comprehensive showroom/design firm that offers elegant interiors which embody both class and comfort.

Originally from Lebanon, Soraya Tabet has always enjoyed helping friends and family members work on their interiors. She traveled regularly to Europe—including Paris and Rome, where she gained extensive knowledge of the elements found in fine interiors—before moving to the United States, earning an interior design degree from Kent State University and opening her own showroom and design firm.

A renovated two-story building, the design of Soraya's studio and showroom reflects that which she strives to create for each client: A harmonious mixture of old and new with a few antiques, modern accents and a hint of European flair. While the designer leans a bit towards traditional design, she respects the contemporary and transitional tastes of her Midwest clientele and enjoys exposing them to the broader world of interior design possibilities.

Mixing Old World design with trendy new elements and accessories, Soraya creates an eclectic combination that her clients find very valuable. Upon

meeting clients for the first time, Soraya is excited to listen as they share their needs, dreams and desires for their new interior. Then, with a firm grasp of those elements, she translates their vision into thoughtful, practical spaces that emphasize comfort and livability as well as elegance.

So that she always has the tools to create wonderful, fresh havens for her clients, Soraya constantly researches industry trends and upcoming styles with long term applicability. She enjoys updating her resource library with beautiful textiles and furnishings as well as introducing new findings to her showroom.

ABOVE
The powder room is a beautiful mixture of old and new. Glass tiles form a striking backdrop for the old chest that serves as a vanity.
Photograph by William Webb, Infinity Studio

FACING PAGE
Ideal for entertaining, the kitchen boasts absolute black granite countertops, a backsplash of porcelain and metal tiles and a mosaic border on the floor, which is echoed in the adjoining dining room. Several doors of the custom cherry cabinetry are adorned with back-lit glass.
Photograph by William Webb, Infinity Studio

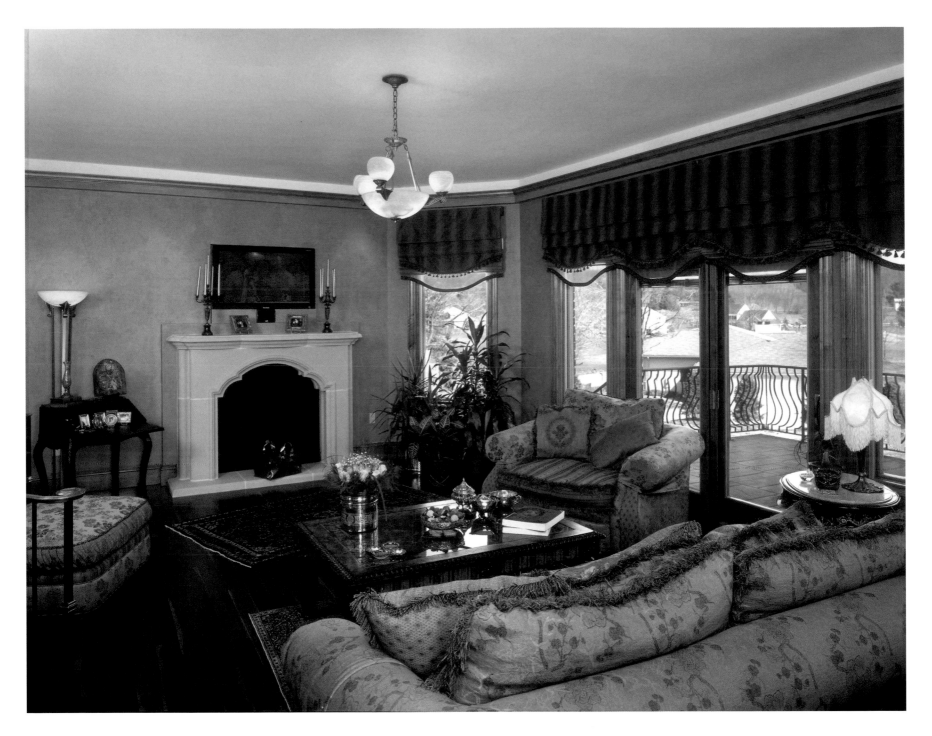

Some designers change the décor of a room, but not Soraya. She has the talent and the "eye" to totally reshape a room into a wonderfully dynamic living space. Her clients find that she may change the color, draperies or furniture and sometimes even the architectural elements—like removing a wall or adding crown moulding—but the true magic occurs when a space is completely revamped into a room they do not even recognize.

In ideal situations, Soraya likes to work in new houses from the floor up to create a cohesive aesthetic that is sure to improve her clients' lives through touches of class and style, but she also enjoys the opportunities for growth

that renovation and remodel projects afford. Soraya relates, "I love meeting new people and I can help all my clients from A to Z with their interior design needs."

ABOVE
By using a soothing color palette, a comfortable and elegant family room was created. Old and new are brought together once again, with multiple fabrics applied to an Old World chair and coordinating sofa. An antique secretary flanks the plasma television; wires to the electronics were cleverly routed through the walls to a reproduction chest on the adjacent wall.
Photograph by William Webb, Infinity Studio

FACING PAGE LEFT
Indirect light from the crown moulding adds to the casual elegance. A collection of masks, displayed within an old frame, hangs against the faux-painted wall above a reproduction chest.
Photograph by William Webb, Infinity Studio

FACING PAGE RIGHT
The kitchen leads into an octagonal-shaped dinette/sunroom with graciously high ceilings.
Photograph by William Webb, Infinity Studio

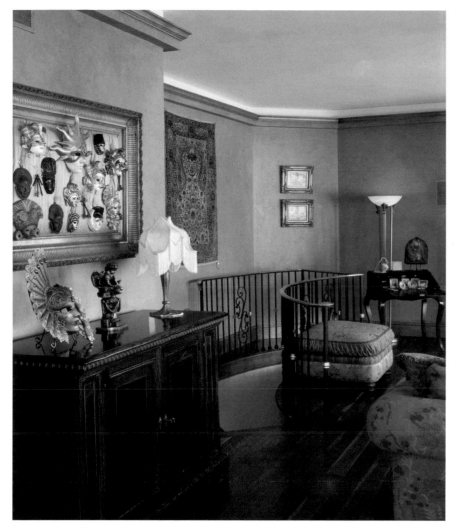

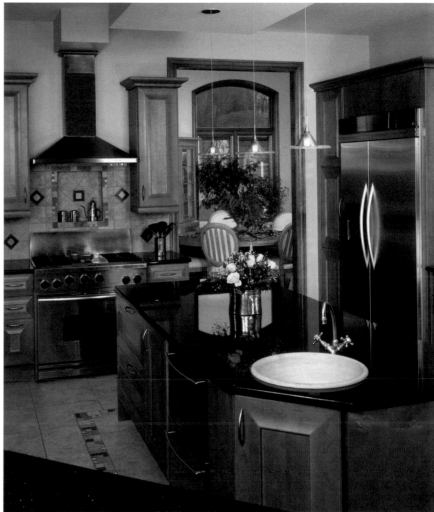

more about Soraya ...

WHAT ONE ELEMENT OF STYLE HAVE YOU WORKED WITH FOR YEARS THAT STILL WORKS FOR YOU TODAY?

The pleasing blend of old and new.

IF YOU COULD ELIMINATE ONE DESIGN TECHNIQUE FROM THE WORLD WHAT WOULD IT BE?

Each era has its own merits, which you can't eliminate whether you like it or not.

WHAT SINGLE THING WOULD YOU ADD TO BRING A DULL HOUSE TO LIFE?

Color through the application of paint.

WHAT IS THE HIGHEST COMPLIMENT YOU HAVE RECEIVED?

My clients are all thrilled with the results, but one said upon moving into his new home, "This is not up to my expectations ... It's way beyond!"

SORAYA INTERIOR DESIGN
Soraya Tabet
1745 West Market Street
Akron, OH 44313
330.836.6699
Fax: 330.836.4554
www.sorayainteriors.com

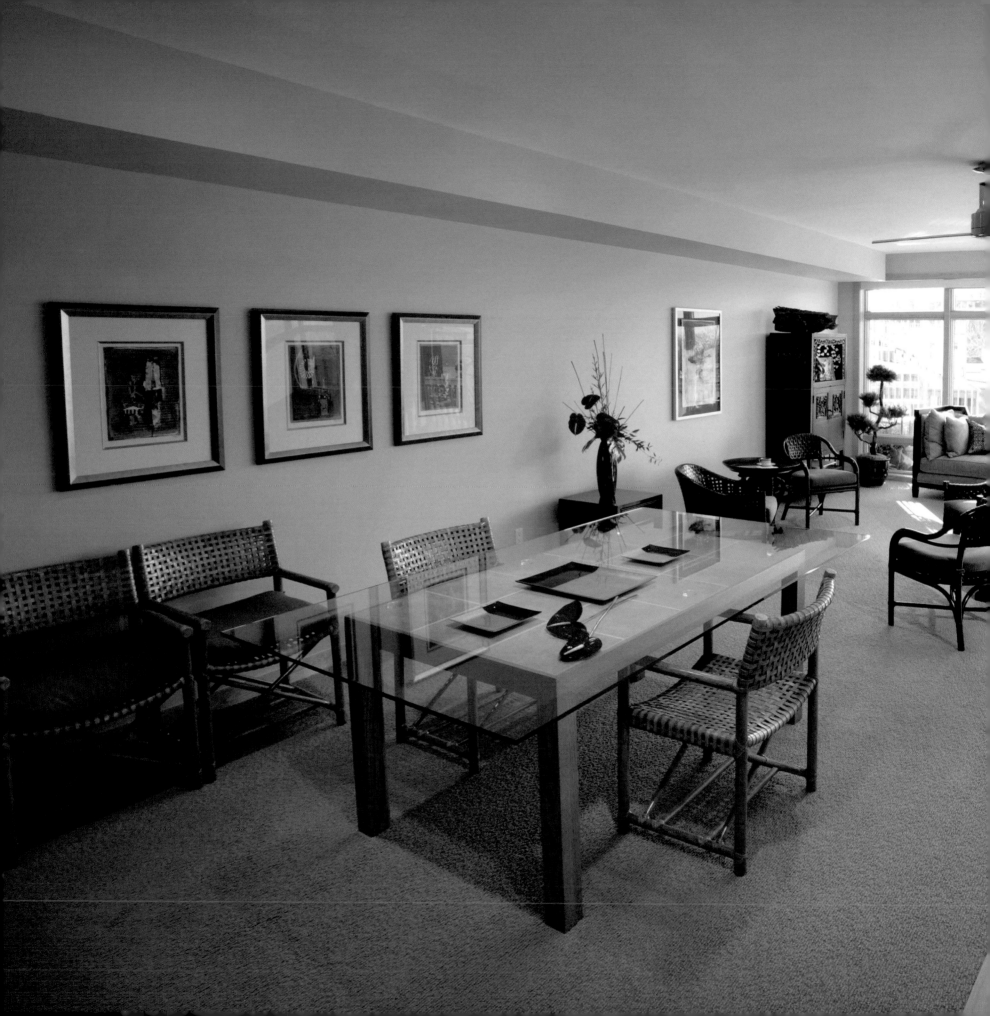

CONNIE TURSKI

CONNIE TURSKI INTERIORS

The Chinese yin-yang, a symbol of balance, is a prominent element of Connie Turski's website. Balance, the Cleveland native says, is a trait of people who live in the Midwest. It's also a characteristic of any good designer's work.

A self-described late bloomer, Connie began as an interior designer 10 years ago, after her career of being a full-time mom. In that short time, she's established herself among the preeminent designers in her area, working with the attitude that beautiful homes are the right of every person.

Connie lives and operates her business in a historic district in urban Cleveland that is currently enjoying a renaissance. Her townhouse was custom built to her exact specifications and the interiors are Connie's own designs. A warm, caring person from a working-class background, she wishes for everyone a home as lovely and comfortable as hers. "The conditions you live in affect your psyche. I want to help people have a better life no matter their economic scenario," she says. "There was a time

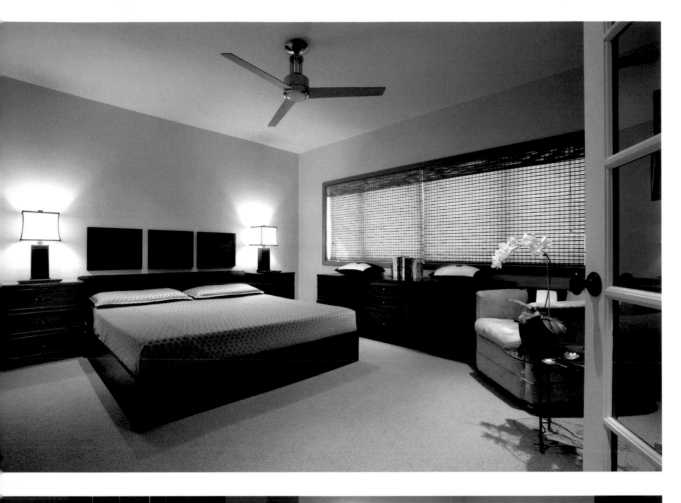

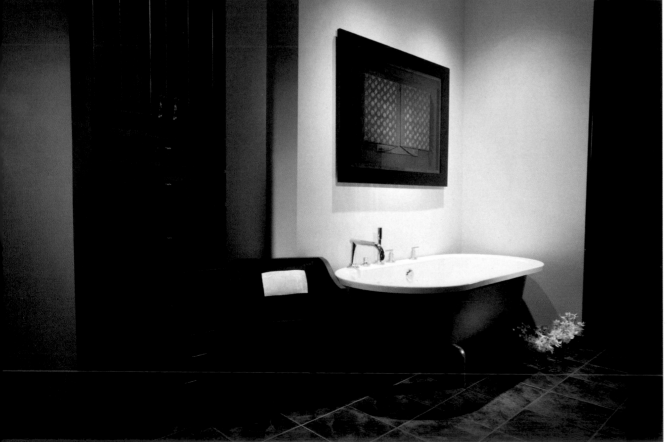

when interior design was the domain of the very wealthy. Those days are gone, and now just about everyone uses an interior designer; people understand that in the long run it saves money."

And as more and more research reveals the effects of our environment on our emotions and our behavior—and, in turn, our health—people are embracing design as a necessity, not a luxury.

Connie believes that design should enrich a person's life both physically and spiritually. That idea becomes her objective with every project that she takes on, and it is the result for which she strives. The designer can't think of a higher compliment than being told by a client that she's had a positive impact on their well-being, and she's glad to be practicing her trade in a time when Americans are taking a more holistic approach toward happiness. "Interior design is a heavy hitter in a good life," she says.

TOP LEFT
The main bedroom's aesthetic is subtly Asian, evoking a refined sense of sanctuary. Ancient Chinese divinatory text Trigrams hangs above the bed.
Photograph by Jerry Mann

BOTTOM LEFT
A well-appointed room—that just so happens to be the bathroom—handsomely serves the needs of its owners.
Photograph by Jerry Mann

FACING PAGE
The sitting/hearth area is immediately adjacent to the kitchen. Concrete was used for the fireplace to balance the element earth into the feng shui mix.
Photograph by Jerry Mann

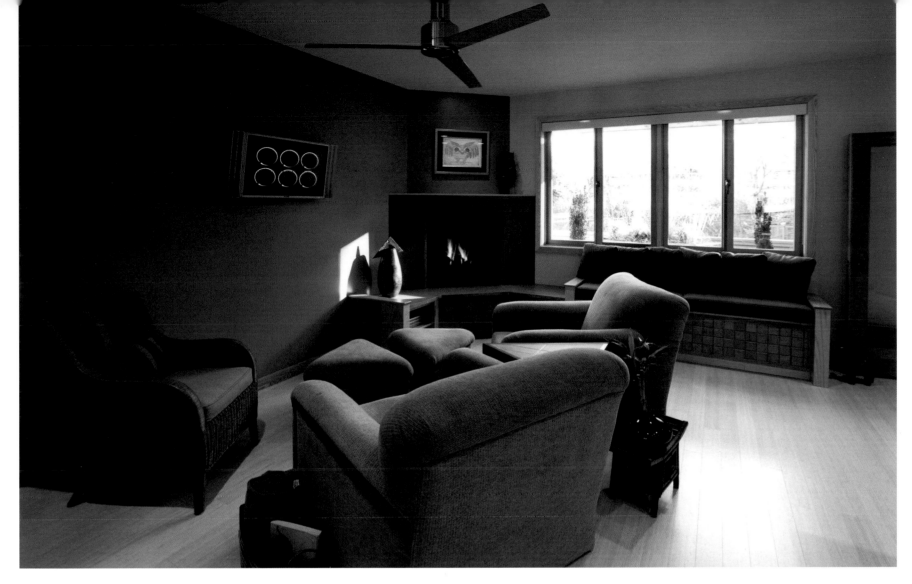

more about Connie ...

WHAT COLOR BEST DESCRIBES YOU AND WHY?

Orange always has been and always will be my color. Orange Crush was one of my childhood pleasures. Today I drive an orange Mazda 3 and like to wear bright orange lipstick. A redhead with yellow tones in my skin, I have a closetful of the bold color.

WHAT ONE DESIGN/BUILDING TECHNIQUE WOULD YOU LIKE TO ELIMINATE FROM THE WORLD?

I'd replace wood framing with metal studs, floor joints, etc. This would save trees and it tends to give more perfect walls. But you need to properly insulate the walls for acoustics, because metal is not acoustic by nature.

CONNIE TURSKI INTERIORS
Connie Turski, Allied Member ASID
2146 West 5th Street
Cleveland, OH 44113
216.664.0513
www.cturskiinteriors.com

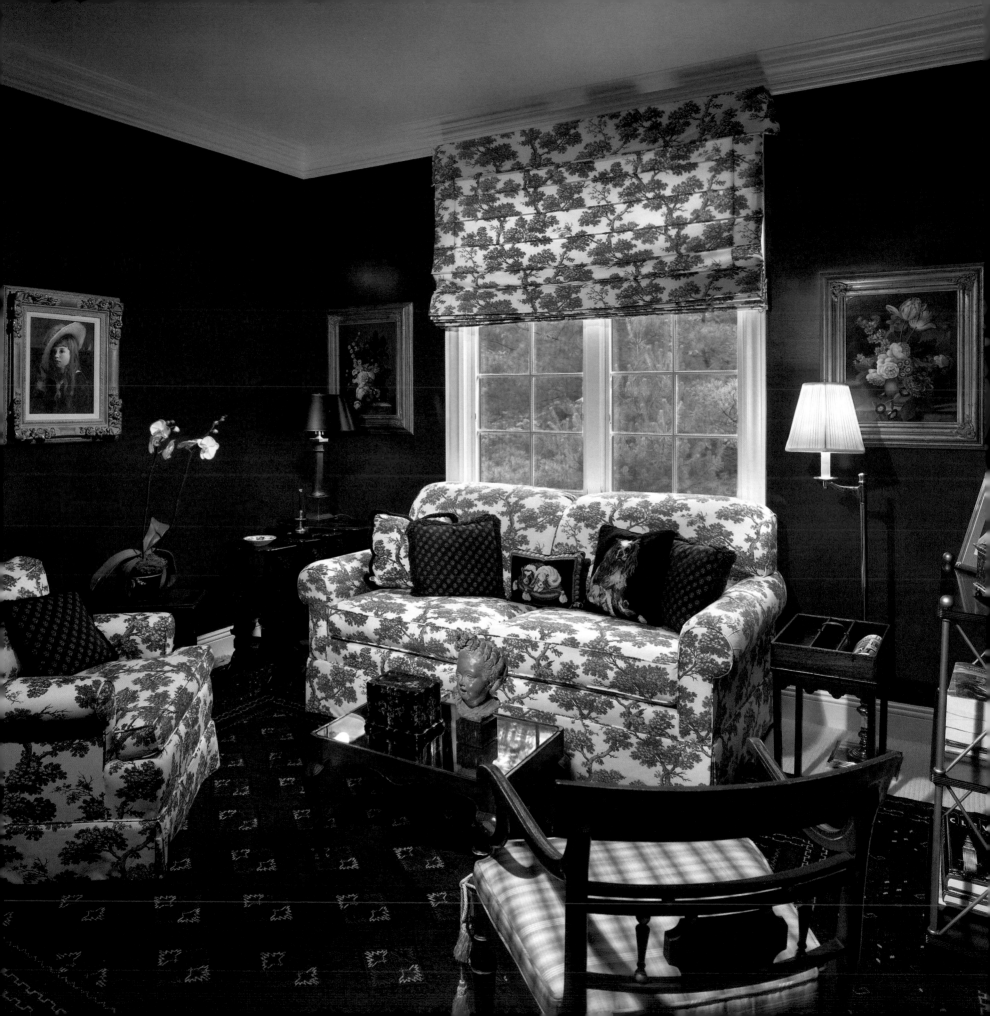

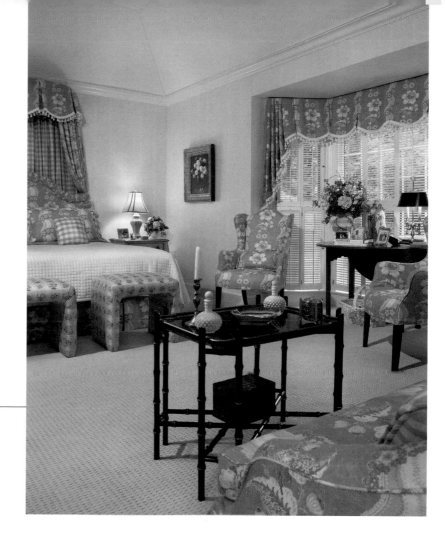

ANNE WEINBERG

ANNE WEINBERG DESIGNS, INC.

Trust, magnificent taste and a desire for creating interiors that leave clients feeling comfortable in their home encompasses Anne Weinberg and her designs.

While growing up, Anne's parents collected 18th-century English antiques, and then she graduated from Vassar with a major in art history that facilitated an extraordinary sense of art, antiques and architecture. Her first job was at Lord & Taylor where she was assistant buyer of decorative fabrics. She was involved in the store displays and discovered that she really had a talent and love for space planning.

Anne has been in the business for 35 years. She started out doing what she calls "budget decorating for young people," but today she concentrates mostly on high-end residential clients. She works for the love of it, for the challenge, to keep her busy, and for the sheer enjoyment of pleasing her clients.

Anne Weinberg Designs, Inc. functions more like a boutique, because Anne has always worked by herself. Her work is highly client driven, but her aesthetic strong suit is mixing pattern and colors. She is "in love" with color and her style is very eclectic. She loves mixing and matching antiques; however, in a room full of very fine antiques, she will always throw in something very Contemporary to keep the room from being too heavy. She considers her designs to be Eclectic-Traditional.

Anne's strategy when working with a client is to listen to her clients and let them speak. She will also take cues from the way that they are dressed and in doing so, she garners a sense of their taste level and sophistication to decipher what design direction is appropriate to take for each client. She loves it when her clients allow her the freedom to decorate to perfection. When clients give her carte blanche, the designs always end beautifully flawless.

ABOVE
Canopy on bed wall hides a window placed inconveniently in a serene, soft blue bedroom within a country home near Cleveland.
Photograph by Jim Maguire of Maguire Photographics

FACING PAGE
Red lacquered walls create a cozy library for reading and conversation.
Photograph by Jim Maguire of Maguire Photographics

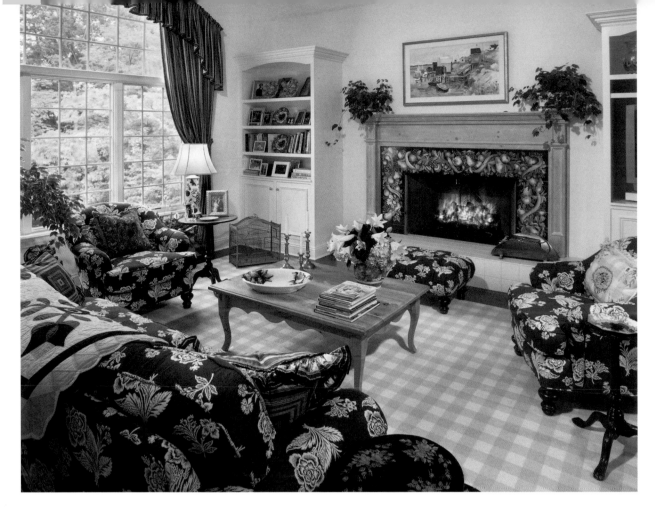

Her clients find her personal attention and efficiency the most valuable aspects of Anne's interior design business. Plus, they enjoy her extraordinary taste. She loves her work, and her personal service is a very important part of her business because she gets very involved with her clients in every way. She always delivers what is expected from her and many times more than what was expected; because of this her clients have an extreme trust in her. They know that she is going to spend their money as carefully as she would her own, and her clients become as loyal to Anne and her designs as she is to them.

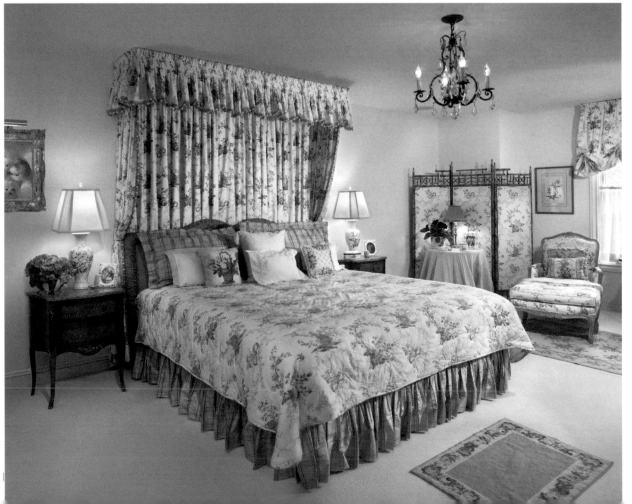

TOP LEFT
Overstated upholstery covered in the same warm red Matelassé creates a warm atmosphere in this two-story family room.
Photograph by Jim Maguire of Maguire Photographics

BOTTOM LEFT
A raspberry and cream chintz creates a feminine French retreat in this mid-town Cleveland home.
Photograph by Jim Maguire of Maguire Photographics

FACING PAGE
Pine paneled walls and a black and white color scheme blend with the magnificent view of the woods.
Photograph by Jim Maguire of Maguire Photographics

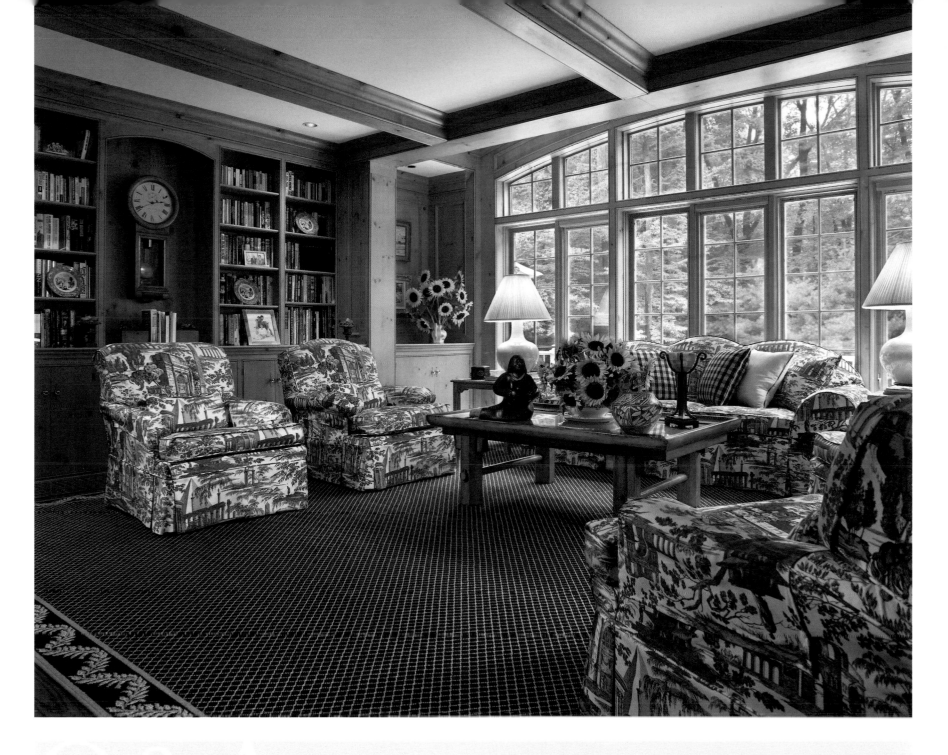

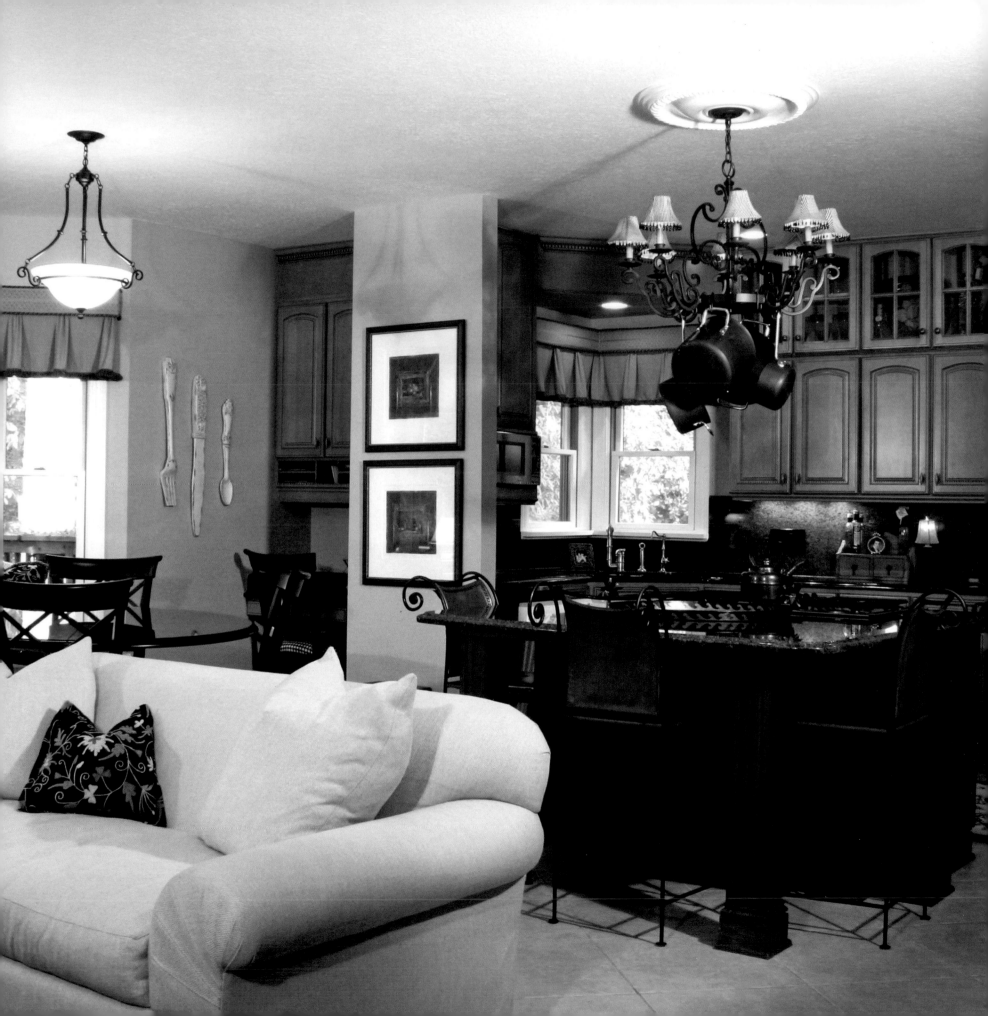

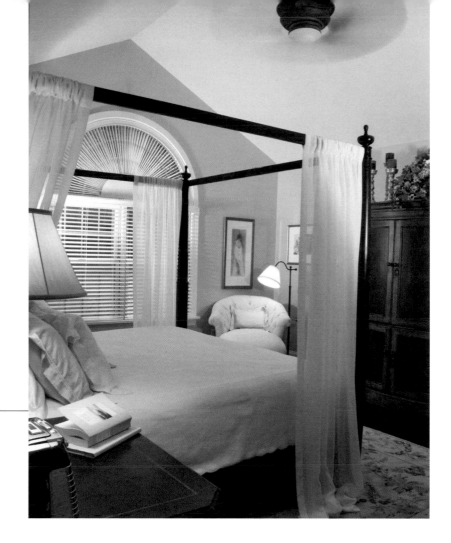

MICKEY M. WEISS

INTERIORS BY MICKEY M. WEISS

What good would a unique artistic vision for interior design be if it could not be readily attuned to the client's lifestyle and work style needs? Mickey Weiss's projects always begin with attentive listening to each client and end with magnificent, yet practical, spaces—spaces that the client will occupy not only with pride, but with comfort as well.

In between the listening and the live-in, Mickey's work process incorporates her knowledgeable and organized approach, shielding clients from the stresses that often accompany interior design projects. She pays exquisite attention to detail, avoids unnecessary expenditures and keeps everything and everyone on schedule and within budget.

"What we find," says Mickey, "is that all design projects call for cooperation between the homeowner, the designer, the builder or contractor, and a variety of professional tradespeople. Sometimes, each professional is so focused on the details and requirements of their particular trade that a homeowner's personal style gets lost in the mix. One of our main functions is to make sure that doesn't happen. In that sense, we become the communications hub for the client and all the professionals concerned. Moreover, as we've played that role, there have often been cases where we've spotted an oversight or flaw in the construction work that, had it gone unchecked, would have resulted in a costly repair for the homeowner down the line."

In addition to residential interiors, Interiors by Mickey Weiss has also successfully completed industrial and commercial projects, including work for advertising agencies, medical offices and hospitals, investment banking and real estate firms, governmental offices and even an amusement park. Among the many organizations benefiting from Mickey's expertise are the American Cancer Society, the Cleveland Ballet, Hope House and the Junior League.

ABOVE
In the master bedroom, the designers created a sanctuary of comfort and beauty by the soft flow of the custom fabric panels and dreamy lilac walls.
Photograph by Ron Cellura

FACING PAGE
The kitchen and hearth room is a great place to entertain family and friends. Sofa by Swaim and custom draperies using B. Berger fabrics.
Photograph by Ron Cellura

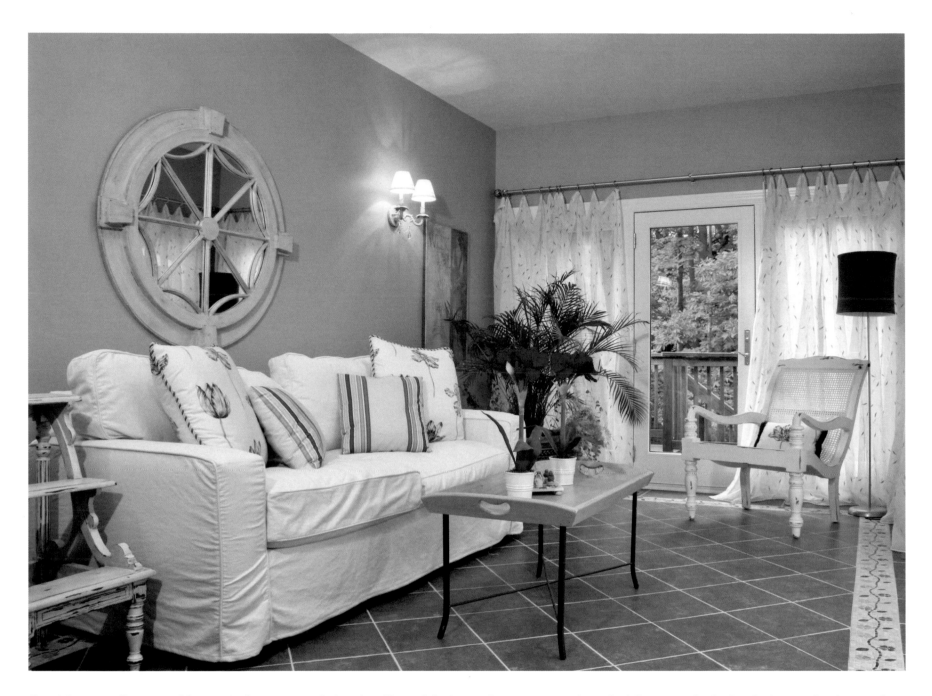

Certainly many clients are able to articulate a sense of what they like and don't like, but Interiors by Mickey Weiss presents an even greater client resource—Mickey's understanding of environments and the possibilities they present. That understanding is supported by her knowledge of the past, in terms of styles and periods, as well as her ability to interpret contemporary trends with a sense of balance, proportion and eclecticism.

Interiors by Mickey Weiss brings a wealth of design experience and market information to each client's plan—whether residential or commercial, or new construction or remodel, or whether style requirements call for Contemporary, Traditional, or a unique and special mood in between. With a 26-year history of working with architects, builders and vendors all over the country, Mickey

and company consistently deliver award-winning design results that conform to project requirements, yet still emphatically reflect the client's personal style with a timeless elegance.

ABOVE
The sunroom is a beautiful entrance to the outdoors and a warm, quiet place to read and relax using terracotta tile with a mosiac border and slip-covered furniture.
Photograph by Ron Cellura

FACING PAGE LEFT
This sunny and bright nursery was created by using warm yellow and cream hand-painted striped walls to complement the round crib and custom draperies.
Photograph by Ron Cellura

FACING PAGE RIGHT
The spa-inspired bath invites residents to relax in the beautiful tub surrounded by limestone and granite.
Photograph by Ron Cellura

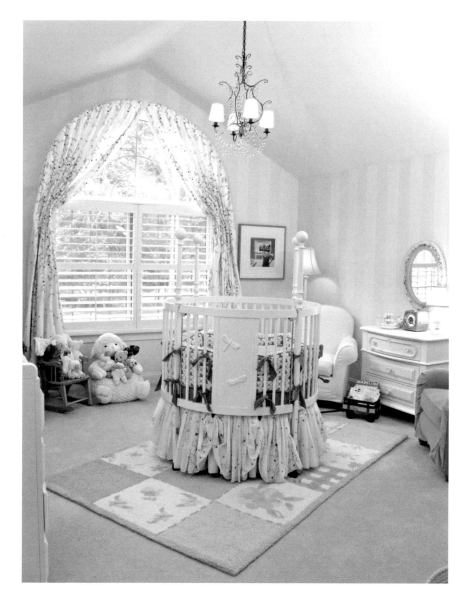

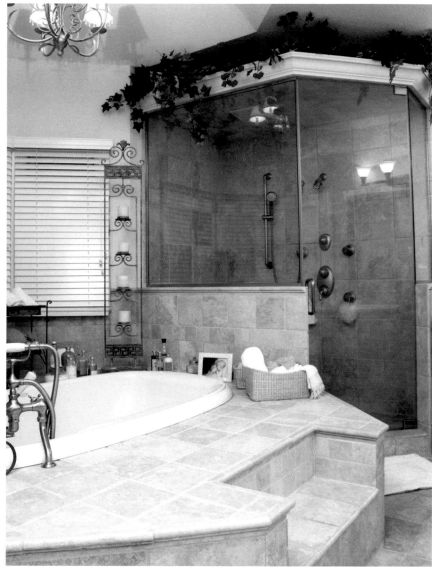

more about Mickey ...

WHAT IS THE BEST PART OF BEING AN INTERIOR DESIGNER?

Meeting so many interesting people, and the satisfaction of seeing clients happy with a job well done. As each of them explains his or her needs, I discover an underlying puzzle I can't wait to solve!

WHAT IS THE HIGHEST COMPLIMENT YOU'VE RECEIVED PROFESSIONALLY?

We had an out-of-town client who needed an entire new home put together in a matter of days. Even working in a town that was entirely new to our team, we were able to perfectly assemble that environment, right up to getting all the beddings in place and the television hooked up so it instantly felt like home.

HOW WOULD YOU BRING A DULL HOUSE TO LIFE?

That's easy—add color and art.

WHO COMPRISES THE MICKEY M. WEISS INTERIORS TEAM?

My partner Barbara Henninger designs from our Pittsburg office, and Kathleen Mocny and I work in both Bedford and Shaker Heights. All three of us excel at drawing out a client's style and presenting the kinds of furnishings that best fit the project's needs. We weave the complex combination of client's preferences into a comfortable and useful setting.

INTERIORS BY MICKEY M. WEISS
Mickey M. Weiss
5222 Richmond Road
Bedford Heights, OH 44146
216.464.3100
Fax: 216.464.3109

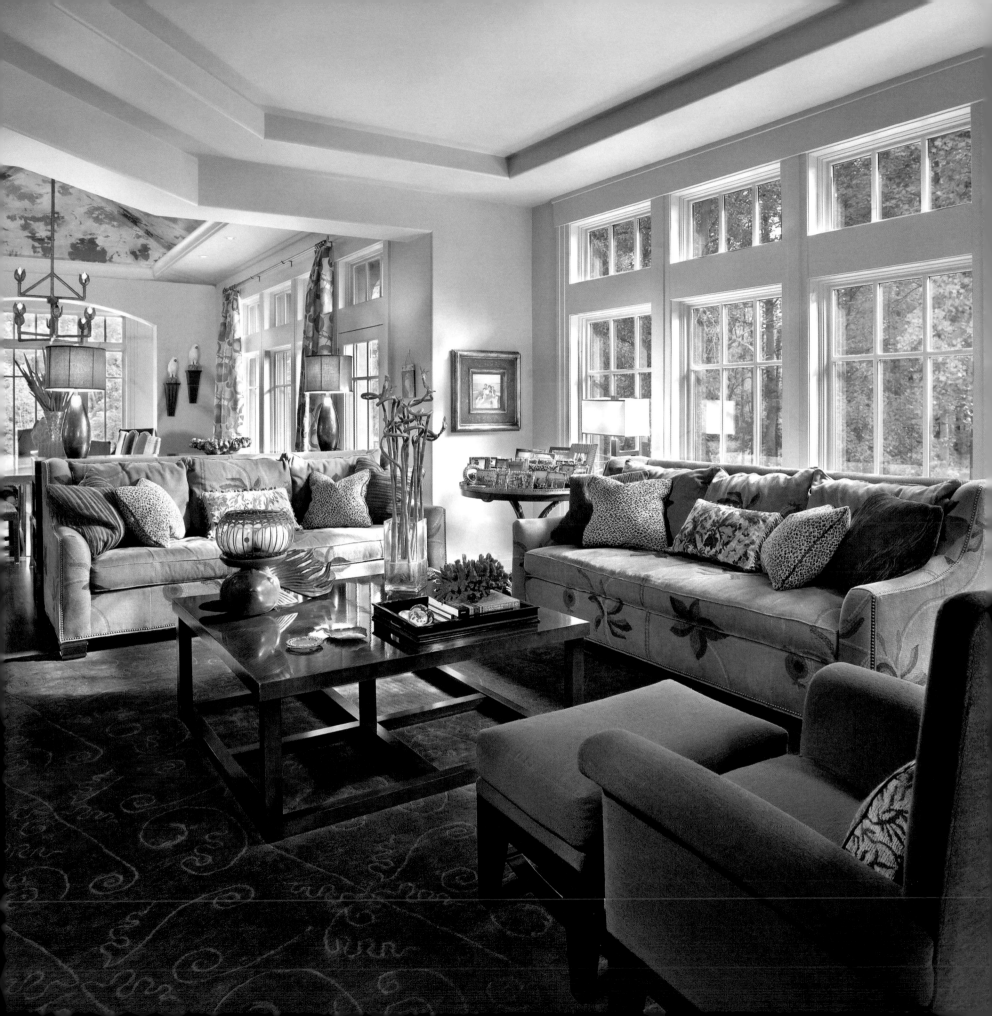

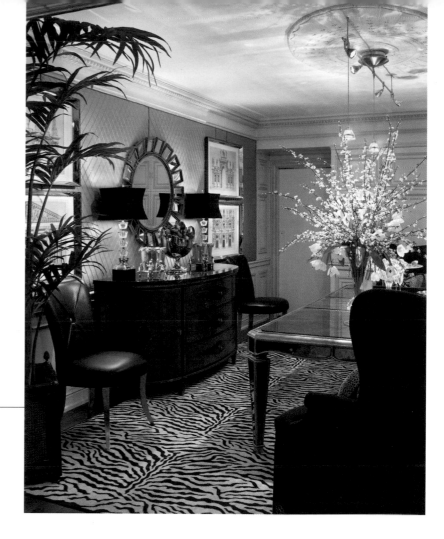

Dan West
Dan West Interior Design, Inc.

Dan West, IDS, of Dan West Interior Design, Inc., has been in the business of producing interior spaces that comfort and inspire for 35 years. Although Dan had been employed for years as lead designer for other firms, his "solo" career was launched in 1978 by participating in a very successful Junior League Showhouse in Akron, Ohio. The media and community response was so overwhelmingly positive that, from that time to the present, his office phone has rung continually.

Dan thinks of himself, mainly, as a residential designer specializing in new construction, remodeling, and historic preservation. However, he also designs commercial spaces and has designed interiors for corporate offices, doctors' and attorneys' offices, restaurants and funeral homes.

He considers himself close to his clientele, much like family and friends. Thereby he becomes extremely involved with their projects in all phases of the design process, collaborating with architects, contractors, builders, and artists along the way. This ensures a cohesive, successful project from the inception to completion. Furthermore, he encourages an open, honest relationship with a great deal of interaction between the client and himself.

As is customary within the design field, Dan feels that the homes he designs should "mirror" the client's lifestyle and interests. He works incredibly hard to assure complete satisfaction. He enjoys guiding his clients to "high-quality design concepts," the importance of appropriate lighting, styles and periods of home furnishings. Ultimately the finished project must reflect the client, not him or the architect.

ABOVE
Designer Showhouse in Akron. Edgy, formal dining room.
Photograph by Jim Maguire of Maguire Photographics

FACING PAGE
Private residence in Kent. Donghia, Cowtan and Tout, Scalamandré, and Clarence House textiles.
Photograph by Jim Maguire of Maguire Photographics

He further explains that "people these days want to relax when they come home." With this in mind, Dan takes pleasure in mixing furnishings and styles within his concepts. This makes for a more enjoyable experience for both him and his client. Fewer clients are requesting "strict period looks" which can get a bit stuffy and overwhelming. They are instead turning toward a more refined, tasteful yet unpretentious feel for their homes.

When asked what he believes is the most important elements in good design, Dan responded, "Good lines and large objects are necessary to anchor a room … It is essential to have a focal point or theme in a room but also equally important to maintain the architectural integrity, especially in older or historic buildings." Many times he contrasts the furnishings with the architecture to create an exceptionally satisfying result.

Dan finds his job very rewarding and attributes his success to his "God-given talent and easygoing nature. But it's like everything else in life; you have to keep learning new ways to do things in order to keep it fresh and interesting." With that in mind, he continually educates himself about textiles, paint, finishes, lighting, building techniques, and the ever-changing trends in home furnishings and interior design. His clients are always grateful for what he achieves.

TOP LEFT
Canton Public Library (Allen Schulman and Associates), 1905. Private office and conference room. Owners: Allen and Christine Schulman.
Photograph by Jim Maguire of Maguire Photographics

BOTTOM LEFT
T. K. Harris estate in Canton, 1930. Lower level ballroom redesigned and furnished. Proud owners: Ed and Judy Cebulko.
Photograph by Jim Maguire of Maguire Photographics

FACING PAGE
Private residence in Kent. Glamorous master bedroom.
Photograph by Jim Maguire of Maguire Photographics

Q&A

more about Dan ...

WHO HAS HAD THE BIGGEST INFLUENCE ON YOUR CAREER?

Frank Lloyd Wright was a genius! His "organic architecture" was ahead of its time.
Also, Addison Mizner's "Old Florida" homes just knock me out!

WHAT SINGLE THING YOU WOULD DO TO BRING A DULL HOUSE TO LIFE?

One of the least expensive ways to change the look of a house is with paint—add color.

WHAT IS THE HIGHEST COMPLIMENT THAT YOU HAVE RECEIVED PROFESSIONALLY?

The highest compliments I have ever received come when clients are so pleased with my work that they refer me to their family, friends or co-workers. One client has already referred 15 people that have become loyal clients. Now that's a compliment!

DAN WEST INTERIOR DESIGN, INC.
Dan West, IDS
4305 Fulton Drive Northwest
Canton, OH 44718
330.493.6200
Fax: 330.493.4417

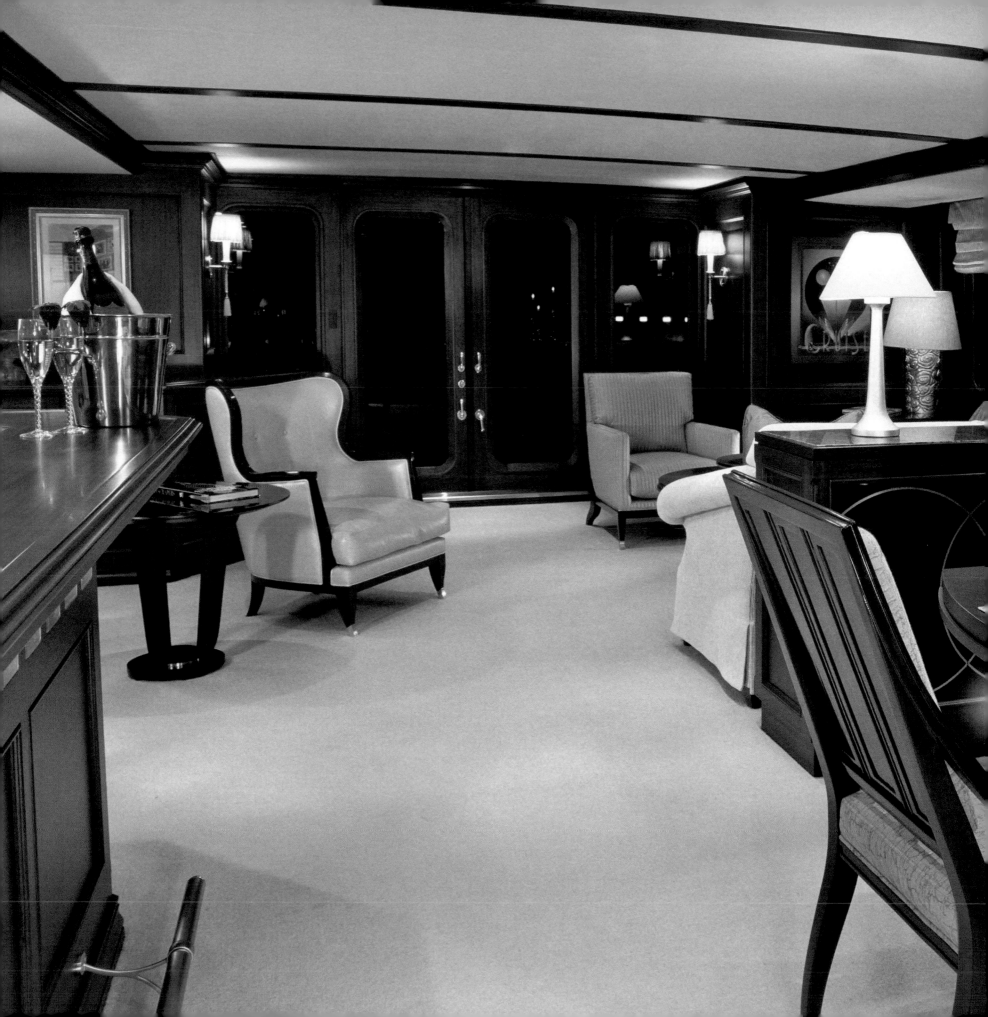

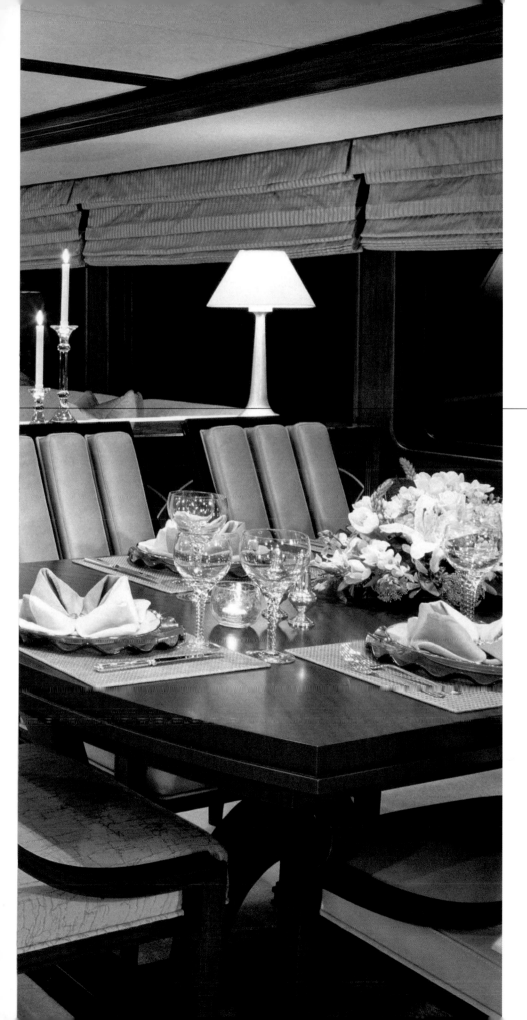

LINDA WIETZKE

LINDA WIETZKE INTERIOR DESIGN. LTD.

At Linda Wietzke Interior Design, Ltd., Linda Wietzke takes pride in creating stylish, comfortable living environments which reflect her clients' personal tastes, while providing impeccable, personalized service.

An interior designer for nearly 30 years, Linda nurtured a lifelong interest in design, when even as a child she rearranged furniture and accessories in her parents' homes. As a professional, Linda says that while she endeavors to create designs that are timeless, she is always aware of current trends and products so that her work remains fresh. With each project she avoids inserting a "Linda Wietzke" look into the aesthetic, but instead strives to reflect each client's personal taste. She takes her client's color and style preferences and injects high style into her designs, most often by encouraging the mixing of styles in furnishings and architecture, and often utilizing favorite pieces belonging to the client.

LEFT
Many of the furnishings in the main salon of this luxury yacht, Top Times, were designed by
Linda with a 1940's French ocean liner influence.
Photograph by Pamela Jones

JOEL WOLFGANG

JOEL R. WOLFGANG INTERIOR DESIGN

Whether Traditional, Transitional or Contemporary, Joel R. Wolfgang Interior Design creates living spaces that clients find simply irresistible and a pleasure to come home to after a long day of work.

Joel Wolfgang studied elementary education before getting a degree in interior design and even today he still finds his educational roots useful when working with his clients. He teaches his clients not only the aspects of good design, but a host of other design awareness and educational points that his clients find invaluable.

A signature look? He doesn't have one. Joel approaches each design by approaching each client individually and giving each their own personal look. He approaches every project by finding out what level of design each client is comfortable with and gives them the style they desire.

LEFT
Gothic traditional custom home in Bratenal, Ohio. Joel is a firm believer that the interior design starts at the front door. Knowledgeable about architecture and construction, he loves to select exterior colors.
Photograph by Jim Maguire of Maguire Photographics

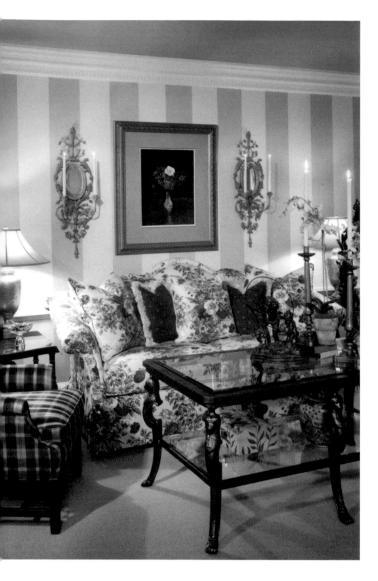

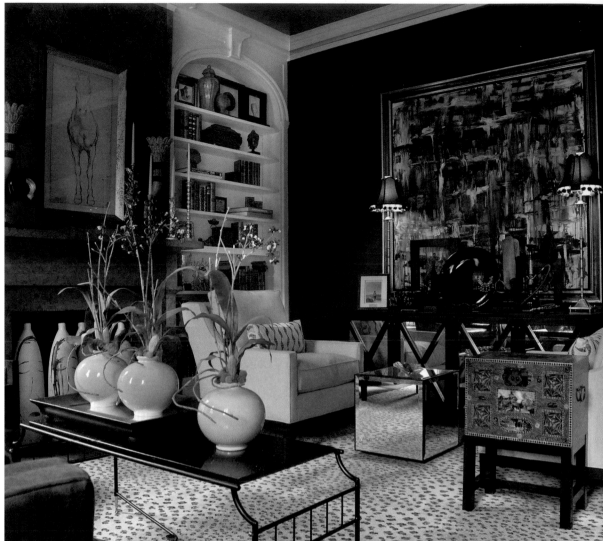

He always likes to push the envelope a bit by taking his designs to a level his clients may not have seen before, thereby creating something wonderful and ideally a home with a very personal flair.

For Joel, the best part of being an interior designer is taking an unattractive, uninviting space and transforming that space into a warm and enjoyable room where, when revealed to the client, they tear up and say, "Oh, my goodness this is just what I wanted! Thank you."

With anywhere between 10 and 12 people on staff and 30 to 40 projects going at any given time, Joel's team is cohesive in their design approach and level of customer service. Every person on his staff from the assistants, to the office manager, to the delivery persons, to the designers work together to make each project a unique and unequivocal success.

Joel prides himself on making the design process—and even the shopping—fun and easy for his clients. With every project he brings his clients' souls and

passions into each aesthetical direction he embarks upon. He knows that his full-service design company, with its harmonious and talented team members, has something to offer every type of client looking to improve their lives through better living.

ABOVE LEFT
Wide vertical stripes painted on the walls and a darker ceiling help to update this more traditional living room in Salem, Ohio.
Photograph by Jim Maguire of Maguire Photographics

ABOVE RIGHT
Trendy and timeless ... this 140-year-old Akron home was a challenge to update and still maintain all of its original architecture and beauty.
Photograph by Mike Steiner

FACING PAGE TOP
Silk wall covering, wool carpeting, linen bed drapes and custom bedding make this a romantic getaway in this Western home.
Photograph by Jim Maguire of Maguire Photographics

FACING PAGE BOTTOM
Architectural detailing with custom John Saladino sofa and Donghia fabric: Luxury at its finest.
Photograph by Jim Maguire of Maguire Photographics

more about
Joel ...

WHAT ELEMENT OF STYLE OR PHILOSOPHY HAVE YOU STUCK WITH FOR YEARS THAT STILL WORKS FOR YOU TODAY?

Keep your background simple and make sure that your artwork and accessories are things that you love. It is easier to change a pillow or a lamp than it is to change a whole room. Keep your background neutral and add in fun with the accessories.

WHO HAS HAD THE BIGGEST INFLUENCE ON YOUR CAREER?

Steven Chase of Rancho Mirage, California and Ken Toney of Bath, Ohio. I knew them both well and learned to appreciate their designs and their styles of design. As I started creating more designs, it struck me how good they truly were.

WHAT SINGLE THING WOULD YOU DO TO BRING A DULL HOUSE TO LIFE?

Re-accessorize it because what is a house without a picture on the wall, or a lamp or pillows on the upholstery?

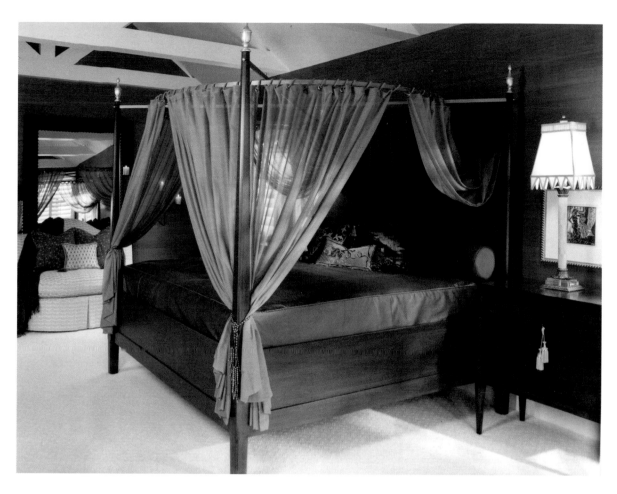

JOEL R. WOLFGANG INTERIOR DESIGN
Joel Wolfgang
3067 West Market Street
Fairlawn, OH 44333
330.836.7400
Fax: 330.836.7407

815 Prescott Drive
Palm Springs, CA 92262
760.325.7070
Fax: 760.322.2770

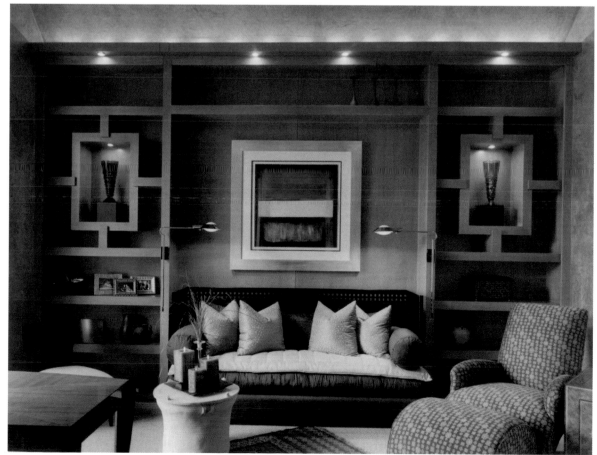

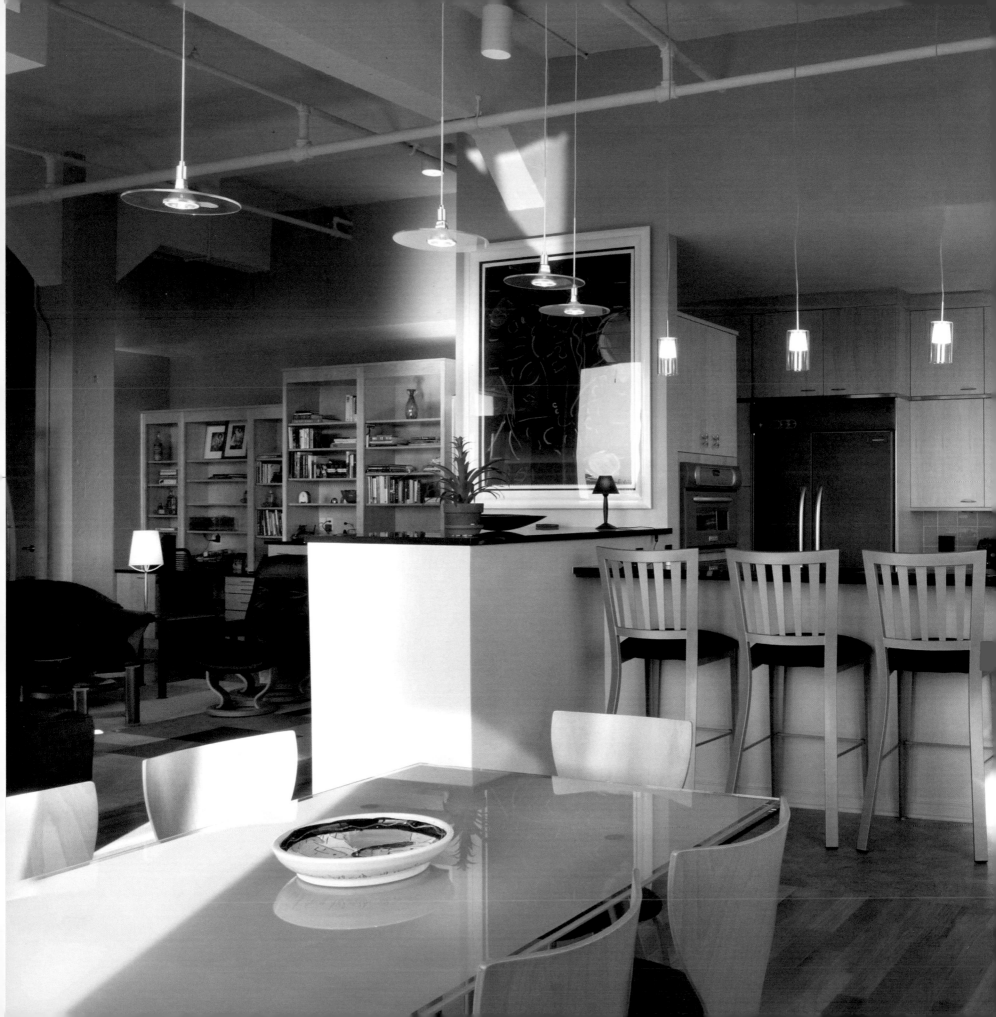

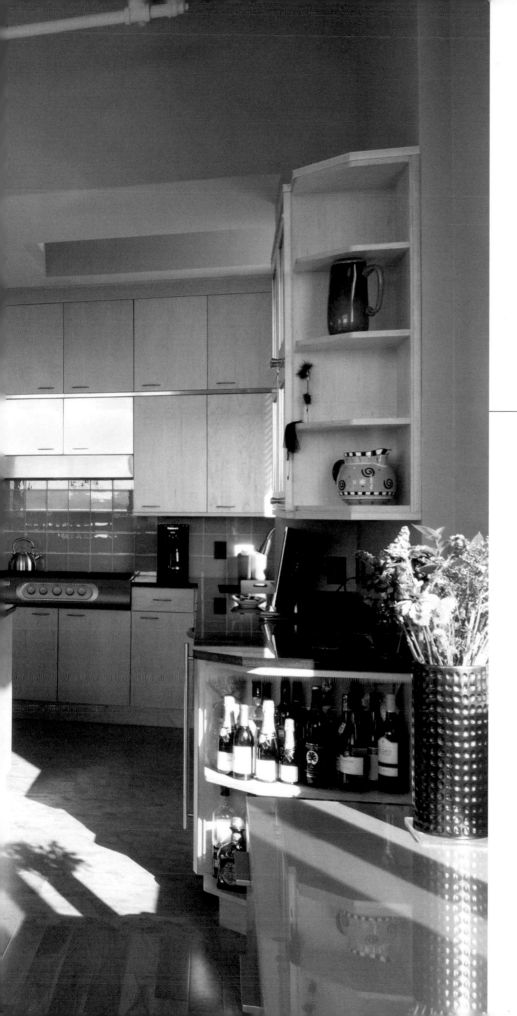

A. MARIS BERNARD

A. MARIS

A Maris Bernard, ASID, of A. Maris, incorporates her understanding of the value of life's joys and challenges into the unique, inspiring, and life-affirming living spaces that she creates for her clients. She knows that life is replete with opportunities to learn and grow both as a person and as a designer, and brings these qualities to her design work.

Working in residential, commercial and hospitality areas of interior design, she has designed everything from high-end homes and exterior living spaces to medical facilities, offices, boutique-type retail stores, condominium lobbies, and atrium spaces. She has developed an area of expertise in condominium design, kitchen design, and remodeling, integrating the design intent of the client with the construction process.

The philosophy that Maris incorporates into all of her projects is one of respect for her clients' personal lifestyles, interests and needs. She interacts with them to create a design that includes all of these elements, and thus the designs themselves reflect a respect for the owners.

LEFT
Natural maple cabinets, black granite tops, stainless steel accents, and white oak floors created the clean, uncluttered look the client desired in this living/study/dining/kitchen area.
Photograph by Gary Kessler Photography

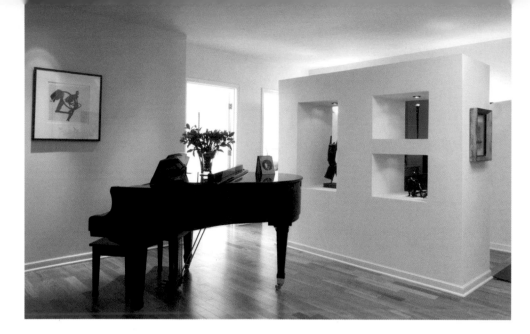

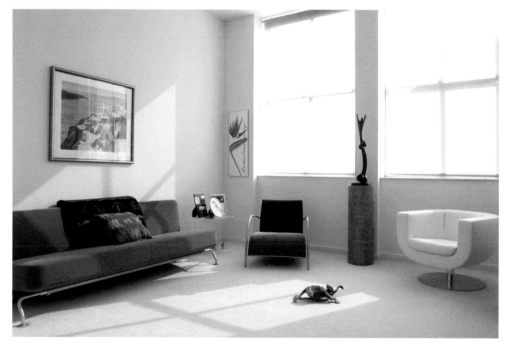

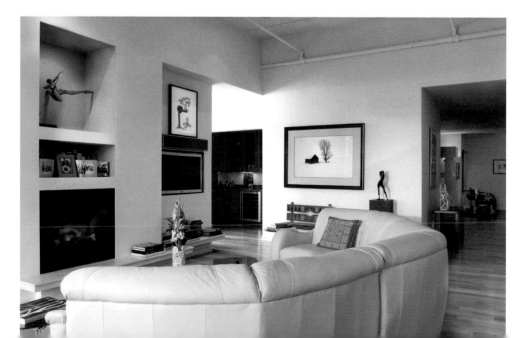

To accomplish this she becomes very close to her clients by interviewing and spending time with them, learning about their public and private lives and how they interact with their home environment. In doing so she garners the essence of each client and creates a catered look that reflects her client's taste rather than her own.

Observation, for Maris, is key in her everyday life and especially when working on her projects. For instance, once she was working to develop a color palette for a client. Having difficulty developing a solution to her problem, she was standing in her kitchen looking into her backyard through a window when she noticed a bird land on the railing of her deck. In an instant it was "Voila!" Inspiration struck and a solution presented itself because she noticed the color combination in the bird's feathers and knew that it was perfect for her client.

Maris's clients appreciate that she truly enjoys her career. She brings a tremendous enthusiasm for her craft to each individual project, which adds energy and assists her in the creative process as well. She helps clients achieve a level of aestheticism that they desire and value.

Ultimately, Maris's goal for her clients is that they love where they live. She hopes that her clients return home each day and feel a sense of warmth, enjoyment and pleasure. "I want them to understand that life and living is a gift—something to be treasured. I hope that my work reflects joy, renewal and an appreciation for life and the wonderful things—and the people—in it."

TOP LEFT
The niche wall was created to separate the music room from the corridor to the bedrooms, providing additional space for the client's extensive sculpture collection.
Photograph by Gary Kessler Photography

MIDDLE LEFT
This room marries form, function (the sofa becomes a bed), and art—a light background amplified by high ceilings, large windows, and color.
Photograph by Gary Kessler Photography

BOTTOM LEFT
The butter-yellow leather sectional centers the room on the custom-designed fireplace with sculpture/photo niches, yet also accommodates the built-in television above the cantilevered marble hearth.
Photograph by Gary Kessler Photography

FACING PAGE TOP
The apple green wall behind the headboard becomes the central theme of this bedroom and creates a focal point for the occupant's photography.
Photograph by Gary Kessler Photography

FACING PAGE BOTTOM
Maris designed this deck, pergola, walkway, wall, and stairs for the hot tub off the master bedroom, with plantings and unique carved corbels provided by the client.
Photograph by Gary Kessler Photography

Q&A

more about A. Maris ...

WHAT SINGLE THING WOULD YOU DO TO BRING A DULL HOUSE TO LIFE?

Bring out my paint chart and add color! I also include art because they really go hand-in-hand. Art can provide color and color can support art: they complement each other.

WHAT HAS HAD THE BIGGEST INFLUENCE ON YOUR CAREER?

I have traveled all over Europe and the United States and I observe and absorb the environment that surrounds me. I look at color, texture, landscape, architecture, and the things that make that area appear unique. Those are the influences that drive me. I have traveled extensively enough to incorporate many different aesthetics in my work. I focus on visiting places which give me inspiration.

WHAT STYLE HAVE YOU USED FOR YEARS THAT STILL WORKS FOR YOU TODAY?

I have never had a specific style or a specific color palette. My aesthetics are all client driven. My style respects my clients' belongings and personal tastes.

Photograph by Rich Sofranko Photography

A. MARIS
A. Maris Bernard, ASID
3548 Erie Avenue
Hyde Park, OH 45208
513.315.0399
www.amarisdesign.com

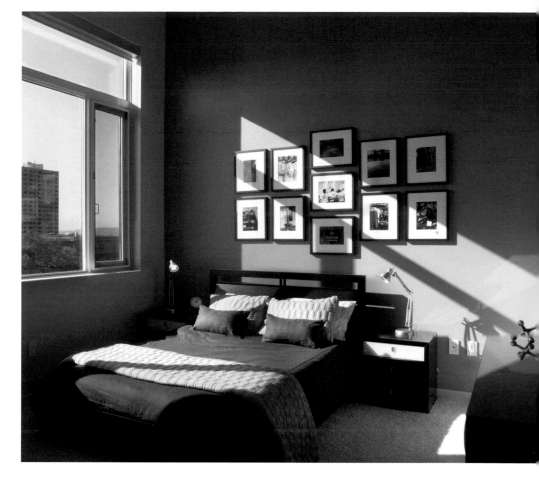

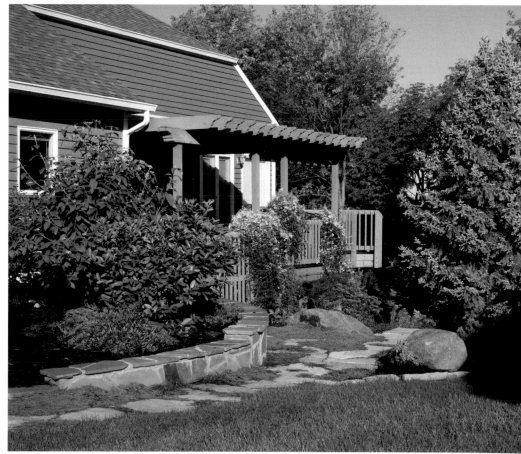

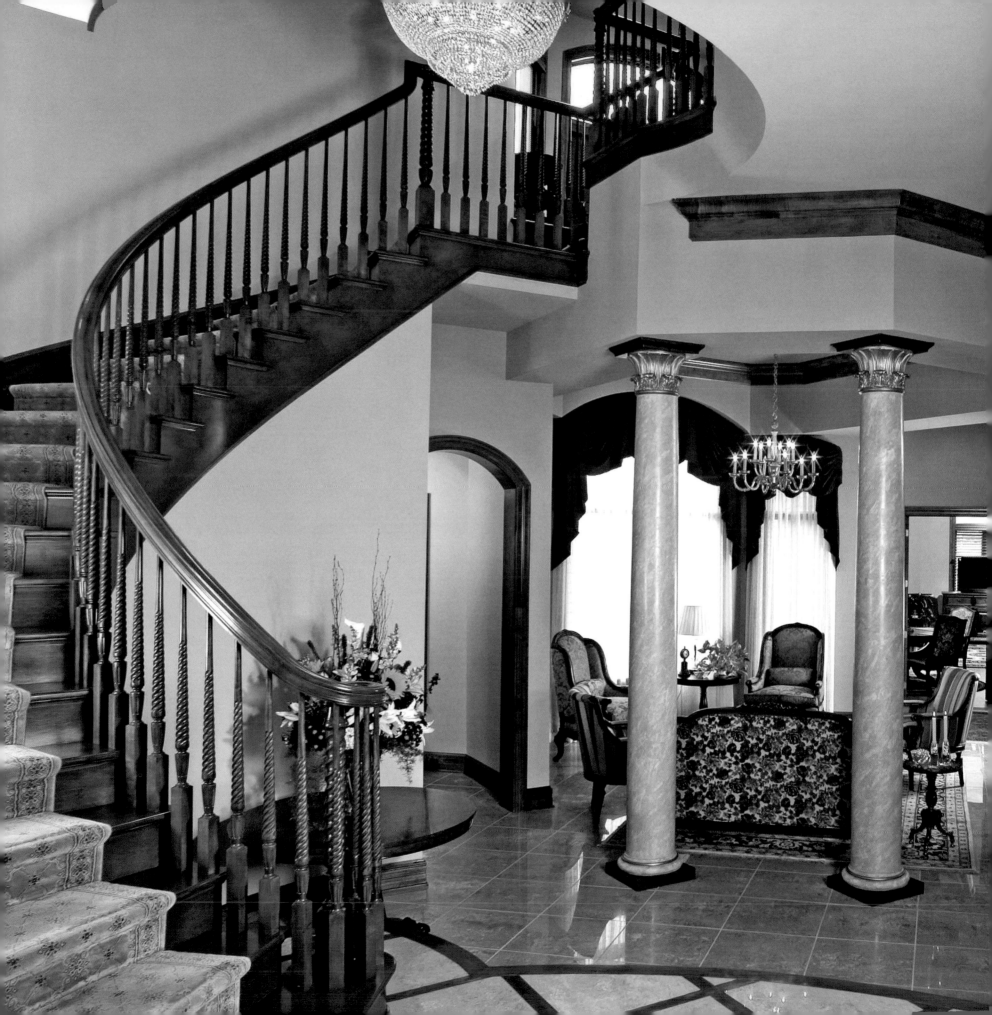

RUTH ANN BOESCH

RUTH ANN BOESCH INTERIORS

R uth Ann Boesch always wanted to become an interior designer. But following high school, college was not an option open to her. Instead, she entered the workplace as a secretary and eventually married. As a young wife, she became a mother of two boys and thus lacked the time or the means to pursue her passion. However, at age 42, with her youngest in college, Ruth Ann decided it was finally time to resume her own education. Her enrollment as a full-time student at Columbus College of Art and Design was the beginning of a 22-year career in interior design.

This delayed start did nothing to stunt her professional success. Before establishing Ruth Ann Boesch Interiors in 2001, she worked as a designer at local furniture stores. In this capacity she earned several awards for her abilities and, in the process, developed a strong and loyal client following.

Ruth Ann takes great pride in her clients' loyalty. She points out one case in which she received a call from a client she had worked with several years before. During the interval they had lost contact, but the client had retained her old business card, searched the Internet and found her through the

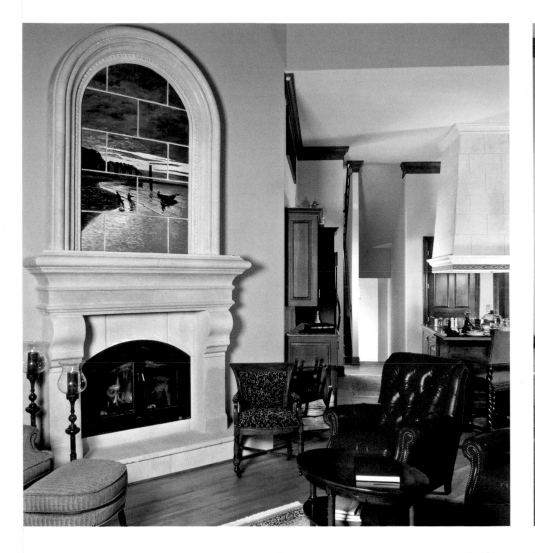

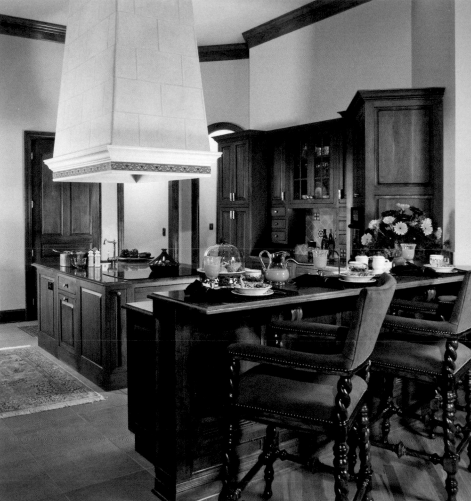

the likes and dislikes of a new client. She understands the importance of taking into consideration all residents' desires and thus insists upon meeting with both people in a couple from the outset of a project. Properly laying this groundwork is the first step toward a successful result.

She also feels that access to competent workrooms, skilled craftsmen and talented artists and technicians is necessary to implement a good design. She has developed a working relationship with several individuals who possess these abilities and relies heavily on them to assure that her clients are pleased.

Clients appreciate Ruth Ann's attention to detail as she helps them make informed selections for their homes both during the design process and afterward. They trust her integrity and professionalism and call on her expertise time and again. Ruth Ann believes that clients should invest in a few high-quality items and gradually add pieces as their budgets permit. She encourages clients to accessorize with interesting lamps, works of art and tabletop items that reflect their personalities.

Ruth Ann notes that clients often find scale and proportion confusing when selecting furniture and accessories. She acknowledges that it is difficult to determine true scale when manufacturers display items in settings that are much larger than typical home settings. It takes a trained eye to discern what will work, and Ruth Ann is always willing to lend hers. Her incredible resolve to help clients make the best decisions leads her friends to call her "too conscientious." But for Ruth Ann Boesch, there's no such thing.

ABOVE LEFT
Ruth Ann had her artist replicate a Monet scene for the mural on the stone above the mantel.
Mantel piece artwork by Julie Bradford, Bradford Decorative Arts.
Photograph by Michael A. Foley, Rycus Associates Photography, LLC

ABOVE RIGHT
The bar and island are composed of Brazilian granite known as Verde Savioa. The handmade
Oriental rug nicely complements the inset tile rug in front of the elevator door.
Photograph by Michael A. Foley, Rycus Associates Photography, LLC

FACING PAGE LEFT
The family room's fireplace was the inspiration for the kitchen's stone-like hood. The hood's
border is the same as that of the inset tile rug.
Photograph by Michael A. Foley, Rycus Associates Photography, LLC

FACING PAGE RIGHT
Decorative tile adorns the lower half of the bathroom's 12-foot walls, while the upper half and
ceiling are painted dark blue to minimize its height. An illuminated mirror complements the
decorative vanity.
Photograph by Michael A. Foley, Rycus Associates Photography, LLC

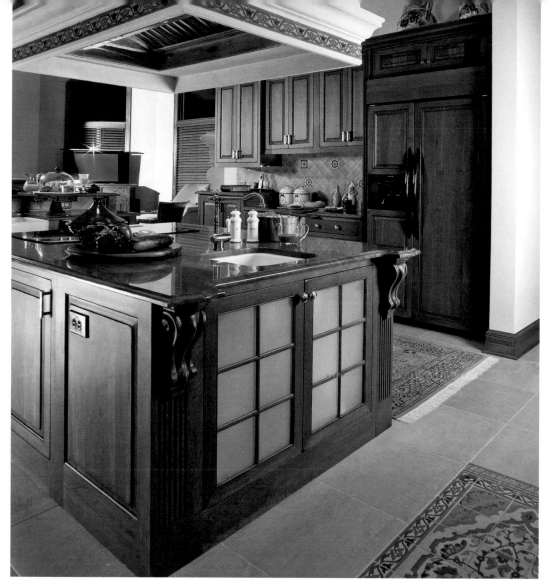

more about Ruth Ann ...

WHAT SEPARATES YOU FROM YOUR COMPETITION?

My designer friends could be considered competition, but we all work independently and support each other.

WHAT IS THE HIGHEST COMPLIMENT YOU'VE RECEIVED PROFESSIONALLY?

I was highly complimented when a client installed at the entrance of his home a bronze plaque displaying my name as the designer.

WHO HAS HAD THE BIGGEST INFLUENCE ON YOUR CAREER?

My mother was a great influence and always supported and encouraged me in everything. She would be so proud.

WHAT SERVICES DOES RUTH ANN BOESCH INTERIORS OFFER?

I offer a complete range of design services, including new construction, remodeling and custom specifications.

RUTH ANN BOESCH INTERIORS
Ruth Ann Boesch, Allied Member ASID
614.475.1714
Fax: 614.475.1714

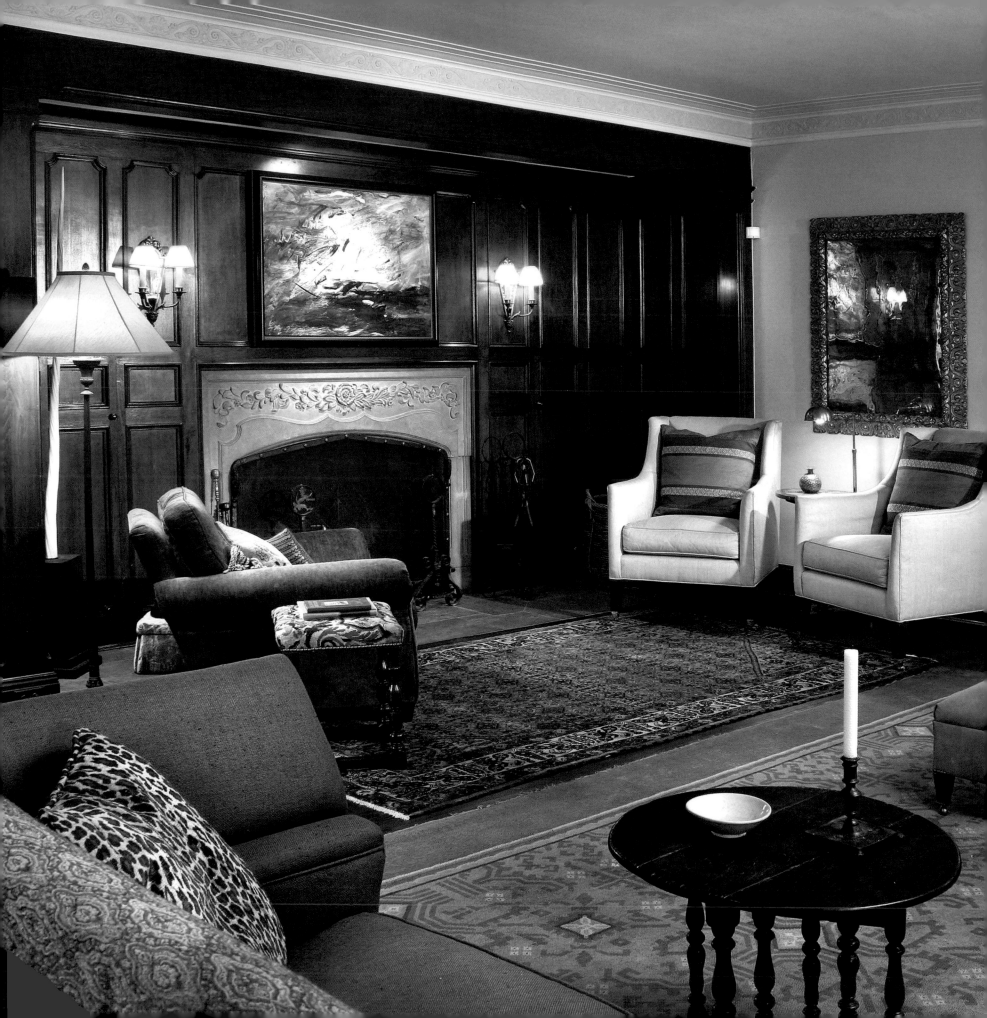

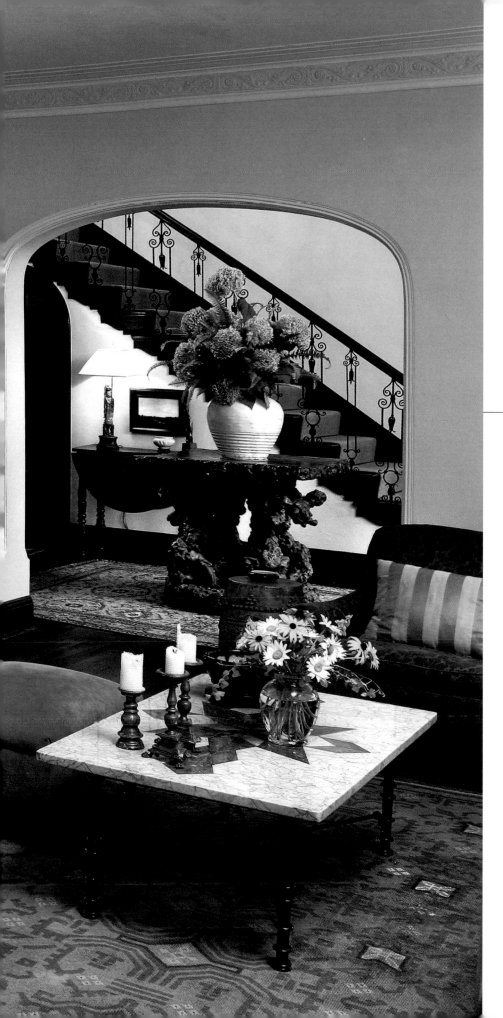

DIGS

Inspired by the success of everything in one place businesses that provide a single source of convenience and quality to consumers, Lori Wellinghoff, a home service pioneer, founded DIGS: Real Estate/Design/ Renovation. Lori's signature one-stop-shop approach appeals to clients seeking an expert organization that offers everything necessary to make a client's home dreams come true.

As President of DIGS, Lori Wellinghoff oversees all aspects of the company's real estate representation, interior/exterior design and renovation practices. Lori is particularly adept in construction-related aspects of design including space-planning and selection of finish materials. To support her firm's endeavors, Lori is joined by best-of-class professionals that fill positions critical to the success of DIGS, including some of the most renowned designers in Cincinnati.

A veteran designer of over 40 years, Garda Mann specializes in "space sculpting" and designing with architectural elements and unexpected

LEFT
This Brian Gibson design for a Tudor estate mixed traditional elements and contemporary art with important antiques including a Chinese burled root entry table and a Narwhale tusk to create a one-of-a-kind living room.
Photograph by Robin Victor Goetz

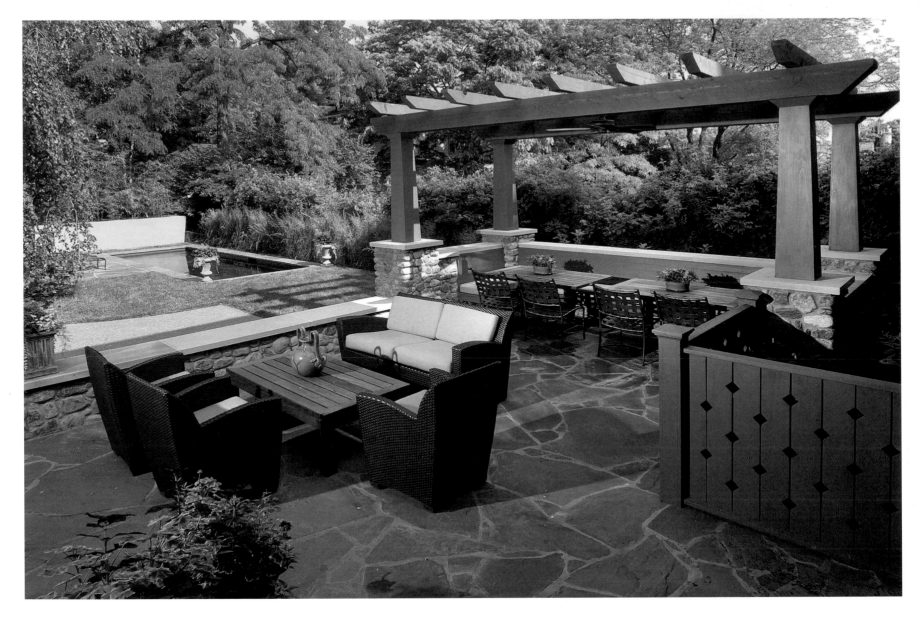

materials to create points of interest versus the traditional "four-wall" approach. Garda's sculpted spaces optimize homeowner usage patterns, day and night light sources, furnishing layout and whole-house flow.

A renowned designer for over 20 years, Brian Gibson draws upon his specialized knowledge of ancient art and artifacts as well as early English and European furniture, combining elements from a variety of periods and cultures to create interiors that are classic, understated, original and supremely livable.

Now a proven success with over 100 clients served, DIGS, based in the Hyde Park Square district of Cincinnati, combines all the creativity and expertise needed to make home dreams reality including: Real Estate Representation to help buyers buy and sellers sell their homes via a strategic partnership with Comey & Shepherd Realtors. Additionally, DIGS offers Interior/Exterior Design which includes anything from space planning for a 4,000-sqaure-foot

penthouse to redecorating a family room to creating a backyard oasis. And finally, DIGS provides Design/Build Construction which includes architecture and construction project management for renovations, home additions, kitchens, baths, landscaping, pools, etc.

Whether clients choose to engage DIGS services individually (a la carte) or in any combination, at a primary residence or second home getaway, DIGS' clients quickly discover the ability to ensure optimal creativity, efficiency, accountability, excellence and success in their residential projects. DIGS raison d'être is to provide its clients with all of the exhilaration and happy endings they deserve, with none of the surprises for which residential projects are notorious.

When you work with DIGS, creating the home of your dreams will be the kind of memorable experience you will actually want to remember.

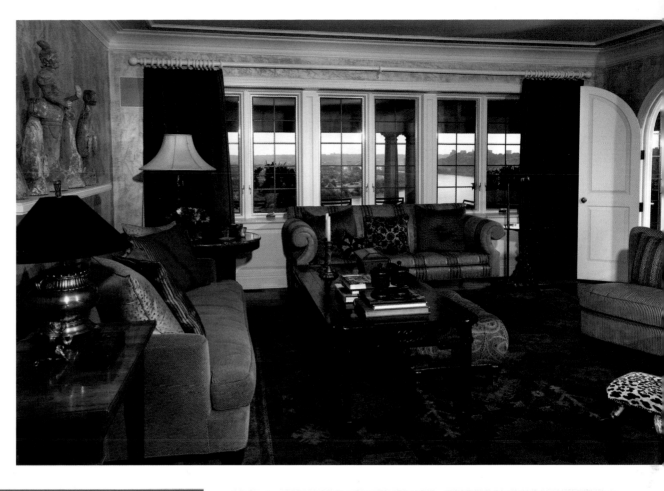

RIGHT
This Brian Gibson design for a Mediterranean-influenced Riverview manor incorporated the client's penchant for Chinese terracotta figures along with an antique Oushak rug all while keeping the view beyond central to the room's magnificence.
Photograph by Robin Victor Goetz

BELOW
This Garda Mann design revived a "plain Jane" family room into a media room/library replete with custom-crafted paneling, mouldings and furnishings that conceal the room's state-of-the-art audio and video equipment.
Photograph by Robin Victor Goetz

FACING PAGE
This Lori Wellinghoff design for a Craftsman bungalow allowed a little house to live large by way of an architecturally sensitive outdoor living/dining area with a lap pool and lounge area beyond.
Photograph by Robin Victor Goetz

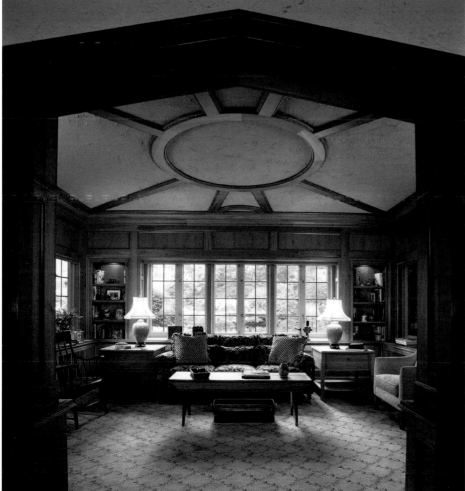

more about DIGS ...

WHAT IS THE HIGHEST COMPLIMENT YOU HAVE RECEIVED PROFESSIONALLY?

We have a client with a highly developed design sensibility (he designs theme parks, city centers, etc.). This client also owns three homes across the country and has always had best-of-class work done in each of his homes. He started using DIGS last year for design and construction and recently sent us an unsolicited e-mail saying that he had never experienced anything as extraordinary as the DIGS way of doing things. It was a glowing, unexpected and an exceedingly affirming note.

DIGS: REAL ESTATE/DESIGN/RENOVATION
Lori Wellinghoff, President
Garda Mann, Principal Designer
Brian Gibson, Principal Designer
3524 Edwards Road
Hyde Park Square
Cincinnati, OH 45208
513.533.DIGS (3447)
Fax: 513.533.3448
www.DIGS-home.com

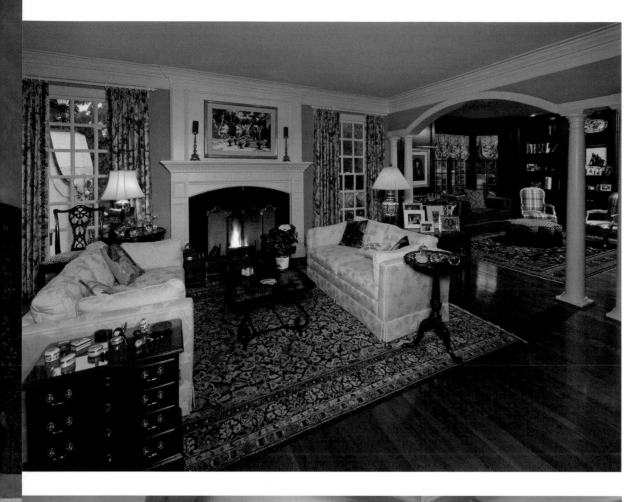

One of HJ's greatest assets to his clients, besides his skilled designs, is his knowledge of the historical perspective of furniture and interiors. He uses this knowledge to teach his clients what the classic forms of furniture and antiques are and where their historical precedent lies. His clients find this extremely valuable because he helps them make selections that are true to the intentions of good classic designs—thus limiting the amount of mistakes made and money spent within a project.

"Painting" sophisticated interior pictures that are well grounded in historic precedent, building upon and improving his clients' historical awareness while making lasting friendships are the hallmarks of HJ's career, and he wouldn't have it any other way.

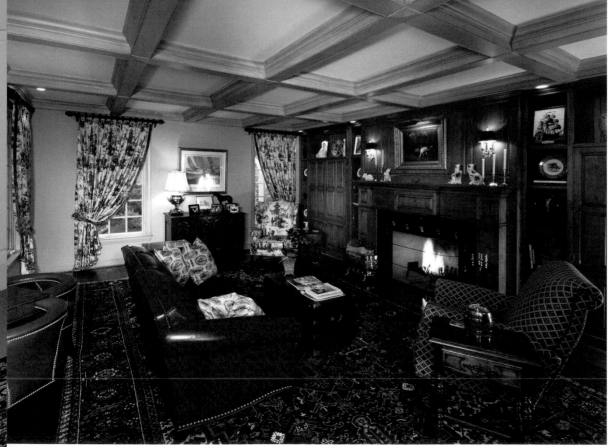

TOP LEFT
A classy, robin's-egg blue living room fronting a panelled library with semi-antique Persian rugs.
Photograph by J. Miles Wolf

BOTTOM LEFT
Hearth room with antiqued alder built-ins, faux-grained box-beam ceiling, glazed chintz toile and authentic cock-fight chairs.
Photograph by J. Miles Wolf

FACING PAGE LEFT
Just for show: Fainting room in Victorian showhouse displays taxidermic birds, miles of black-coque boa trims and maribou lamp shades.
Photograph by J. Miles Wolf

FACING PAGE RIGHT
A place out of the sun. This 42-foot veranda features sisal rugs, rain-proof portieres, palms and ivy.
Photograph by J. Miles Wolf

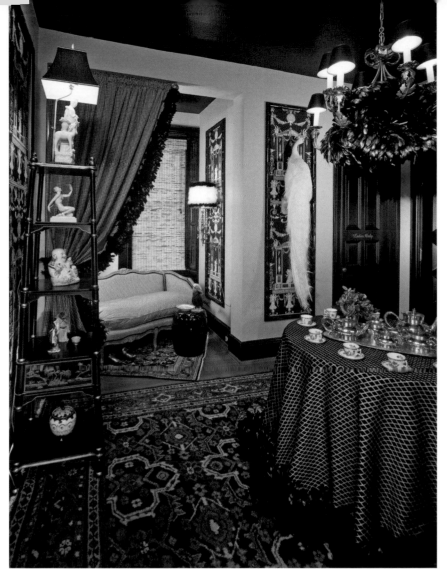

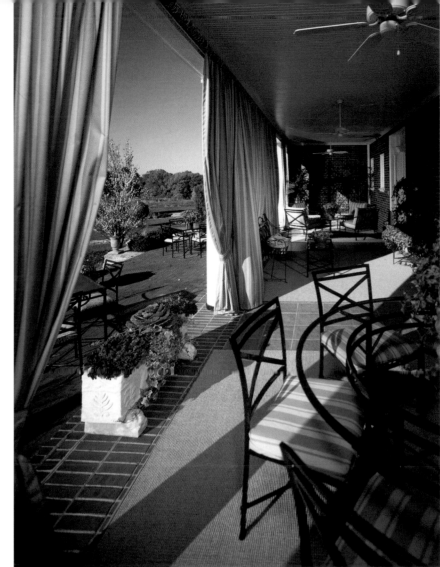

more about HJ ...

WHAT ONE PHILOSOPHY HAVE YOU STUCK WITH FOR YEARS THAT STILL WORKS FOR YOU TODAY?

Live casually with elegant things, OR It's not about buying furniture, it's about building a collection.

NAME A PET PEEVE.

My prime example is the Queen Anne cocktail table. Queen Anne never had a cocktail in her life. She might have had a tea table, but there is no such thing as a Queen Anne cocktail table; that was made up by a furniture stylist and it has no historical precedent.

WHAT SEPARATES YOU FROM YOUR COMPETITION?

A thin veneer of extremely good taste.

WHAT IS THE GREATEST LESSON THAT YOU HAVE LEARNED IN YOUR CAREER?

To be a careful listener and listen to what they don't say just as much as what they do say.

NAME ONE THING THAT MOST PEOPLE DON'T KNOW ABOUT YOU.

I know nothing about computers or the Internet and I'm perfectly happy.

GREIWE INTERIORS, INC.
HJ Euless, ASID
2107 Grandin Road
Cincinnati, OH 45208
513.871.3095
Fax: 513.871.9008
www.greiweinteriors.com

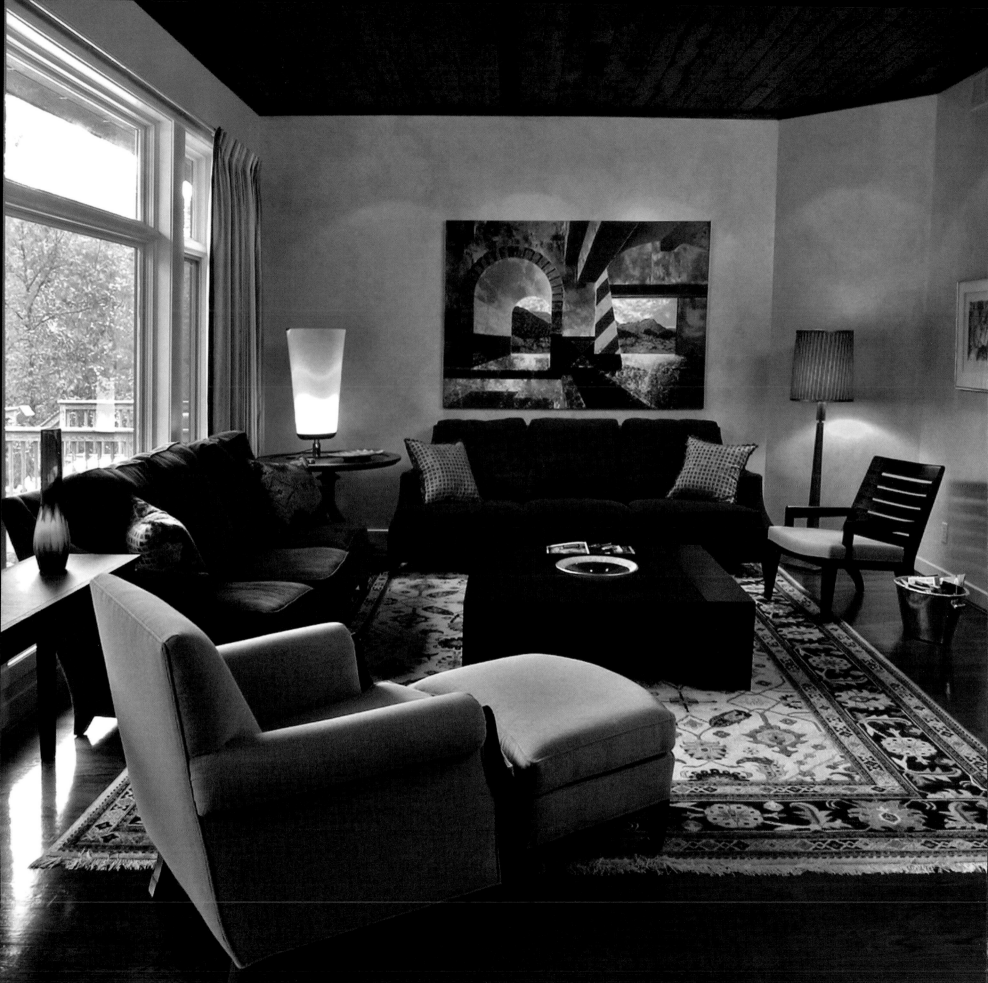

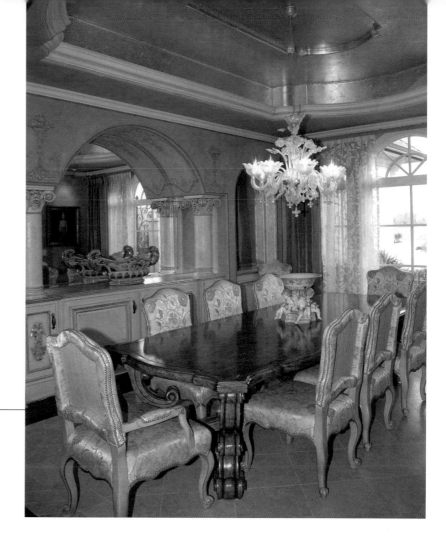

MEG FIORA

FIORA DESIGN

Growing up, Meg Fiora wanted to be a doctor to improve and save lives. As she grew older, being a doctor was not appealing anymore, yet little did she realize that she would be improving the lives of her clients through beautiful interiors designs that improve the quality of life through extraordinary living.

A high-end residential designer, Meg enjoys the freedom that her clients allot her with projects because they trust her expertise, her creativity and her decisions. She enjoys the fact that she has the opportunity to express the personality of each homeowner through the design of their homes.

Working in the areas of remodeling and new home construction, Meg enjoys working with architects on custom homes, creating drawings of the architects' ideas and enhancing them to meet each client's personality, needs and lifestyle.

Her aesthetic is catered to her every client. She can work in Traditional to Contemporary, but her style is to avoid over accessorizing, as there is a fine line between tastefully accessorizing and "cluttering" that can easily be crossed. Meg prefers artwork and accessories be placed within a room with purpose and reason, and she utilizes her clients' collections and the "objets d' art" they love. Although she doesn't like her interiors to be overly done, at the same time she doesn't consider herself to be a minimalist.

Her clients find her sense of color and her inherent sense of explaining the intangible to be the most valuable. During the planning stages of a home it is hard for a client to look at the architect's blueprints and fully understand the context. They find it invaluable that she is able to translate the potential reality of the future finished look from a very difficult-to-grasp set of plans.

ABOVE
The ceiling's gilded soft shapes complement the gorgeous carving on the table and chairs.
Photograph by Matt Fiora

FACING PAGE
This classic, modern and eclectic family room has a tremendous amount of personality.
Photograph by Robin Victor Goetz - RVG Photography

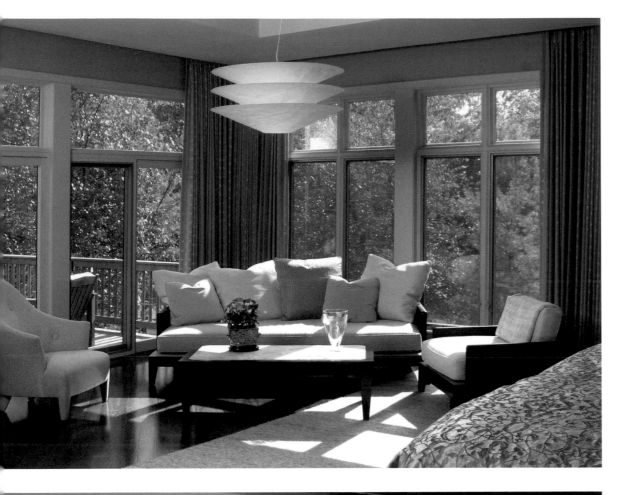

Working with two employees that assist her and a host of subcontractors, Meg knows that she has the right circle of tradesmen to help her with any aspect of a project she embarks upon. She has a fabulous custom cabinet man, a wonderful ironworker, a very savvy decorative painter and an exceedingly talented drapery maker at her disposal for any project. She has a good body of people that enjoy working with her, and that really pays off for her and her clients.

Today, Meg is not a doctor as she planned to be, but she is still saving people's lives through life-changing interior designs because of the amazing beauty that is born from a home that functions well.

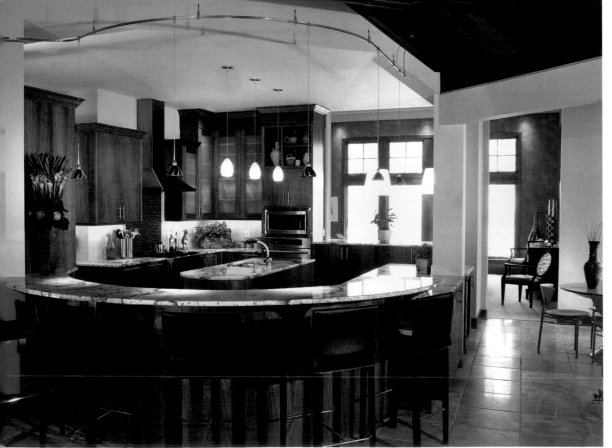

TOP LEFT
To keep things quiet and subtle and to bring the outside in, beige tones were incorporated for a busy couple's master bedroom.
Photograph by Robin Victor Goetz - RVG Photography

BOTTOM LEFT
Warm Koa wood and textural granite countertops make for a cozy and inviting space, despite the centrally located kitchen with minimal natural light.
Photograph by Robin Victor Goetz - RVG Photography

FACING PAGE LEFT
A play of geometrics on the ceiling and floor sandwiches the focal points and moves the eye through this pleasing composition.
Photograph by Robin Victor Goetz - RVG Photography

FACING PAGE RIGHT
This Tuscan master suite's luxurious quality is enhanced by the ceiling detail and faux painting.
Photograph by Matt Fiora

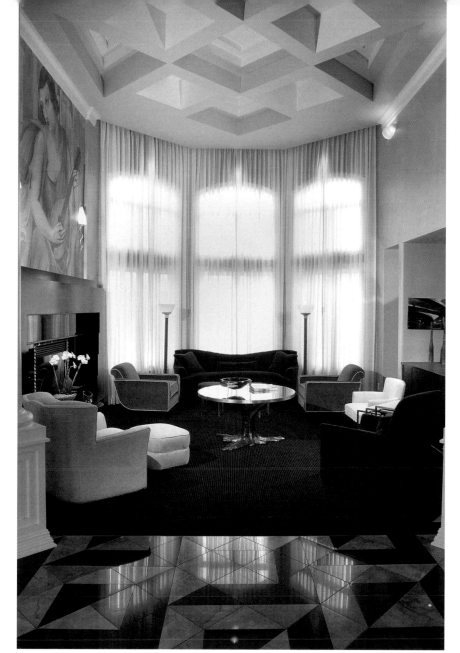

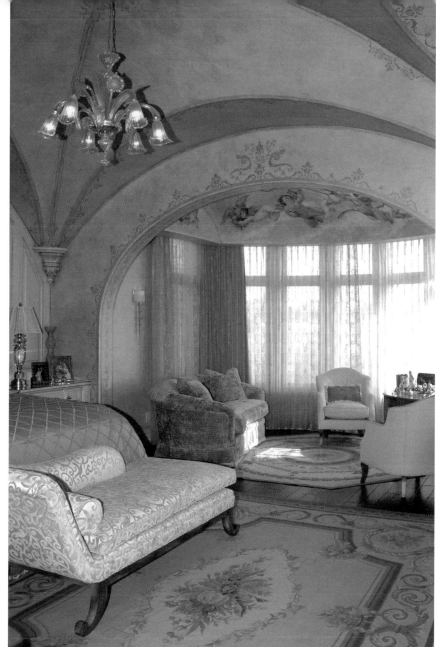

more about Meg ...

WHAT IS A SINGLE THING THAT YOU WOULD DO TO BRING A DULL HOUSE TO LIFE?

Bring color and texture to the home, something as simple as paint and beautiful artwork or textile to give it drama.

WHAT IS THE HIGHEST COMPLIMENT YOU'VE RECEIVED PROFESSIONALLY?

The thank you notes and phone calls complimenting Fiora Design for the wonderful job that we've done for our clients.

WHAT IS THE BEST EXPERIENCE THAT YOU HAVE HAD WITH A CLIENT?

The ones that stand out the most are the clients that know what they like. They are more opinionated and they are not afraid to progress with some ideas that might not be the typical thing.

FIORA DESIGN
Meg Fiora
1118 Pendleton Street
Cincinnati, OH 45210
513.369.0500
Fax: 513.369.0502

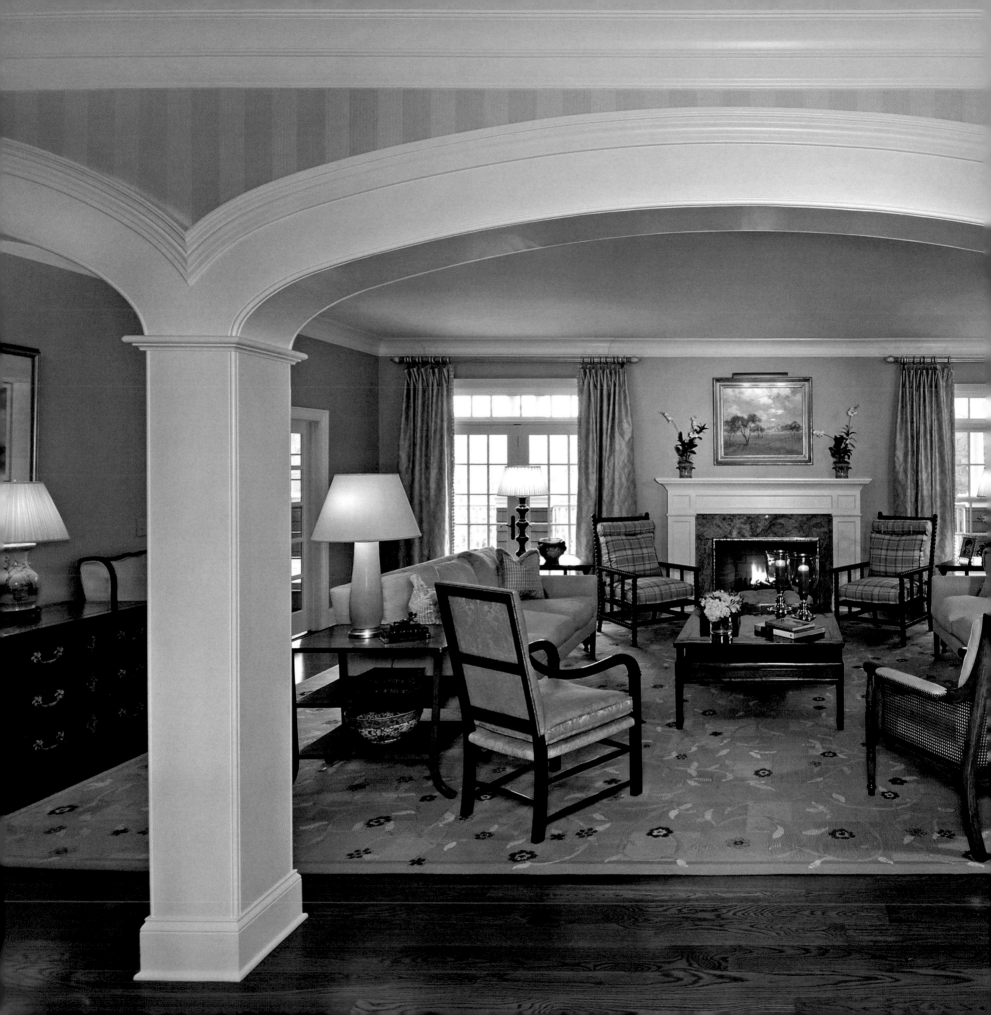

DOUGLAS M. GREIWE

GREIWE INTERIORS, INC.

A fourth-generation interior designer, Doug Greiwe of Greiwe Interiors shares his exquisite taste with Greater Cincinnati by bringing together sophistication and welcoming comfort. Doug's work is subtly permeated by his experiences while living in New York City, where he attended the Fashion Institute of Technology. The seasoned designer understands the desires of his clientele and translates their wishes into livable tableaus with a touch of the unexpected.

Although he enjoyed having access to the Big Apple's wealth of art and design, Doug was happy to move back home to Ohio and carry on the family tradition. The 125-year-old Greiwe Interiors has acquired a base of clients that spans four generations, yet new patrons find their way to the respected company every day because as Doug relates, "Greiwe is synonymous with excellence." Clients routinely express their amazement at Doug's ability to make their dreams come true, a sentiment that he finds supremely rewarding.

LEFT
Cool colored walls, silk draperies and rich wood tones bring added warmth to a casual yet elegant living room.
Photograph by J. Miles Wolf

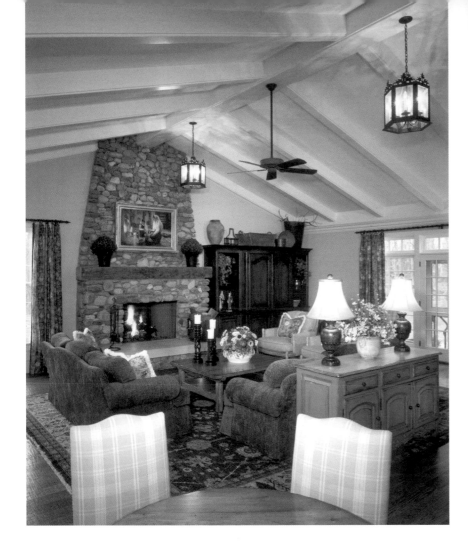

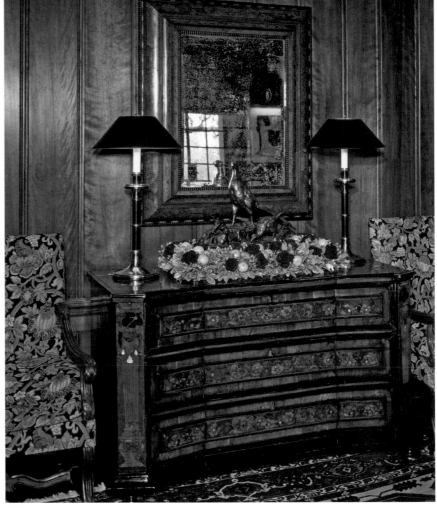

Ever since he was a child, Doug has been acutely interested in design and even recalls the precise moment that he made up his mind to pursue the profession. Upon delivering furniture for the family business to a restaurant that his father had designed, the owner raved about the wonderful interior and Doug thought, "Wouldn't it be incredible if someone had something that fantastic to say about my hard work?" He has never looked back.

Established in 1881, Greiwe Interiors began painting churches as far away as California. Today, the emphasis is on residential interior design. Doug's projects take him all over the country, from the West Coast to Colorado, Montana, Maryland, Florida and many destinations in between. Doug enjoys working with homeowners to design interior spaces that enhance their quality of life and believes that building relationships and providing outstanding customer service are paramount to an enjoyable and successful design experience.

The firm boasts a 4,000-square-foot showroom and studio filled with accessories and furniture that have been acquired from various international destinations. Clients enjoy browsing the extensive offerings and are privy to

the creativity of not just Doug, but of his entire team. The Greiwe designers feed off of each others' energies to devise truly innovative results for each client.

Doug is well versed in a variety of styles, so rather than confining an interior to just one genre, he approaches projects by ascertaining the overall feeling and ambience that the client wishes to achieve. He is intimately familiar with both the design and construction aspects of interiors and has even collaborated with architects and builders to develop entire house plans. But whether clients desire floor-to-ceiling design or just a one-room update, Doug Greiwe is equally happy to lend his talents.

ABOVE LEFT
Douglas achieves a warm and comfortable family room by using large rugs, colored accent fabrics and distressed furniture. The river rock hearth provides added dimension and texture.
Photograph by J. Miles Wolf

ABOVE RIGHT
A spectacular ebony-inlaid Italian buffet with mother-of-pearl accents sets the mood in the casual dining room.
Photograph by J. Miles Wolf

FACING PAGE
This former hunting lodge-turned-residence incorporates the use of the antique Oriental rugs and fine antique furniture. Texture and color were used to enhance the warm wood paneling.
Photograph by J. Miles Wolf

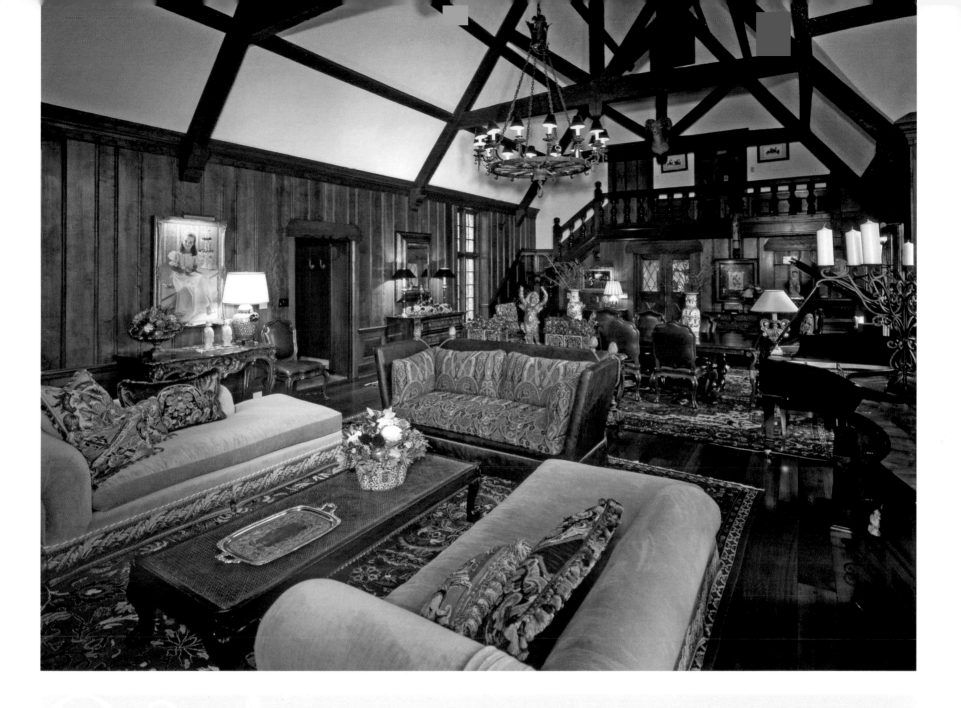

more about Douglas ...

WHO HAS HAD THE BIGGEST INFLUENCE ON YOUR CAREER?

My father, for his integrity, work ethic and astounding creativity.

IF YOU COULD ELIMINATE ONE DESIGN STYLE FROM THE WORLD, WHAT WOULD IT BE?

Right now my problem is furniture that is manufactured overseas. What was being made in the United States is now being done overseas, and the quality has suffered. I'm mindful to select only the highest quality of items for my discerning clients!

WHAT ELEMENT OF YOUR BUSINESS DO YOUR CLIENTS FIND THE MOST VALUABLE?

My ability and desire to listen to their wishes. The more information that I exchange with clients, the better my solution is, because it will truly cater to their lifestyle.

GREIWE INTERIORS, INC.
Douglas M. Greiwe, ASID
2107 Grandin Road
Cincinnati, OH 45208
513.871.2077
Fax: 513.871.9008
www.greiweinteriors.com

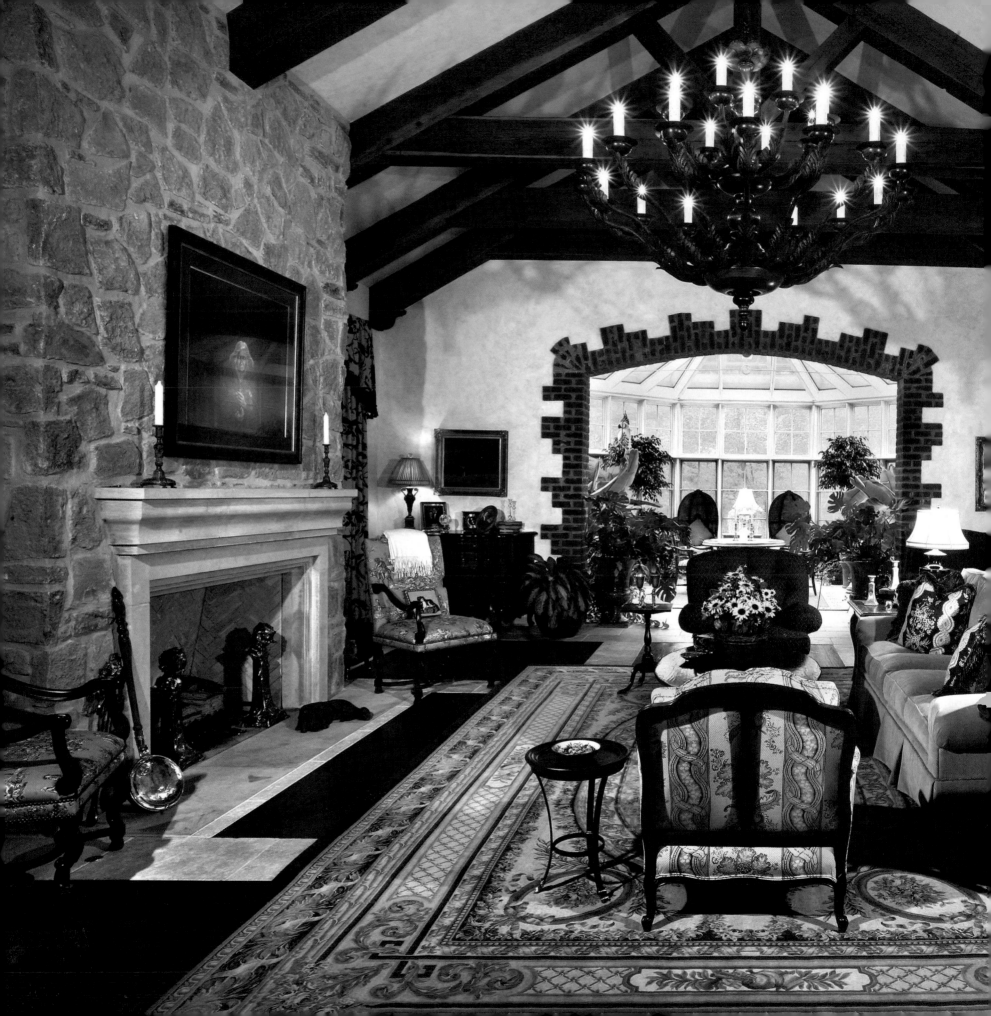

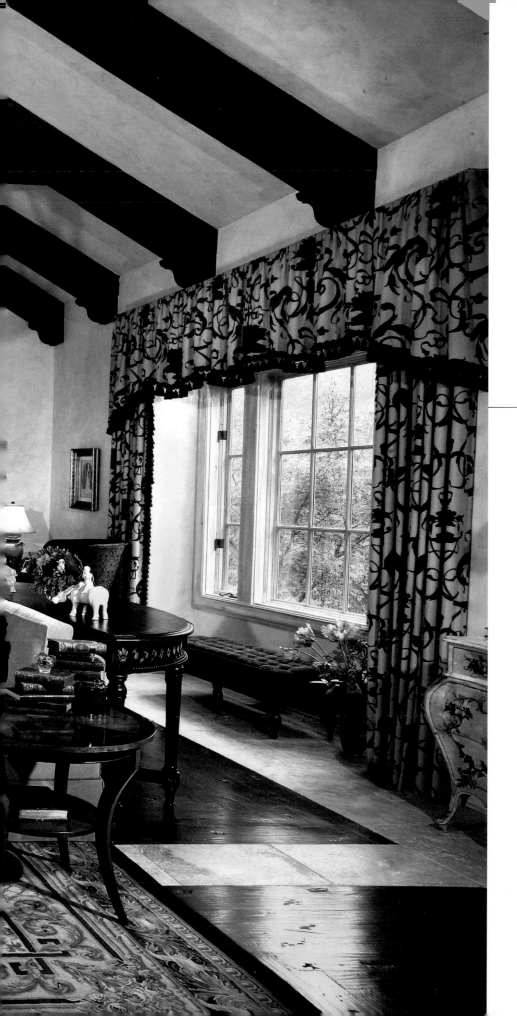

HOUSE OF FRANCE

Kim France entered the field of interior design when she was able to turn a personal tragedy into a new and exciting career. When her moving van was struck by a train, destroying all of her family's belongings, Kim seized the opportunity to learn the furniture and interior design business. As she surveyed the destruction of family heirlooms, antiques, and cherished possessions collected over the years, Kim decided to attack the problem of her empty house with the use of nearby High Point, North Carolina—home of the International Home Furnishings Market—as her guide and tutor.

Each day, Kim would study, research and pour through the vast library of furnishings, accessories, and textiles that can be found in the furniture capital of the world. Amazed at how much fun the design process was, Kim began educating herself with more intricacy in the field, and upon completion of her project, she had become somewhat of an expert. To her surprise, friends and neighbors raved, "I love it! Who's your designer?" Word quickly spread of Kim's talent and fresh ideas.

LEFT
A well-balanced color palette brings architectural elements alive while warming an exceptionally large space. Interior design by Kim France and House of France Design Team.
Photograph by Robin Victor Goetz - RVG Photography

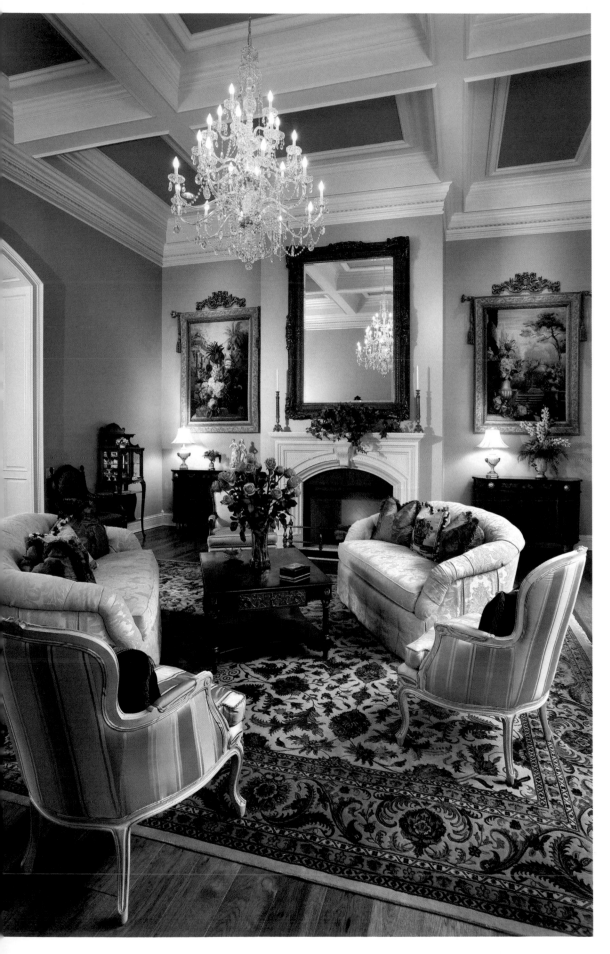

Happy to lend her time and newfound gift, the hobby grew into a full-time commitment when she accepted a position with a notable North Carolina design firm. Her enthusiasm to learn and her ability to absorb knowledge were quickly noticed by her design co-workers. Kim was retained by home builders to consult on building materials, space planning and custom finish work. She was hired to assist and design elite commercial office space as well as high-end cosmetic dentistry offices.

When Kim moved to Cincinnati, Ohio to marry her husband Bill, the two decided to collaborate on a small design shop to showcase Kim's design abilities and to fill a niche market for casual, yet elegant, European home furnishings. What started as a boutique, burgeoned into two large-scale showrooms—5,000 and 13,000 square feet, respectively—established just two years apart. With such a comprehensive offering of furnishings, accessories, lighting, area rugs, draperies, original artwork and gifts for the home, clients are able to find the perfect piece, whatever their personal style.

House of France is a favorite spot for casual shoppers as well as those seeking serious interior design assistance. Professional interior designers staff both showrooms seven days a week and are ready to consult on decisions of all sorts, from color selection to comprehensive whole-house projects. The best part? Design clients have the unique opportunity to touch, sit in, use, and see firsthand, examples of items they might be considering. This eliminates the apprehension that many people feel when ordering from pictures in a catalog.

LEFT
Formal elegance on a grand scale becomes welcoming and livable. Interior design by House of France Design Team.
Photograph by Robin Victor Goetz - RVG Photography

FACING PAGE TOP
A custom Savonnerie area rug anchors this European casual living room in traditional French colors. Interior design by Kim France.
Photograph by Robin Victor Goetz - RVG Photography

FACING PAGE BOTTOM
English antiques are paired with canopy bed hand-carved in Italy, making this bedroom breathtaking as well as soothing. Interior design by House of France Design Team.
Photograph by Robin Victor Goetz - RVG Photography

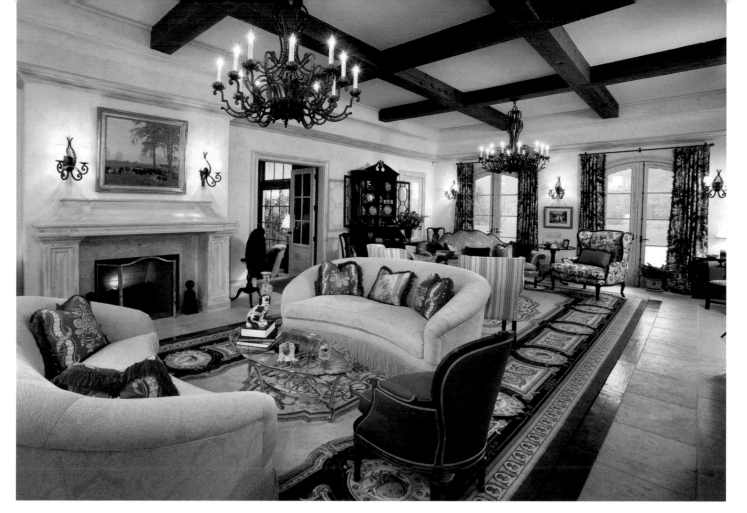

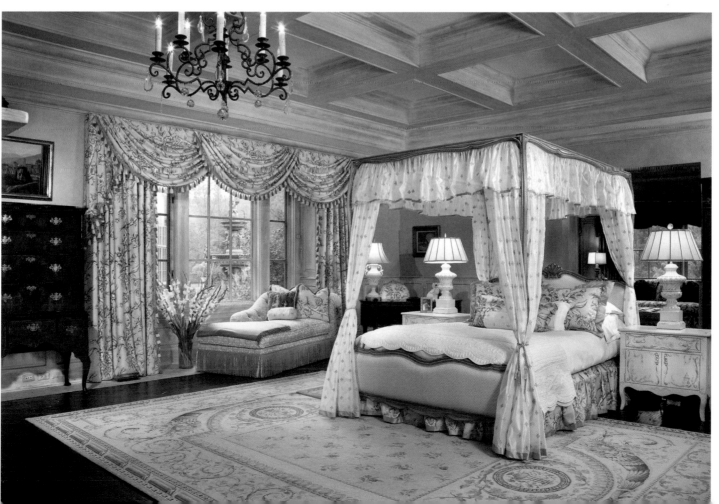

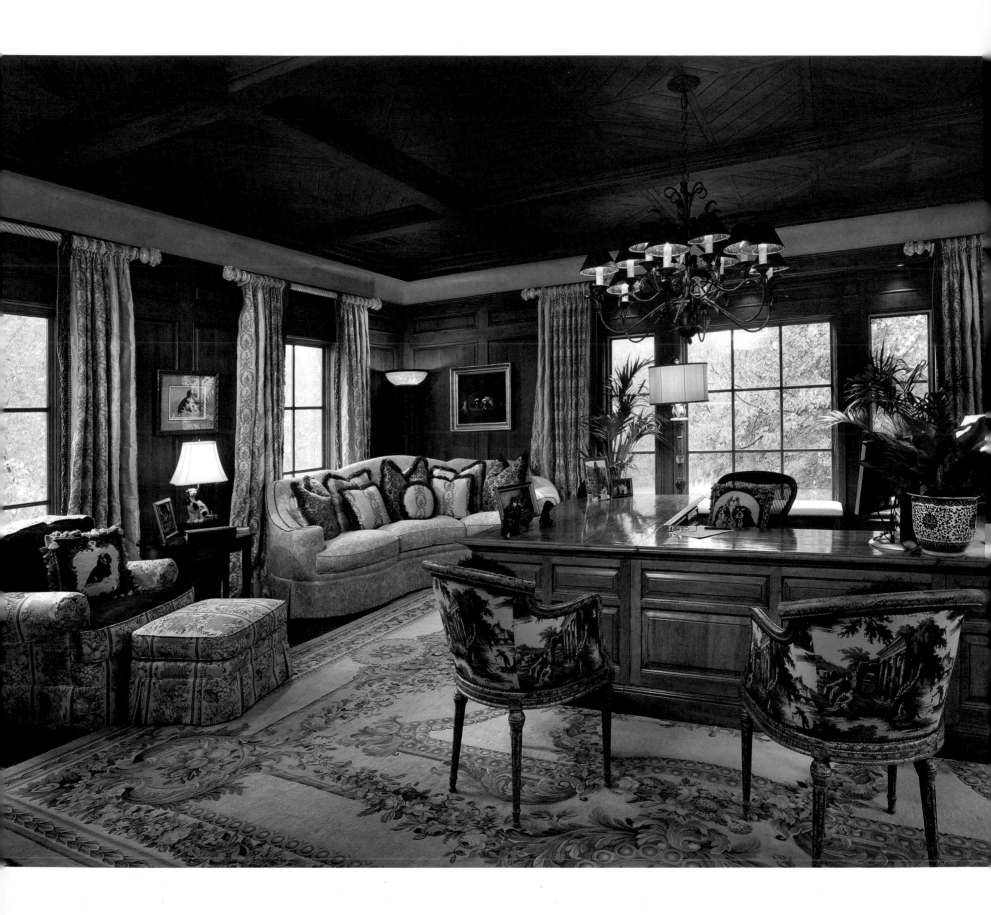

Kim personally selected each member of the House of France design team and has an enthusiastic confidence in her staff's ability to clearly communicate ideas and patiently guide clients through the interior design process. Although most clients prefer to work with one main designer, each team member values and calls upon the talents and ideas of their co-workers. Needless to say, the firm runs with amazing efficiency because no member of the team ever gets "stuck" on a design. Within a matter of minutes, several professionals will gather, share ideas and come up with a breathtaking solution.

A healthy balance of seasoned designers and new talent is the key to House of France's tremendous popularity. Kim notes that because of this composition, new designers develop their skills at incredible rates and experienced team members enjoy their younger associates' fresh perspectives.

Sometimes, projects warrant multiple designers to deliver a cohesive result in a timely manner, and House of France never disappoints. On one occasion, a couple commissioned the firm to design a residence of exceptionally large proportions. The 26,000-square-foot estate was lovingly warmed, softened and personalized through frequent brainstorming sessions and a logical division of responsibilities. With two years of diligent work and the collaboration of many creative minds, the project came to a successful completion. Kim relates, "At the first walk-through, the house was already beautiful with real stucco walls and creamy travertine floors. It was like a delicious vanilla Häagen-Dazs ice cream cone, but we made it a Ben & Jerry's hot fudge sundae with all the toppings!"

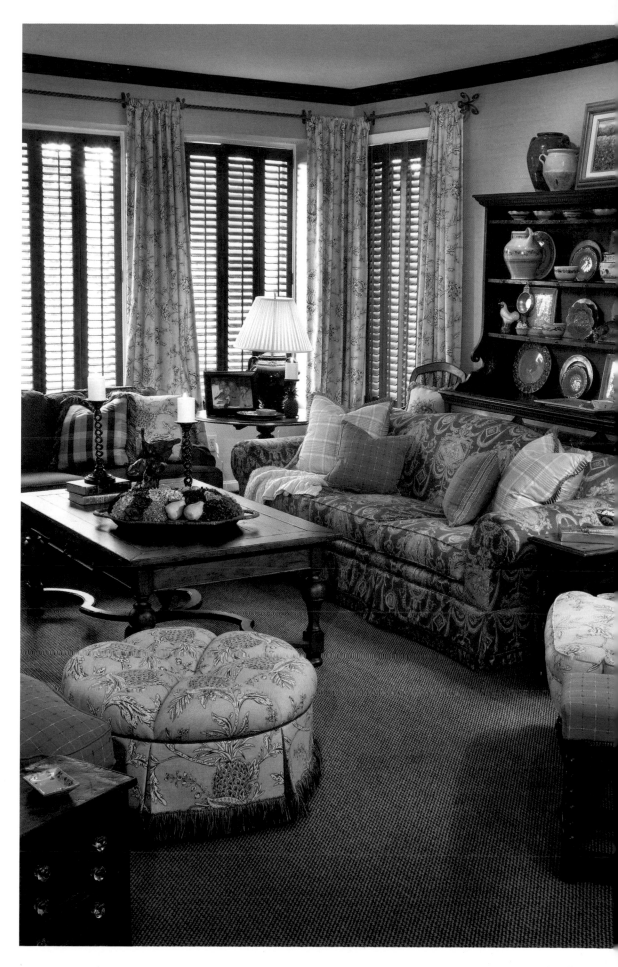

RIGHT
French pottery from Provence inspired the warm color palette for this cozy family room. Interior design by Danielle Forster Campman, Allied Member ASID.
Photograph by Robin Victor Goetz - RVG Photography

FACING PAGE
Silk embroidered draperies shimmer on walnut paneling in this home office. Interior design by Kim France and House of France Design Team.
Photograph by Robin Victor Goetz - RVG Photography

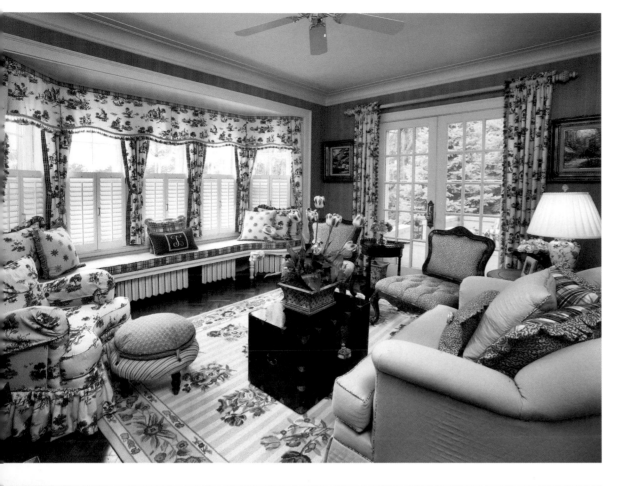

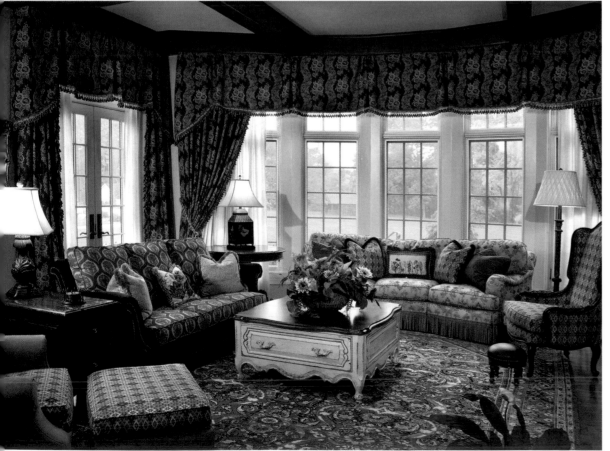

The firm offers a full spectrum of services: storyboards, renderings, furniture placement studies, custom millwork design, material selection and literally anything else that lends itself to the creation of spaces that comfortably envelope the client in thoughtful surroundings. Behind the scenes, Kim's husband and partner, Bill—who studied fine art in college and oversees all of the firm's art buying—is hard at work, tending to the business side of things so that she can focus on steering her team in new, creative directions. Because the Frances have seven children, Kim is particularly adept at understanding the unique needs of growing families. She encourages her team of designers to look at each interior as if they were the client, because creating a beautiful home is not enough. "Anyone can create a beautiful room. The real talent lies in the ability to create a beautiful room that will enhance and improve the lives of the people who live there."

Each project has a drastically different set of requirements. The House of France team thrives on the opportunity to stretch themselves creatively and invent original layouts, schemes and ideas. They never fall back on something just because it worked well in the past. Kim raves about her designers: "I feel blessed to work with each one of them. They all consistently surprise me with their abilities. They are a wildly talented group of professionals who wholeheartedly enjoy sharing their creativity."

TOP LEFT
The sunroom in this circa 1920 home remains sophisticated amid cheerful patterns. Interior design by Sharon M. Masters, Allied Member ASID, IIDA.
Photograph by Robin Victor Goetz - RVG Photography

BOTTOM LEFT
The English Tudor exterior of this estate blends effortlessly with the Tuscan furnishings found within. Interior design by Cathy Kapellas, Member Allied ASID.
Photograph by Robin Victor Goetz - RVG Photography

FACING PAGE TOP
The dining room table, hand inlaid with rosewood and olive burl, is central in illustrating how good design makes "Traditional" fresh and exciting. Interior design by House of France Design Team.
Photograph by Robin Victor Goetz - RVG Photography

FACING PAGE BOTTOM
Bronze fountain designed by House of France.
Photograph by Robin Victor Goetz - RVG Photography

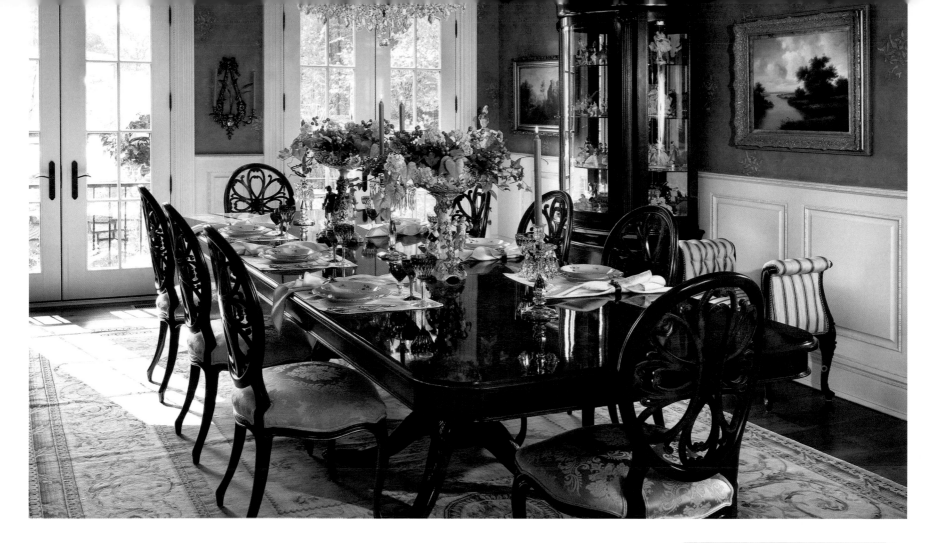

more about House of France ...

HOW WOULD YOU DESCRIBE YOUR DESIGN TEAM?

They are a wildly talented group of professionals who wholeheartedly enjoy sharing their creativity.

DO YOU OFFER DESIGN SERVICES OUTSIDE OF CINCINNATI?

I have done multiple residences for many of my clients. This has occasionally required that I work outside my city of residence. I have become very comfortable with working remotely and will travel to personally oversee the installation and successful completion of every project.

HOW DO YOU DIVIDE YOUR TIME BETWEEN CASUAL SHOPPERS AND CLIENTS WHO DESIRE LARGE-SCALE DESIGNS?

We feel blessed when we are given the opportunity to help a client create a beautiful home from start to finish. However, we are equally thrilled to help someone select the perfect chair for their den. House of France gives new meaning to the phrase "personal service."

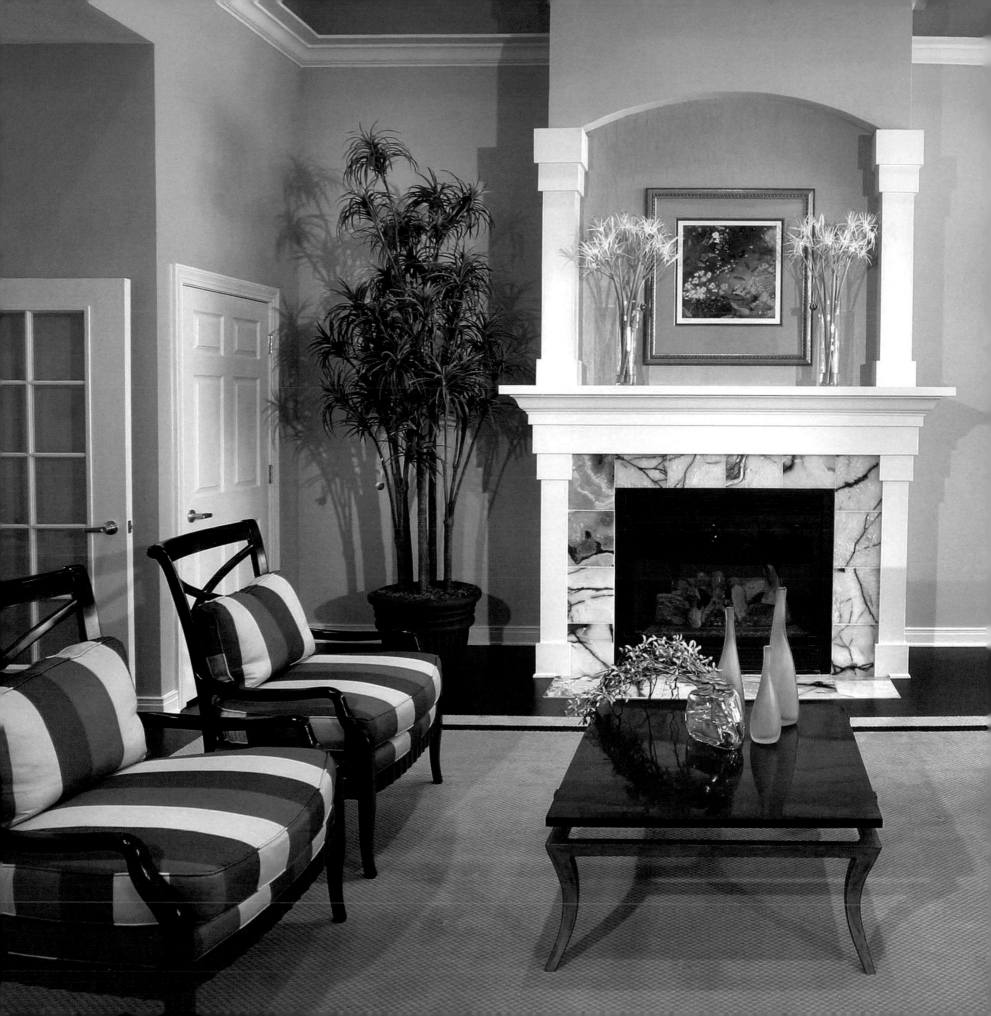

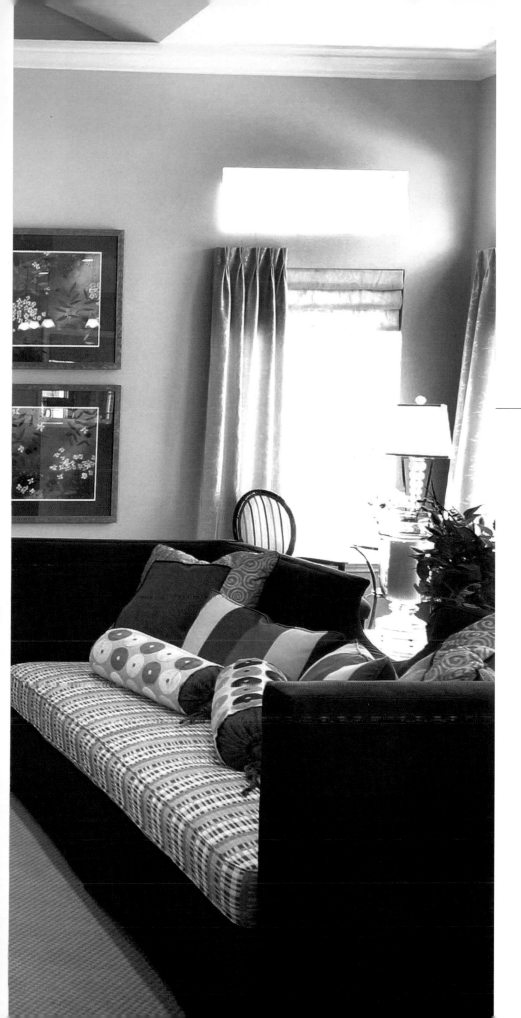

JANE HUGHES

FENTRESS-HUGHES INTERIORS

Growing up in Cincinnati, Jane Hughes' artistic side was encouraged and nurtured by her architect father and supportive mother. And not just through words; while other little girls thoughtfully tried to stay within the lines of their coveted coloring books, Jane was not given those books but rather reams of blank newspaper where her original creations were the focus. When the family moved into Jane's childhood home, she chose the entire color scheme of her room, and with the help of her father, designed the room's modular furniture. Consequently, a telling sign of her future design insight, not a thing was changed even through her college years.

Shortly after graduating from Miami University in Oxford, Jane relocated to Florida where she joined a firm specializing in resorts and apartment property design. This early experience, like all diverse life experiences,

LEFT
The tranquil green walls combined with the onyx fireplace surround are complemented by the dark, rich earth tones of the burnt cork floors and the Jefferson-inspired sofa.
Photograph by RVGP Photographics, Inc.

| 179 |

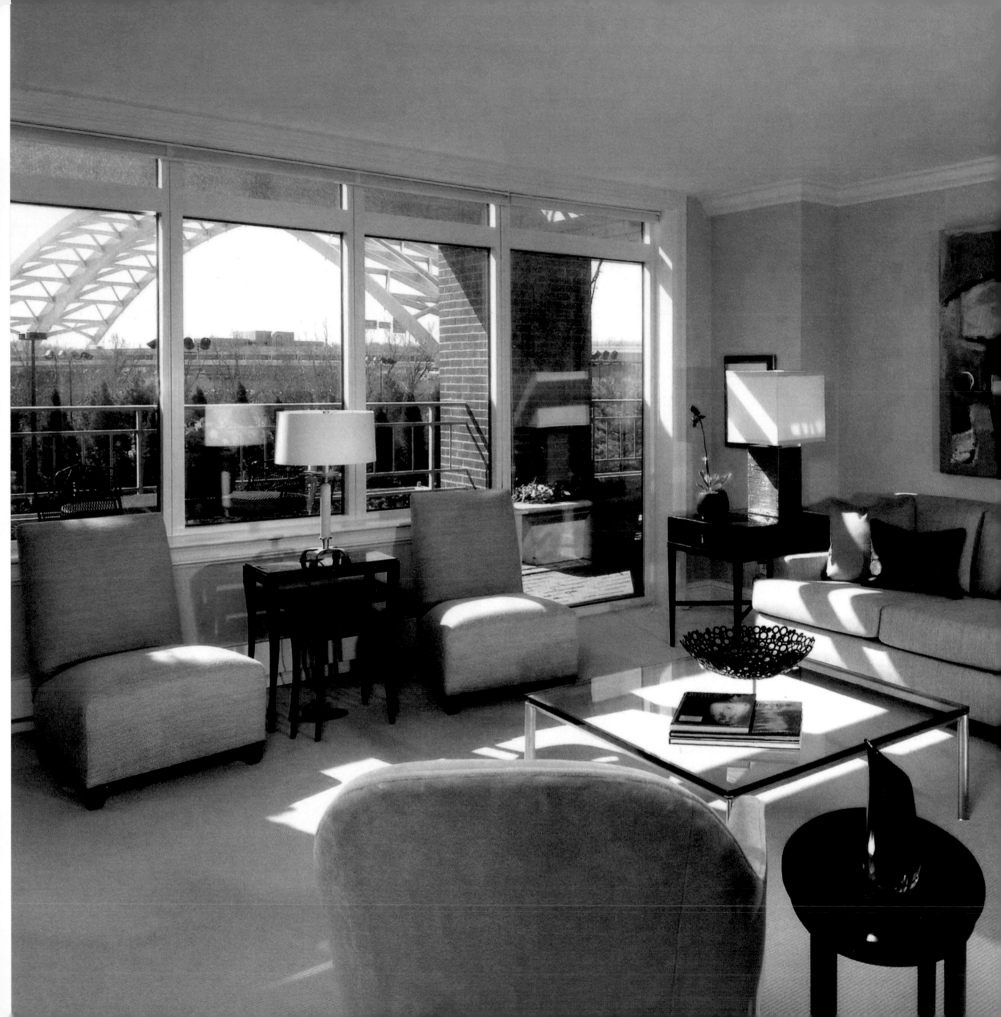

with pas

aging par

All you

and can

Ha

Artw

Th

The

mo

WHAT

I am mo

happy t

the inter

SUSAN JACKSON

JACKSON INTERIORS

S usan Jackson is forever a student of color, texture and light.

She can walk in the woods for hours looking at the interplay of sunlight in nature and interpolate those contrasts of natural textures into her design. "It's the interplay of elements that makes a design really work," she says.

She is also a sailor, athlete and international traveler. The colors and moods of the sky and earth as they embrace each other at sunrise and sunset excite and calm her spirit. Many of her clients are away from their homes during the day. Her goal is to provide a space that not only functions well, but also is comfortable, creates an environment that nurtures their spirits, renews them for the day ahead, and gives them solace to rest.

Susan translates this fluently to her commercial endeavors too, conveying a corporate identity and competence apparent to anyone who fords the doors.

LEFT
Urban living at its best, spectacular river and city views provide an ideal backdrop for entertaining. Sleek furnishings and décor add to the sophisticated ambience.
Photograph by Don Denney

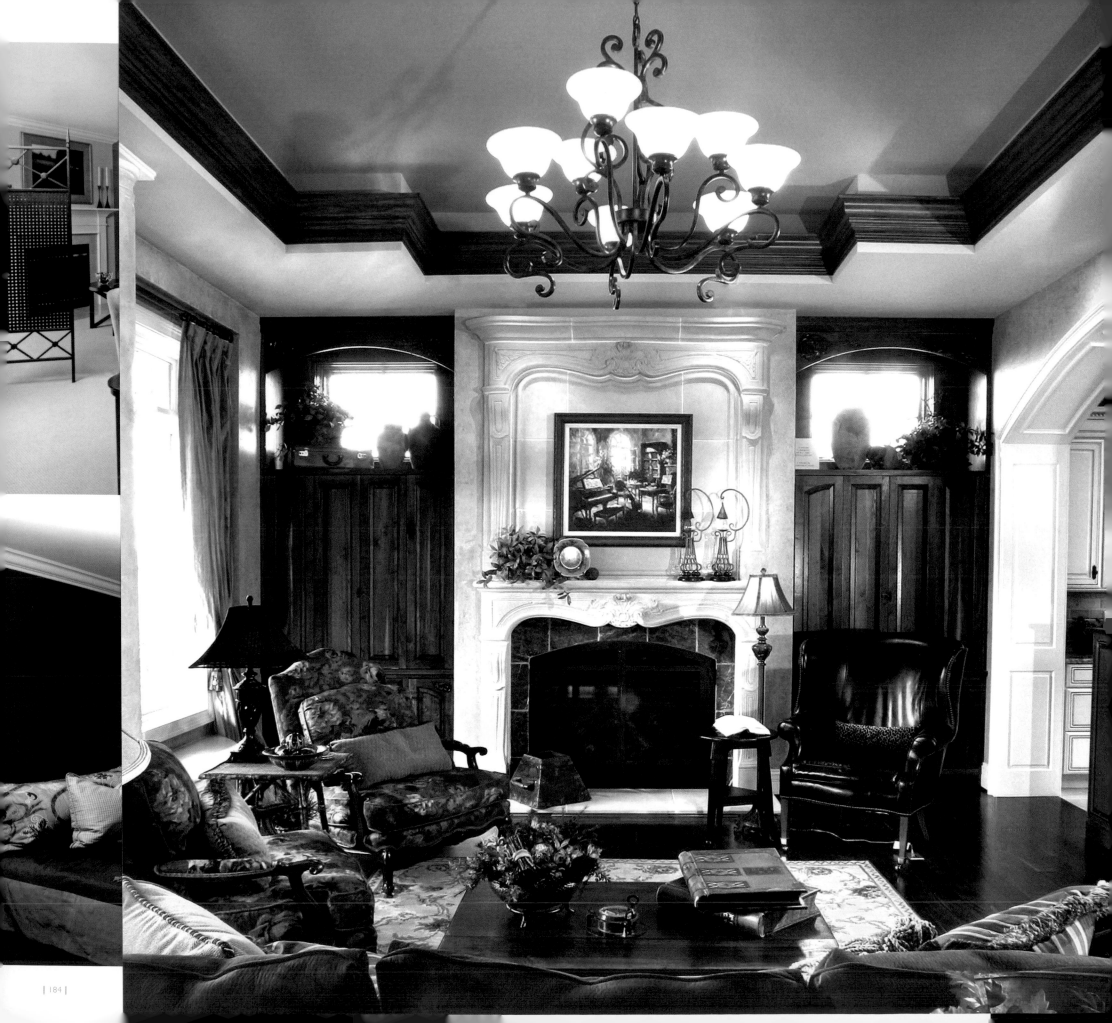

DIANE KIDD
KIDD INTERIORS

For Diane Kidd, creative integrity is paramount when designing wonderful interiors for the clients she befriends and for whom she inspires better living through sophisticated dreams turned realities.

Working in the high-end residential market for 35 years, Diane knows that achieving her clients' dreams and expressing their lifestyles is the secret to her success.

Diane has owned her own business since the beginning of her career and built an impressive clientele. She had a staff of four designers and 11 staff members, a studio and a showroom, but the more work she got, the farther away from the hands-on design approach she found herself. In a bold, unusual move, three years ago she sold everything and downsized to a one-person design business. This move allowed her to personally offer her magnificent creations to a select clientele base. Now, she loves to do what she does best: The art of creation. Today, she personally lends her magic touch to every minute of every project.

Her style ranges from Contemporary to Traditional, whatever her clients' desire. Her forte is Traditional with an uncharacteristic twist. She enjoys implementing surprising elements and accessories in unique ways. For Diane, comfort is a priority in all of her designs. Her designs function, they are comfortable and, of course, every project is beautiful.

Over time, Diane has learned what it takes to be a designer's designer. As she has grown over the years, expanded her horizons and learned from clients as well, she feels she has reached a pinnacle where her work is truly great design and beyond mere decoration. "I've achieved a level of artistry that I'm proud of," Diane says.

ABOVE
Surrounded by French exposed wood and tapestry fabric, the family cat enjoys lounging in his master's favorite chair.
Photograph by Robin Victor Goetz, RVG Photography

FACING PAGE
Adjoining the kitchen in this French villa, a comfortable yet elegant gathering room boasts a carved limestone fireplace, reclaimed walnut floors and complementary walnut built-in cabinets, one of which conceals the television.
Photograph by Robin Victor Goetz, RVG Photography

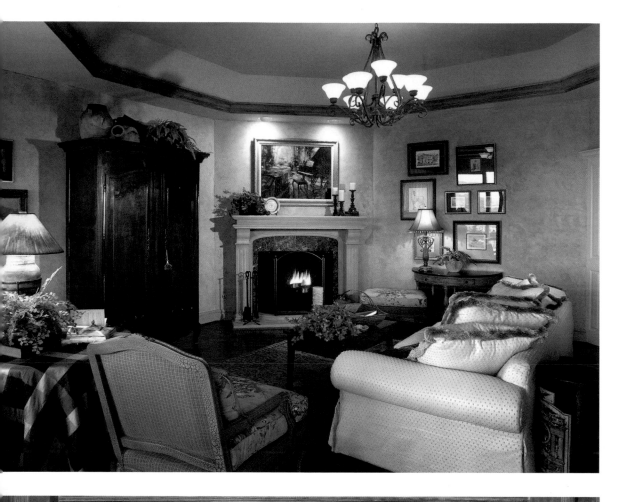

According to Diane, her attention to detail sets her apart from the competition and contributes to her repeat clients. By getting to know her clients, their styles and tastes before beginning a project, Diane receives an understanding of her clients' aesthetic taste. Taking out all the technical jargon and mundane details, the clients do not need to wade through miles of design materials unrelated to their projects, which allows them to envision the final picture of the projects, even before they begin. Ultimately, she puts every element into context for her clients.

Diane's passion for creating and seeing a client smile is what drives her every day to cater fresh designs that reflect her artistry and her clients' lifestyles and dreams.

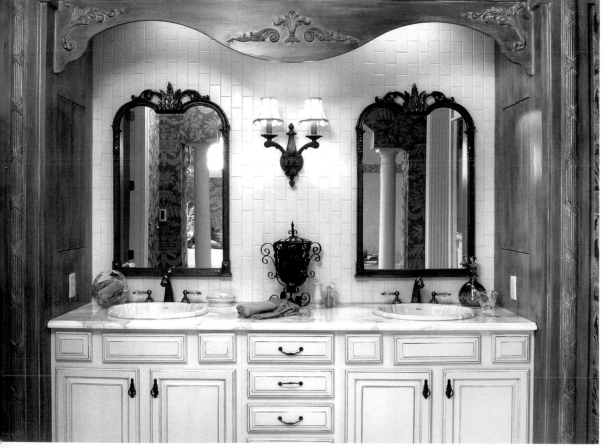

TOP LEFT
This French Country great room is complete with an antique armoire, which houses the family's entertainment system and collection of sketches.
Photograph by Robin Victor Goetz, RVG Photography

BOTTOM LEFT
An Old World look is achieved in the master bathroom with quartz mosaic flooring, a hand-carved valance, columns, granite counter, antique silver crystal faucets and a faux finish. Gilded mirrors atop porcelain subway tiles complete the vanity.
Photograph by Robin Victor Goetz, RVG Photography

FACING PAGE LEFT
The library/guest room features a custom-designed built-in Murphy bed to accommodate the occasional overnight guest. Venetian plaster on the walls and ceiling is peeled away to reveal an Old World map.
Photograph by Robin Victor Goetz, RVG Photography

FACING PAGE RIGHT
A copper tin ceiling and stucco hood with cherry surround set the stage for a gourmet kitchen. Tumbled limestone backsplash, floor and farm sink along with granite counters and copper vegetable sink make this area the owner's favorite place to spend time.
Photograph by Robin Victor Goetz, RVG Photography

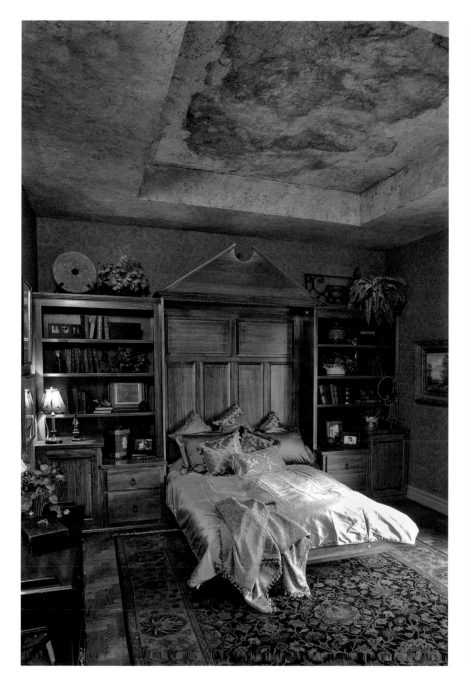

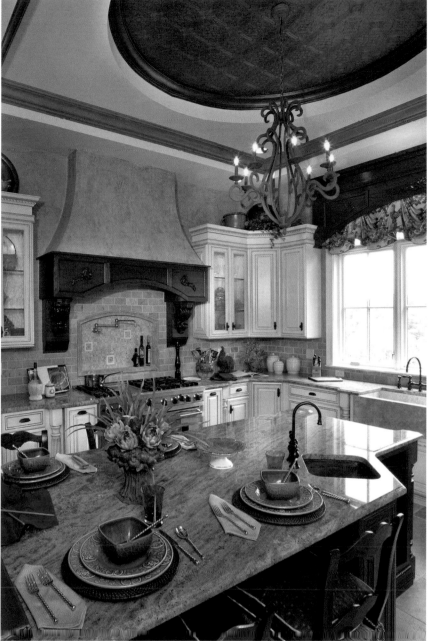

Q&A

more about Diane ...

WHAT IS THE BEST PART OF BEING AN INTERIOR DESIGNER?

At the completion of a project, having clients who have become friends, and knowing they are enjoying a space that I've created, that is truly their own. When they refer me to their best friend or a family member, I know that the project has been a success.

WHAT SINGLE THING WOULD YOU DO TO BRING A DULL HOUSE TO LIFE?

Paint color ... that is what usually perks up a room or a home the most. You can do so much with color on the walls.

WHO HAS INFLUENCED YOUR CAREER?

Bunny Williams.

KIDD INTERIORS
Diane Kidd
11273 Loftus Lane
Union, KY 41091
859.384.6849
Fax: 859.384.8849
www.kiddinteriors.com

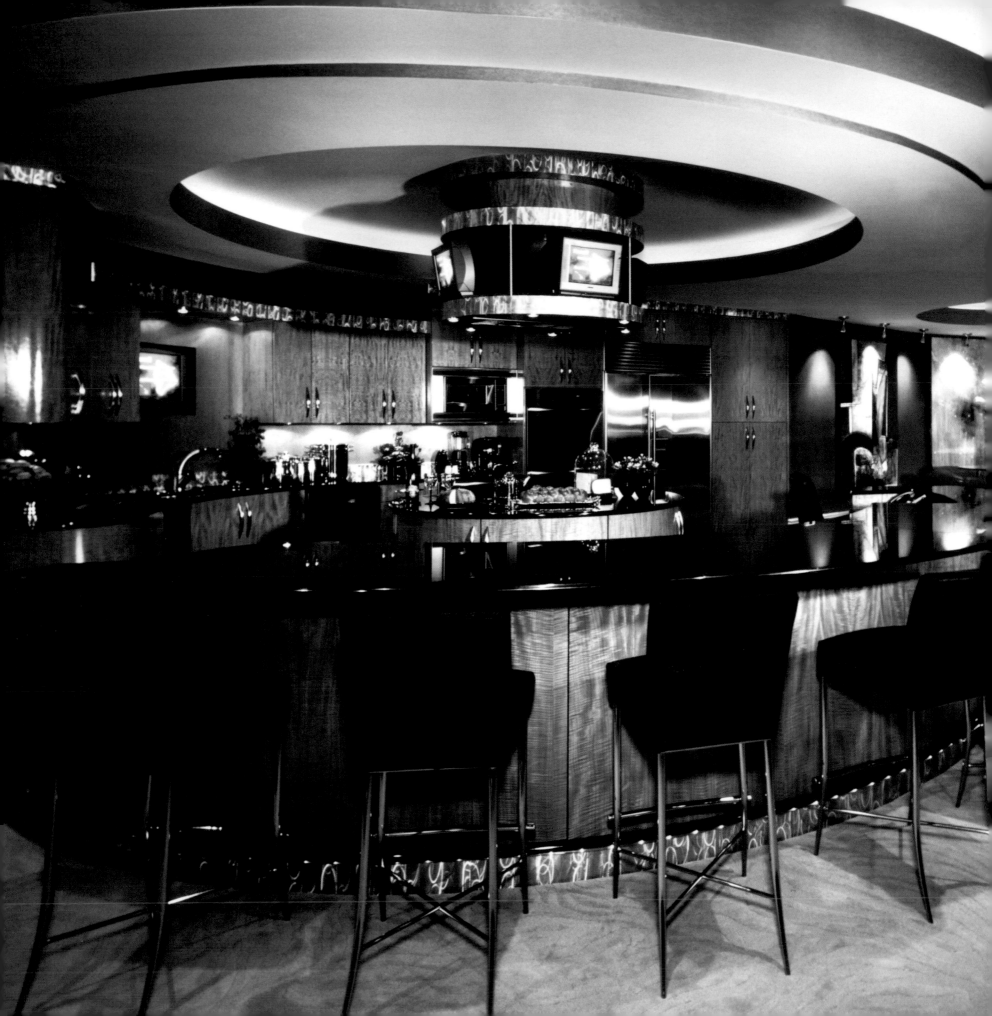

David A. Millett

David A. Millett. Inc.

For 35 years, interior designer David Millett has been a beacon of knowledge for clients across the United States and Europe who are looking to venture beyond the common. David's clients are well traveled and therefore have been exposed to the benefits of fine art and design. They are looking to take their acceptance and understanding of design beyond the process of "furniture shopping," and David interprets their wishes with a straightforward and purposeful hand.

Much like David's approach to the designer/client relationship, his most successful projects reflect an appreciation, almost a reverence for uncompromisingly honest taste—in a word, timelessness.

LEFT
Like the professional athlete for whom he designed this penthouse, David Millett combined grace, style and substance in sleek packaging. Soft, organic shapes create warmth.
Photograph by Miles Wolf

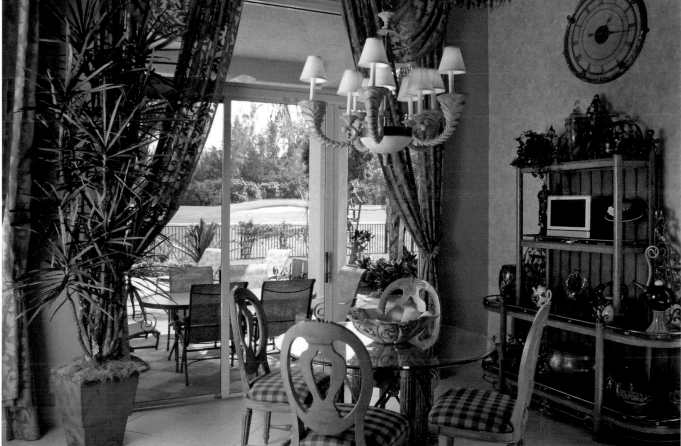

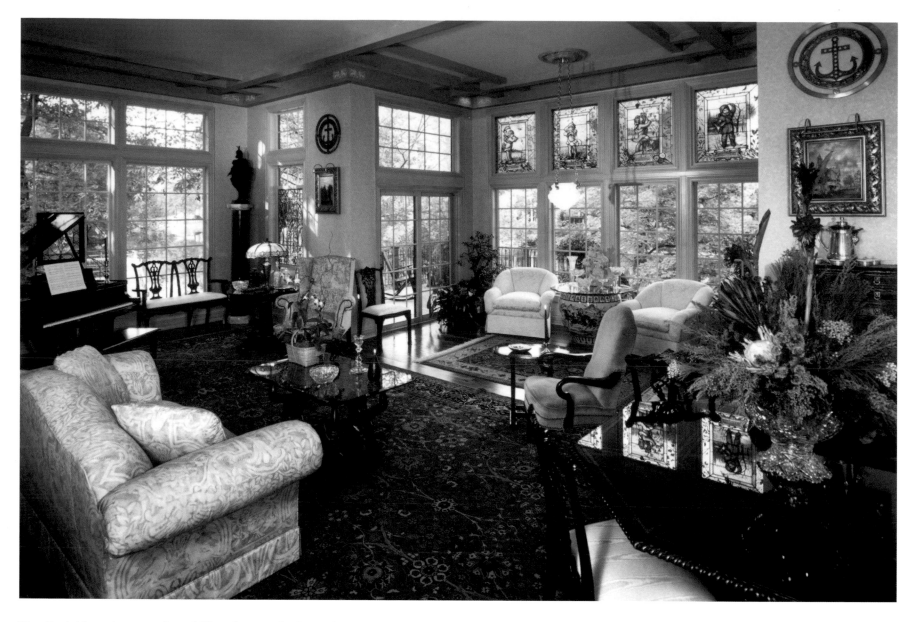

His clients' long-term needs and lifestyles supply the outline for each project. David has a passion for the relationships he forges with people and for translating the client's wish list into a lifestyle which will remain realistically appropriate even after the magic sparkle has settled. When we accept ourselves and how we live our lives, the first honest step in the design process is completed. David and his staff make the rest happen and ask the clients to guide them along the way with their feedback and reactions. The result is not so much a singular look for the designer but rather an uncompromising marriage of fine art and lifestyle for the client. There is no "one size fits all" approach, as no two clients, whether in residential or commercial design have the same needs, taste or dreams. David is versatile in any medium.

The David A. Millett design studio incorporates 13,000 square feet of showroom space which includes lighting, rugs, furniture, accessories and

original art. The benefit of this becomes apparent as client and designer begin to visualize the ideal design solution. The elegant showroom vignettes afford the client the opportunity to realize the possibilities without real life restraints.

ABOVE
Swedish-style architecture and interior by David Millett. Antique stained glass in transom windows sends colorful shafts of light throughout this storybook cottage.
Photograph by Miles Wolf

FACING PAGE LEFT
This romantic interior pays special attention to small details. The designer created a serene spot from which to admire the finer things in life.
Photograph by Miles Wolf

FACING PAGE MIDDLE
Dramatic lighting, comfortable proportions and jewel box surface treatments make this dining room and its guests feel like exceptionally well-kept secrets.
Photograph by Miles Wolf

FACING PAGE RIGHT
Architectural and decorative features in this home's grand entry were designed by David Millett to create an unforgettable first impression.
Photograph by Miles Wolf

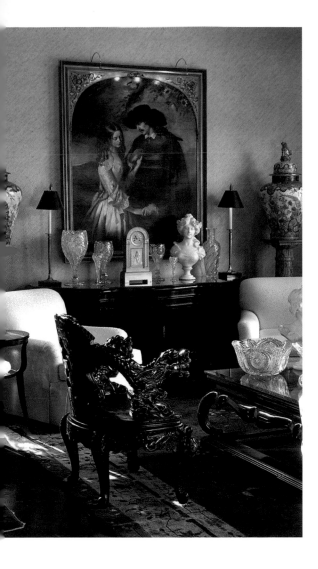

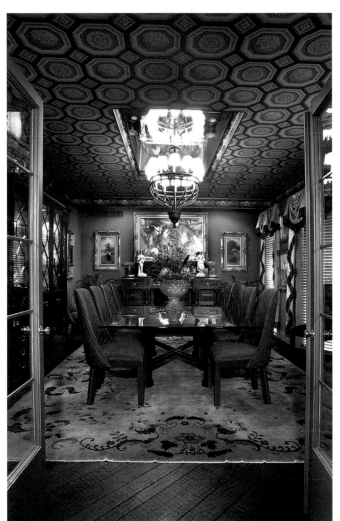

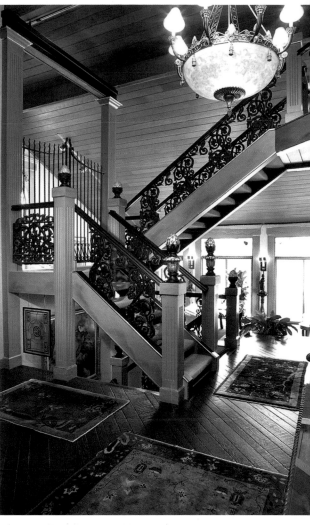

more about David ...

HAVE YOU RECEIVED ANY AWARDS OR OTHER RECOGNITION?

I've been featured many times on HGTV's "Interiors by Design" and have received numerous architectural design awards, some from the National Wood Council. I've won the International Sub-Zero contest for kitchen design. Locally, I've earned approximately 50 home builder awards and twice been the recipient of *Cincinnati* magazine's "Annual Interior Design Competition." Over the years I've participated in and received awards for the AVOC, The Cincinnati Ballet, Opera Guild and four Junior League Showhouses.

WHAT SEPARATES YOU FROM YOUR COMPETITION?

Talent, reputation and relationships within the industry. A fondness for my clients keeps the inspiration alive.

WHO HAS HAD THE BIGGEST INFLUENCE ON YOUR CAREER?

As a young man, I worked with interior designer Edgar Stockwell. Although I was born an artist, it was that experience which changed my life forever.

DAVID A. MILLETT, INC.
David A. Millett
7885 East Kemper Road
Cincinnati, OH 45249
513.489.3887
Fax: 513.489.3972

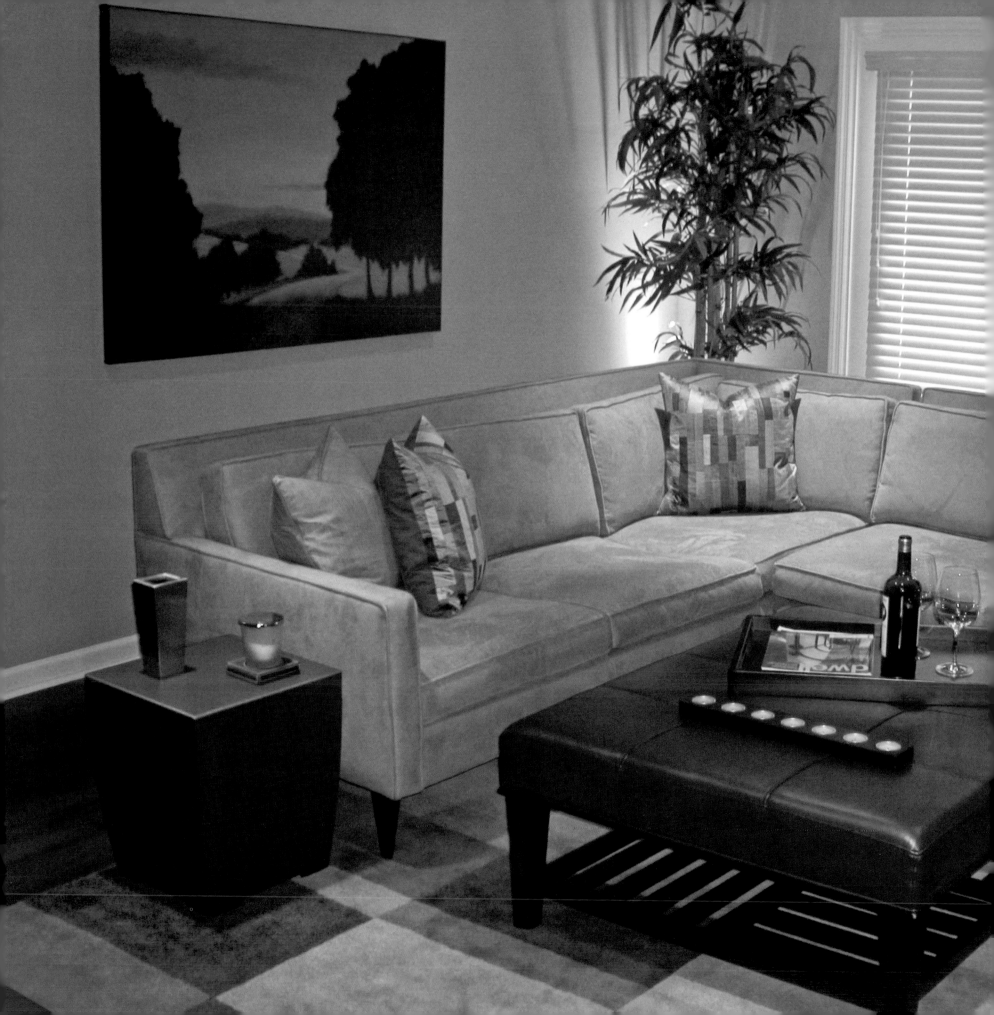

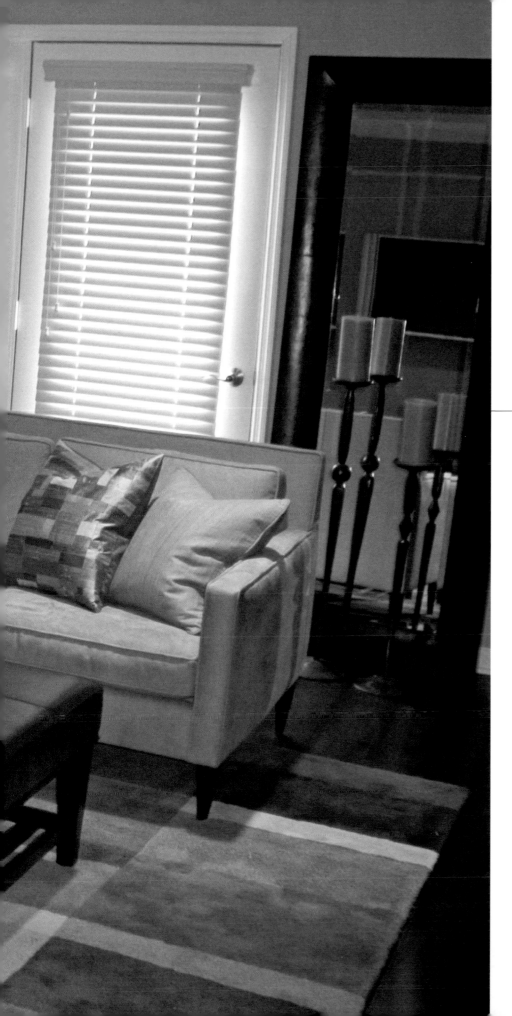

SCOTT A. SAMMONS

SCOTT SAMMONS INTERIOR DESIGN, LLC

Scott Sammons Interior Design provides a broad spectrum of interior design services that range from consultation to space planning to entire interior renovations for clients on any budget.

When working with clients, Scott doesn't rely on the staunch "rules" of interior design to fuel his creativity when planning living spaces. His philosophy: if it looks wonderful and the client is happy, then a design is successful. Guiding them around interior design "mistakes," he designs with the possessions his clients hold dear in mind. Scott's main objective is to incorporate his client's sense of style, while relying on his knowledge of aesthetics to astutely complete each project.

Much of Scott's clientele consists of the more budget conscious. He really enjoys his clientele because while the grandest creations are appreciated, even the smallest of design gestures create a sense of wonderment and

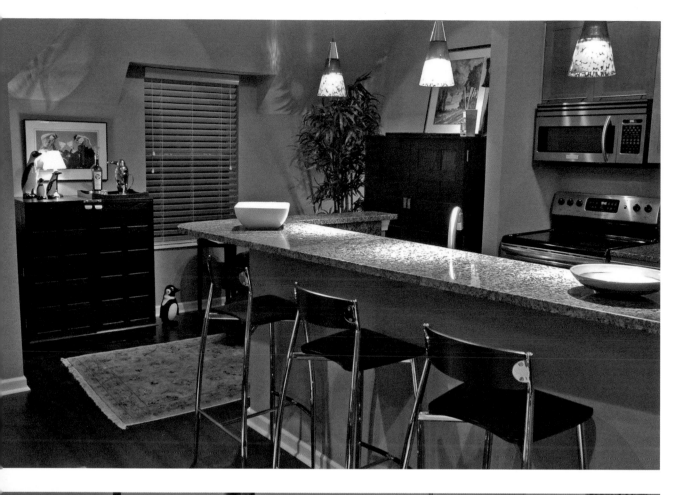

awe. The most surprising element of Scott's firm is its stellar customer service to all projects from the diminutive to the comprehensive. Scott will even consult with clients at their homes for as little as an hour or two discussing such basic design problems as furniture placement or color palettes.

Most of Scott's clients have never consulted with an interior designer before, which thrills the artist within him as he loves the opportunity to introduce the inexperienced to the art of fine living.

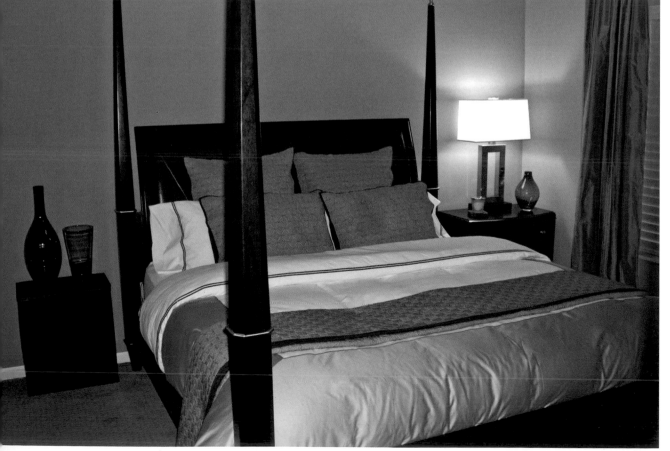

TOP LEFT
Transformed from a dull apartment kitchen, this breathtaking, fully equipped chef's dream now has granite counters, rich wood floors and a sleek cocktail bar rest in the background.
Photograph by Joseph McCarty

BOTTOM LEFT
An inviting master suite boasts rich finishes, luxurious linens and silk draperies.
Photograph by Joseph McCarty

FACING PAGE LEFT
This stylish bench provides a convenient place for workday items and woes to be left at the door.
Photograph by Joseph McCarty

FACING PAGE RIGHT
Once the dining room of a basic apartment, this comfy reading corner, in a completely renovated condo, is replete with a home office armoire.
Photograph by Joseph McCarty

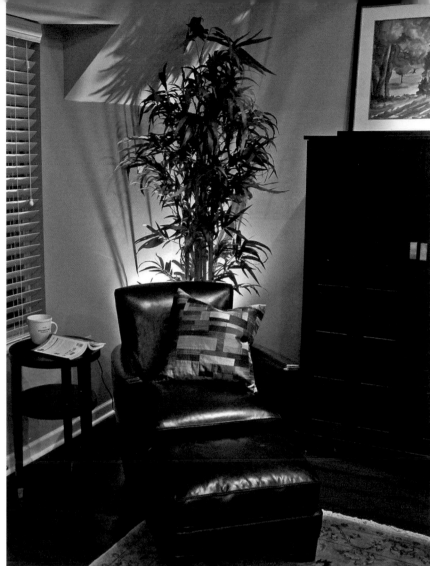

more about Scott ...

WHAT IS THE BEST PART OF BEING AN INTERIOR DESIGNER?

Every client is different and every job is a new challenge.

WHAT DO YOU LIKE MOST ABOUT DOING BUSINESS IN YOUR LOCALE?

Columbus is full of friendly people from all over the country. We get a lot of transplants.

WHO HAS HAD THE BIGGEST INFLUENCE ON YOUR CAREER?

My late grandmother. She was constantly decorating and changing her interior.

WHAT ONE ELEMENT OF STYLE OR PHILOSOPHY HAVE YOU STUCK WITH FOR YEARS THAT STILL WORKS FOR YOU TODAY?

No rules. If you like it and it makes you feel good, then I will figure out how to do it.

SCOTT SAMMONS INTERIOR DESIGN, LLC
Scott A. Sammons
Columbus, OH
614.579.3350
www.scottsammons.com

| 199 |

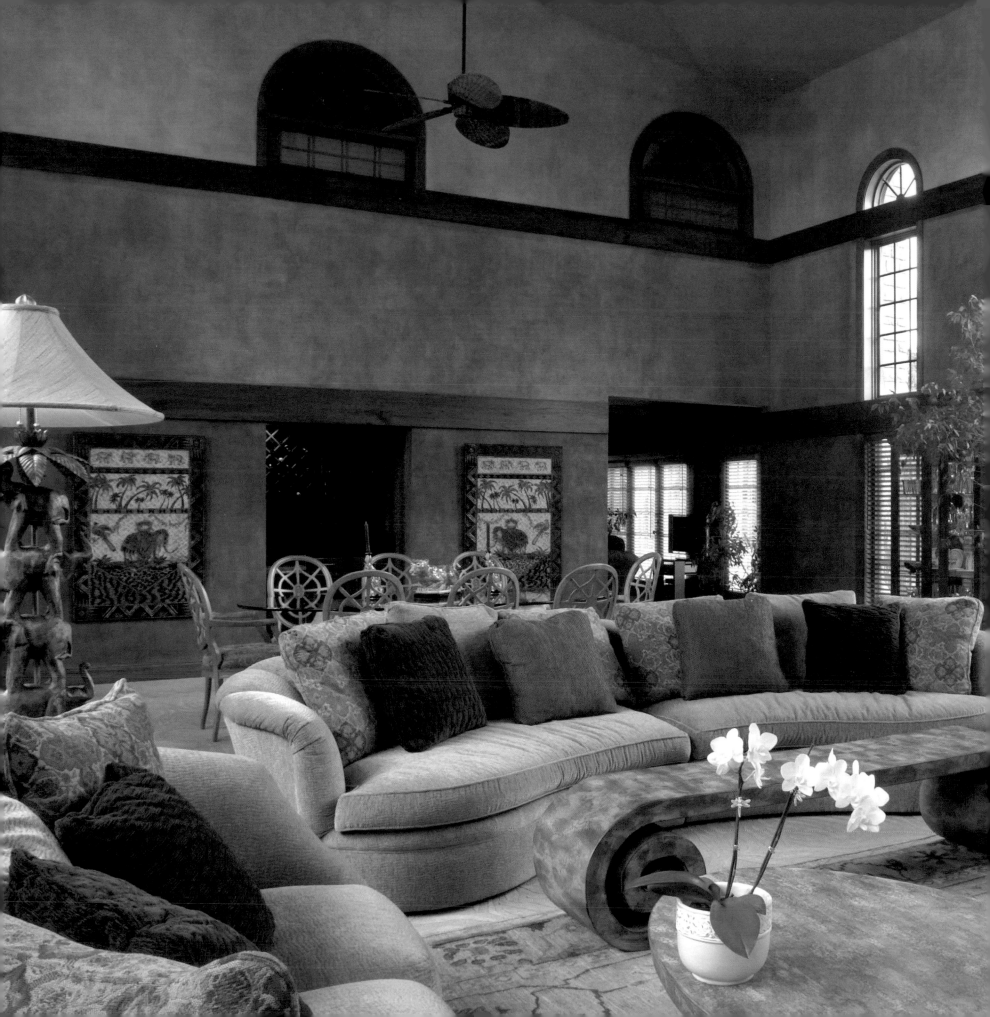

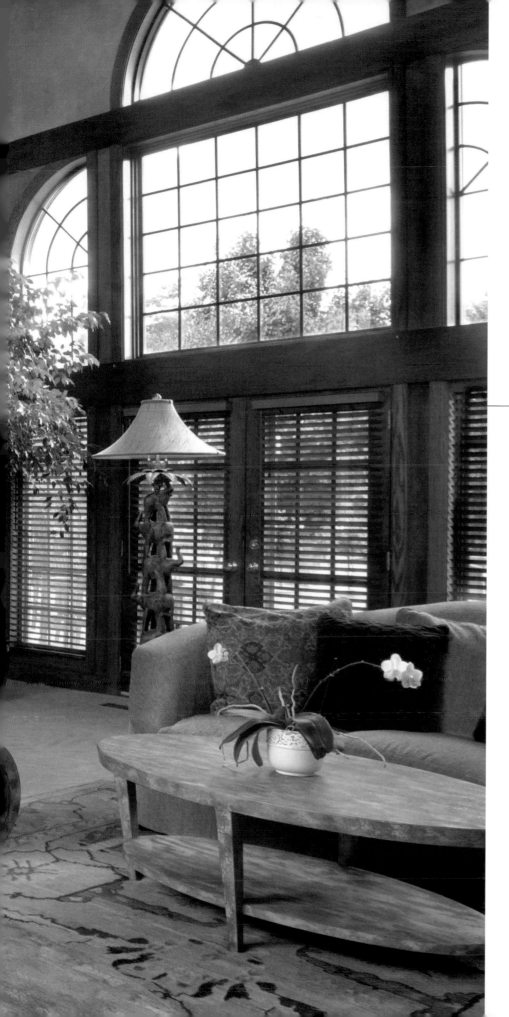

ALAN TREECE
VALERIE MAKSTELL INTERIORS

Alan Treece of Valerie Makstell Interiors is well known in the Cincinnati area for his natural "eye" and his brilliant use of color, making him highly sought after for clients who are looking for exquisite interior designs.

In the late 1960s, Alan joined a major furniture manufacturer in North Carolina. He was assigned to be the assistant of a famous interior designer designing the factory showroom. Because of his natural ability to envision the layout and the flow of an interior he quickly climbed the ladder of success.

He chose to move to Cincinnati in 1974 and joined a local retail store as their principal designer, and eventually, co-owner.

In the late 1980s, wanting more freedom, Alan chose to open his own studio out of his home. Because of industry standard changes, he chose to join Valerie Makstell Interiors. Alan had met Valerie while visiting her showroom, which is geared to both retail and outside designers.

LEFT
At an impressive two and a half stories high, the great room of a 22,000-square-foot house features a subtle Moroccan theme with elephant lamps and a natural palette. The ceiling and walls are warmly faux finished, with the lightest band on top and subsequently darker layers divided by wood beams. All coffee tables are custom.
Photograph by Gary Kessler

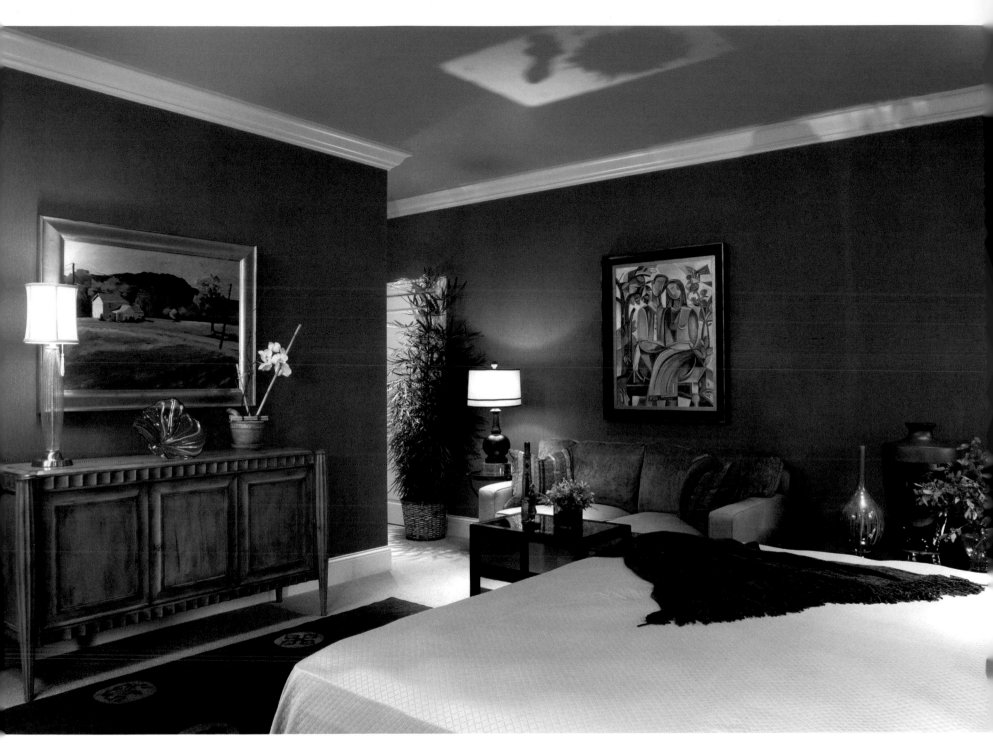

Today, all of Valerie's on-staff designers work independently for their own clients while having the wonderful resources that a "firm" must possess in order to serve its customers to the fullest. The resources at Alan's disposal include a 25,000-square-foot showroom with over 300 different products and two galleries that contain some of the finest accessories and furniture in the country.

A hallmark of Alan's interior design style is his renowned use of color and the clean look that he incorporates into every project. He never over accessorizes

ABOVE
This is the client's 12th home in 30 years, and Alan has designed them all. The condo's master bedroom boasts commercial-grade wallpaper in a warm cinnamon hue that acts as an early detection system in case of a fire. At the base of the bed lies a one-of-a-kind "Good Luck Charm" rug.
Photograph by Gary Kessler

FACING PAGE TOP
In a condo's living room, the creative work of local artists is displayed against the backdrop of silk-looking wallpaper that is actually vinyl. A 60-inch square coffee table boasts a solid bronze base and a carefully chiseled and polished glass top.
Photograph by Gary Kessler

FACING PAGE BOTTOM
From custom art glass to a stunning McGuire dining table with bamboo chairs, this interior exudes quality and warmth.
Photograph by Gary Kessler

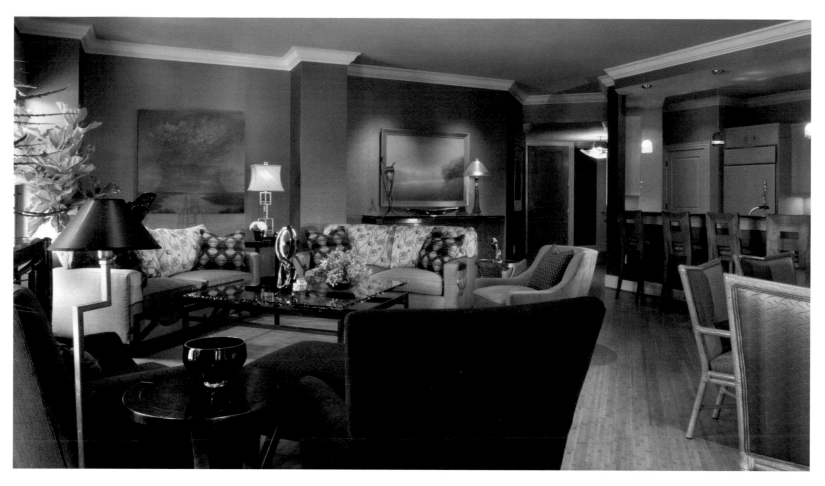

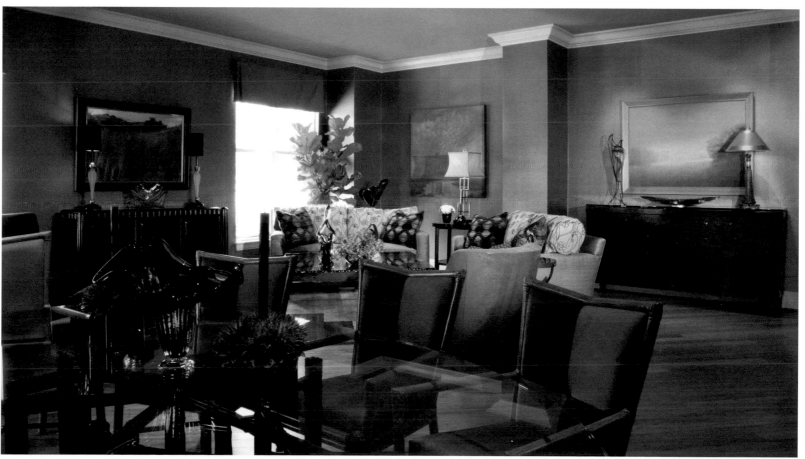

and uses these techniques and styles to design specific interiors for each client. He always gets to know his clients first before deciding what design strategy to implement.

Proud of every project he touches, Alan says that the highest compliment he has received was when a client, upon the revelation of her completed project, started crying with joy because he had met and exceeded all of her expectations.

Finding his honesty refreshing and valuable, all of Alan's clients become good friends because of the relationship that he develops from working so closely and for an extended amount of time on their projects with them. He knows that for a splendid, cohesive and awe-inspiring project, he must find out what is in his clients' hearts and heads. He does this with an extraordinary ease and grace that encourages clients to openly reveal their thoughts and dreams, thus creating a lasting friendship. To Alan, that friendship is priceless.

TOP LEFT
The master bedroom's adjacent sitting area is adorned with a tropical theme. A beach mural graces the ceiling and three walls, while tumbled travertine flooring evokes the warmth of sand. Echoing rolling waves, the Burch wall system carries out the idea of relaxation, as does the sofa made from Thailand water hyacinth.
Photograph by Gary Kessler

BOTTOM LEFT
To match the resident's enthusiasm for cooking, professional-grade appliances were incorporated in her condo's kitchen. Three unique pendant lights accentuate the bar area, while exquisite hardware enhances the custom cabinetry.
Photograph by Gary Kessler

FACING PAGE
All elements—from the jellyfish ceiling fan to custom art glass pieces, shadow boxes and area rugs made in Nepal—lend themselves to capturing the residents' world traveling interests and creative spirit. The chenille sofa and chairs are topped with multicolored pillows, which echo the beautiful kitchen backsplash. Additionally, a programmed lighting system slowly draws the shades for a gradual awakening and adjusts the level of light throughout the day.
Photograph by Gary Kessler

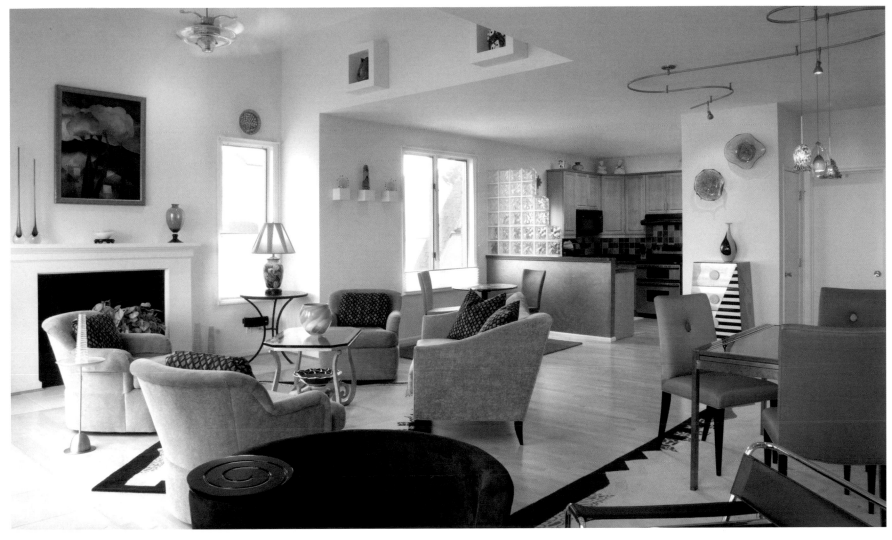

more about Alan ...

NAME ONE THING MOST PEOPLE DON'T KNOW ABOUT YOU.

That I have no secrets.

WHAT ONE PHILOSOPHY HAVE YOU STUCK WITH FOR YEARS THAT STILL WORKS FOR YOU TODAY?

Honesty in my relationships.

WHAT IS A SINGLE THING YOU WOULD ADD TO BRING A DULL HOUSE TO LIFE?

Paint color.

WHAT IS THE BEST PART OF BEING AN INTERIOR DESIGNER?

Getting inside a client's head.

VALERIE MAKSTELL INTERIORS
Alan Treece
1050 Mehring Way
Cincinnati, OH 45203
513.241.1050
Fax: 513.241.9691

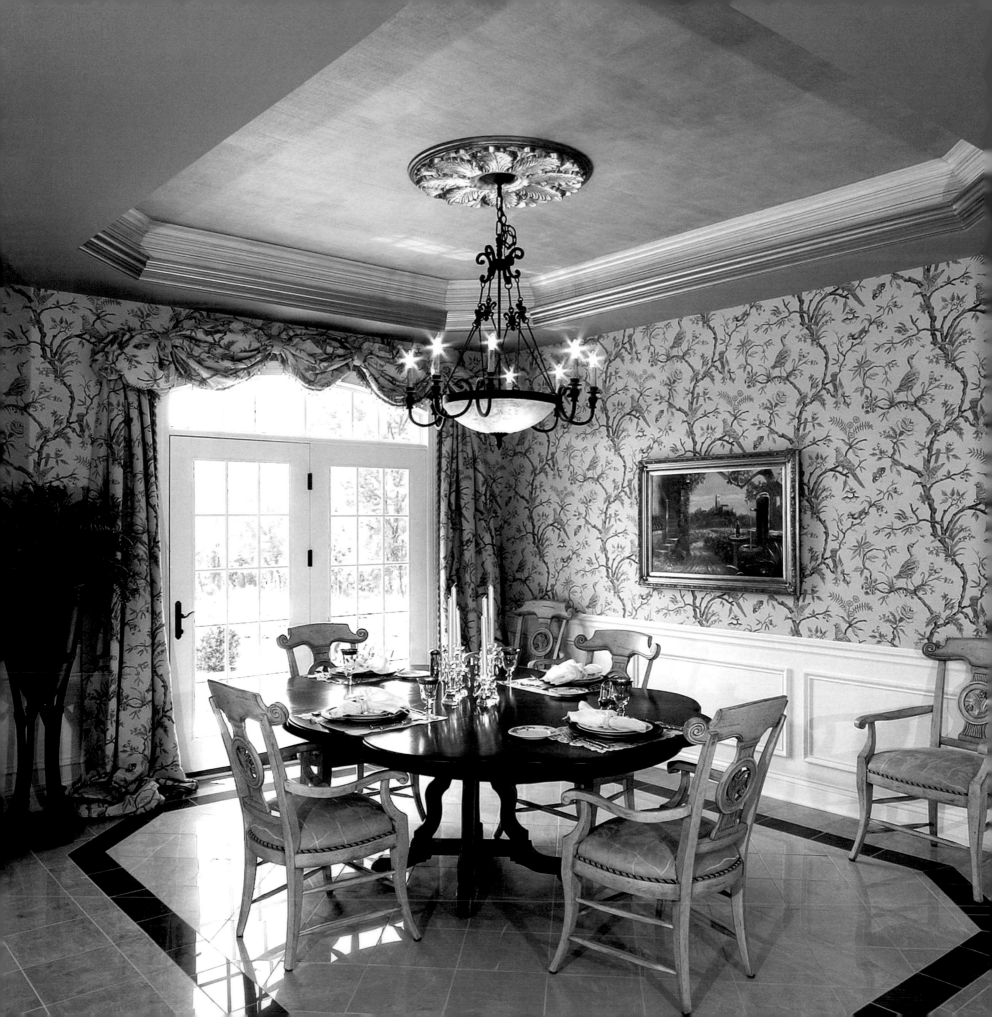

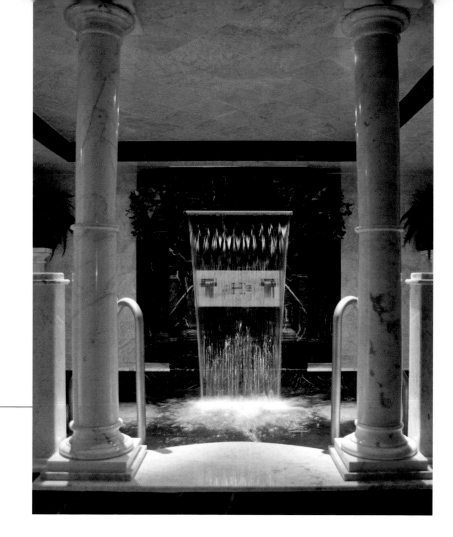

GEORGE E. WERNER, III
GEORGE EDWIN INTERIORS

For George Edwin and his interior design firm of the same name, the beauty is in the details, and whether it's in Ohio, Europe, the Philippines or China, no place is too far or obscure for George to bring his unique and wonderful designs to the people there.

George grew up in a family-owned small town hardware store where the desire to create wonderful homes and living spaces came naturally to him. He attended the University of Louisville, where his professors encouraged him to get into the field of interior design before moving on and graduating from the University of Cincinnati and getting a scholarship to attend Parsons for his master's degree.

Being in the interior design business since 1969 has given George a unique perspective, much knowledge and experiences that rival his competition. He has had the opportunities to design a ranch home in Argentina, homes in Paris, France and Granada, Spain, and furniture in the Philippines, as well as Indonesia, and he has had the distinction of being one of the first designers to ship from China.

"Detail, detail, detail," George says regarding his most notable attribute. His attention to detail extends to such elements as crown mouldings, drapery trims, pillow trims, accessories, artwork, etc. He loves designing for clients, figuring out what they want, what their dreams are, what their goals are and finding the things that they would never have found on their own. His work transcends all styles from Traditional to Contemporary. He tries not to be trendy with his designs. He also likes his rooms to be functional aesthetically, by allowing for quick changes like pillows and accessories.

As a very service-conscious design firm, George not only creates the designs, he does the installations himself, he hangs the art, and he even arranges the bookshelves. He even goes shopping if his clients need help with purchasing

ABOVE
This Grecian spa in a renovated home features a luxurious pool with jets and a dramatic waterfall surrounded by white and black marble.
Photograph by Deogracias Lerma, Deogracias Lerma Photography

FACING PAGE
Like the perfect necklace offsetting a couture gown, the light fixture adds simple class and charm in this elegant French-Italian dining room.
Photograph by Ron Kolb, Exposures Unlimited

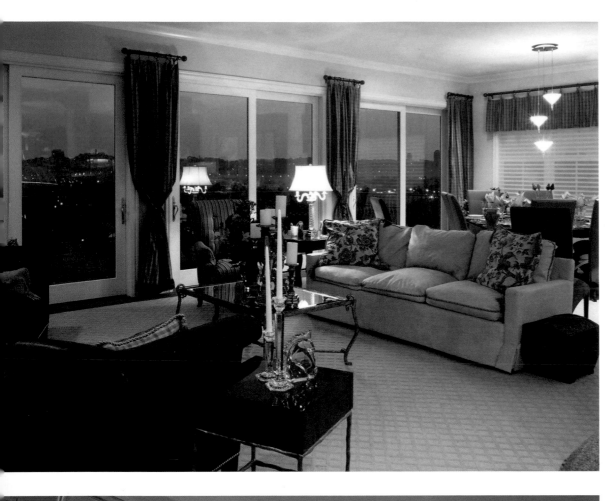

China, crystal, place mats and silverware. If his clients need help hosting parties he will help them with the plans from start to finish. George Edwin Interiors is a full-service design organization and so much so that he tells his staff, "remember the reason that our clients buy from us is … you can go and buy a chair anywhere, but what you can't do is make it look like a piece of art."

George believes that each project is like a painting—the client is the artist, the home is the canvas and George and his staff are the brush. The painting always looks better when painted with a wonderful brush.

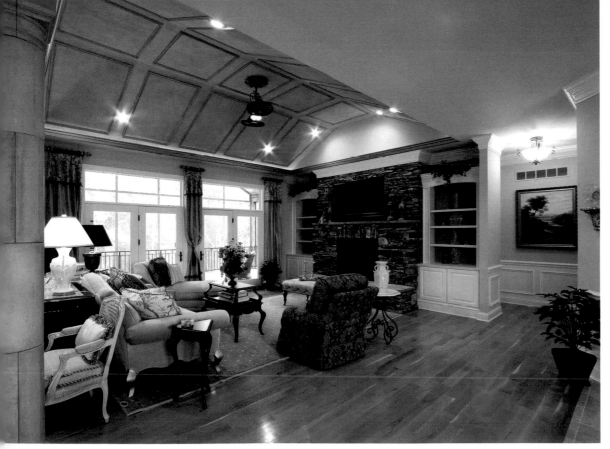

TOP LEFT
Remarkable sunset views only add to the beauty of this exquisite great room and comfortable dining room.
Photograph by Ron Kolb, Exposures Unlimited

BOTTOM LEFT
Stretching out from the foyer, the home's spectacular great room stands as a testament to the elegance that can be achieved when design works in concert with construction.
Photograph by Ron Kolb, Exposures Unlimited

FACING PAGE LEFT
The gallery bridge which connects the upper floor bedrooms also serves as an architectural work of art separating the foyer from the great room.
Photograph by Deogracias Lerma, Deogracias Lerma Photography

FACING PAGE RIGHT
The formal dining room has an Old World charm that makes guests want to linger long past dessert.
Photograph by Deogracias Lerma, Deogracias Lerma Photography

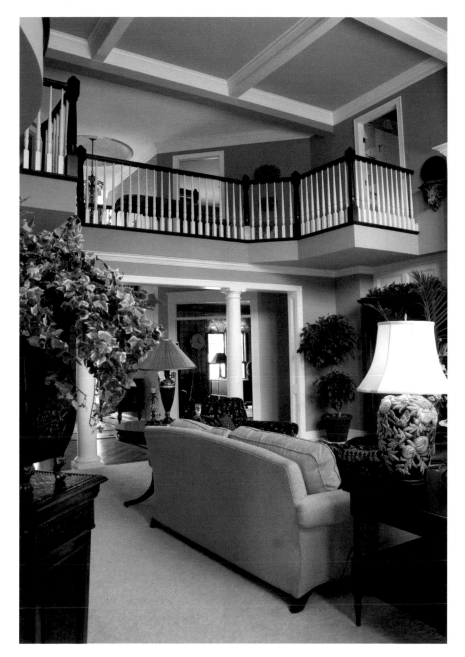

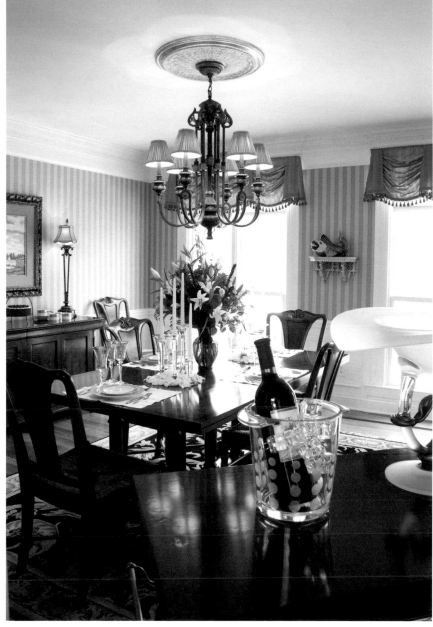

more about George ...

WHAT IS THE HIGHEST COMPLIMENT THAT YOU HAVE
RECEIVED PROFESSIONALLY?

Just seeing our clients' faces when they walk in and see the final product because it is
always far beyond their expectations.

WHAT SINGLE THING WOULD YOU DO TO BRING A DULL HOUSE
TO LIFE?

Add color through accessories.

WHO HAS HAD THE BIGGEST INFLUENCE ON YOUR CAREER?

Adrian Greenburg. He taught me that you can be a good designer, but if you can't sell
the deal, then you haven't accomplished a thing. He taught me how to sell my talent.

GEORGE EDWIN INTERIORS
George E. Werner, III
523 Centre View Boulevard
Crestview Hills, KY 41017
859.341.4409
Fax: 859.341.3634
www.georgeedwininteriors.com

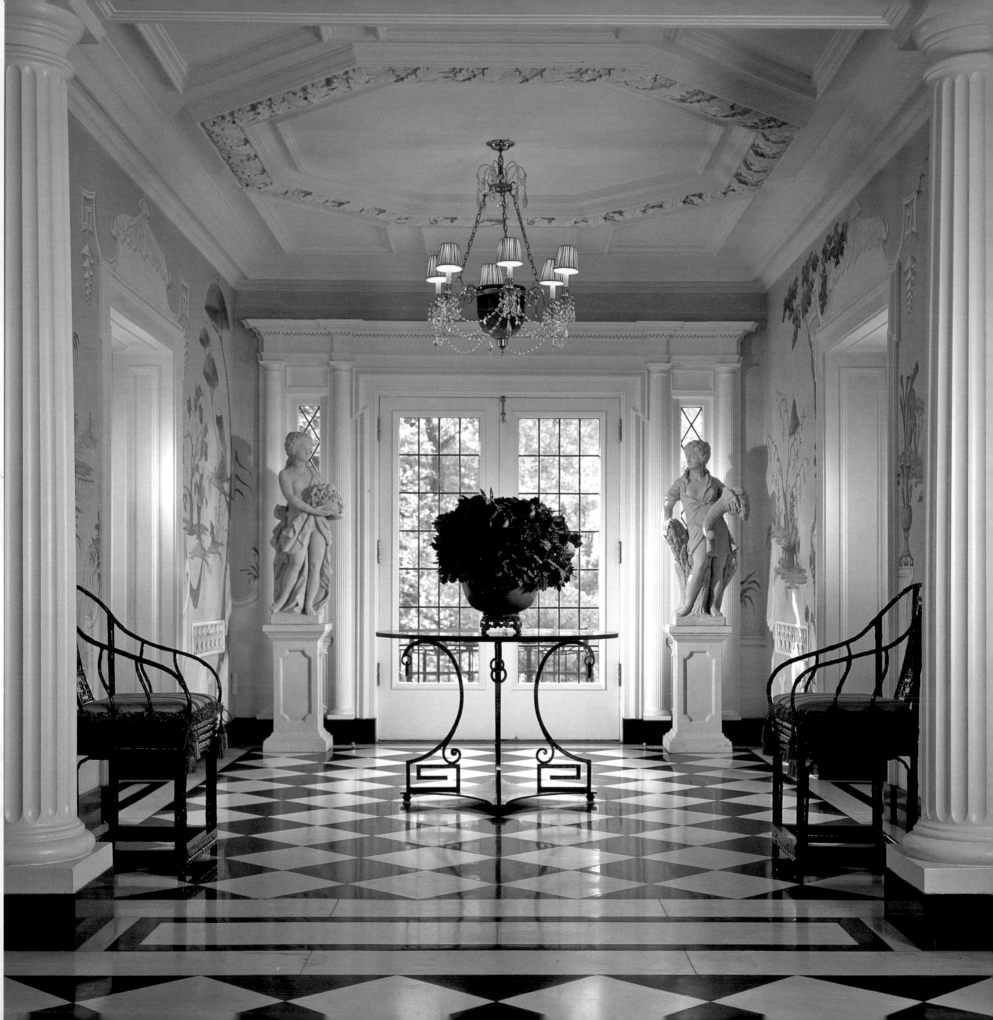

ASTORINO

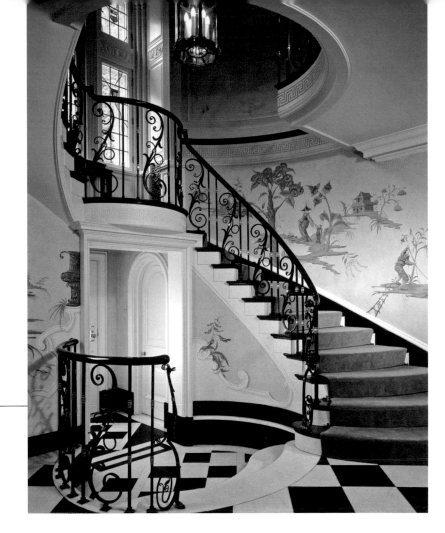

What started as an architect's vision of excellence gained increasing momentum through the 1970s and into the next century as engineers, construction experts and interior designers joined the Astorino team. Whether clients desire one element of this comprehensive service offering or the whole package, they unquestionably benefit from an adept team of creative professionals collaborating on their behalf.

Because the interior designers have the support of architects, engineers and builders, they are able to proffer possibilities that extend far beyond the traditional scope of their profession. From remodeling an area to renovating a whole house or even creating it from the ground up, there is nothing that the Astorino team cannot accomplish. The designers—many of whom are affiliated with the American Society of Interior Designers—wholeheartedly enjoy the opportunity to better their clients' lives through beautiful surroundings.

For their one-of-a-kind creations, the Astorino designers draw on an extensive resource library, and clients appreciate the assurance that if the perfect item cannot be ordered, it will promptly be designed and created to their exacting specifications. A few miles down the road from Astorino's Pittsburgh office is a state-of-the-art millwork shop, where architectural elements and custom cabinetry are fabricated and specialty crafts such as antique restoration, gold leaf application, hand carving and pattern making take place. These artisans work hand in hand with the interior designers of Astorino and are so proficient in their trades that outside architecture and interior design firms utilize their consultation services as well.

Astorino's stylistic capabilities are wide ranging, since each project is guided by the client's unique needs and wishes. Historically, the firm has been drawn to Traditional design, as dictated by regional tastes, yet the design team excels equally in Transitional and Contemporary genres. Whether working in

a specific vernacular—such as British West Indies, French Country, Tuscan or English—or with a more modern aesthetic, a common thread of exceptional quality weaves throughout Astorino's impressive portfolio.

Within Astorino's interior design studio, small teams are assembled for each project, so clients have the distinct advantage of fresh ideas and different points of view contributing to the creation of their residential interior. Clients who choose to work with the internationally celebrated firm expect professional results, but they oftentimes have no idea just how much of a personal and enjoyable experience awaits them.

The designers glean inspiration for high-end residential interiors from their experiences in commercial, educational, athletic, religious, cultural and civic sectors. It may be said that Astorino's specialty is diversity, as the firm's mission statement conveys a collective desire to "enhance the strategic vision of each client and enrich the quality of the human experience by shaping the space in which people live, work and play."

TOP LEFT
A gracious living room with multiple seating vignettes features a series of windows which overlook Pittsburgh's Heinz Field.
Photograph by Ed Massery

BOTTOM LEFT
Ideal for entertaining, the avant-garde dining area adjoins a rounded bar.
Photograph by Ed Massery

FACING PAGE TOP
Replete with elegant sofas, chairs and end tables, the formal living room is saturated with natural light. Custom window treatments frame garden views and draw attention to the exquisite ceiling detail.
Photograph by Kim Sargent, Sargent Architectural Photography

FACING PAGE BOTTOM
Crystal stemware and lighting elements sparkle against the stately dining room's deep wood paneling and furnishings.
Photograph by Kim Sargent, Sargent Architectural Photography

more about
Astorino ...

WHAT DO CLIENTS COMMONLY SAY ABOUT THEIR ASTORINO EXPERIENCE?

Frequently, clients express their gratitude for our ability to understand their wishes and beautifully translate their preferences into a physical space that they are proud to call home.

WHY IS COLLABORATION SO CRUCIAL?

Each designer brings unique strengths to the Astorino team, and working closely with a variety of professionals ensures that our creativity grows at a healthy pace.

DOES ASTORINO HAVE ANY ADAGES?

Yes—the best way to get one good idea is to come up with many.

WHAT IS UNIQUE ABOUT ASTORINO'S DESIGNS?

Everything! We strive for innovative solutions and never repeat a design.

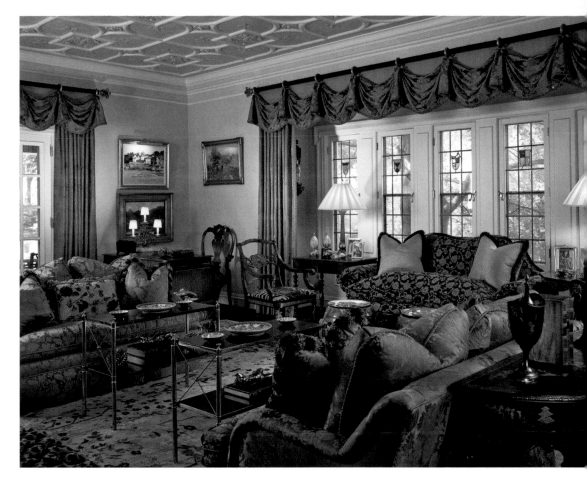

ASTORINO
Pittsburgh
227 Fort Pitt Boulevard
Pittsburgh, PA 15222
412.765.1700
Fax: 412.765.1711
www.astorino.com

Palm Beach Gardens
Golden Bear Plaza 11770 U.S. Highway One
Suite 205
Palm Beach Gardens, FL 33408
561.626.0101
Fax: 561.626.0505

Naples
1300 3rd Street South #302
Naples, FL 34102
239.261.8057
Fax: 239.261.8857

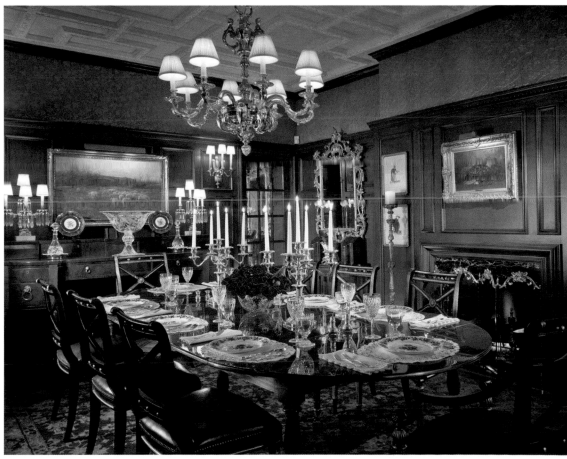

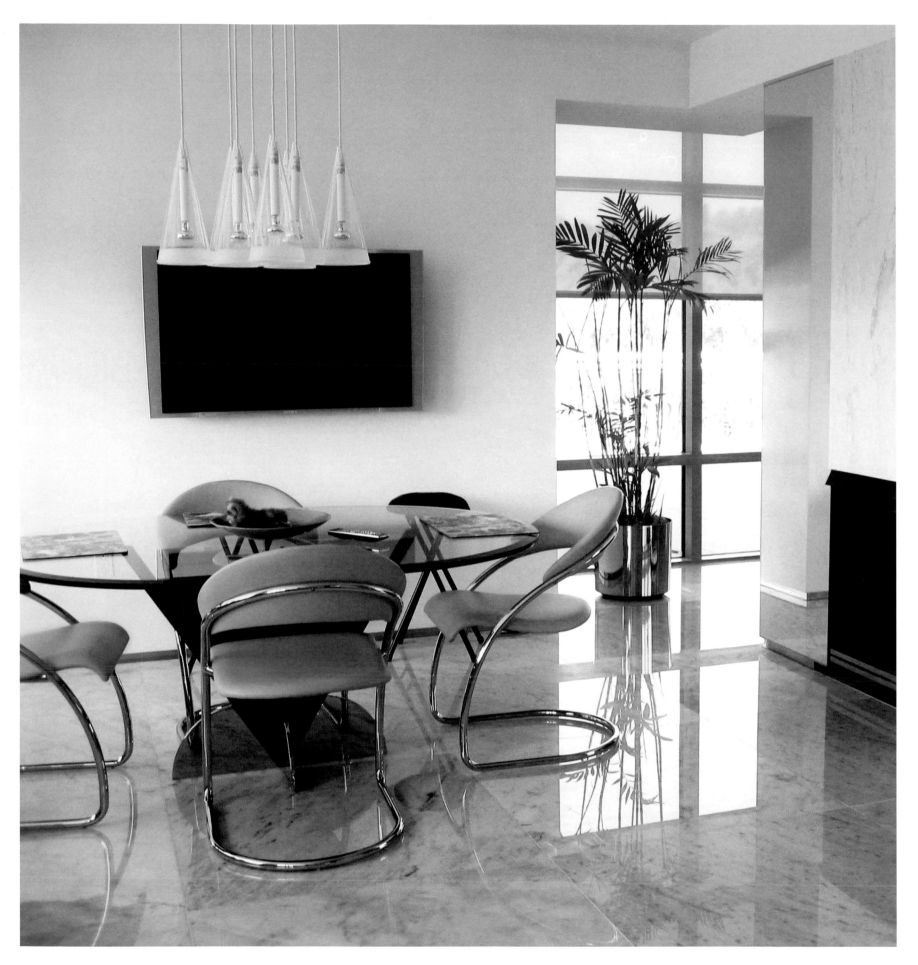

Jean frees herself from the technical side of architecture by collaborating with engineers, who are all too thrilled to give her free rein on the design. A Palm Beach residence with a 10-foot-square onyx spa tub required a complicated electrical system, and rather than downsizing the design—and her clients' wishes—she researched the perfect solution, which led to applying for a government patent. With limitless creative ingenuity, Jean has given these specialists some quite challenging parameters but with their combined zest for innovative solutions, dreams always come to fruition.

The vast majority of her projects are of a remodel, renovation or addition nature, yet she has also been involved with ground up design and equally enjoys such opportunities. In line with her enterprising spirit, she appreciates the challenges which renovation projects present: "No matter how well I plan, there are always secrets hidden beneath walls, and in the midst of the construction phase, I love coming up with clever plans in response to the existing architecture."

Without a moment's hesitation, she accepts projects that would send most design professionals running in the opposite direction. One such undertaking began as a concept in her college days and ended up in built form just a few years later. The cantilevered house, situated on a hillside, was no easy task, as

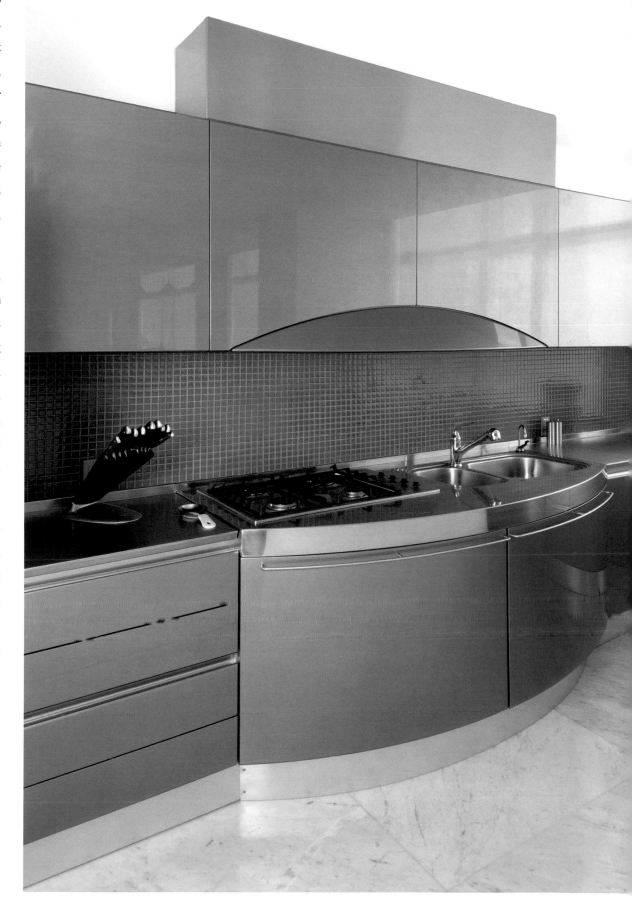

RIGHT
A mosaic backsplash blends with the cabinetry to frame the crisp work surface.
Photograph by Craig Thompson

FACING PAGE
The penthouse's breakfast area is complete with a plasma television and two-way fireplace.
Photograph by Craig Thompson

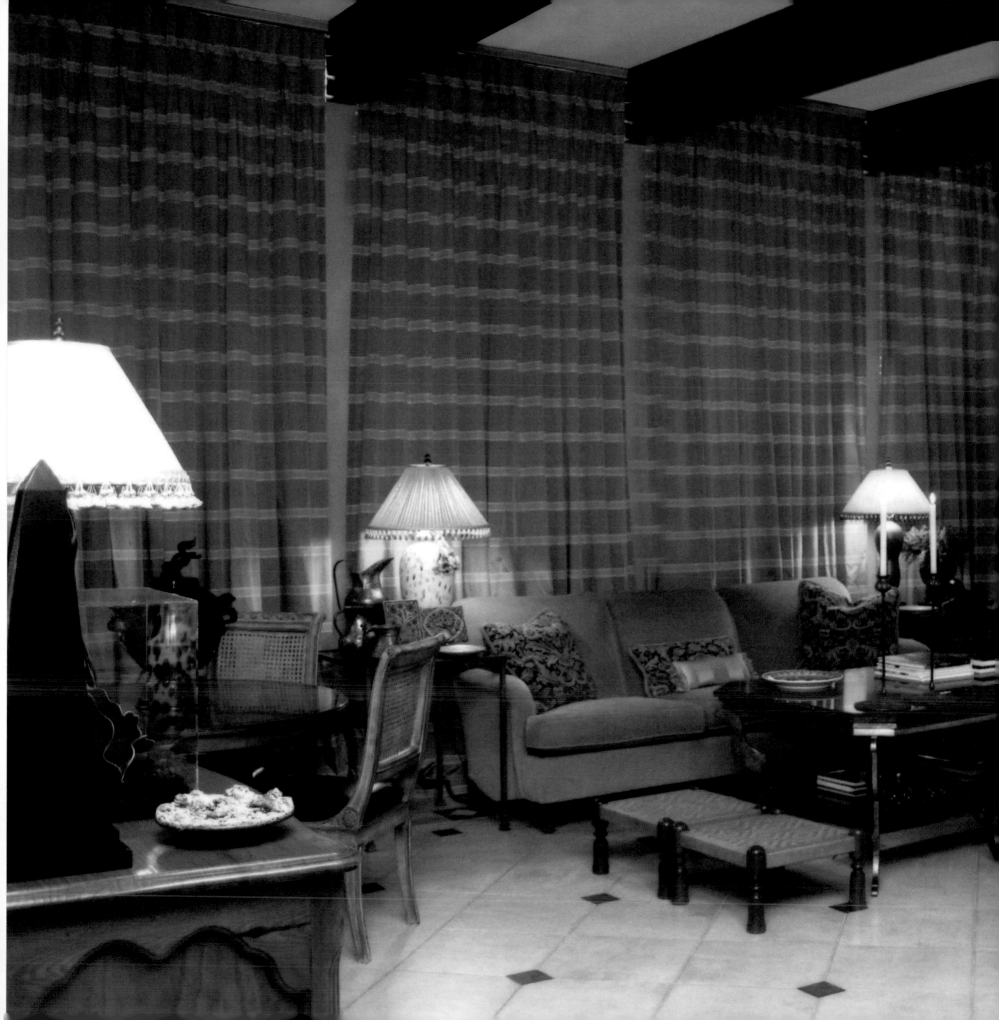

NACHUM GOLAN
STEVE HOUGH

NACHUM GOLAN INTERIORS, INC.

Nachum Golan is much more than a shaper of space, as his loyal clients will agree. Indeed, Nachum maintains that his work is uniquely personal—and his firm reflects it. In order to pursue design sources, Nachum travels with his clients, many of whom have been with him since the inception of Nachum Golan Interiors, Inc. in 1973.

Nachum's desire to pursue a design career led him to leave Israel, his country of birth, where at the time the need for such services was limited. Settling in Pittsburgh, he earned his interior design degree from the Art Institute and worked as a designer in a high-end department store before opening his own company. When Steve joined him as his business partner in the mid-1970s, the firm rose to a new level. The two designed homes across the country and because of project demands maintained a second office in Southern California for several years. Their work has earned the firm ample exposure in many regional publications, and the two have further established themselves in the arts, cultural, gay and Jewish

LEFT
The designers' living room, a high-ceilinged and spacious room with multiple seating areas, is great room for entertaining. The large trestle table provides ample surface for photos of family and friends.
Photograph by Nichole C. Merritt

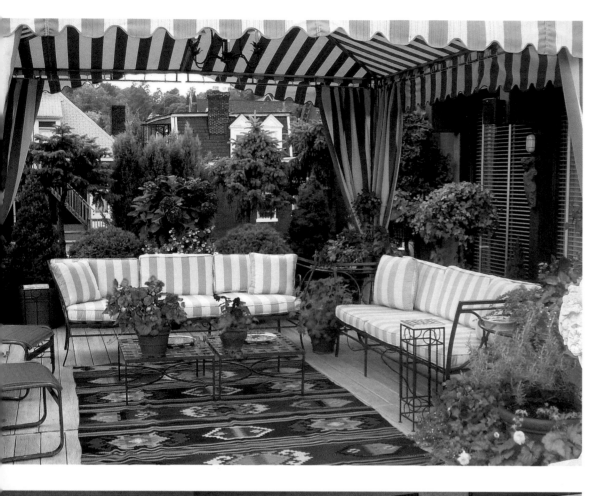

communities in Pittsburgh, working with such groups as the Pittsburgh Opera, PERSAD, the Pittsburgh AIDS Task Force, and their spiritual homes, Bet Tikvah and Rodef Shalom, among other charitable organizations.

While their designs range from Classic Contemporary to period work, Nachum and Steve emphasize the importance of scale in each design. Their projects always start with floor plans, even before color or texture. They cater to the wishes of clients, who often vacation in the grand hotels that pepper exotic locales. The two strive to capture this luxury in each home and particularly in the master bedroom and bath. While they have designed professional offices, women's clothing shops, salons and even a car dealership and a grocery store, their primary focus remains residential interiors, and they limit commercial work to existing clients' businesses.

Nachum credits the intimate nature of his company for the success he has experienced therewith. While at one time they employed a staff of designers, Nachum and Steve quickly recognized that they work best as a pair. Working together allows interior design to permeate all aspects of their lives, a condition necessary to their creative profession. They completely immerse themselves in each project, expanding their business network and feeding their cultural knowledge with their global expeditions. Their work thus becomes boundless, allowing them the freedom to fully explore their clients' personalities and desires and develop long-lasting, trusting friendships with each.

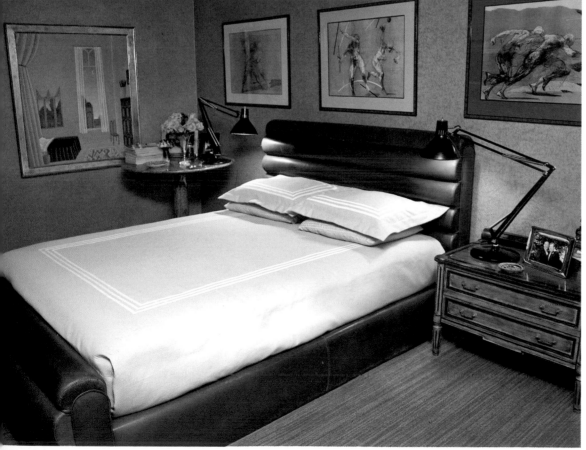

TOP LEFT
Roof garden, which is partially shaded by a canopy, provides outdoor space for relaxing and entertaining.
Photograph by Nachum Golan

BOTTOM LEFT
Master bedroom in soft neutral tones with upholstered leather bed.
Photograph by Nichole C. Merritt

FACING PAGE LEFT
Country French chest in living room with glass sculpture by Dale Chihuly, Pallssy plate and tortoise shell boxes.
Photograph by Nichole C. Merritt

FACING PAGE RIGHT
Powder room with pedestal sink, antique Venetian mirror and tea paper wall covering.
Photograph by Nichole C. Merritt

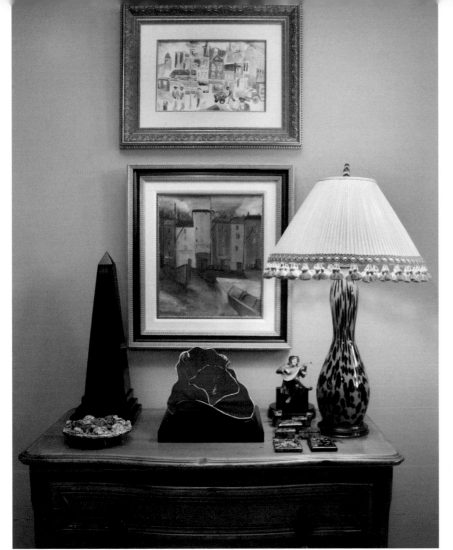

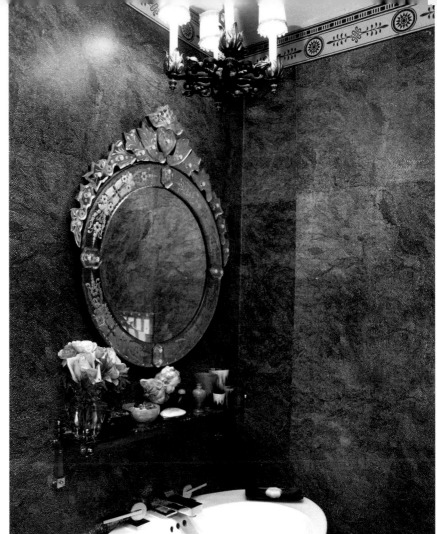

more about Nachum ...

WHAT PERSONAL INDULGENCE DO YOU SPEND THE MOST MONEY ON?

My passion—opera! Steve and I are very involved with the Pittsburgh Opera. We're fortunate to have such an excellent opera company here. We also travel extensively to enjoy performances in other locales.

WHAT COLORS BEST DESCRIBES YOU AND WHY?

Neutral colors such as sand, camel and beige, which are evocative of Jerusalem, my city of birth, where the sun reflecting off the limestone building facades gives the city its reputation as the "City of Gold." These same colors also appear in the soft sands along Israel's Mediterranean coastline and in the deserts of Israel's interior. So neutral colors are very much a part of me, and I feel that they provide a perfect background for art.

WHAT IS THE BEST PART OF BEING AN INTERIOR DESIGNER?

Certainly, it is the personal relationships I build with people who have achieved greatness in their respective fields or in their communities. I am incredibly stimulated by successful people.

NACHUM GOLAN INTERIORS, INC.
Nachum Golan
Steve Hough
5001 Baum Boulevard, #505
Pittsburgh, PA 15213
412.687.8464
Fax: 412.687.6057

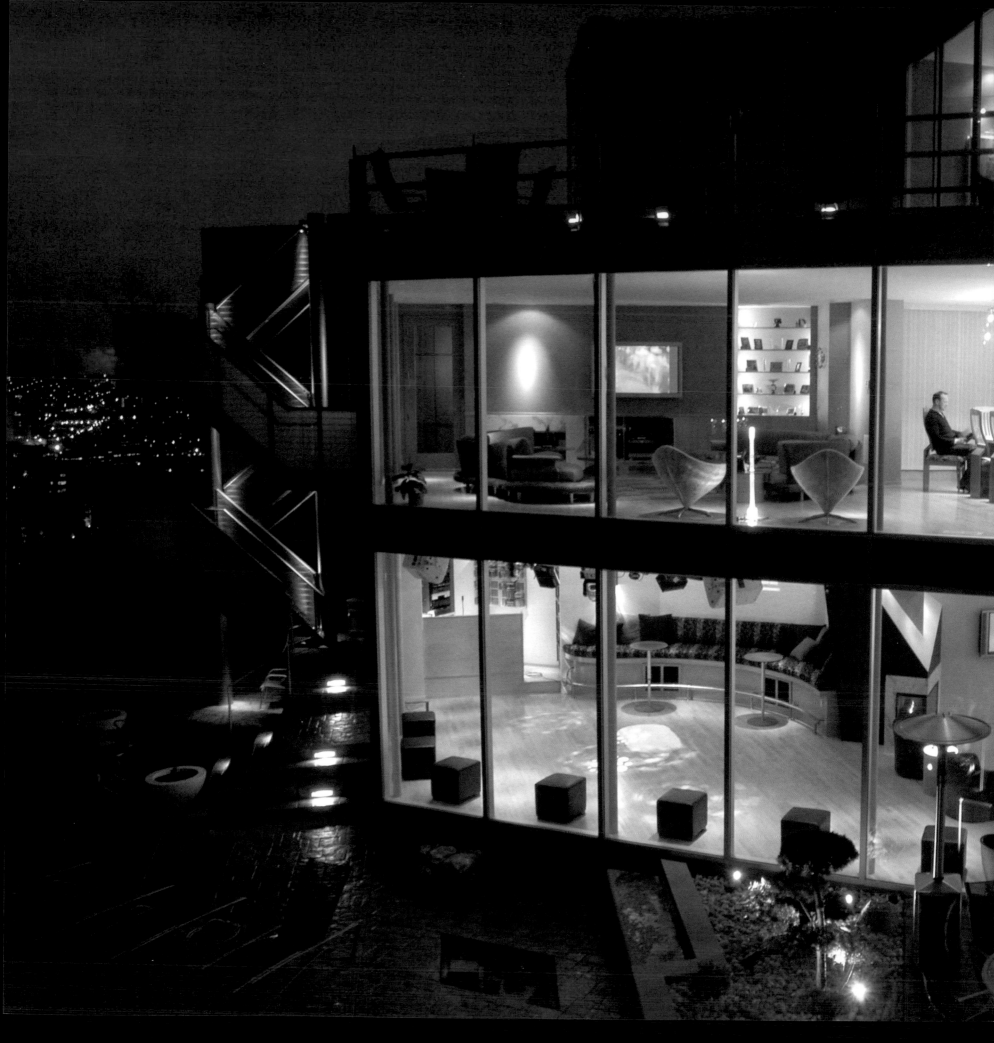

BILL KOLANO

KOLANO DESIGN, INC.

A man with a passion for living in great houses, Bill Kolano's architectural and interior design expertise —along with a love for cooking, entertaining and being surrounded by beautiful objects—ensures that clients receive uniquely expressive results.

Bill's multidisciplinary company, Kolano Design, is comprised of over a dozen creative professionals who research lifestyle trends and translate them into Traditional and Contemporary interiors. Clients benefit from the firm's diversity and unique approach: first, reference materials are assembled, then Bill and his clients discuss the images until preference commonalities begin to emerge; the designer may notice a subtle feeling to which someone is drawn or perhaps more tangible elements such as color or stylistic theme. An interesting perspective for an interior designer, Bill believes that his profession is not about inventing a unique thought, but rather pulling together metaphoric materials in a fresh, exciting way.

LEFT
The home, with spectacular views, is lifestyle-indulgent, cleanly colorful, and technologically alive. Like a curving hillside, the house wraps around, allowing people to see and be seen from a variety of different levels.
Photograph by Scott Goldsmith

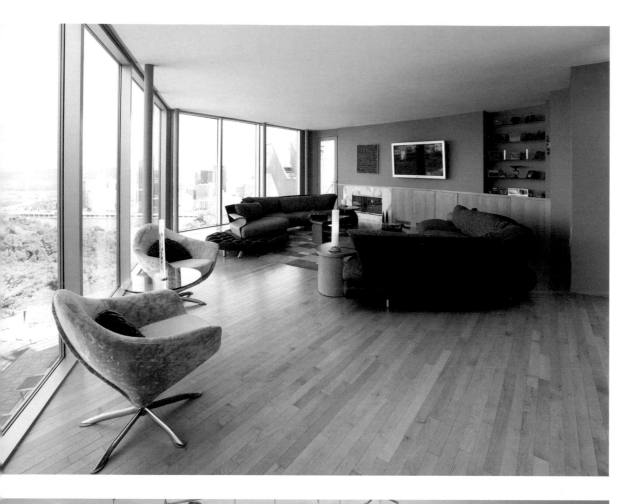

Although Bill works in many styles and vernaculars, the design of each interior starts with a strong floor plan and is bound by his attention to detail, classic proportions, exquisite lighting and selection of natural materials such as wood with hand-rubbed finishes and stones of varying textures.

One of the most unique and challenging projects to Bill's credit is situated on Mount Washington and overlooks downtown Pittsburgh. The U-shaped architecture inspired Bill to blur the indoor/outdoor distinction and capitalize on the tremendous vistas. The home is intimate enough for two, yet contains ample space for hundreds of guests to mingle comfortably.

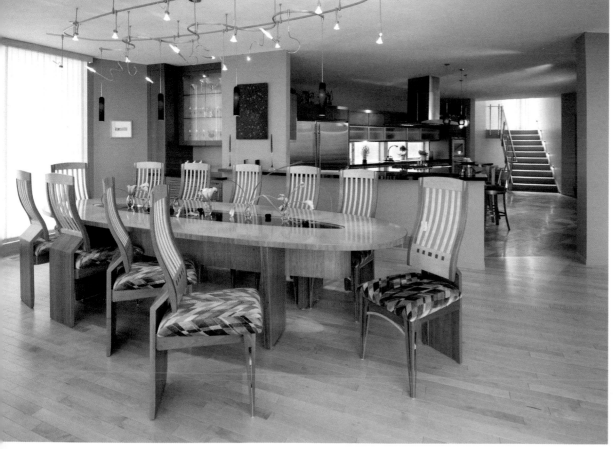

TOP LEFT
The living room is for everyday life and overlooks the downtown.
It includes soft curved seating, upholstered in luxurious textures.
Photograph by Maria Bevilacqua

BOTTOM LEFT
The dining room includes custom handmade furniture sitting on
light wood floors, with sculptural lighting.
Photograph by Maria Bevilacqua

FACING PAGE TOP
The kitchen includes an island with seating, curved fireplace and
breakfast area. Natural limestone floor and rustic glazed wall tile
complement the contemporary natural cherry cabinetry.
Photograph by Maria Bevilacqua

FACING PAGE BOTTOM
The ground floor is a stimulating amusement complex including a
dance floor with lighting and DJ booth, bamboo garden, bar,
lounge, steam sauna, gym and wine room.
Photograph by Maria Bevilacqua

Q & A

more about Bill ...

HOW DOES A HOME'S GEOGRAPHIC LOCATION AFFECT YOUR DESIGNS?

Although ultimately interior design is centered on the residents, it is important to be mindful of the locale. For example, in Florida, we use bright, vibrant colors that are comfortable in brilliant sun. In New England, the same hues would look completely out of place next to their grayed-down neighbors.

WHAT IS YOUR THEORY ON MAKING PEOPLE FEEL COMFORTABLE IN THEIR SPACE?

For an interior to be comfortable, people must be surrounded with a certain degree of familiarity and structure. You can push the limits only so far. Very few clients are comfortable in rooms proportioned like a railroad car or in environments with tilted walls.

IN WHAT STYLE DO YOU PREFER TO SURROUND YOURSELF?

I have a wide appreciation of stylistic genres: My office is extremely Contemporary while my private residence is quite Traditional.

KOLANO DESIGN, INC.
Bill Kolano, ASID
6026 Penn Circle South
Pittsburgh, PA 15206
412.661.9000
www.kolano.com

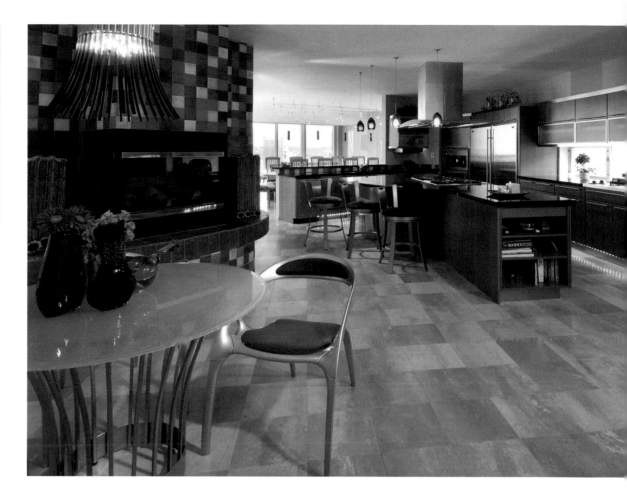

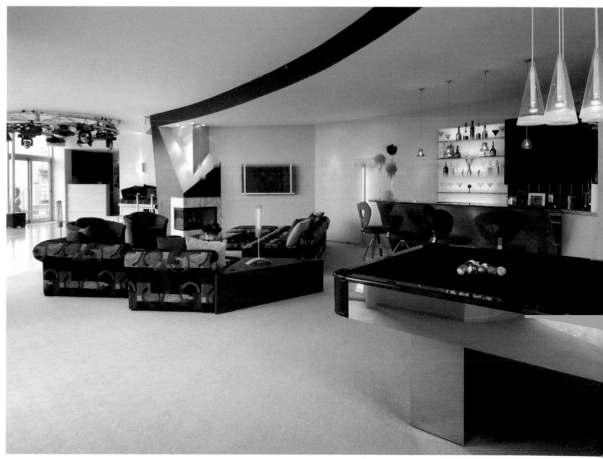

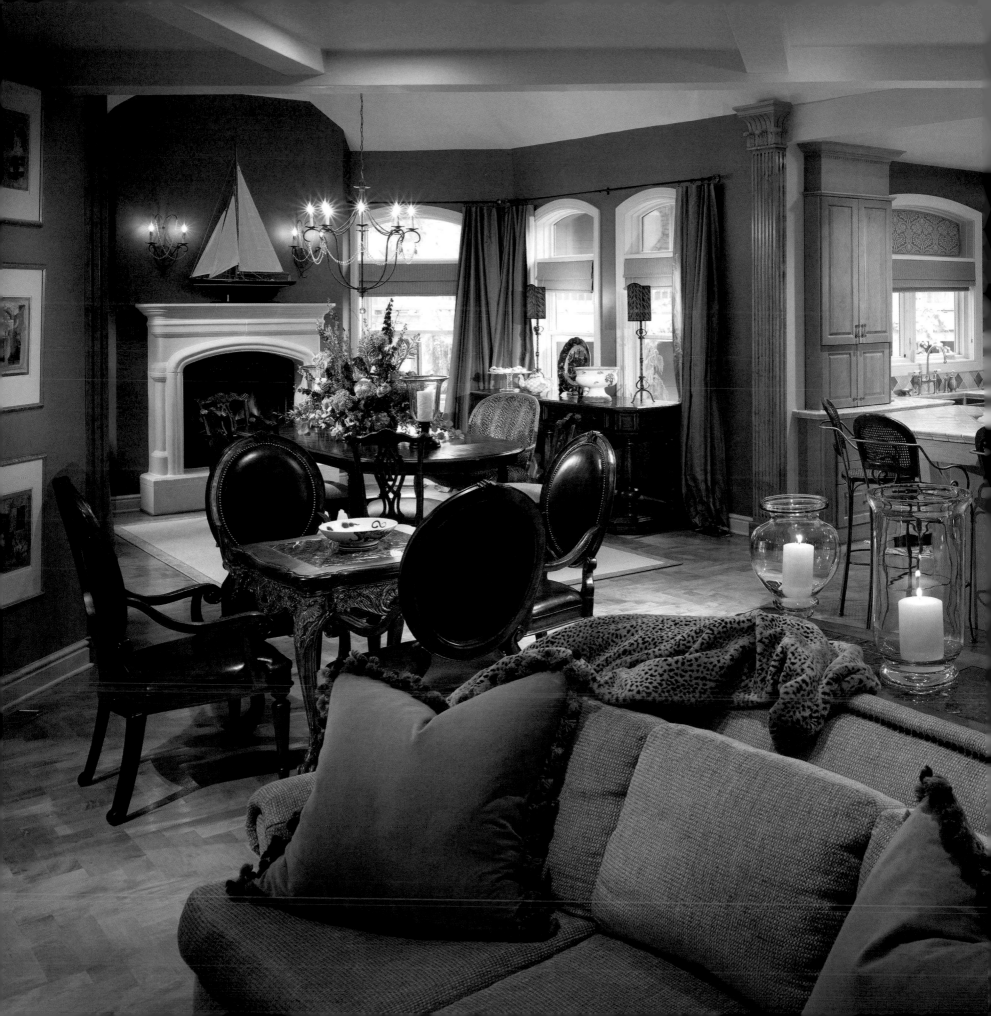

ANGELA LOWDEN

ANGELA LOWDEN DESIGNS, INC.

As much as Angela Lowden's clients enjoy her work, the designer admits that she quite possibly enjoys it even more. Each project begins with casual conversation as the designer familiarizes herself with the personalities and needs of her clients. Rather than simply designing a beautiful space, she chooses to take the process to a more meaningful level by considering what kind of atmosphere will make residents feel at ease, how to take advantage of the views, the most effective way to maximize square footage and of course what styles they find appealing.

Before Angela delved into the vocation of interior design, she had a very fulfilling career as a high school social studies teacher. While the two professions may seem unrelated, Angela applies her outstanding people skills to her design work; she excels at helping her clients define

LEFT
A view of a lake home's open plan encompassing the dining, kitchen and living areas.
Photograph by Edward Massery, Massery Photography, Inc.

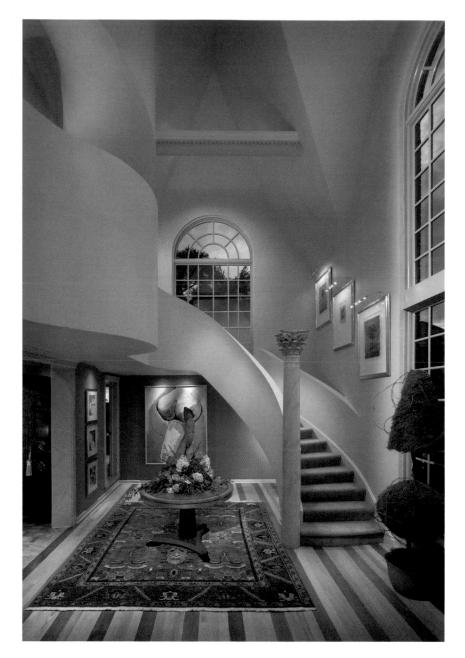

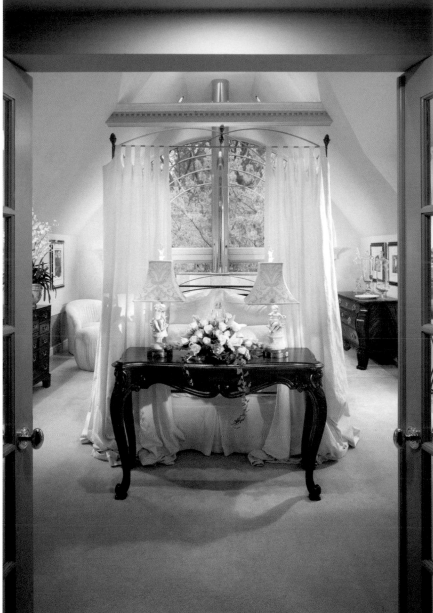

their sense of style. Once Angela had completed her interior design degree from The Art Institute of Pittsburgh, she established Angela Lowden Designs, Inc.—a one-woman practice that emphasizes personalized service and creativity.

Nearly two decades later, in 2000, Angela founded Art Expression, a charity program designed to nurture school children's creativity. She believes the creative process to be therapeutic, and by encouraging a love of art while building children's social skills and self esteem, the benefits are manifold.

She nurtures her clients in much the same way, because whether they need complete interior architecture design, a remodel plan or just a one-room redesign, each space is tailored to its residents. Through color, architectural

elements, space planning, furniture selection and other tools of the trade, she is able to set the stage for families to make memories.

ABOVE LEFT
A view of a majestic entry hall which utilizes undulating curves and ambient light complemented by the client's contemporary art collection.
Photograph by Edward Massery, Massery Photography, Inc.

ABOVE RIGHT
A romantic bedroom with sweeping architectural features and illuminated with abundant natural light.
Photograph by Edward Massery, Massery Photography, Inc.

FACING PAGE
A symmetrical dining room complemented by a cove ceiling, an arcaded panel, trompe l'oeil wallpaper, antique chandelier and a handmade Turkish carpet.
Photograph by Edward Massery, Massery Photography, Inc.

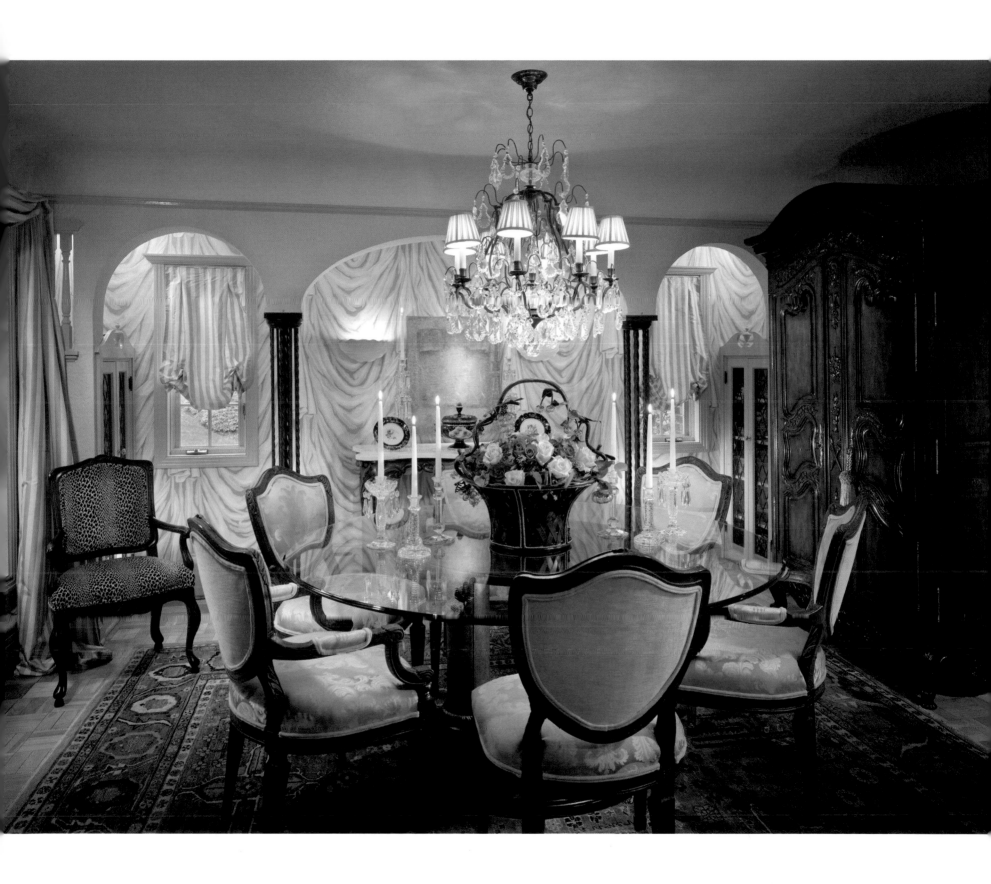

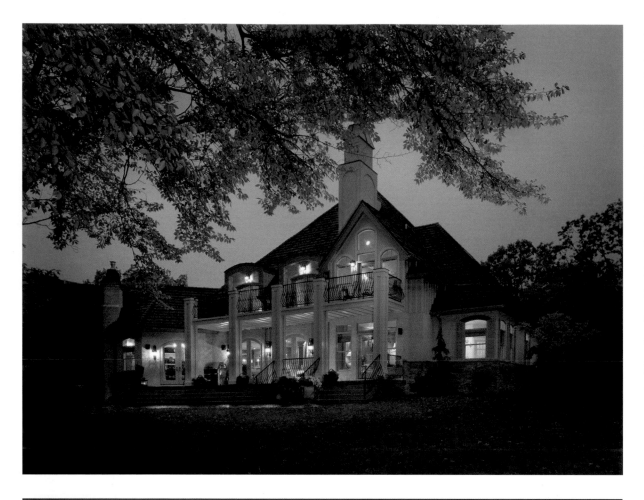

Angela draws inspiration from her clients' preferences and their existing architecture, but also from her personal experiences. A subtle international flair weaves throughout her work, since her vast mental bank of images includes beautiful settings throughout Europe. She has explored old castles in Switzerland and England, the many sites of France and Italy and even had her picture taken with Pope John Paul II inside his private chapel in the Vatican. She appreciates the European respect for history, as new architecture softly intermingles with its awe-inspiring precursors. It is a similar juxtaposition of old and fresh that she desires to create for all of her patrons.

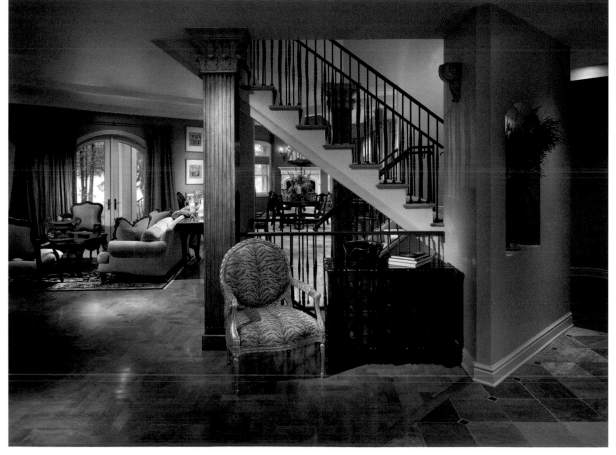

TOP LEFT
A lakeside view of an illuminated Provencal home at twilight.
Photograph by Edward Massery, Massery Photography, Inc.

BOTTOM LEFT
The foyer area in a lakeside home providing an expansive view of the first floor distinguished by an angular staircase and columns.
Photograph by Edward Massery, Massery Photography, Inc.

Based in Pittsburgh, Angela lives in a suburb just south of the city that boasts beautiful homes from the late 1920s. The designer's historical residence echoes her lifestyle—sophisticated and warm at the same time—and impressively, her teenage son's friends are just as comfortable in the space as her own. Reflective of Angela's passion for art, she has tastefully surrounded herself with beautiful works and enjoys the opportunity to expose visitors to the impressive collection. Though each design is guided by a combination of client wishes and site feasibility, she finds particular intrigue in giving old houses a new perspective or even a romantic European feeling that will enhance the residents' lives.

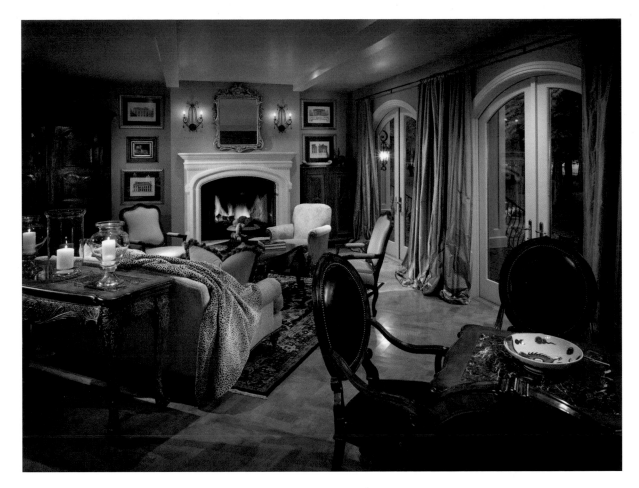

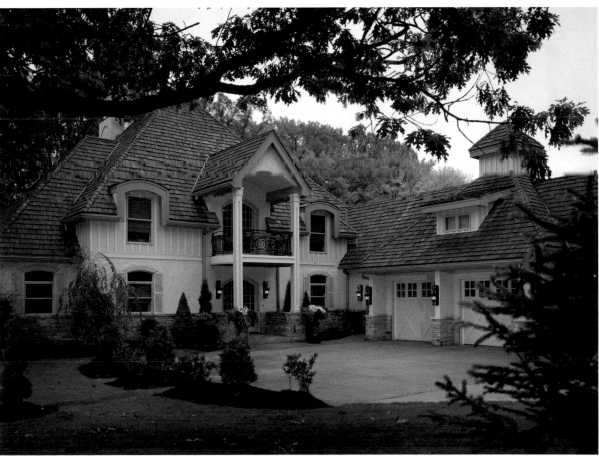

TOP RIGHT
A sumptuous living area in a lakeside home accented with an antique French armoire and herringbone maple floors.
Photograph by Edward Massery, Massery Photography, Inc.

BOTTOM RIGHT
A facade of a lakeside Provencal home featuring a balcony defined by an Art Nouveau railing.
Photograph by Edward Massery, Massery Photography, Inc.

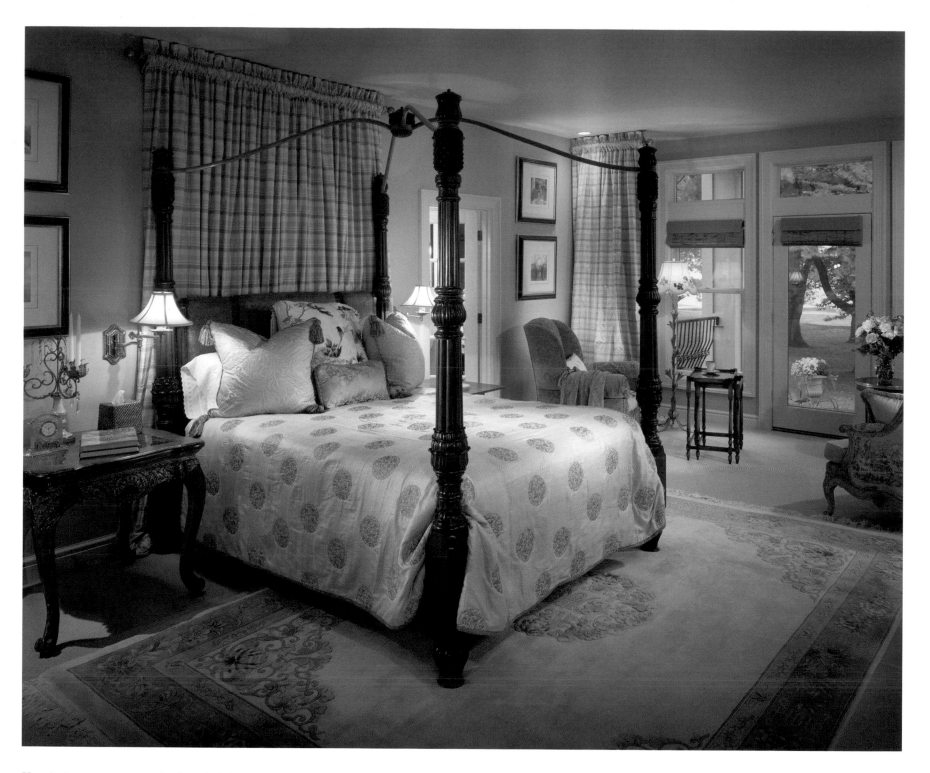

Her designs are not merely thoughtful in aesthetic and function but also from a Green perspective. She utilizes the Green Alliance in her area to identify environmentally friendly materials and incorporates pure textiles such as wool, cotton and silk whenever possible, kindly introducing clients to the importance of protecting the home from potential allergens. Additionally, Angela is mindful to employ passive energy and in the case of ground up design—in collaboration with architects—building orientation and room organization become key factors in the overall plans.

Mixing the best classic elements of various styles in a complementary manner, Angela Lowden's designs universally evoke feelings of warmth and happiness.

ABOVE
A bedroom with a soft relaxing ambience provides a soothing view of a lakeside panorama.
Photograph by Edward Massery, Massery Photography, Inc.

FACING PAGE TOP
A plush, inviting family room utilizing symmetry and vivid color is accented with antiques and a Turkish tribal rug.
Photograph by Edward Massery, Massery Photography, Inc.

FACING PAGE BOTTOM
Angela and Jim Lowden at the Paris Opera House.
Photograph courtesy of Angela Lowden

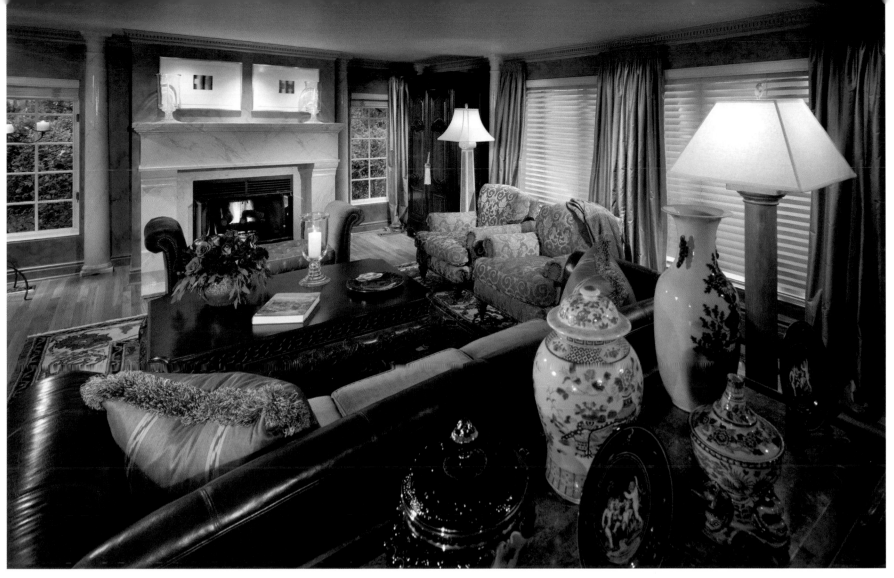

more about Angela ...

WHAT COLORS BEST DESCRIBE YOU?

Warm tones. They complement my coloring and I've always been drawn to autumn time.

WHAT IS THE HIGHEST COMPLIMENT YOU'VE RECEIVED?

Several clients have expressed that my work evokes the feeling of welcoming comfort.

OF WHOSE WORK ARE YOU FOND?

I admire Mario Buatta's exuberant color sense and Philip Johnson's architectural prowess.

WHAT BOOK HAVE YOU FOUND PARTICULARLY INFLUENTIAL?

Annette Tapert's *The Power of Style* is a great story about women like Jackie O. who have found influence and power through their sense of style.

ANGELA LOWDEN DESIGNS, INC.
Angela Lowden
31 Spalding Circle
Pittsburgh, PA 15228
412.561.3006
Fax: 412.341.3505

Index of Designers

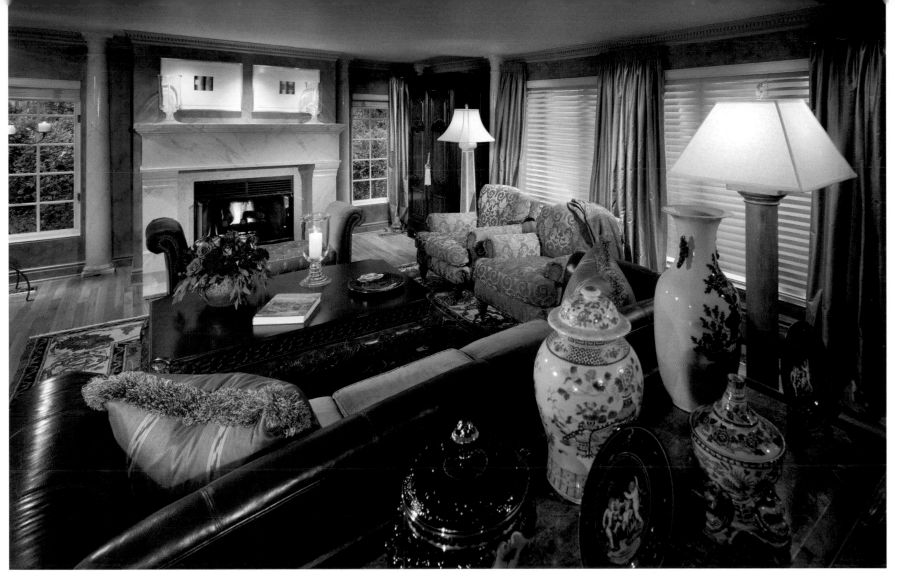

more about Angela ...

WHAT COLORS BEST DESCRIBE YOU?

Warm tones. They complement my coloring and I've always been drawn to autumn time.

WHAT IS THE HIGHEST COMPLIMENT YOU'VE RECEIVED?

Several clients have expressed that my work evokes the feeling of welcoming comfort.

OF WHOSE WORK ARE YOU FOND?

I admire Mario Buatta's exuberant color sense and Philip Johnson's architectural prowess.

WHAT BOOK HAVE YOU FOUND PARTICULARLY INFLUENTIAL?

Annette Tapert's *The Power of Style* is a great story about women like Jackie O. who have found influence and power through their sense of style.

ANGELA LOWDEN DESIGNS, INC.
Angela Lowden
31 Spalding Circle
Pittsburgh, PA 15228
412.561.3006
Fax: 412.341.3505

Publishing Team

Brian G. Carabet, Publisher

John A. Shand, Publisher

Steve Darocy, Executive Publisher

Monique Kennedy, Associate Publisher

Beth Benton, Director of Design & Development

Julia Hoover, Circulation Director

Michele Cunningham-Scott, Art Director

Mary Elizabeth Acree, Graphic Designer

Emily Kattan, Graphic Designer

Benito Quintanilla, Graphic Designer

Elizabeth Gionta, Managing Editor

Rosalie Wilson, Editor

Lauren Castelli, Editor

Anita Kasmar, Editor

Kristy Randall, Senior Production Coordinator

Laura Greenwood, Production Coordinator

Jennifer Lenhart, Production Coordinator

Jessica Garrison, Traffic Coordinator

Carol Kendall, Project Manager

Beverly Smith, Project Manager

PANACHE PARTNERS, LLC

CORPORATE OFFICE

13747 Montfort Drive

Suite 100

Dallas, TX 75240

972.661.9884

www.panache.com

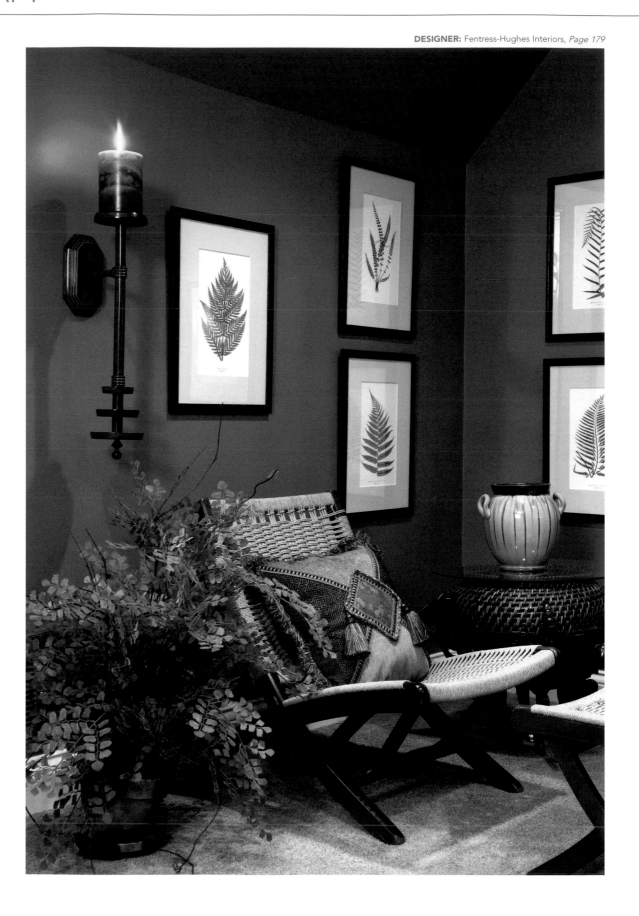

DESIGNER: Fentress-Hughes Interiors, *Page 179*

Dream Homes Series

Dream Homes of Texas
Dream Homes South Florida
Dream Homes Colorado
Dream Homes Metro New York
Dream Homes Greater Philadelphia
Dream Homes New Jersey
Dream Homes Florida
Dream Homes Southwest
Dream Homes Northern California
Dream Homes the Carolinas
Dream Homes Georgia
Dream Homes Chicago
Dream Homes San Diego & Orange County
Dream Homes Washington, D.C.
Dream Homes the Western Deserts
Dream Homes Pacific Northwest
Dream Homes Minnesota
Dream Homes Ohio & Pennsylvania
Dream Homes California Central Coast
Dream Homes Connecticut
Dream Homes Los Angeles
Dream Homes Michigan
Dream Homes Tennessee
Dream Homes Greater Boston

Additional Titles

Spectacular Hotels
Spectacular Golf of Texas
Spectacular Golf of Colorado
Spectacular Restaurants of Texas
Elite Portfolios
Spectacular Wineries of Napa Valley

City by Design Series

City by Design Dallas
City by Design Atlanta
City by Design San Francisco Bay Area
City by Design Pittsburgh
City by Design Chicago
City by Design Charlotte
City by Design Phoenix, Tucson & Albuquerque
City by Design Denver

Perspectives on Design Series

Perspectives on Design Florida

Spectacular Homes Series

Spectacular Homes of Texas
Spectacular Homes of Georgia
Spectacular Homes of South Florida
Spectacular Homes of Tennessee
Spectacular Homes of the Pacific Northwest
Spectacular Homes of Greater Philadelphia
Spectacular Homes of the Southwest
Spectacular Homes of Colorado
Spectacular Homes of the Carolinas
Spectacular Homes of Florida
Spectacular Homes of California
Spectacular Homes of Michigan
Spectacular Homes of the Heartland
Spectacular Homes of Chicago
Spectacular Homes of Washington, D.C.
Spectacular Homes of Ohio & Pennsylvania
Spectacular Homes of Minnesota
Spectacular Homes of New England
Spectacular Homes of New York

**Visit www.panache.com or call
972.661.9884**

PANACHE PARTNERS, LLC

Creators of Spectacular Publications for
Discerning Readers

INDEX OF DESIGNERS